CLASSICAL ART
AND THE CULTURES OF
GREECE AND ROME

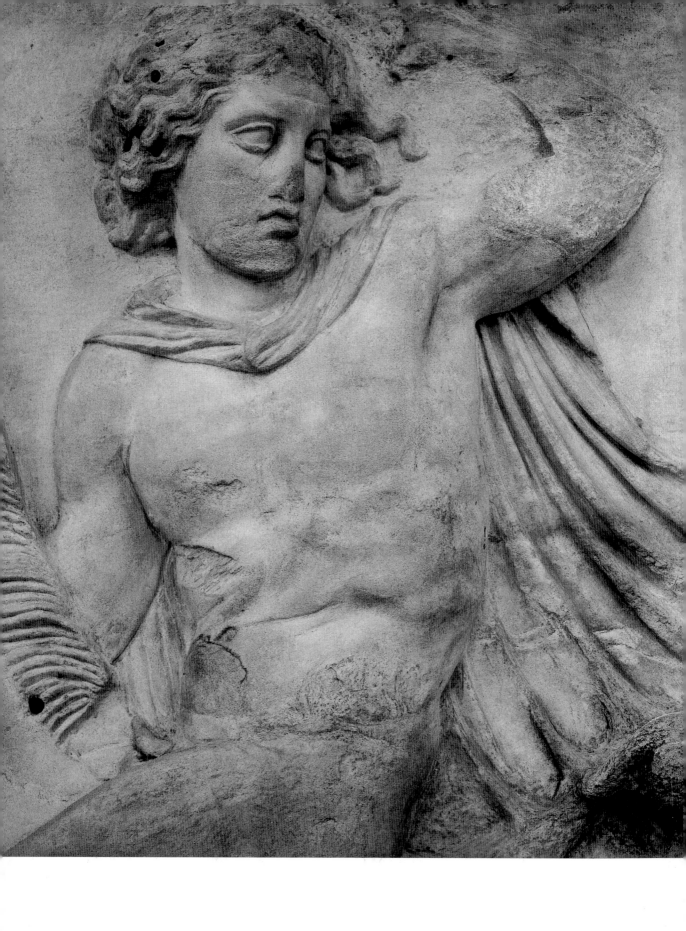

CLASSICAL ART AND THE CULTURES OF GREECE AND ROME

John Onians

YALE UNIVERSITY PRESS
NEW HAVEN & LONDON

Designed by Gillian Malpass

Printed in Singapore

Library of Congress Cataloging-in-Publication Data

Onians, John, 1942–
Classical art and the cultures of Greece and Rome/John Onians.
p. cm.
Includes bibliographical references and index.
ISBN 0-300-07533-2 (cloth: alk. paper)
1. Art, Classical. 2. Art and society – Greece. 3. Art and society – Rome. I. Title.
N5610.O5 1999
709′.38 – dc21
98-43738
CIP

A catalogue record for this book is available from
The British Library

Frontispiece: Detail of a horseman from the frieze
from the Parthenon, Athens, 447–432 BC (see fig. 35).

For
Isabelle and Charles

Contents

Acknowledgements

The origins of this book go back forty years to a summer afternoon when a curious schoolboy asked his father why exactly he had put him, like his older sister and brother, on the path to a Classical education. The argument started by that question continued until my father's death, though I had realised much earlier that his *Origins of European Thought* contained some compelling answers.

At Cambridge Jocelyn Toynbee, R.M. Cook and others introduced me to Classical archaeology, and David Oates provided a measure of the Greeks' achievement by pointing out the areas in which they never rivalled their Near Eastern predecessors. In London new perspectives were gained from Anthony Blunt, who admitted me to the Courtauld Institute to study the methods of art history in the hope that one day they might be used to subvert the then-current approaches to Greek and Roman art, and above all from E.H. Gombrich, who, at the Warburg Institute, introduced me to the 'Classical tradition' and, more significantly, made me conscious of the plasticity – and rigidity – of the human mind. Later much was learned from my colleagues and students at the University of East Anglia, as well as from the art in the Robert and Lisa Sainsbury Collection. Also important were the contacts I made as a visiting teacher at the University of California, Los Angeles, Mount Holyoke College, Northern Arizona University, Oberlin College, the Ecole des Hautes Etudes en Sciences Sociales, Paris, and the Institute for Art History in the National Museum, Delhi. Conversations with fellow scholars during periods spent at the Centre for Advanced Study in the Visual Arts, Washington, the Getty Center for the History of Art and the Humanities, Santa Monica, and the Wissenschaftskolleg, Berlin, generated new hypotheses and tested some to breaking. Discussions, begun in Washington, with Martin Powers on the cultures of early China were essential for putting those of Greece and Rome in context. No debates have been more fruitful than those with friends who were also specialists in Antiquity, especially Richard Gordon and Martin Henig. None has been more enjoyable, or more fundamental, than those with my wife, Elisabeth de Bièvre.

My indebtedness to the authors of the secondary literature on the Classical world is enormous, but it is to those who made that world, especially to the ancient craftsmen of the texts, paintings, sculptures, buildings and all the other objects that are its

surviving witnesses, that I owe the most. The opportunity to travel the length and breadth of the lands that shaped and were shaped by the Greeks and the Romans, visiting sites and museums, and to relate what I saw to a similar experience of the material remains and landscape settings of comparable ancient civilisations in North Africa, the Near East, Asia and the Americas, was a privilege offered by the late twentieth century which I gratefully accepted as allowing me more confidently to reassess the Classical world in a global framework.

The initial suggestion that I attempt a fresh interpretation of Classical art and culture came from John Fleming and Hugh Honour who, in 1966, commissioned me to write the volume on Hellenistic and Roman Art in their Penguin Style and Civilization series, expanding the brief in 1976 to cover the whole of Classical art. This book is the belated response to their challenging invitation. It is also my answer, addressed now to the generation of my own daughter and son, to the question I long ago asked my father.

Finally, I thank Yale University Press, and especially Gillian Malpass, the volume's editor and designer, and Delia Gaze, its copy editor, for giving it such satisfying form and finish.

Preface

There is no recent extended single-author study of Classical art in the English language. Some will feel that this is a good thing. For one person to write intelligently and responsibly in one book about a topic that potentially embraces hundreds of thousands of artefacts produced during a thousand years over an area of several million square miles is not easy, and the welcome growth in the awareness of the variety, complexity and ambiguity of Greek and Roman art in recent years has only increased the risk that any study of it might simply not be worthy of its subject. Describing, let alone explaining, the art and ideas on which, for better or worse, much of later European art has been founded could well be thought an impossible enterprise.

Against this depressing conclusion, though, stands the very stubborness and coherence of that later influence. The power of Greek art over Rome, and then of Greek and Roman art over later generations, resided less in the multiplicity or complexity of that art than in its embodiment of a limited number of traits, traits such as the hardness, mathematical regularity, lifelikeness, uniformity, physical energy and emotional expressiveness of Greek art, or the memorability, monumentality, personality, material and formal richness, flexibility and simplicity of that of Rome. Emerging and fading away, sometimes more than once during a period of ten centuries, these and other traits – often sets of traits – shared by tens of thousands of objects, are the attributes that came to define a tradition now known as Classical. Each trait, or group of traits, developed in a particular place or area in particular circumstances. To analyse these traits and the circumstances in which they came to prominence is more difficult than to classify and survey the works in which they are embodied, but it is also potentially more valuable, since it may help us to understand not only Classical art, but aspects of the art and culture it later affected. Whatever the reasons why much of the later art of the European continent shares features with that of Greece and Rome, whether it is because its makers recognised the Greeks and Romans as exemplary, and imitated them, or simply because it developed in similar circumstances, a knowledge of how and why those features came first to be manifested is equally desirable. To understand the nature and the origins of the principal features of ancient Greek and Roman art is also to begin to understand both their survival and their re-appearance.

The goals of this book are thus limited. It does not deal with all of Greek and Roman art, but concentrates on what many would consider its most characteristic forms and the environments in which these developed, especially Athens, the Hellenistic cities, such as Alexandria and Pergamum, and Rome. Among its principal themes are: the distinctiveness of early Greek art, and the way it, and early Greek society and culture generally, were formed by a unique ecology; the independence of lifestyle of Alexander's artist contemporaries, their and their successors' personal relationships with both patrons and models, and the new psychological engagement elicited in the viewer by works created out of such relationships; the distinctively Roman skills of memory that made possible their conquests, that gave stability to their empire and that underlay the reduction and compression so frequently found in their art and architecture; the elasticity of the imagination that was generated in the Romans by their unprecedented domination of the world's resources, and the flexibility and abstraction of sculpted, painted and built form that such a mental capacity allowed and encouraged them to produce; and, finally, the dependence of both the triumph of the Christian religion and the effectiveness of its art on a conjunction of new needs with the maturing of habits of mind developed over the preceding period. As can be seen from this summary, not only are the properties of Classical art that this book addresses limited in number, so too are the explanations offered here for their appearance. Out of the multiplicity of factors that might be invoked to explain the genesis of any individual work there is here a concentration above all on the few whose underlying importance appears so profound as to determine the overriding characteristics not just of large groups of art objects, but of whole categories of what is often called culture.

This term, culture, is, however, here used more broadly than usual as a way of suggesting a more open approach to the definition and explanation of the properties discussed. Its use in the volume's title and in its chapter headings is designed to remind us that what we frequently celebrate as a high 'cultural' achievement is often best understood, not just as it might be by an anthropologist, as part of a community's complex of ways of doing and thinking, but as it might be by a biologist, as the natural product of the nurturing influence of a limited set of environmental factors on a living organism capable of reproduction and adaptation. Culture, from *colere*, 'to cultivate', 'tend', here draws attention less to the high status of particular human behaviours and more to the process by which they come to be established. Having said that, in each chapter the word has a different emphasis. In the first and last chapters, on the Greek Workshop and the Christian Church, its use draws attention to the extent to which two very different physical and psychological environments each fostered a distinctive way of thinking and of making art. In the Conflict and Competition chapters what is at stake is the way particular social conditions, themselves largely determined by the environment, as was described in the first chapter, produced such concentrations of energies and interests that many different social groups, from craftsmen to philosophers, tended to create, over time, sequences of products that could readily be seen as moving in a limited number of directions. In the Character chapter the focus shifts, throwing into relief new tensions. While Alexander's actions in enlarging the Greek world encouraged people to attribute a new importance to the active role of the individual, whether in history or in art, the experience of that enlargement also increased in many the awareness of their passiveness, and ultimately of their vulnerability. In the Memory

and Imagination chapters the focus is on the way two distinctively Roman mental apti-tudes were each so strengthened by the intensification of the conditions in which they thrived, that they came in turn to nurture new and specific behaviours, behaviours which were important for both the making of art and the response to it. Throughout there is the implication that in the field of culture, almost as in that of agriculture, dif-ferent life-forms at different stages of their development in different environments are associated with different yields. The real, if obscure, process this last analogy implies is, in a sense, the underlying theme of the whole book.

The paradox is only that this process seems from the start in the Greek workshop to partake less of the organic and more of the mechanical, with men and women becoming the product of an ever more controlling social and educational formation and with visual art the mirror of the transformations of body and mind in which this resulted. The resolution of this paradox lies in the recognition that this process is itself a natural one. It was above all because the people who adapted to the stony landscape of Greece relied so much on the use of hard metallic tools for its exploitation that they came to think of themselves in ways that no one had done before. It was thus because the Greeks came to imagine themselves as made of stone and metal that they represented themselves in life-size statues of marble and bronze. More importantly, it was because they thought of themselves in this way that they were so successful when confronting other peoples who did not. Greek art, then, is a powerful testimony both to a core Greek experience and to the disturbing secret of their success.

Those Europeans who for two and a half thousand years imitated the Greeks in their rigorous education and in their mineral self-representation came to share both that secret and its benefits, regardless of the costs. Today those same benefits are now available to people anywhere in the world, with similar, albeit lower, costs. To some of these benefits and costs of so-called western civilisation this book might eventually serve as a brief accountant's guide. Such is the importance claimed here for an under-standing of Classical art and the cultures of Greece and Rome.

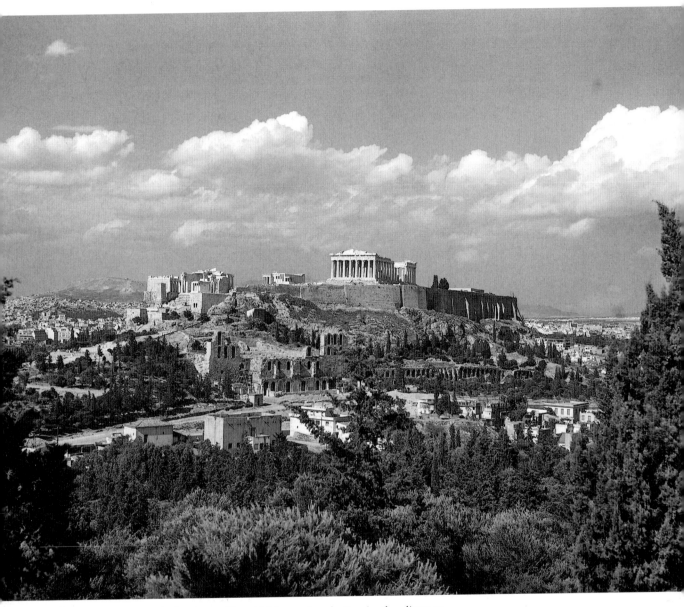

1 View of Athens with the Acropolis and Mount Lycabettos in the distance.

Chapter One

THE CULTURE OF THE GREEK
WORKSHOP

Man as Raw Material

We readily think of our minds and bodies in terms of the chemical and the electrical, the hidden elements and energies of which we believe our world ultimately to be composed. The early Greeks often thought of themselves in terms of the more substantial materials they saw around them. Consciousness itself was literally embodied and feelings expressed in the *thumos*, the damp breath of their lungs. Their bodies were full of liquids. The *thumos* behaved like dew. Blood and other fluids were like streams of water. Bones were for them stone-like. Their most familiar Creation story told how Deucalion and Pyrrha, lone survivors after a punitive flood, were commanded to create a new race by throwing over their shoulders the 'bones of their mother', an expression they understood to mean the bones of Mother Earth, stones. One of these stones was said to have turned into Hellen, father of Dorus, Xuthus and Aeolus, the founders of the principal Greek tribes, Dorians, Ionians and Aeolians, making all Greeks its progeny. The most obvious starting point for this myth, as of others, is false etymology. The chance similarity between the Greek word *laos*, 'people', and *laos*, one of their words for 'stone', led to an assimilation that is implicit in the *Iliad* (XXIV, 611) and explicit in Pindar (*Olympians*, 9, 45 and 46). This correspondence between the words gave the myth its overt rationale, but its compelling authority derives from the dominant role of stone in the Greek experience. A unique combination of geology, climate and land use left Greece a land of increasingly bare mountain ranges separating fertile plains. Probably in no other place where the conditions for life were similarly propitious did the bones of mother earth, often brilliant marble, have such visibility and such importance in people's lives. Interestingly too, this was nowhere more true than in cliff-girt Attica, the area in which most of what later became recognised as typically Greek culture – whether in the form of institutions, of literature or of art – acquired its distinctive shape. Athens itself was built around the exposed limestone Acropolis with Mount Pentelicon, source of the marble for its greatest buildings nearby (fig. 1). It was as natural for those who lived in Greece and the Greek islands to think of themselves as made of stone as it was for those who lived in the alluvial plains of Mesopotamia and

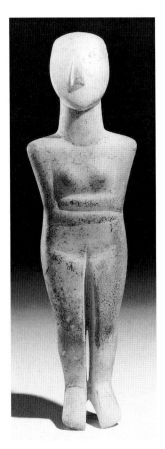

2 Female figurine, marble,
*c.*2500 BC.

elsewhere to think of themselves as made of clay. The unique nature of this relationship helps to explain why nowhere else in the world do we find already in the third millennium BC marble as the material for a myriad small representations of the human body (fig. 2). The inhabitants of the Aegean and of the Greek peninsula must have experienced an unconscious affinity with the rock with which they were surrounded long before the chance assonance of the words for 'people' and 'stone' brought this identification to the surface of their minds and led to its expression in the story of their origins.

The notion that the Greeks were a people descended from stone ancestors gains further significance when it is connected to another early myth, that of the four races of men, each made from a different metal. This is found in Hesiod's *Works and Days* (109–201), composed probably in the late eighth century BC. According to Hesiod, five successive races or generations were fashioned by the gods and four out of the five are each said to be made of a different mineral. The first was made of gold and its members lived long, carefree lives. The silver race was corrupted and lived less well, though still much better than their successors, the bronze. They were not only themselves made of bronze, lived in bronze houses and worked with bronze, they were enormously strong and spent their time in fighting with bronze weapons. Then came a race of heroes who also spent their time at war. The last race and the worst, Hesiod's own, is made of iron and involved in perpetual conflict. What gives this account its particular edge is that the passing of the generations brings a generally closer material correspondence between man, his artefacts and his tools, especially his weapons, an idea that is taken up by Plato in the *Republic* (415A). There Socrates describes the four classes of men as gold, silver, bronze and iron, with a clear implication that the last two groups, the craftsmen and farmers, are like metal tools for the first.

That the Greeks wrought their self-image in these ways is revealing. Their ideas of what their bodies were made of and of the uses to which they would be put were highly unusual. In other cultures man's nature was described in other terms. Anxiety about it often focused on what happened after death. There was often an assumed kinship with the plants or animals with which men and women lived. When the question 'what are we made of?' was posed the most frequent answer was, as in the biblical Creation story, of clay. Such an answer explains most of our properties, our hardness and softness, our moistness and dryness. It also suggests how we start off soft and malleable, acquire rigidity with age and, after death, finally break up. There are occasional stories of individuals, classes or races being made of stone, metal and other materials in other cultures when individuals or groups have found it desirable to claim particular attributes. Only in Greece did such stories constitute a central tradition, with references to clay men, as in the Prometheus story, being relatively peripheral. Of the factors that formed the distinctive Greek approach none was more influential than the ready availability of stones and minerals in their naked mountains and the special importance of the crafts that developed as they learnt how to work them.

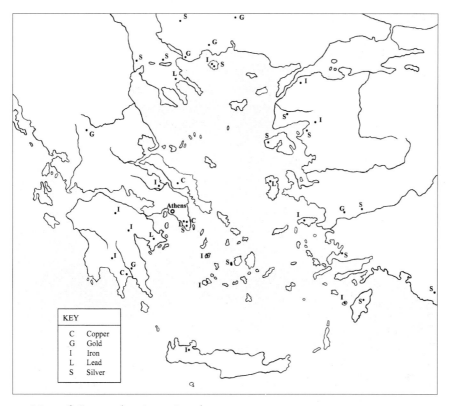

3 Map of Greece showing mineral resources.

The mountains of Greece, unlike the plains of the Near and Far East, were rich in hard workable stones, in minerals and in timber (fig. 3). Unlike the mountains of Asia, which possessed similar resources, they were also surrounded by seas, which facilitated trade, including he acquisition of additional supplies of vital ores from remote islands, copper from Cyprus in the east and iron from Elba in the west. The simultaneous availability of both metal ores and firewood for smelting was particularly vital. The metal could be used to make tools to work the other materials. Bronze could be turned into weapons, stone into buildings and wood into ships. The ships could in turn be used to transport agricultural and craft products. The development of craftsmanship was essential for agriculture and trade, civil and military life. Craftsmen's attitudes were so prevalent in early Greek communities that they had profound implications for their self-perception. Ultimately they led many to consider themselves as both raw material and tool.

This affected the way the Greeks viewed themselves and the way they expected to treat and be treated by others. The idea of being like stone or metal implies a general adaptability for utilitarian purposes. Those who think of themselves as made of a workable raw material can readily accept being reshaped for any purpose. They may allow others to do the shaping or they may shape themselves. If people think of themselves as tools they can shape either others' raw material or their own. All that is necessary is that someone identifies the end to be achieved and determines the shape required in order to achieve it. At whatever level this happens the consequences for people's

self-consciousness, self-awareness, self-fashioning and self-exploitation are enormous. The Greek and subsequent Western activity in these fields is a result of a uniquely materialist approach to humanity. The notions of man as raw material and man as tool, which appear at the beginnings of Greek culture, are less explicit today but no less influential.

People familiar with the imagery of these myths had an affinity with stone and metal which prepared them to express their being in stone and metal statues. They also, as we shall see, gained a particular empathy with the masonry wall constructed out of carefully jointed blocks. More essentially the kinship between Greeks and worked stone and metal accommodated an assimilation between man and artefact that was to become a fundamental feature of Western culture. It looks forward to the development of such man-shaping institutions as the gymnasium concerned with the training of the body and the school with the education of the mind. It prepares us to understand why sculptures and paintings that represent those properties, and buildings that embody them, are principal traits of the tradition they inaugurated. The Greek sense of themselves as endowed with mental dispositions that made them similar to a particular class of artefact helps us to understand the character of both their culture and their art. In their art the Greeks are not represented, they are. Greek art is often concerned not so much with representation as with being. Nowhere is this more true than in their sculpture. Their concentration on more or less life-size, marble or bronze portrayals of the naked male body constitutes an attempt to capture the essence of the most important object in their experience, the stone- or metal-like body of a well trained soldier (fig. 4).

The sense of affinity between man's body and the physical world around him also explains the extraordinary parallelism between the theories of physics and medicine. The Greeks' tendency to think about both the world and their bodies in the same terms that they thought about man-made products led them to ask different questions about them from those asked in other cultures. What interested them was less, 'Who made it?', than, 'Of what is it made, what are the inherent properties of that material and what is its configuration?'. Nor were they easily satisfied by the answers. Like the craftsman who asks such a question of his rival, they did not rest until they had got hard answers responding to their needs. As far as questions about the world were concerned the answer that proved most satisfactory from their point of view was that it was made up of four substances with which craftsmen worked daily, earth, air, fire and water. Similar questions about the human body received similar answers. This was seen to be governed by a balance between four humours. Ill health was due to an imbalance between them and to a lack of moderation in the properties of heat and cold, wetness and dryness, the temperaments. Such theories developed to fairly full formulation in the work of Empedocles around 450 BC before becoming established in the works of Plato and Aristotle. The body, like the world, was seen as a collection of raw materials, only in a more unstable mixture. It was affected by sickness in much the same way as the world was by bad weather and natural disasters, but more frequently. No one could do much about disasters in the world, but the new type of medical craftsman, such as those who contributed to the corpus of so-called Hippocratic texts, developed complicated methods for adjusting the humours and the temperaments, methods that often, as in a manufacturing or repair process, involved mechanical intervention through cupping, torsion, ligature and surgery.

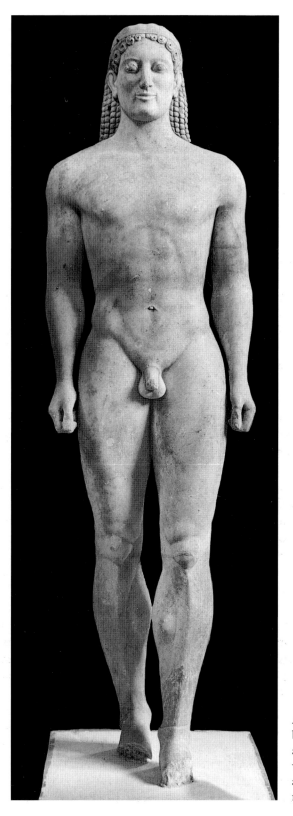

4 Funerary statue of Kroisos,
base inscribed: 'Stand and mourn
at the monument of dead Kroisos,
whom furious Ares once destroyed
as he fought in the front ranks',
marble, Attic, *c*.525 BC.

The Body and Its Tools

The craftsman is first interested in raw materials in order to make tools and it was as an assemblage of tools or instruments (*organa*) that later Greeks increasingly saw the body. Plato talks about the senses as instruments (*organa*) for learning (*Republic*, 508B). Aristotle uses the same word when he calls the legs the 'instruments of locomotion' (*Generation of Animals*, 732B), the hands the 'instruments of instruments' (*On the Soul*, 432A) and talks generally of the 'instruments of breathing' (*Parts of Animals*, 664A) and 'the digestive instruments for the working [*ergasia*] of food' (*Generation of Animals*, 788B). For the greatest Greek biologist digestion was best understood as food-processing.

The Greeks' tendency to think in terms of raw materials and tools exercised a continuous influence on their attitude to language. When, early on, they looked at their names in order to find out what they were made of, they were essentially mining the name as if it was a mountain. When they thought they had discovered their material origins, finding the word *laos*, 'stone', in the word people, they may be said to have imagined themselves to be the result of a process of transformation like that experienced by any raw material. A similar process of word-mining discovered the origins of smaller groups, of Myrmidons in *murmekes*, 'ants', and of Spartoi in the *spartoi*, 'sown', snake's teeth, as discussed in the next chapter. Words they also thought of as tools. Other peoples used spoken words for many purposes, for getting favours from superiors, enforcing obedience in inferiors or obtaining agreement from equals. They also showed their general belief in the more instrumental function of written words by using them for administrative records, historical commemorations, curses and spells. The Greeks went much further. For them words, both spoken and written, had a greater physical reality and instrumental value. Homer repeatedly describes speech in terms of 'winged words' which pass the 'defensive barrier of the teeth', portraying them as projectiles thrown from behind a fortification. He sees them in a sense as weapons or tools and repeatedly demonstrates their utility in establishing power relationships, as through command, seduction and above all persuasion. Early lyric poetry is also exceptionally instrumental in the way it works on the emotions, whether it is encouraging military virtue, erotic indulgence or sad remembrance. Later still, Aristotle looking back at Greek poetry and Greek rhetoric found it natural to classify both in terms of their effect. Tragedy was designed to excite pity and fear, comedy laughter. The chief function of rhetoric was to persuade. Authors working in each of these genres were described as practising a *techne*, 'skill', a term originally applied only to manual and manufacturing skills but now applied to all activities where rules were applied to achieve a particular result. Manual skills provided the models for mental ones.

Greek poets began as *aoidoi*, 'singers', but they soon became *poietai*, 'makers', craftsmen of the spoken word. This material they, like other artisans, carefully shaped according to *rhuthmos*, 'form', and *metron*, 'measure'. But it was in their use of writing that they were most craftsmanlike. In the process of adapting the Semitic alphabet to their own unrelated language the Greeks refined its already remarkable ability to represent sound. By giving the letters separate functions they allowed voiced sounds such as a, e, i, o and u, the vowels, to be represented by one set of signs, and sounds such as b, c, d and g, the consonants, to be represented by another. By breaking speech down further than before, into its constituent elements, they were able to give it a fuller

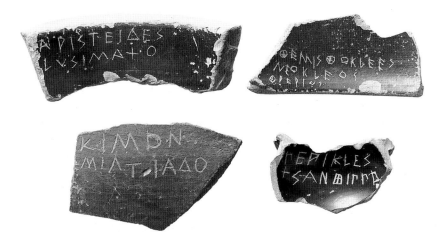

5 Ostraka from the Athenian Agora with the names of Aristeides, Themistokles, Kimon and Perikles, fifth century BC.

material expression. Greek spoken words were perhaps already more like tools or weapons than those of other cultures because of their role in political and military life. With their sounds accurately transcribed in stone or bronze and painted on pottery their full force was preserved. Whether letters served to inscribe dedications, identify figures on vases, record laws, mark votes for ostracism (fig. 5), assert artistic authorship or preserve oral compositions, their ability to reproduce speech more fully enabled them to communicate more effectively.

So strong was the Greek sense of the physical reality of words that Plato in the *Cratylus* (388–90) imagines names being made as tools (*organa*) by a 'name-smith', *onomatourgos*, just as a weaver's shuttle is made by a carpenter. Like the carpenter, who makes the shuttle under the guidance of the eventual user, a weaver, the 'name-smith' is to be guided by a *dialektikos*, an expert in discussion. Later in the dialogue he further exploits the idea of words as material things when, in the spirit of the earlier etymologies, he extracts their meanings from their sounds. Again in the *Theaetetus* (202, 203), comparing words to other things, he asks what are the 'elements' (*stoicheia*) of which they are made and decides that it is not syllables, but letters (*grammata*) and the discrete sounds represented by letters. He even goes on to define articulate speech itself, *logos*, as a process of material production. It consists of the stamping or imprinting of the flow from the mouth and is comparable to the control of water or the projection of an image on a mirror (*Theaetetus*, 206C). In a similar vein *logos*, compelling speech or argument, can be described as 'binding with iron or adamant' (*Gorgias*, 508E). It was this mechanistic approach to words that helped to create the mental climate in which Aristotle could develop the particular form of *logos* that we call logic as a systematic instrument. As he says in talking of proofs at the beginning of his treatise on rhetoric: 'If one is supposed to defend oneself with one's body, why not with verbal argument [*logos*]?' (*Rhetoric*, I, I) This instrumental approach to logic led long after his death to all his works on that subject being grouped together under the title of the *Organon*, or *Tool*. A spoken word was a powerful instrument. A written one was even better. A word system for winning arguments was a supreme tool. Greek speech, Greek writing and Greek logic, each progressively rendered language more tool-like. For a people who thought of themselves as a collection of raw materials they were valuable instru-

ments. Combined and employed by one person's mind, they were well adapted for working on and shaping that of another.

It was the experience of the physical environment and the material activities of daily life in early Greece that shaped this verbal imagery. Later, in Classical Athens, where both hard substances and the crafts to work them were even more important than they were elsewhere, it was the physical materiality of this imagery, encased first in performances, lectures and theories and then above all in written scrolls, that gave it a new substance and authority of its own. Transferred to the schools and libraries, first of the Hellenistic world and then of Rome, this imagery influenced the thinking of those who knew nothing of the conditions that produced it. The environment and activities of early Greece still indirectly shape thought today.

Military and Civil Crafts

The first writer who stands back and describes the Greek way of living is Hesiod and it is he who first presents its underlying principles. His most personal work is a poem whose later title, *Works and Days*, well suggests its engagement with craft activities, especially those of the farmer. At the beginning, however, he reflects briefly on Strife, a condition that, as he points out, affects the whole of life. There are two sorts of Strife, one is worthy of blame, the other of praise:

> For one encourages evil war and battle, being cruel. Her no one loves, but it is through the necessity that comes from the decisions of the deathless gods that men honour this severe Strife. But the other . . . is much kinder to men. She wakes to toil even the idle. For a man grows eager to work seeing his neighbour, a rich man who hastens to plough and plant and to arrange his house well. And neighbour is jealous of neighbour as he pursues wealth. This strife is good for men. And potter grudges success to potter, and builder to builder, beggar is jealous of beggar, and bard of bard.
>
> *Works and Days*, 11–26

Hesiod could have described life in terms of other concepts than conflict. Nor, having focused on conflict, did he need to stress its presence in the marketplace as well as the battlefield. In the literatures of Mesopotamia or Egypt the recurrent themes are unpredictability and impermanence. War, except as a source of unpredictability, does not have much importance, nor do craft and commerce. Hesiod found it natural to stress the importance of conflict precisely because he and his contemporaries would have experienced its predominant influence on both military and civil life, as we shall see in the next two chapters. In the first we find how conditions in Greece required all male citizens, whatever their activity in ordinary life, to be prepared to act as soldiers. In the second we find how even in civilian life competition was liable to be equally intense. Hesiod does not specifically mention tools in his celebration of Strife, but he was well aware that in all these contexts success depended on skill in deploying them. This was why they had such importance in the Greek mind. Whether in the marketplace or on the battlefield, a sense that one was made of stone or metal and that one's body consisted of a set of instruments that one was trained to use was equally reassuring.

Chapter Two

GREEK ART AND
THE CULTURE OF CONFLICT

The General as Craftsman and the Soldier as Artefact

> The Trojans advanced with cries and screams, like birds. . . . But the Achaeans
> advanced in silence, breathing strength, seeking in their hearts to protect each other
>
> *Iliad*, III, 2–9

In these words, preserved in Homer's *Iliad*, a work composed probably in the early
eighth century BC, the people known to us as the Greeks for the first time in the
written record distinguish themselves from other communities. Silent and strong they
are united by their desire to offer each other mutual defence. Their opponents, the
Trojans, a related population who lived in north-east Asia Minor, are as noisy and dis-
organised as a flock of birds. While the individuality of the Trojans reduces their eff-
ectiveness, the conformity of the Greeks in body and spirit enables them to perform
as a team. Later the essence of this conformity is revealed. While the Trojans are like
natural objects, the Achaeans are like artefacts. They

> stood firm . . . awaiting the Trojans and noble Hector, knitting spear with spear and
> shield with overlapping shield. Shield pressed on shield, helmet on helmet, man on
> man . . . so close to each other . . . Thinking to go straight ahead they desired to
> fight. But the Trojans struck together first, with Hector in the lead going straight at
> them, like a destructively rolling boulder which a wintry torrent pushes down from
> the brow of a crag . . . until it arrives at the plain and rolls no more in spite of its
> momentum.
>
> *Iliad*, XII, 126–42

Hector may claim that 'the Achaeans will not long hold out against me, even if they
have formed themselves up like a tower' (*Iliad*, XII, 151–2), but against the united for-
mation even his energy has no effect. Against a well-built tower the natural boulder is
powerless. The Trojan is like an irregular rock falling under its own weight. The Greeks
fit together like blocks of worked masonry. In Book XVI this image is further developed.
Marshalled by their leader, Achilles, the Myrmidons, close their lines,

6 Scheme of the phalanx.

as when a man knits together the wall of his lofty house with close-fitting stones, keeping out the force of the hot winds, so did the helmets and bossed shields fit together, shield against shield, helmet against helmet and man against man.

Iliad, XVI, 211–15

In motion now, the formation drives all before it. As the *Iliad* continues Homer pulls back the surface of his epic embroidered with a thousand bloody combats and petty passions to reveal underneath the deadly effectiveness of the Greek warrior once he is integrated into a tight formation. In single combat or in the confusion of a sudden engagement Greeks and Trojans are evenly matched. It is only their ability to work in a regular configuration, described in the text as a *phalanx*, that gives the Greeks their decisive advantage (fig. 6).

Homer does not explain the secret of the phalanx. He outlines only its appearance and its effect. But the imagery of his language ensures that we understand that the formation's strength depends on two factors, the ability of the general to shape his men to fit like stones in a wall and the readiness of those same men, when subjected to such shaping and co-ordination, to function as an integrated whole. The success of the phalanx is assured by the unique organisational skills of its commander and the unique training of both body and mind of the soldiers of which it is composed. These are the qualities that enable the Greeks from Europe to become members of a fighting unit whose effectiveness gives them victory over the Asiatic Trojans. The ability to form a phalanx is not the sole determinant of the identity of the Greeks in the *Iliad*, but it is the critical one. A major theme of the poem is the successful conduct of war, how to avoid defeat and achieve victory. The perfect phalanx is presented as the key to both. It is a key held only by the Achaeans.

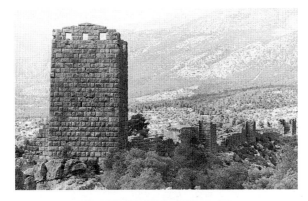

7 Towers and wall, Aigosthena, third quarter of fourth century BC.

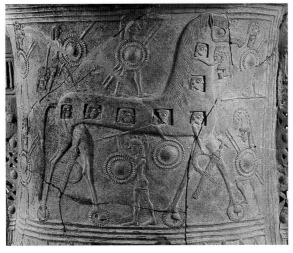

8 Trojan horse, detail of relief amphora from Delos mid-seventh century BC.

The value of a tight formation of armed men was certainly recognised by earlier peoples. What the text of Homer suggests is a new and precise awareness of its merits. These are repeatedly alluded to in the language used to describe it. Most expressive is the word 'phalanx' itself. Related to the English 'balk' or 'plank', it was regularly used in Greece in its original sense, for a log or length of timber. To describe a row of armed men as a 'balk' of timber credits them with a remarkable rigidity and unity, qualities similar to those implied in the comparison with the wall and the tower. When the poet compares the general to a builder and the armed warriors to stones that fit so well together that the wind cannot penetrate them he offers a more explicit account of how the rigidity and unity are achieved. The wall, like the tower, shares these properties with a balk of timber (fig. 7). Where masonry and timber objects differ is in their relative advantages. The attributes of the immobile stone wall or tower are principally defensive; those of the balk, which might be rolled forward, are offensive. Both attributes, incidentally, were combined in the wooden horse that rolled into Troy with such deadly effect and which was represented soon after the *Iliad* was composed as resembling a mobile building, its crew of warriors marshalled phalanx-like at regularly spaced windows (fig. 8). The image of the building of the wall is particularly successful because it characterises the distinctive abilities of both commander and men.

The commander, like the builder, knows the configuration he desires and how to pick and prepare his men to make it up. The men, like the stones, must have inherent properties of strength and solidity and must also be in some sense pre-shaped. Homer's language persuades his listeners that Achilles' success in drilling the Myrmidons is possible only because both he and they think in such terms. The essence of the Greeks' superiority was all the clearer for those who remembered that Hector, the best of the opposition, was neither builder nor building block, but a rough and tumbling boulder.

The Greeks desired to see in the members of the formation the properties of hardness, sharpness and regularity familiar in the constituents of the masonry structure. Similar desires lie behind comparisons between warriors and organic nature. One example is the story of the origin of the Spartoi, or 'sown men', the aristocracy of Thebes. These were said to be descended from the warriors who grew from the rows of snake's teeth sown by Cadmus, founder of Thebes, on the order of Athena, warriors who immediately engaged in combat with each other. Snake's teeth possess inherently, and more perfectly, many of the properties people sought in stones, and others besides. They are harder, sharper, more regular than even the most carefully finished blocks. They also fulfil a commander's dream. Arrayed in three rows in the snake's jaw those

9a The body of Sarpedon stripped of its armour, detail of a kalyx krater painted by Euphronios, Attic, *c*.525 BC.

behind move up unbidden when necessary to replace those in front. A phalanx made of men who sprang from snake's teeth was even better than one made of men who sprang from stones. So vital to the early Greeks was the effectiveness of this military formation that they developed accounts of their origins whose main appeal was that they suggested that the properties required were naturally theirs. Achilles' Myrmidons offer another example of the same phenomenon. Their reputed descent from *murmekes*, 'ants', made them seem uniquely warlike, well organised and indomitable. The aptitudes of ants as builders combined with their fondness for operating in lines prepared for Homer's comparison between the Myrmidons' formation and a well-built wall. Even in late sixth-century Athens it was natural for similar reasons to compare armed men with lesser creatures, as on a great red-figure calyx crater by Euphronios which celebrates the importance of armour to the warrior. On one side we see Sarpedon, a Trojan ally and Lycian chief, pitiful and naked after he has been killed and stripped of his armour by the Greek Patroclus (fig. 9a). On the other side, warriors are shown enthusiastically putting on armour such as that he has lost (fig. 9b). One has a shield decorated with a scorpion, the other with a crab. The comparison between the segmented exoskeletons of the aggressive arthropods and the hoplite's armour could not have been made more elegantly. The Greeks readily thought about themselves in terms of things in their environment that possessed the properties to which they most aspired,

9b Warriors arming, detail of a kalyx krater painted by Euphronios, Attic, *c*.525 BC.

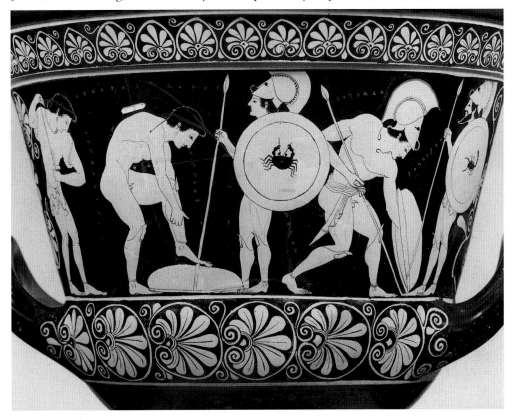

those that were essential for one principal purpose, war, and for one form of war, fighting in the phalanx.

The Necessity of the Phalanx

Hesiod described war as a 'necessity' for his eighth-century contemporaries and this necessity derived from Greece's geographical and historical situation in the first millennium BC. Although economic life recovered after the fighting and turmoil associated with the collapse of the Mycenaean kingdoms after 1000 BC, this did not bring an end to conflict. Instead warfare became an endemic system for stabilising relationships. As settlements established themselves in the narrow valleys of the peninsula the growth of their populations often exceeded that of their ability to produce food. There was frequently the temptation to look beyond the surrounding mountains to the land of neighbours, and rival towns coveted each other's territories. Whether for defence or for attack each community needed its own armed force. Successful farming was possible only where military strength guaranteed security. Without territorial control it was always possible that a neighbouring state might invade and appropriate surplus production, as the Spartans did in Messenia. In the Near East such territorial control, once established by a major centre, was fairly stable. In Greece no community could be sure that a new year might not bring a predatory incursion from an ambitious neighbour anxious if not to conquer at least to damage him. A high level of military preparedness was either really necessary for survival, or perceived as being so, and this profoundly affected the way of life.

What above all distinguished the Greek situation from that of communities with a comparable level of urban development in the Near East and elsewhere was the need to rely on local manpower. While the rulers of Egypt and Mesopotamia could call on feudal dependants and others to enlarge their armies when needed, the Greek city states, surrounded as they were by rivals in similar positions, had to content themselves with maximising the efficiency of their own limited human resources. To do this all men of fighting age in the community had to be healthy, disciplined and heavily armed. Above all they had to be trained to fight in a highly efficient formation, the phalanx, which as we saw had already been recognised as a key feature of Greek warfare and which gained increasing prominence in the seventh and sixth centuries (fig. 6). The ability of the upper classes to operate as cavalry was still important, but their importance was increasingly marginalised by the collective force of the larger body of 'hoplites' (from *hopla*, 'arms'), heavily armed foot-soldiers. These were the class of people, often city dwellers, who might not be able to keep horses, but who had enough resources to acquire body armour, a sword, spear and shield. The significance of the armour itself for the individual is well illustrated by the Sarpedon vase (fig. 9a and b), but it was its use in a military formation that was most critical. The ability of a few hundred of such hoplites to maintain an absolutely regular rectangular formation, operating either as a long column or as a broad front, was most often decisive in determining the outcome of critical battles. To be effective it was vital that each warrior should be able to maintain a position about six feet apart from his neighbours whether they were beside, in front of or behind him. Each had to have enough room to wield

his weapons, the spear and shield, but must leave no space that the enemy could penetrate. This was the basis of the phalanx which became an increasingly vital instrument of war from the eighth century onwards as the improvements in economic life produced a sufficient supply of men of sufficient wealth to equip themselves to the required level.

The 'necessity' that led to the development of citizen armies made up of heavily armed and well trained soldiers was a force that became a principal factor shaping Greek culture. The need for better armour advanced technology. The need for health, strength, discipline and motivation led to the enforcement of strict regimes for young men. Most far reaching were the consequences of the need to prepare men to operate in the phalanx. Such properties as unity, uniformity, regularity and measure, which were familiar in buildings and other products in other cultures, were now required in people. They were aspired to by men zealous to defend their homes and they were desired in them by women anxious for their own protection. At the same time the need to strengthen the motivation of each male in the service of society profoundly changed the concept of the individual. It produced an attention to all forms of psychological persuasion, especially the imposition of a system of rewards and honours and the exposure to examples suitable for imitation, in life, in literature and in art. It also led to the encouragement of increased participation in the decision-making process. The necessity that led to the development of the phalanx also forged new institutions, which sustained it. These included the Great Games at Olympia and elsewhere, special forms of music, literature and art, training and education, and democracy. At the Great Games health and strength were rewarded. By music uniformity of movement and mood was instilled. By literature and art examples were propagated. By training and education regularity and order were infused into the body and the mind. By democracy decision-making was vested in those who had to execute its most dangerous conclusions. Most important were training, the key to efficiency, and democracy, the key to motivation. Military training existed in some form in all Greek states and was typically required for *ephebes*, the male children of native and free members of the community who were past adolescence. It was at its most highly developed in Sparta and enabled that state to become during the fifth century one of the most powerful in Greece. Democracy, rule by the *demos* or 'people', involved the participation in decision-making by all male *politai*, 'citizens' of military age. It was less widespread than military training and found its fullest development in Athens. The military basis of democracy is apparent in the word *polites* or 'member of the polis'. *Polis*, like the Indian *pur*, means 'fortress' and was used for citadels, such as that at Mycenae. It was the original designation of the fortress of Athens, now called the Acropolis. The Greek word for war, *polemos*, shares the same root. A *polites* was first and foremost a warrior, 'member of a fortress'. It was the 'members of the fortress' who became the members of the phalanx. The extension of the vote in Athens in the sixth century BC laid the foundation for the city's military success in the fifth. The Peloponnesian War at the end of that century was between Athens, the state whose soldiers had the highest level of individual motivation, and Sparta, the state whose soldiers were best trained. Motivation and training were the attributes most required in the successful phalanx.

War had a profound impact on the structures of Greek life. It also provided the principal themes of its art and literature. Much of Greek art and literature reveals the

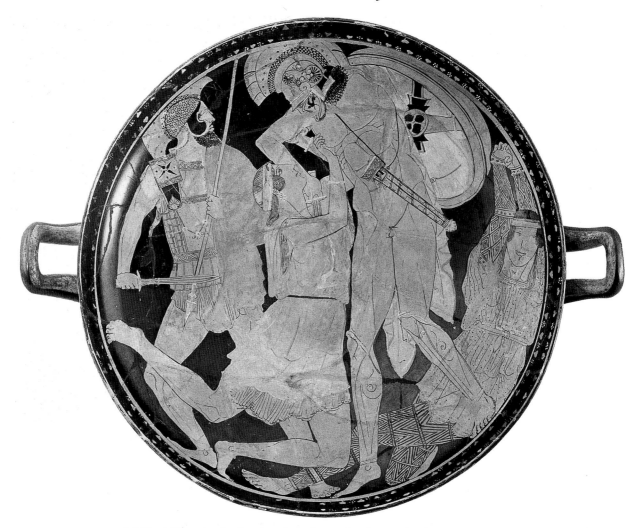

10 Achilles killing Penthesilea, interior of a cup by the Penthesilea painter, Attic, second quarter of the fifth century BC.

dominance of military concerns. Following the composers of epics such as the *Iliad*, the first known individual composers of short poems from the seventh century onwards, authors such as Archilochus, Tyrtaeus and Solon, also devote much attention to the celebration of military achievements. History writing too emerges in the fifth century as the study of two great wars, the Persian and Peloponnesian, in the works of Herodotus and Thucydides. In the development of monumental painting, as well, warfare had a central role, being the subject of the most important group of works in fifth-century Athens, the lost decorations of the Painted Stoa or Stoa Poikile, executed by Polygnotos, Panainos and Mikon and showing Marathon and other battles. Indeed, in art generally, warfare and the activities leading up to it, and following it, are far and away the most common theme. Most striking is the prominence of such scenes in the two contexts in which they are rarest in other cultures, relaxation and religion. The paintings that adorn the vessels used for drinking and dining often show scenes either

of combat or contest, whether between mythical heroes, between heroes and monsters, or between Greeks and their enemies, or scenes of preparation for such combats and contests (figs 9, 10, 18–20). Similar topics fill the metopes and continuous friezes of the temples of individual cities and the treasuries erected at cult centres (figs 32 and 67–70). The most popular sculptural figure-type, both at shrines and in cemeteries, was the standing youth, naked and ready for military training (figs 4 and 30), and when a sculptor's workshop is represented on a cup the typical statue shown is of an armed and aggressive male (fig. 53). No monument illustrates the predominance of the military in art better than the Parthenon (447–432 BC), built within the original *polis* or citadel of Athens to house the warrior goddess Athena (figs 11, 32, and 33, 35 and 36, 70 and 71). Its surviving fragments are often thought of as an expression of calmness and refinement, but as completed it was an embodiment of distinctly warlike tastes. Outside, fighting and violence was the subject of all the sculpture. One pediment showed the goddess's

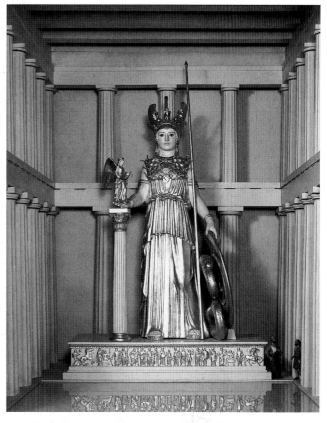

11 Parthenon, interior reconstruction, Athens, 447–432 BC.

violent birth when Poseidon cut open Zeus' head with an axe, and the other the struggle between Athena and Poseidon for rule over Attica. The metopes illustrated fights between Greeks and Amazons, Greeks and Persians, Gods and Giants, and Lapiths and Centaurs (fig. 70). Round the cella ran a procession, religious in reference but predominantly military in content, consisting almost entirely of mounted cavalry (figs 35 and 36). Inside, a huge statue of the heavily armed warrior goddess dominated, her shield decorated with reliefs of the battles of Greeks and Amazons on one side, Gods and Giants on the other (fig. 11). Even her sandals were adorned with the fight between the Gods and Giants. Perhaps no major religious building of any culture – and hardly any building of any type – has been so comprehensively decorated with scenes related to war. This, however, is less surprising when it is remembered that the temple was conceived by Pericles (fig. 12), who ruled Athens as *strategos* or 'general', and that it was paid for out of the treasury of the Delian League. It was natural for war to be a central concern of fifth-century Athens. Athenian power was founded on the success of the Athenian phalanx at Marathon (490 BC) and of the Athenian fleet at Salamis (480 BC) and guaranteed by her leadership of the defence League. At Athens, as elsewhere, even those works of literature that appear to raise questions about individual commitment and those works of painting that celebrate the abandonment of social and physical discipline testify ultimately to

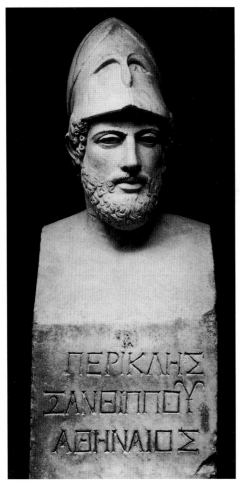

12 Pericles, herm portrait, Roman marble copy after mid-fifth-century BC original by Kresilas.

the overwhelming priority of such concerns. The social criticism of Attic drama developed in reaction to an oppressive social control. The sensual licence of many scenes on Greek drinking vessels equally documents a natural reaction to extreme physical discipline and danger. Many wine vessels have scenes of war or athletics on the front and debauchery on the back. Others have even more complex ways of celebrating both the requirements of military preparation and the opportunities it created for indulgence. A red-figure cup shows young men practising with the discus on one side, older men involved with the more deadly javelin on the other and, on the interior, an erotic encounter between the two (figs 13a, b and c). The suggestion that physical training leads not to war but to sex would have been an appealing one when such activity was an inescapable obligation. The scenario would also have been a particularly believable one following a post-practice party. Fighting and the preparation for fighting confronted the Attic male at home as in public. Success in battle was so vital and depended on such intense exercise and commitment that it dominated all aspects of art. There has never been a culture where such pacific activities as visiting a temple or drinking wine were so likely to bring one face to face with war.

The Iliad: *Women at Home, Men at War*

One element of the oppressively military social formation associated with warfare in fifth-century Athens was the obligatory performance of the *Iliad* at the state's festivals. The great epic was as relevant then as in the eighth century and had a greater official status. Both its two major themes deal with the issue of military effectiveness. One is that of human relations off the battlefield, the other is that of tactics on it. An understanding of human relations is seen to be critical both for avoiding war where that is possible and for ensuring essential co-operation when it is not. A knowledge of tactics is represented as the key to ultimate military success. Each theme plays its part in shaping the poem, as it also played its part in shaping the Greek mind.

Fundamental to the first theme is the notion that an intense interest in women on the part of the individual male is potentially destructive not only for him but for the

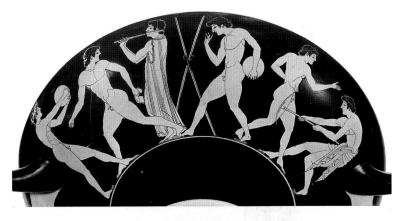

13a Young men training
with the discus, exterior of
a cup, Attic, first quarter of
the fifth century BC.

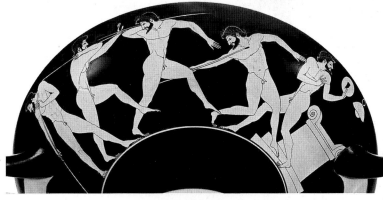

13b Older men training
with javelins, exterior of a
cup (see figs 13a and c).

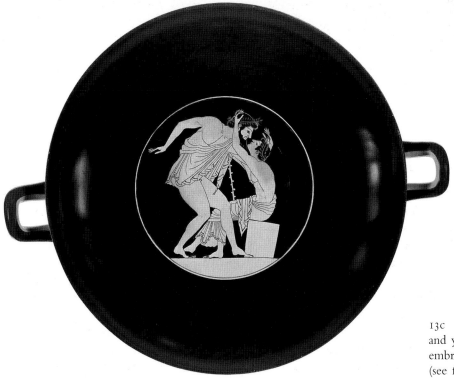

13c Older man
and younger man
embracing, interior of a cup
(see figs 13a and b).

whole community. If the Trojan prince Paris had not fallen in love with Helen and led her away from her home to his own city the war would not have happened in the first place. Similar involvements later both prolong the war and threaten to prevent its successful conclusion. The tale begins with an account of the troubles brought on the Greeks by the obsessions of two of their leaders, Agamemnon and Achilles, with two women, Chryseis and Briseis. After Agamemnon's passion for Chryseis brings a plague on the Greek army he is forced to give her up. When, as compensation, he is awarded Achilles' prize, Briseis, the hero sulks and refuses to fight. From that moment onwards the Greeks are threatened with destruction. By contrast, the most positive female role on the Greek side is taken by Thetis, Achilles' mother, who eventually provides him with the arms necessary for him to turn the tide of conflict. The best attitude towards women is that of the Trojan Hector, who nobly resists the pleas of his wife to stay at home and protect his family. Instead he goes off as temporary saviour of his city, telling her to return to the loom and leave war to men. Love of man for woman is portrayed as the greatest danger to the state, since it leads to the defeat of the Trojans, as it had almost to that of the Greeks. It is contrasted with the love of man for man, that is, of Achilles for his friend Patroclus, which is what eventually brings the moody hero back into the battle to deal the decisive blow to the enemy. His desire for Briseis almost brings destruction to his people, his affection for Patroclus brings salvation.

The second theme concerns the conduct of the battle itself. The key element in tactics, the one on which defence and thus survival ultimately depend, is, as we have already seen, the ability of the individual to operate in a tight formation, the phalanx. Only as a phalanx can fighting men substitute for fortifications, and this theme is cleverly built into the architecture of the twenty-four books of the *Iliad*. In Book VII the wavering Greeks build a stone wall around their ships, but by Book XII it emerges that the gods never approved of the fortification and although two of the Greeks plant themselves at the entrance like mighty oak trees they cannot stop the gates being smashed by the mighty Hector. In Book XIII the wall itself is penetrated. Only when the best of the Greeks form themselves into a phalanx 'making a fence of spears and serried shields' is the tide held. Standing close together 'shield against shield, helmet against helmet, man against man' and with their spears aligned across them, they prove better than any built defence (*Iliad*, XIII, 130–52). Later, in Book XVI, the same formation is used once again, this time for offensive purposes, when the Myrmidons manage to drive the Trojans out of the encampment. This is when Achilles forms them into ranks like a man building a wall (*Iliad*, XVI, 211–15). Such a phalanx, although it is referred to only twice in the whole poem, has a critical role in first halting the attack and then repulsing it. It is better than a real wall as a protection for the community.

Both themes are brought together in Book XVIII when Achilles, fired by his love for Patroclus, receives a superb set of weapons from his mother. With their greatest warrior inspired and armed the Greeks are now invincible, as the remaining narrative reveals. The overall arrangement of the twenty-four books into four sections of similar length ensures that there is no mistaking the importance of the two themes. The first six books document the damage done by the love of women, the last six books prove the advantage of the love of men. The wall built in Book VII is unwished by the gods. The body armour of Book XVIII is ordered by one deity and made by another. The

>>>>>>TROJAN ADVANCE>>>>>>TURNING POINT>>>>>>GREEK RESURGENCE>>>>>>

	WALL	WALL	PHALANX	ACHILLES'	
	BUILT	PENETRATED	FORMED	SHIELD	
BOOK I	BOOK VII	BOOK XII	BOOK XIII	BOOK XVIII	BOOK XX

14 Scheme of the *Iliad*.

whole story pivots around the half-way point at the end of Book XII and the begin-
ning of Book XIII, when the uselessness of the wall and the impregnability of the armed
phalanx are both demonstrated. There is no mistaking the epic's message. A commu-
nity depends on its young men loving each other more than women and being so
armed and disciplined that they can eventually constitute a better defence than any
fortification.

There is much in the poem that is common to other epics in other cultures, tales
of honour and heroism, pride and passion, but these are set like ornaments in an overall
scheme that in its final written form has substantial rigidity. Through the correlation
of wall and body armour, phalanx and fence, a firm symmetrical design is created.
Centred on the Greek camp and with a wall half-way to the beginning and armour
half-way to the end, the *Iliad* has a symmetrical arrangement that resembles that of the
shield described in Book XVIII with its concentric rings (fig. 14). An epic celebration
of military virtues strengthened by a rigid organisation, it becomes in itself a sort of
shield. Recited for didactic purposes on public ceremonial occasions, the poem cer-
tainly served as well as any armour to improve the community's protection. Those who
heard the description of the shield made by a divine craftsman and decorated princi-
pally with representations of two cities, one of which is besieged, would have sensed
a correspondence with the poem made by a divinely inspired *poietes*, 'maker', whose
subject was the fate of two settlements, the Greek camp and the besieged city of Troy.
In later Greek usage a body of armed men was regularly called a 'shield' because of
its protective function, and it would not have been hard to think of a poem that cel-
ebrated the power of such a body as a shield too. As we saw earlier, the tendency to
use metaphors from the world of artefacts was to become a distinctive trait of the
Greek cultural tradition as a whole. The *Iliad* played a major role in its formation and
consolidation.

War and Art: The 'Military' Style of Pottery

The special links between the worlds of war and craft in the eighth century, when
Homer first expressed them in his epic, are well documented by what have come to
be seen as the first monuments of a truly Greek art. It was then that a great series of

15 Amphora with
scene of mourning at
a warrior's funeral (the
'Dipylon Vase'), Attic,
mid-eighth century
BC.

16 Amphora with scenes of charioteers and footsoldiers, Attic, late eighth century BC.

pottery wine-mixing bowls and amphorae were produced in Athens for display over the graves of wealthy members of the aristocracy. Both these specially commissioned pieces and a number of the vessels placed inside the tomb directly and indirectly celebrate military interests. Some show well-drilled women at the funerals of warriors, others soldiers, ships, chariots and horsemen (figs 15 and 16). These vases are normally called 'Geometric' in style, as if they somehow anticipate the supposedly abstract mathematical interests of later Greeks, but it would be much better to call the style 'Military', given that the qualities they reveal are so precisely those valued in a war situation and specifically associated with warlike activities in the contemporary epic. Again and again the rows of armed men are reduced to a series of black silhouettes, like human towers, and shields and spears are arranged in repetitive patterns like the components of a fence (fig. 15). Since the subjects chosen for their decoration show that the people for whom they were made wanted to be remembered above all for their military interests it is natural for the vessels to reflect these preferences in overall configuration and ornament. There had been many loosely similar styles of pottery in other cultures, probably because of the influence of basketwork, but elsewhere the geometrical properties had never been so assertive and the human form never so consistently schematised into triangles and parallel lines. The unique connection of this group of vases with the military values that were central to Greek life and literature at the time suggests that it is these values that they reflect. If they exploit the geometrical it is primarily because of the importance attached to what we might call 'geometricality' in the context of war.

In the following century similar interests characterise the vases designed for more private use not just at Athens, but at Corinth and in eastern Greece as well. No longer monumental and funerary in their associations, they are intended for domestic display. Abandoning ritual subjects in favour of more direct allusion to war and fighting, they frequently feature either rows of aggressive animals, such as lions and boar, or repetitive pairings between these and other aggressive animals and their prey (fig. 17). Given that in Homer warriors are often compared to such savage animals, it is easy to recognise such beasts as more colourful stand-ins for human protagonists. By subjecting wild animals to order and discipline the craftsmen combine two principal forms of epic warrior-imagery, the idea of them as abstract regular configurations and the idea of them as beasts. The regularity that the animals display was as alien to animal conflict in the natural world as it was essential to human combat in Greece. When real warriors are shown they are even more chillingly regular than before and the prominence of geometrical decoration on their shields confirms the military associations of such patterns on the earlier vases (fig. 19). What is added to the repetitive bands and regular configurations of the earlier period is a new insistently rigid perfection in the detailed ornamentation, as in the rows of triangles that often ring the vases' bases. Perhaps the most direct testimony to the Greek aptitude for endowing tableware with military properties is the visual punning involved in the design and decoration of a particular group of Corinthian cups. Shields figure prominently in the decoration of many Greek cup types, but in the Corinthian group and its Athenian derivatives scenes of shield-bearing warriors are applied to a form that more directly than most recalls the same shields in its concave profile with flanged lip (fig. 18). The craftsmen who made such cups for warriors or would-be warriors to drink from knew that their customers would

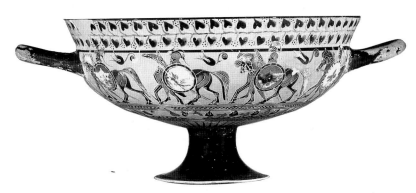

17(*left*) Jug with pairs of animals, Corinthian, sixth century BC.

18(*above*) Cup with shield-bearing cavalrymen, Attic, second quarter of the sixth century BC.

19 Krater with shield-bearing cavalrymen and pairs of animals, Corinthian, first quarter of the sixth century BC.

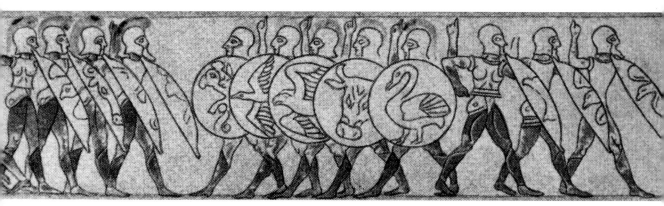

20 Confrontation between the front ranks of two phalanxes, detail of a Corinthian scent bottle, the 'Macmillan Ary-ballos', early sixth century BC.

be attracted by such products. The desires of consumers for forms that evoked military life exerted a constant pressure on artistic production.

Two other products of this period, a pot and a poem, furhter emphasise the extent to which male preferences were dominated by this military aesthetic. The pot is a tiny early sixth-century *aryballos*, a bottle to hold the perfumed oil used by men after athletic exercises (fig. 20). On its delicate frieze we find the best surviving portrayal of a collision between the front ranks of two phalanxes, their order perfectly maintained even at the moment of impact. The owner who set out to make himself attractive by anointing himself with oil from this elegant container must have seen such scenes as representing the essence of desirability. The currency of just such an obsession is confirmed by a slightly earlier poem, a love lyric of Sappho. In splendid mockery she opposes her tastes as a woman to those of her male contemporaries: 'some say the most beautiful thing in the world is an army of horsemen, some say an army of foot-soldiers, some a fleet of warships . . . , but I say it is one's beloved' (Sappho, 38, 1–3). Beauty can be defined as that which one desires to see, and the composition and decoration of the *aryballos* and the other vases directly evoke the patterns that would have been created by the armies of horsemen and foot-soldiers and the fleets of ships, that gave Sappho's male peers the greatest visual pleasure. The perceptive poetess was all too aware that the unique preoccupation of Greek society had produced the extraordinary effect that supreme aesthetic pleasure was associated not with the sight of a beautiful individual but of a military formation.

War and Art: Phalanx and Temple

The desire for military qualities in private pottery was driven largely by the pride associated with the possession of those highly valued attributes. But the reason those attributes had such status was the overriding desire for military security, and it was this desire that also and more decisively influenced the design of the principal public artistic expression in Greece, the temple. The distinctively Greek temple-type consisting of a long rectangle entirely surrounded with columns is virtually unique in architectural

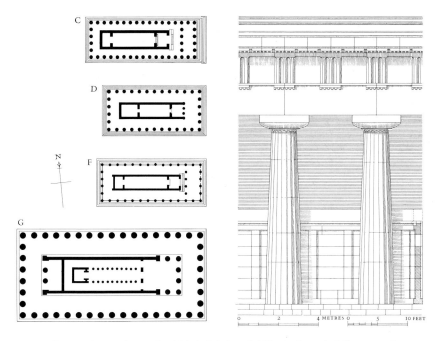

21 Selinus, plans of temples 'C', 'D', 'F' and 'G', sixth and fifth centuries BC.

22 Columns of Temple of Hera ('Basilica') and side of Temple of Neptune, Paestum, mid-sixth and early fifth centuries BC.

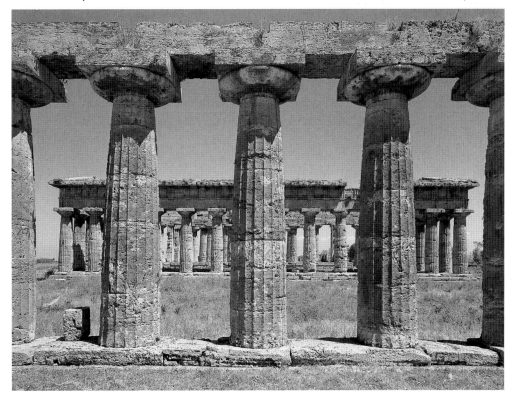

history (fig. 21). Equally unique are its precise geometry and its use of a single stan-
dardised column throughout (fig. 22). Elsewhere in the world columns rarely appear
on the exterior of temples, except on a single façade, and are frequently of different
design and placed at varied intervals. No explanation has ever been offered for the
rapid establishment of a constant preference for such a configuration. If, however, there
was at the time of its emergence an overriding interest in objects that embodied the
properties of the phalanx (fig. 6) the appeal of all its distinctive attributes could be
understood. Whether or not there is a connection between the appearance of the first
few temples ringed by wooden colonnades and the experiments with the phalanx in
the eighth and seventh centuries, it is with the firm establishment of a standard stone
building type in the sixth century that the correspondence becomes really suggestive.
By then a recognition that the phalanx of warriors and the temple of the protective
deity were the chief guarantees of the city's freedom must have become universal.
Frequently, as at Athens, the temple was sited within its main fortress (figs 1 and 32).
In this context it was highly appropriate for the divine image of the city's patron to
be surrounded by a colonnade, which recalled the aligned ranks of the community's
living defence system. The placing of columns on all sides, the insistent regularity of
their spacing and the accuracy of their alignment all recall the attributes of the well-
drilled phalanx. Even features that represent variations on that regularity may derive
from the same source, as for instance the enlargement or closer spacing of corner
columns, unknown in other cultures, which could well recall the need to place the
strongest warriors at the most vulnerable points of the formation. The numbers of
columns on the short sides of the typical temple may also relate it to the phalanx. The
Spartan and Athenian type, which we know best, ultimately became established as eight
deep, and six may well have been a regular depth for smaller communities. It was obvi-
ously impossible to have a temple as large as a whole phalanx, which had a much
longer front, but each phalanx was divided up into units and a temple could be seen
as representing one of these. The character of the stylobate or platform on which the
temple stood is also compatible with the assimilation to the phalanx. The inexplicable
use of steps all round, steps often too large for people to use easily, would have a pow-
erful meaning if it was seen as hinting that the columns themselves could descend from
the stylobate and move in any direction, just as the men of a phalanx were trained to
move backwards or forwards, either in line ahead or in line abreast. If we turn to the
details the same correspondence appears. The precision of their execution reminds us
of the qualities of well-finished weapons, and the sharp arrises or edges between the
concave flutes of the Doric shaft recall the sharp, hollow-ground edges of sword blade
and spear point. The terms used later in antiquity by Vitruvius to describe particular
details, for example, the *echinus*, 'spiny sea-urchin' or 'hedgehog' of the Doric capital
and the dentils, 'little teeth', of the Ionic frieze (fig. 38), all suggest that the forms of
the Greek temple came across as generically defensive or aggressive. The more modern
term 'egg and dart' for another element of the Ionic frieze suggests the same. What
the use of the term 'dart' reveals about the form of this last moulding is the more
remarkable in that it originates in the Near East as a soft leaf pattern. Nobody could
have found the curving leaf forms remotely aggressive when they first appeared, yet
by 500 BC the outlines of the larger leaves had become as sharp as the rim of a shield

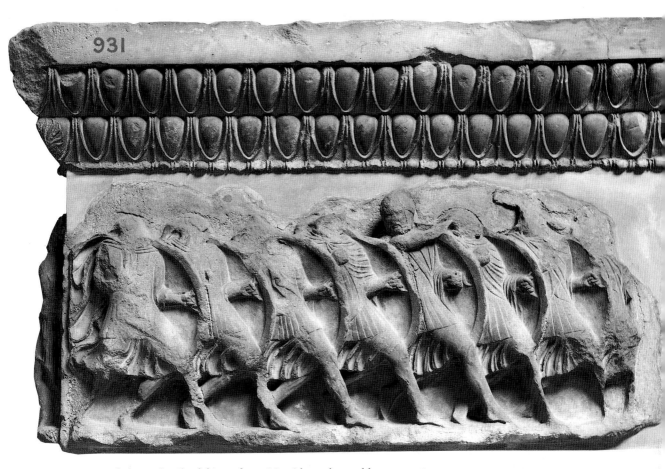

23 Lycian phalanx, detail of frieze from Nereid tomb, marble, *c.*390–380 BC.

and their inner surfaces had acquired a shield-like convexity, while the line between the leaves took a form somewhere between a lion's claw and a sharply tapering blade. A similar adaptation of an Eastern leaf pattern is the moulding known by Vitruvius as an astragal and by later writers as a 'bead and reel'. Here the leaves have been transmuted into a rigid alternation of convex circles and paired sharp verticals. In both mouldings a naturalistic leaf is transformed into something that to us evokes either an artefact or a hard organic object, but which to a Greek would probably have recalled that on which his survival depended, the front rank of the phalanx. Some need must have led the sculptors to transform a leaf into something else, and since one of the main reasons for erecting these costly stone temples was to increase a sense of security this particular need may have been the decisive influence on the minds of those who carved their decorations. Since the carvers of these mouldings would themselves have been trained as members of the phalanx, the forms their hands shaped could easily have been unconsciously influenced by what their eyes desired to see. To them and to the whole community the temple would have worked better if it expressed the properties of the formation on which the security of all citizens depended. Nothing was

more important to them than a regular alternation of hard round shields and sharp pointed spears and swords (fig. 16). Those who commissioned, designed and carved these works on behalf of the community, who in some cases would have been the same people, would have known in their bones the military significance of the temple. They must have tended to see in the leaves a hint of the alternating series of shield and spear that they wished to see in the front of the phalanx and unconsciously modified the motif in a way to suggest the same to others. The strongest evidence that people did respond to the egg and dart in this way is provided by the Roman versions where the pointed leaf actually becomes an arrow or spear, but an earlier monument that hints at a recognition of the connection is the Nereid tomb, now in the British Museum, commissioned in the early fourth century by a powerful Lycian, probably the ruler Erbbina, to celebrate his military achievements. Here the moulding has been doubled to create a powerful disciplined rhythm which is reinforced by the astragal below and when this combination is juxtaposed with a representation of an advancing phalanx the viewer can hardly fail to sense the affinity between the arrays of ornaments and warriors (fig. 23). This affinity, however, was even more important in large sacred structures. The entire organisation of the Greek temple and especially its unique attributes of geometrical and mathematical accuracy, regularity and precision all have close parallels in aspects of contemporary military formations.

In any other culture the idea that a temple might suggest a military formation could seem far-fetched. Only in Greece did a tradition of assimilating the phalanx to a fence, a wall or a tower prepare for a reverse assimilation of a building to a phalanx. After the *Iliad* the idea of men as masonry often recurs. Around the time that the stone temple appears, in the early sixth century BC, young men are likened to towers both in a Homeric epigram and in a fragment of Callinus of Ephesus. Even more strikingly, Alcaeus claimed that the walls of a city were made not of stone but of men able to defend themselves. Still later in the fifth century Euripides says explicitly that 'the columns of a house are sons', because of their ability to defend it (*Iphigeneia in Tauris*, 57). It was probably at that period too that some Greek architectural writer, later used by the Roman writer Vitruvius, gave the analogy canonical authority in his claim that the form and proportion of the Doric column were both directly copied from the male body (Vitruvius, *De Architectura*, IV, 1). More than any other architectural element, the single Doric column possessed the strength and stability required of the Greek hoplite. Arranged in a rectangular formation they possessed the properties of the phalanx. If we and other Europeans before us find such a claim about a column a natural one to make it is probably only because our minds have been predisposed to do so by their exposure to Greek culture. From the perspective of any other cultural tradition the analogy would probably betray an exceptional cast of mind.

War and Philosophy: Kosmos *and* Harmonia

The notion that war shaped Greek art and architecture will be unattractive to many, but it did receive explicit support in fascist Germany. The idea that war had a similar influence on aspects of Greek philosophy and especially on the Greek interest in math-

ematics is also emotionally disturbing, but it has to be taken seriously. The role of war in the essentially cosmological tradition out of which philosophy was to grow is beyond question. Hesiod already portrays the origin of the world in terms of constant conflict in the *Theogony*, and at the beginning of the *Works and Days*, which offers an interpretation of the order of contemporary life, he asserts, as we have seen, that Eris, Strife, is the principle ruling human affairs. More than a hundred years later, with the beginning of more truly physical speculation, first Pherecydes and then Heraclitus describe the organisation of the universe as being the product of the conflict between opposed forces. According to Celsus, writing in the second century AD:

> Pherecydes, who lived long before Heraclitus, invented the myth that army was drawn up against army and that Cronos was the leader of the one and Ophioneus of the other and he recorded their challenges and fights and that they had agreed that whoever of them fell into Ogenos [Oceanos] would be the defeated and that those who pushed them down would win and possess the heavens.
>
> <div align="right">Origen, Contra Celsum, VI, 42.</div>

According to Celsus, too, Heraclitus said: 'It is necessary to know that war is common and that justice is strife and that all things come into being through strife and necessity' (Origen, *Contra Celsum*, VI, 42), while another source made him say that 'War is the father of all and king of all . . .' (Hippolytus, *Ref.*, IX, 9, 4).

Much more influential on the subsequent history of philosophy, however, was Pythagoras around 500 BC. There are great problems in dealing with Pythagoras, since he himself apparently tried to prevent the dissemination of his views, being anxious to keep them as the mysterious source of power of his own disciples. Yet, there is a large later literature on this legendary figure and much of what is credited to the Pythagoreans generally is likely ultimately to derive directly from him. This is almost certainly the case with the notion 'that number is a first principle and as it were a material cause of entities, determining both their conditions and states and that the elements of number are the odd and the even' (Aristotle, *Metaphysics*, A, 5). Pythagoras is also likely to have outlined the conception, described by Aristotle in the same passage, that the universe relies on a balance between opposed forces, the polarities of Limited and Unlimited, Odd and Even, One and Many, Right and Left, Male and Female, Square and Rectangular, Light and Dark, Straight and Curved, etc. Mathematics underlie his concerns here and there is no view with which he is later more firmly associated than that arithmetic and geometry are the keys to the well-being of both man and nature. War and arithmetic come together in the opposition between 'one' and 'two', which is the archetypal polarity from which all others depend. Conflict and number both had a place in many Near Eastern cosmologies, but only in Greece, where conflict was habitual, could numbers be seen as opposing forces in this way, and only in Greece, where military discipline and the maintenance of regular formations were the basis of security, could the security of the universe be understood as based on the prevalence of mathematical order.

The extent to which the ideas of the Pythagoreans echo military ones is remarkable. Take, for example, the way they illustrated the opposition between the square and the rectangle, which was by placing right angles around pebbles or dots, beginning

with either one or two (Aristotle, *Physics*, 203A). The resulting configurations closely resemble the arrangement of the phalanx (figs 6 and 24). In both number-pattern and phalanx, alignment and constancy of interval are essential. The Pythagoreans also gave great importance to a *tetragonos*, or 'square' figure, which, in name at least, corresponds to a 'square' military formation known from fifth-century sources. Again, the number pattern that they revered above all was the *dekas* (fig. 21c), which reminds us that the earliest reference to *dekas* was to a company of ten soldiers (*Iliad*, II, 126). The Homeric soldiers may have never arranged themselves in the specifically Pythagorean pattern, with its successive rows of one, two, three and four pebble-dots arranged in the form of an equilateral triangle, but the magic of the name and of regularity infuses both configurations. The phalanx precedes the Pythagorean number-patterns, and, given that the Greeks certainly used little stones in board games that simulated battles, it is likely that pebbles were used to show young men the different formations of the battlefield

24 Pythagorean number forms: a) square; b) rectangular; c) *dekas*.

long before they were used to illustrate points of mathematics. An understanding of the importance of the exact alignment of units in rows, so crucial to the covering of front and flanks with a wall of shields and spears, was a vital military secret before it became a philosophical mystery.

The most brilliant use that Pythagoras and his followers made of the numerical and geometrical configurations was to illustrate the ordering principles of the universe. The *dekas* noted above, for example, otherwise known as the *tetraktys*, they saw as an embodiment of the harmonic musical proportions as represented by the relations between the numbers one, two, three and four, proportions that had a special importance since it was music that the Pythagoreans saw as the key to the design of the heavens. Having discovered for the first time that the notes of the octave were related to geometrical proportions that were visible in the relations between varying string lengths, they were able to use the image of a mathematically fixed musical harmony as the key to a more coherent and satisfying scheme for understanding the relations of heaven and earth, uncertainties about which had long troubled man. The whole universe or *kosmos*, as they, for the first time perhaps, called it, was presented as

a system of concentric circles with the orbits of the different planets held stable, like the notes of the octave, by the rules of musical *harmonia*. Each planet was claimed to emit a note reflecting its distance from the centre. There is nothing overtly military in this pattern of lines controlled by music, but the terms chosen, *kosmos* and *harmonia*, point back once again to the world of war. The cognate terms, *kosmos*, 'order', *kosmeo*, 'I arrange', 'I marshal', *kosmetor*, 'supreme commander', all have a predominantly military reference in Homer (*kosmeo* exclusively so in the *Iliad*), as in the *Iliad* (e.g., I, 16 and 375; II, 554; X, 472; XII, 85 and 87; XIV, 379) and often it is precisely a simple numerical arrangement that is referred to, for example, 'in five divisions' at X, 472, and 'in three rows' at XII, 87. The terms could also be used in civil life and applied to artefacts, especially to those associated with women, but much the best prototype for the Pythagorean usage with its reference to an overall order of an essentially mathematical and linear character is in the context of warfare, where alone such ordering had a vital role. The use of the term *harmonia* strengthens this connection. Hesiod in the *Theogony* makes Harmonia a daughter of Ares, god of war, along with her sisters Panic and Fear: 'Also Cytherea bore to Ares, the shield-piercer, Panic and Fear, terrible gods who drive in disorder the dense phalanxes of men in numbing war, with the help of Ares, sacker of towns; and Harmonia, whom high-souled Cadmus took as his wife' (*Theogony*, 933–7). Panic and Fear destroy the order on which the phalanx depends for its success. Harmony implicitly reinforces it. This is because Harmonia is the personification of 'fitting togetherness'. As is clear from Homer, the original references of *aro*, 'I join', and its cognates *harmozo*, 'I fit', *harmos*, 'a joint', *harmonia*, 'a joining', were to the world of material crafts such as stone masonry or carpentry. In the *Odyssey*, for example, *harmonia* is several times used to refer to fastenings such as those that hold the parallel planks of a ship together. Thence the words were transferred to the military context, which is the one most frequently found in the *Iliad*. An excellent example is provided in the passage quoted earlier: 'The ranks fitted better [*arthen*] together when they heard their king. As when a man knits together [*ararei*] a wall of his lofty house with close-fitting stones, keeping out the force of the hot winds, so did the helmets and bossed shields fit [*araron*] together' (*Iliad*, XVI, 210–15). Achilles achieves the fitting together of the tight formation by his words. He is a *kosmetor* creating a *kosmos*. The similarity between the two ideas of *harmonia* and *kosmos* is illustrated by the parallel between the function of the *harmostes*, the governor of Sparta's subject communities, and the *kosmetes*, the magistrate in Athens and elsewhere who was in charge of the *ephebes*, or young men of military age. Both brought order to the potentially unruly.

The military associations of Pythagorean harmony are also brought out by its emphatically musical nature. Music was a principal aid in Greek military training. This is documented throughout Greek history. On the seventh-century Chigi vase a flute-player leads marching soldiers and is instrumental in keeping them in step (fig. 25). In the fifth century, Thucydides credits a major Spartan victory to flute-players who were placed among the soldiers 'so that they should advance marching together and in time and so that the formation [*taxis*] would not break up as tends to happen with the forward movements of large armies' (*Histories*, V, 70).

The Greek recognition of the power of music to create a strong and disciplined phalanx is well expressed in the myth of Amphion using the music of his lyre to

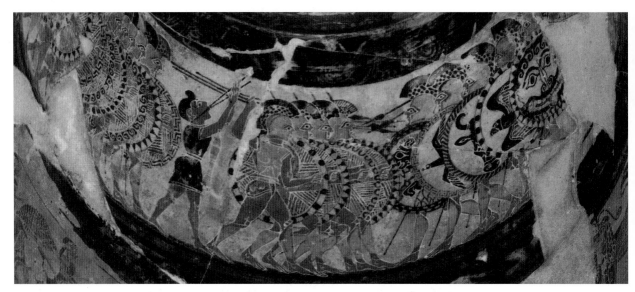

25 Flute player and armed warriors, detail of *oenochoe* (the 'Chigi Vase'), Corinthian, third quarter of the seventh century BC.

summon the stones to build the wall of Thebes. His stones were like the soldiers of Achilles, whom Homer describes as forming a human wall. Thebes was a model of the primal city and with its seven gates could be related both to the seven notes of the octave and to the seven heavenly bodies. It was also celebrated for its armies and we have already seen how the story that Cadmus, its great warrior king, raised an army of foot-soldiers by sowing snake's teeth emerges as a myth to explain the origin of the regular ranks of the phalanx. Cadmus is himself explicitly linked to music by Hesiod in the passage quoted above where he marries Ares' daughter, Harmonia. There is a sure Pythagorean connection for Cadmus, since Pythagoras' followers called the number, or rather number-pattern, eight, *kadmeia*, probably after the name of the Theban citadel, just as they called other potent number-patterns *harmonia* and *kosmos*. Thebes, with its associations of regular rows of soldiers and walls laid in musical measures was a prototype of stability and order long before similar properties were discovered in the system of the universe. It is also quite possible that Cadmus and his wife Harmonia were directly assimilated to the *kosmos* and *harmonia* of the Pythagorean cosmology. Cadmus is spelt Kassmos on a vase where he is shown riding in a chariot drawn by two naturally disharmonious animals, a lion and a boar, with his wife Harmonia (fig. 26); the vase was found at the site of Rhegium, which is close to Croton and which became the home of another Pythagoras of Samos, the famous early fifth-century sculptor discussed below. Cadmus was certainly associated with the maintenance of military order and the balancing of opposites – as in his setting of the soldiers who grew from snake-teeth seed against each other – and as the founder of the greatest city of mythology he was an admirable model for a Pythagorean first principle.

Whatever the relevance of the Cadmus story it is evident that *harmonia* was associated with order long before Pythagoras. The connection arises both from the word's Homeric meaning of a fastening that binds parallel planks and from the role of music

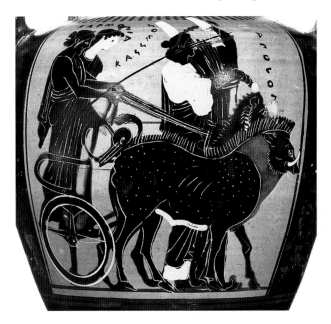

26 Kadmus/Kassmos with his bride Harmonia in a chariot drawn by a boar and a lion, detail of an Attic amphora, *c.* 500 BC.

in ensuring the tightness and regularity of formations of soldiers. Both these references help to explain the role that *harmonia* has in maintaining the order of the Pythagorean *kosmos*. *Kosmos* and *harmonia* are two of the key terms in the Pythagorean programme of reducing the universe to numbers, primarily because they had long been associated with numerical order on the battlefield. If there is any truth in the later stories that Pythagoras turned to those terms, and through them to numbers, when looking for the basis of the order of the universe, it is probably because he sensed the unique convergence in the preoccupations of the Greek mind. Since the anxieties his contemporaries felt about their world as a whole were similar to their anxieties about their city's survival in war, they would respond well to a view of the world that saw its safety as being dependent on the same features as did their cities. In so doing he did more to give mathematics a central role in culture than anyone before him.

War and Philosophy: The First 'Mathematicians'

Given the uncertainty about the real beliefs of Pythagoras it is significant that several ancient stories about him accord with the idea that he constructed his philosophical system very much with a military goal in view. When he reputedly left Samos in 518 BC all sources agree that he went to Croton in southern Italy. He might have gone anywhere; so his choice of remote and poor Croton as his destination must be telling. The city that he selected as the base for his community was famous for a specific set of associated attributes: for its cult of the physical hero Heracles, for the general health of its population and above all for the prowess of its athletes. At one Olympic Games the first seven runners in the foot race were from Croton. Most famous of all was Milo, six times Olympic victor at wrestling. There is thus a natural presumption that

what attracted Pythagoras to the city was its highly trained and unusually tough male population. This would be confirmed by the stories of his actions on arrival. According to these he immediately persuaded the older citizens, who had recently lost an important battle, that he was the right person to instruct their sons and he soon built up a group of either three or six hundred (depending on the source) young male adherents. These were apparently called the *mathematikoi* in contrast to the older men who were only *akousmatikoi*. While their elders learnt his philosophy only by attending to his 'heard sayings' or *akousmata* the young men actually followed his mental training in rigorous 'disciplines', *mathemata*, literally 'that which is learnt' and so became the first true mathematicians. Given the secrecy of the Pythagorean organisation and the lack of early records it is impossible to be sure what really went on in Croton at this period, but whether the number was three hundred or six hundred it sounds just like the number of the phalanx at its most efficient. There is no direct evidence for the military activities of the Pythagorean *mathematikoi*, but within a few years of Pythagoras' arrival the Crotoniates embarked on a course of military expansion. In 510 BC they attacked the much larger and wealthier neighbouring city of Sybaris, according to some sources on the recommendation of Pythagoras himself, and defeated them. If Pythagoras had wanted to test the hypothesis that by bringing mathematical order to a physically healthy and well trained community he could guarantee its security, he did so. By setting the mathematically educated forces of a small city associated with a controlled masculine life-style against the less mathematically formed troops of a much larger one associated with effeminate luxury and uninhibited indulgence, he effectively demonstrated the superiority of the Limited over the Unlimited, of the Square over the Rectangular, of One over Two, of Man over Woman and of Good over Evil, that is, of six of the fundamental tenets of his philosophy. What he offered was a sort of 'mathematical proof' of his ideas.

War, Mathematics and Art: The 'Square' Man

After Pythagoras had introduced the idea of the mathematical man, it soon surfaced again in other areas of Greek culture. The slightly later sculptor of the same name, who, like the philosopher, moved from Samos to south Italy, to the city of Rhegium, was, according to Diogenes Laertius (VIII, 46), 'the first to aim for an effect of *rhythmos*, 'measured form', and *summetria*, 'mathematical proportion'. As most of his statues were of athletes it is quite possible that he was following the example of his namesake and compatriot in literally applying mathematics to the perfect warrior material. At the same time a rather looser correspondence between mathematics, the military and art is indicated by the famous lines of the sculptor's contemporary Simonides: 'It is difficult for a good man to come into being, square [*tetragonos*] in hands and feet and mind, wrought without blame' (Simonides, 5, 1 and 2, quoted by Plato, *Protagoras*, 339A). The metaphor 'wrought' makes it clear that Simonides is thinking of someone being shaped square as a block of wood or stone is shaped by a craftsman and there is one obvious context in which someone thus shaped is truly 'better', that is, in the context of defence. A square man fits better with everyone else to make a tight formation. Homer had long before compared the ranks of Myrmidons to a well-built wall; Socrates in Xenophon's *Memo-*

rabilia (III, 1, 6) uses the same image of the phalanx, comparing it to a wall constructed of bricks and stones, and later Demetrius of Phalerum still saw a strong formation as a wall in which all the bricks had been carefully laid (Polybius, *Histories*, X, 24). The Greeks habitually thought of soldiers in the phalanx as well-cut stones, planks or bricks and the word 'phalanx' suggests the same analogy.

The ultimate expression of the Greek interest in the protective value of squared blocks as barriers is their use of rectangular vertical blocks to mark boundaries. One type were the plain *horoi*, or boundary stones, of the Athenian agora, each of which is inscribed 'I am the boundary of the agora' (fig. 27). More potent were the herms, or rectangular blocks crowned with heads of the god Hermes, which the Greeks erected as symbolic fence posts in many positions, as in front of their houses or fortresses. A typical example from Periclean Athens was the Hermes Propylaios by Alkamenes, known through Roman copies, which was placed in front of the Propylaea, gateway to the Acropolis (fig. 28). We get a picture of how these herms were thought of from the record of the dedication of three of them in the so-called Stoa of the Herms, as

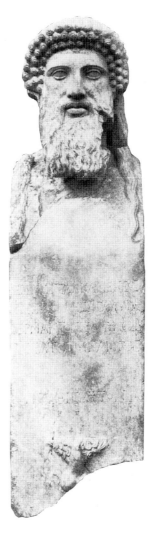

27 (*far left*) Boundary stone from Athens, inscribed: 'I am the boundary of the Agora', marble, *c.*500 BC.

28 Hermes Propylaios, marble, Roman copy of a late fifth-century BC original by Alkamenes set up at the entrance to the Akropolis.

a means of commemorating the success of the Athenian generals who defeated the Persians at Eïon in Thrace in 475 BC. The three rectangular images were marked not by the names of the generals but by three eloquent verses. One of these referred to the heroism of their achievement, another said that the herms were there to commemorate the virtue (*arete*) of the generals and to encourage succeeding generations to develop similar qualities, while the last told how just as Homer once made Menestheus of Athens an outstanding commander (*kosmetor*) of the Greeks so too it is right to call these men 'orderers' (*kosmetai*) of war and of manliness (quoted by Aeschines, *In Ctesiphon*, 184). A row of herms was apparently chosen as the best means of representing both the marshals' manly virtue and their distinctive skill. It was their square shape and their almost certainly regular alignment that made them so effective in this role. A line of square blocks representing three warriors was a perfect illustration of the mathematics of the military *kosmos*. They were probably also made three in number so that they would each recall an individual general, who would thus be seen as a stand-in for the square god, guardian of frontiers. The Athenians were used to according supreme authority to groups of three. Civil life was governed by three principal archons or magistrates, while military campaigns such as that which we know best, the Sicilian Expedition, were led by three generals. Herms were described by Thucydides and others as *tetragonos*, as was Simonides' 'best' man and what made them both especially 'good' was their ability to protect. If a squared shape was regarded as a guarantee of security it is easy to see how the *tetragonos* geometrical figure not only fascinated the Pythagoreans but appealed to the Greeks in general.

A similar admiration for square men may well have influenced the series of sixth- and fifth-century grave stelai of young men, often armed warriors, in which the figure is virtually co-extensive with the rectangular vertical slab of marble on which it is carved in relief (fig. 29). Even the true statues, the so-called *kouroi* or youths, also embody the properties of the blocks from which they were originally cut (fig. 4). However, by far the most authoritative celebration of mathematical regularity, and of squareness in particular, was the statue of the Doryphorus by Polykleitos of Argos made around 440–430 BC (fig. 30), now lost but known through several Roman copies. Pliny the Elder (*Natural History*, XXXIV, 55) tells us that it was called *quadratus* by Varro and it is generally agreed that this translates the Greek *tetragonos*, an earlier designation of the statue perhaps used by the artist

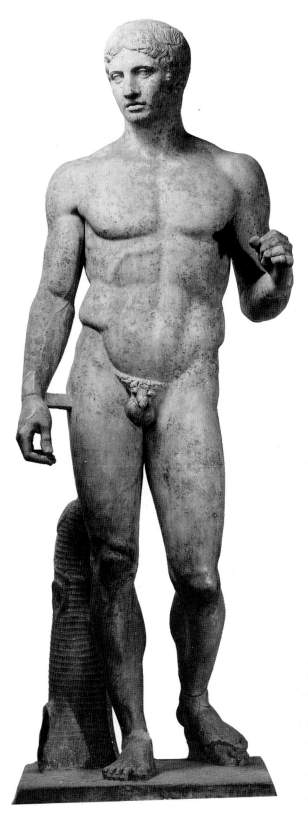

29 (*facing page*) Pollis as warrior, tomb relief from Megara, inscribed: 'I, Pollis, the beloved son of Asopitos, speak, having died not a coward [but fighting] in the line of battle', marble, *c*.480 BC.

30 Doryphorus, by Polykleitos, marble, Roman copy of a bronze original of *c*.440 BC.

31 Geometry of Doryphorus (see fig. 30).

himself, which was later applied to all statues of similar composition. What is certain is that Polykleitos constructed the statue using an elaborate system of *summetriai*, mathematical proportions, which governed the relation of all the parts to the whole, and that he wrote a treatise entitled the *Canon* or *Rule* in which these were all described. Probably the essential geometry of the proportional system of the *Canon* as revealed in the Doryphorus was indeed a scheme of squares (fig. 31). The Doryphorus was the ultimate expression of the general principle of mathematical order that had been given its most articulate celebration by the philosopher Pythagoras; and Polykleitos was probably only developing the practices of the earlier fifth-century sculptor Pythagoras. The development of mathematical proportions in Greek sculpture has often been directly connected with the influence of Pythagoras, whose ultimately military frame of reference was discussed earlier, and Polykleitus' choice of subject for his *Canon* confirms this connection. The Doryphorus, or spear-bearer, is a soldier wielding the typical weapon of the hoplite in the phalanx. If, as is suggested by Pliny (*Natural History*, XXXIV, 5, 10), he is also an Achilles-type, he is in a sense the personification of the hero who is presented in the *Iliad* as the greatest expert in the tight geometrical formation. Homer compares the ranks of Achilles' Myrmidons to a house built with close-set stones and Polykleitos' 'square' soldier would fit well in such a construction. Inscriptions and text demonstrate that Polykleitos devoted most of his attention to making statues of warriors and athletes and the *Canon* must have been his attempt to give the type its most perfect formulation. It is tempting also to think that the exceptional character of the Doryphorus as a heroic spear-bearing warrior of perfect proportions may commemorate the skills of the 'thousand picked Argive troops, for whom the city had for a long time provided at public expense a course of training in matters relating to war', who are referred to by Thucydides (*Histories*, V, 67). The reproduction of the statue on an Argive funerary stele would accord well with it having been an official commission recognised as a role-model for Argive youth. Polykleitos' position

as an authority in this regard may be alluded to by Plato when, in the *Protagoras*, he twice refers to him as a teacher and example of excellence (*Protagoras*, 311C and 328C), not far from the passage where he talks about the difficulty of fulfilling Simonides' plan for making a perfect or *tetragonos* person (339A). Polykleitos' *tetragonoi* statues, like Pythagoras' *mathematikoi* men, were young males reduced as far as possible to mathematical constructs, 'wrought square' by their teachers or trainers, as Simonides would have said. They were the perfect blocks in the wall of the phalanx.

Mathematical Art versus the Mathematical Army

Around the same time that the Doryphorus was being made by the Argive Polykleitos as the most completely mathematical Greek sculpture, Iktinos the Athenian was constructing the Parthenon (447–432 BC) as the most mathematically complex Greek temple, and it is likely that both were endowed with similar properties for the same reason. The Parthenon was commissioned by Pericles, who ruled Athens as *strategos*, to commemorate the defeat of the Persians. It was intended to give the Athenians a new confidence in their wealth and power and to induce in the rest of the Greeks a new respect (fig. 32). Decorated with scenes of war and housing a great armed statue of

32 Parthenon, Athens, 447–432 BC.

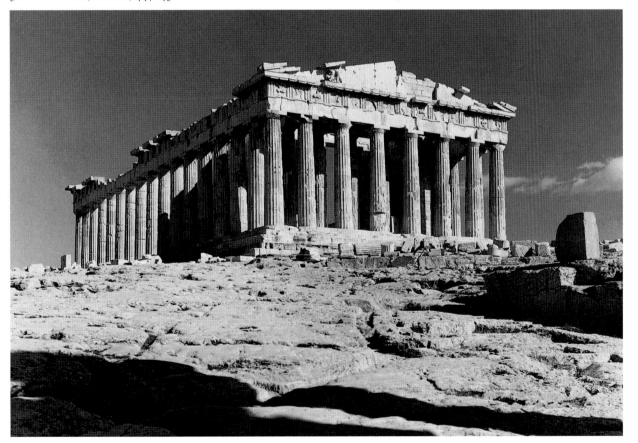

33 Parthenon 'refinements' diagram (see fig. 32).

Athena adorned with further scenes of fighting, as noted earlier, it also expressly celebrated military themes. Yet, the most effective aspects of the Parthenon's display of military expertise were probably its most mathematical features, the so-called refinements: the downward curvature of the edges of the temple platform, the reduction in the spacing between the columns towards the corners and the convergence of the axes of the columns, which meant that if projected skywards they would all meet, a set of modifications of strict rectangularity effected with extraordinary accuracy (fig. 33). Existing explanations of these features, some of which had begun to emerge earlier, see them as aesthetic devices designed somehow to improve the appearance of the building in the eyes of viewers, but none is based on the known interests of such potential spectators. If, on the other hand, the preceding arguments are accepted an explanation can be proposed that relates directly to contemporary concerns. What might they have meant, for example, to visiting Spartans or their allies? In view of what was said in Greece about the equivalence between formations and buildings and in view particularly of Iphigeneia's statement in Euripides' *Iphigeneia in Tauris* (57) that 'the columns of a house are sons', the unique properties of the new temple might have been seen first and foremost as an index of the ability of the Athenian army to manoeuvre in tight formation for maximum effectiveness. The converging columns, the strengthening of the corners and the curving of the stylobate according to a perfect mathematical series are all witnesses to a level of discipline and control that challenged that of their enemy. A Spartan could also have noted that the temple's proportion of 8 × 17 columns made it closely resemble the *pentekostys*, a basic unit of his army consisting of 132 men, who would in the Spartan phalanx form a unit of 8 × 16. It was not necessary for the numbers to correspond exactly, any more than it was necessary for the refinements to have precise equivalents on the battlefield. The Athenians were doing only what armies in modern times do when they produce peacetime parades and displays of dexterity and synchronisation, placing, for example, a pyramid of men on a single motorcycle in order to intimidate their rivals with a display of almost superhuman control. Nor was it essential for people to know exactly what was the basis of the building's configuration. Getting an uneasy sense of its exceptional mathematical co-ordination would have been enough to achieve the desired effect. It is possible, too, that the curvature of the stylobate and the strengthening of the ends would have been perceived as a deliberate allusion to the specific adaptation of the formation with which the Athenians had, in 490 BC, won the Battle of Marathon and with it the respect of all of Hellas. On that occasion they had defeated a much larger Persian force by strengthening the flanks and weakening the centre of an extended phalanx. Advancing downhill at the run they had broken the opposing army by parting just before impact, thus allowing the Persian centre to rush through them, leaving the remainder to be mopped up by a new phalanx that was formed when the two ends reunited in a rigid block. The startling ability to keep in formation and then to break and reform, all on the run, which the Athenians revealed at Marathon, was given great prominence by Herodotus in his account of the engagement (*Histories*, VI, 112–14). The Spartans, as much as the Persians, may have become nervous about the tricks that the Athenians could play with the standard formation. If the Parthenon was sensed in some way to be the architectural equivalent of a flexible phalanx this would have only increased their insecurity.

34 Remains of earlier temples set into the wall of the Akropolis, Athens, after 479 BC.

If the Athenians sensed the same correspondence they would, of course, have felt more secure and we do indeed get a clear impression of how they would have responded to such a building psychologically from the text of *Iphigeneia in Tauris* quoted above. It was during a nightmare about the collapse of her parents' house that Iphigeneia saw a column sprout hair from its capital and then speak with her brother's voice, an experience that elicited the comment likening the columns of a house to sons (*Iphigeneia in Tauris*, 47–57). The Athenians who watched the play sitting under the Acropolis during the Peloponnesian War were as anxious about their city as Iphigeneia about her home. Euripides knew when he wrote those lines that the audience would look up in their anxiety at the recently erected columns of the Parthenon above. We have only to change Iphigeneia's interpretation of architecture to 'the columns of a city are its young men' to understand how the building might have affected those who saw it. Euripides was exploiting long-standing anxieties. When the Athenians rebuilt the defensive walls of the Acropolis after the final repulse of the second Persian invasion in 479 BC, they built into it in a conspicuous position over the Agora the reconstructed entablature of one predecessor of the Parthenon and the abbreviated colonnade of another (fig. 34). Unless the regular geometry of the temple's external colonnade embodied some mystery of security it is difficult to see why such careful reconstructions of them in the new wall would have been necessary. The

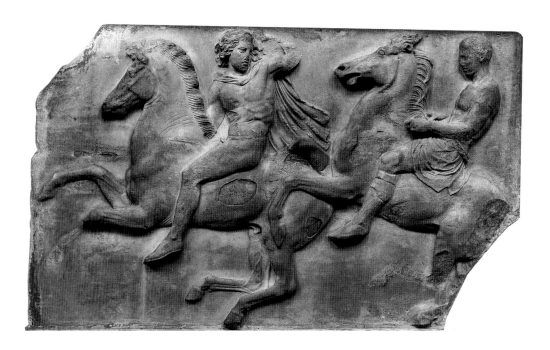

Pythagoreans called one of their magic number patterns *kadmeia* after the citadel of Thebes. The Athenians increased the protective magic of their own citadel by building an architectural number pattern into it. In Classical Greece mathematics, architecture and military security were intimately connected.

The Parthenon, the brainchild of the Athenian leader Pericles, reveals itself as a manifesto of military excellence in all its aspects. The home of the warrior goddess, Athena, it was, as we have seen, full of military imagery. The frieze that surrounded the cella does not show war itself but its subject, the Panathenaic procession, is a perfect vehicle for celebrating the military ability of Attic youth, especially their discipline, control and the ability to maintain formation. The majority of the frieze, that is, both long sides and one end, is taken up with one element of the procession – a parade of cavalry – and this is represented in such a way that we repeatedly see marshals imposing overall order on the men and feel the same control passed on from the men to their horses. The result is rank upon rank of riders, several abreast, who whatever their speed always keep together and hold their relative positions (fig. 35). There is a calculated relation to the colonnades below. Marshals are most prominent at the corners and there too the flow of free movement is arrested (fig. 36). Finally there is an overall correspondence between the relative numbers of the figures in the relief and the relative numbers of the two different orders of columns used on the building. The large number of men matches the equally large number of Doric columns on the exterior and the small number of women on the east façade relates to the few Ionic columns in the *opisthodomos* (fig. 37). Vitruvius' notion that Doric was adapted from the male body and Ionic from the female probably originated at this time, and the women of the frieze do look particularly column-like, a correspondence that is made explicit in the slightly later so-called Caryatids of the nearby Erechtheum, whose draperies are made to look like the shafts of the structure's fluted Ionic columns (fig. 38). Everything about the

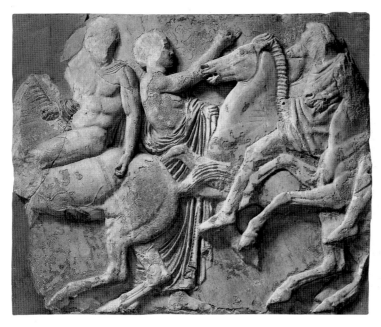

35 (*facing page bottom*) Horsemen, detail of frieze from Parthenon, Athens, 447–432 BC (see figs 36 and 37).

36 Marshal, detail of frieze from Parthenon (see figs 35 and 37).

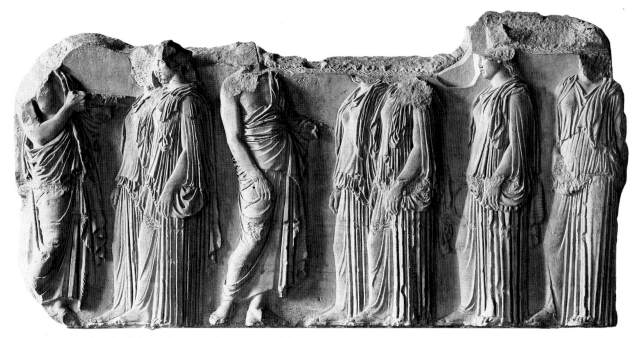

37 Women, detail of frieze from Parthenon (see figs 35 and 36).

Parthenon, from the column-like girls to the man-like columns, is calculated to suggest Athens' supremacy in the field of military discipline. It embodies very much the same qualities as the Doryphorus of Polykleitos and, as if to emphasise this, several of the male figures in the frieze appear, as has been repeatedly noticed, directly to copy that 'canon'.

The Parthenon, which was paid for out of the defence budget of the Delian League, was almost certainly designed to prevent war by its display of strategic attributes. So too probably was the Doryphorus. Athens and Argos were the two states most hostile to and fearful of Sparta. As a result they had the most reason to commission mathematical works of art in the tense years that preceded the Peloponnesian War. Still, buildings and sculptures with a military aesthetic may be an effective deterrent in peacetime, but they are little help against a truly military society if hostilities do break out. When war came mathematical art was of little help against a mathematical army. Thucydides describes with awe how at the great Battle of Mantinea in 418 BC the Athenians, Argives and their allies were helpless before the Spartans. Fascinated, as by the mathematical perfection of a destructive automaton, he records how the Spartan forces were divided into seven *lochoi*, each *lochos* being then subdivided into four *pentekostys* and each *pentekostys* being further subdivided into four *enomotiai*. The whole was drawn up in a uniform block, 448 men across and 8 deep. In psychological preparation for the fight the Spartans sang their national war songs and reminded themselves that careful training over a long period was more useful than stirring speeches. They then advanced in step, as noted above (p. 33), with flute-players setting the rhythm (fig. 25), and so overwhelmed their opposition (Thucydides, *Histories*, v, 67–9). It was the arithmetic of the Spartan military machine arranged in geometric formations, the

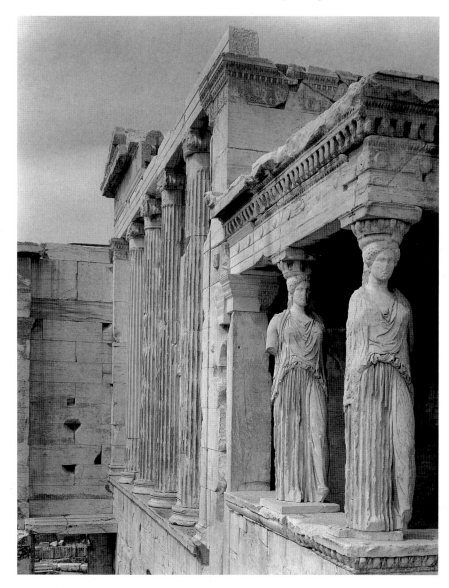

38 Porch of the maidens (the 'Caryatid Porch') and west façade, Erechtheum, Athens, 421–406 BC.

precision of the whole held together by music, that proved superior to the combined forces of Argives and Athenians. It was the mathematics of the Spartans that their enemies most feared and it was this mathematics that brought them victory. In a few years a Spartan governor or *harmostes* brought the Spartan brand of *harmonia* to Athens and was appropriately installed alongside Athena on the Acropolis.

Plato and the Mathematical Guards

All this Plato experienced as a young man and it was probably the memory of these events as much as anything that inspired him eventually to write the *Republic*, in which he tried to build mathematics more deeply into the state than the Spartans, Argives or

Athenians had done. In his account of an imaginary society he set out to make his elite as mathematical as only works of art had been before. By reviving and consolidating the mathematical education of Pythagoras he hoped to 'produce' a regiment of Doryphorus-like *phulakes* or 'guards' (usually incorrectly translated as 'guardians'), able to act together with as great a restraint and precision as was manifest in the Parthenon. A state ruled and defended by such men would enjoy, he must have hoped, the same stability as the mathematical and harmonious universe.

In developing his system Plato makes explicit what we could only infer in the case of Pythagoras, that the principal and basic function of mathematics is military. At the beginning of Book VII, when Socrates is moving to outline the education of the guards, the top class of his state, and looking for subjects that will lead young men from 'that which comes into being to that which is' (*Republic*, 521D), he stresses that the subjects chosen will have to contribute to the development of their abilities as warriors (*Republic*, 522C). The only ones suitable, he concludes, are the four *mathemata* or mathematical subjects, arithmetic, geometry (subdivided into plane and solid), astronomy and music (in the form of harmonics), a list that Socrates claims to borrow from his contemporary, the Pythagorean Archytas. We are told explicitly how each has military as well as general philosophical value. 'For the soldier must learn [arithmetic] by marshalling his troops' (*Republic*, 525B).

> Obviously so much of [geometry] as relates to warlike operations will concern us. For pitching a camp, occupying a position, closing up or deploying troops, and for other formations both in battle and on the march, a knowledge of geometry will be of advantage.
>
> *Republic*, 526D

Similarly the justification of astronomy is that a knowledge of 'seasons and months and years is no less necessary for campaigning than for agriculture and navigation' (*Republic*, 527D). In the case of music Plato does not give a military justification at this point, since he is here concerned only with the abstract theory of harmonics, but the military function of music had already been explained at *Republic*, 400–04, and recalled most recently at *Republic*, 522A: 'music is the counterpart of gymnastics'. The significant point is that for Plato the primary function of the four mathematical arts – which would later become the quadrivium and the basis of Western European education – is military. That they can also be used to instil higher truths is a secondary, if also an essential point. Admittedly, in the second half of the *Republic*, where Plato is above all concerned with the instilling of absolute values for civil purposes, he does not emphasise their military value too much, because this would give them a distastefully utilitarian aspect. Yet, when he mocks all the earlier tragedians who claimed that Palamedes, a Greek hero of the Trojan wars, had invented arithmetic and so was able to use it to marshal the ranks of the army and to count ships and other things (*Republic*, 522D), he indirectly confirms the currency of the assumption that arithmetic, the basic element of the loftiest Greek philosophy, was invented for military purposes. And, when he says that the 'rulers [of the community] are those who are best at philosophy and best equipped from birth for war' (*Republic*, 543A), he suggests that the qualities required for the elite in both civil and military spheres are identical.

Plato realised that the fundamental test of his invented state, like that of all Greek

states, and the test that Athens had recently failed when confronted by Sparta, was its ability to survive an attack. This is why at the beginning of the *Timaeus*, which is presented as the sequel to the *Republic*, Socrates is described as being impatient to find out the successfulness of his design:

> I might compare myself to someone who seeing beautiful animals, either created by the art of the painter or really alive, but inactive, feels a desire to see them moving or exerting themselves in some conflict which is appropriate to their bodies. I feel the same way about the city we have described. I would enjoy hearing someone go on with the story, describing the contests which a city engages in, describing how this city engaged in such contests with other states, how she arrived at a war situation in an appropriate fashion and how once in it she made a display appropriate to her education and training, both in her deeds in the field of action and in her discussions in the field of words with each of these cities.
>
> *Timaeus*, 19B

Socrates here professes no interest in any other aspect of his perfect state. He is not concerned whether it is internally stable or whether its rulers understand absolute standards. He wants only to know how effective it is militarily. There can be no clearer indication of why the *Republic* was written. This aspect of the most important text in the history of Western philosophy has never received full acknowledgement because later writers were reluctant to admit what Plato and all Greeks knew, that the original purpose of a mathematical education was as an instrument of military training.

Socrates' desire to see his work of art in action is not satisfied immediately. First, he must hear an account of the origin of the universe. This is put into the mouth of Timaeus, who came from Locri, a city near Croton, and who was himself a prominent Pythagorean. The Pythagorean universe he portrays relies as much on mathematical order as does Plato's republic and is evidently intended as its prototype. Timaeus first describes the spherical nature of the divine artificer and his design of the universe in imitation of himself as a system of concentric rings arranged in complicated arithmetical ratios. He then goes on to show how the human head is made spherical after the same ultimate pattern and how the human being, like all of nature, is made up of essentially geometrical shapes arranged in arithmetical series. Man is less perfect than God, having a body as well as a spherical head, but he is still far more perfect than the lower animals, which have long heads and odd-shaped limbs because of the inactivity of their souls. We hear how the four elements are each made up out of four regular solids, how phenomena such as the colours in the outside world are based on mathematically proportioned mixtures and how the health of our bodies depends on similar proportions between the humours. Finally Timaeus tells how death comes when the joints between the 'triangular' tetrahedra of fire out of which our blood etc. is made come loose and the body collapses. The implication is that the body, like a wall or a phalanx, collapses when its tight material geometry is destroyed. The mathematics that is essential for the education of the guardians of the *Republic* is even more essential for the layout of the universe and our bodies. The Pythagorean nature of the mathematics of *kosmos*, state and human body is explicit. Plato follows Pythagoras in arguing that the mathematical order essential for the security of cities has its model in the enduring system of the heavens.

The *Timaeus* is only an interlude in preparation for the story of the *Critias* where we at last have the story of a conflict between an idealised early Athens and a corrupt Atlantis. The theme of the story, which is unfortunately incomplete, is the support that the gods gave to a good city similar to that described in the *Republic* in its battle with a corrupt rival. The tale is appropriately put into the mouth of Critias, a disciple of Socrates who was associated with two misconceived attempts to reform the flawed Athenian democracy by setting up an oligarchy based partly on a Spartan model. With other young aristocrats he was a member of the oligarchic Council of Four Hundred set up in 411 BC to halt the decline in Athenian fortunes and of the even more extreme Council of Thirty, which was established under Spartan protection when the war was finally lost. The Council of Four Hundred, of which he was a leader, in many ways recalled the three (or six) hundred *mathematikoi* who provided the basis for Pythagoras' power. Plato knew that the ambitions of both the Four Hundred and the Thirty were fatally flawed, but he knew too that they had come closest to anticipating his programme, that they were influenced by the educational principles of both Pythagoras and Socrates and that the Thirty had tried to implicate Socrates in their projects. As a sequence, the *Republic*, the *Timaeus* and the *Critias* represent a complete celebration of Pythagorean culture, beginning with the formulation of a state ruled by a mathematically trained military elite, going on to an exposition of the mathematical basis of the whole universe, and ending with a description of the ultimate test of a perfect mathematical state in a war situation. Plato's most elaborate discussion of mathematics in the *Republic* and the *Timaeus* is directly associated with preparation for conflict, the war that was to have been described in the *Critias*.

Plato connects mathematics with the military. He also connects it with material artefacts. In the *Timaeus* the universe itself is explicitly described as a complex artefact, the product of the divine artificer. So too is man, the product of the demigods. We are even invited to think of the state in the *Republic* as an artefact, as Socrates implies when he says that in looking back at it he feels like someone looking at a painting of an animal who wants to see it really in action. The city of the *Republic*, the universe and man in the *Timaeus* are all mathematical artefacts, the city like a painted animal, the universe like a large building and the human body like a sculpture. The use of mathematics made it possible to perfect the Homeric imagery of man and community as regular artificial constructs and to apply the same vision to the universe.

Greek mathematics was never, of course, exclusively military in character. Nor was the detailed direction of its development shaped only by military considerations. It had broad roots in ancient Egypt and Mesopotamia and these were expanded in Greece. It was, however, the importance of absolute order in the military sphere that gave mathematics a dominant role in all of Greek culture and it was its almost magically protective power that made it the mysterious key to the stability of the Homeric phalanx, of the Pythagorean *kosmos* and the Platonic state, and to the visual excellence of the Doryphorus and the Parthenon. If the mathematics of the Greeks had not been founded in war it would never have been treated by them with such respect. Later generations of Europeans have rarely admitted to the military foundations of what is often claimed to be one of their highest and most peaceful activities. Perhaps they, like Pythagoras, have been unwilling to divulge the ultimate military secret, the hidden power of mathematics.

The Power of Women and the Aesthetics of Peace

Mathematics was implicitly rejected in favour of 'erotics' by Sappho in the lyric quoted earlier, and later in the same poem she opposes the aesthetics of sex to those of war even more clearly. Provocatively taking Helen, who almost destroyed Greece, as her first example of an object of sexual desire, she goes on to sing of her own darling, Anactoria:

> I would rather see her lovely walk and the shining
> sparkle of her face than the chariots of the Lydians
> and armed infantry fighting.
>
> *Lyra Graeca*, I, 209

The palm of beauty is awarded not to military dispositions but to a personal love. The preference for the sexy walk of a single woman over the march of disciplined men and for a shining face over a squadron of gleaming chariots show how different are her tastes and how different the values on which they are based. Helen is for Sappho the real hero of the history of Troy, and the power of love greater than the force of war.

According to the *Iliad*, Aphrodite first caused the war by promising Helen to Paris and then prolonged it by offering the doomed Trojans ineffectual assistance. By contrast it was the virgin Athena, uninterested in sex, who by her material help brought the Greeks their inevitable victory. Sappho knew all too well the way the epic warned against sexual love. So did Greek males who predictably had a double reaction to the message. There can be no doubt that in its celebration of the love of Achilles for Patroclus the *Iliad* contributed to the elevation of male bonding, just as did such institutions as the gymnasium and the Great Games. It is also certain that the warnings about the dangers of love for women in the end proved counter-productive. Greek youths were so persistently warned of the dangers of attraction to women that desire for them slowly came to rival war as an obsession. The requirement to suppress heterosexual love for the sake of the community only increased the individual's fascination with it. Private passions have almost as important a place in early Greek poetry as public virtues. From the outset they seem to be presented in the context of an alternative life-style and even an alternative aesthetic. Often they are associated with an abandonment of arms and military obligations.

Sappho's contemporary, Alcaeus, also from Lesbos, was proud to announce to his countrymen that he had broken the code of honour by throwing away his armour on the field of battle and running away. Not that he could spurn military values as Sappho had done. Many of his poems celebrate the pleasures of love but many others, as we saw earlier, glorify war. The sense of a deep split in the Greek male's personality is already felt in the work of the slightly earlier Archilochus, who, although he virtually earned his living as a soldier, was also ready to boast about throwing away his shield in an abandonment of duty. Alcaeus has also left us, beside the robust hymn to the phalanx mentioned earlier, one of the most remarkable and sensitive stories of seduction. Finally, a third poet to celebrate leaving his shield on the field of battle is the

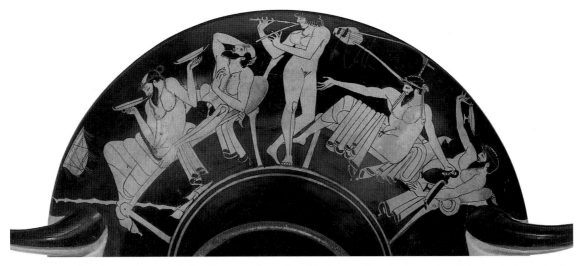

39 Dancing female musician and drunken revellers, detail of a vase by the Foundry Painter, Attic, early fifth century BC.

mid-sixth-century writer Anacreon, who did for male love what Sappho had done for female and who stated his preference for love over war as clearly as she:

> I do not like the man who, drinking beside the full mixing bowl,
> talks of conflicts and mournful war, but rather one who brings to
> mind lovely laughter mixing the Muses with the splendid gifts of Aphrodite.
>
> *Lyra Graeca*, II, 197

Here Anacreon also draws attention to the origin of the conflict of interests in the field of poetry. His reference to drinking reminds us that it was at symposia, drinking parties, that these lyric verses would be sung. At such *symposia*, where the survivors of the rigours of battle and exercise would come together to relax, it was equally natural both to commemorate the qualities that enabled the participants to come through such ordeals and to welcome the opportunity to abandon them. Wine became so important in Greece because it was such a powerful aid to relaxation. Under its influence abandonment increased and with it sexual indulgence. This is why three of the male poets who glorify sexual love are also agreed in their mocking of military virtues. That they also share both features with the first great poetess shows how in such circumstances love became directly opposed to war. Love could not of course seriously challenge military values in the public arena, but in the *symposion* it readily emerged as an alternative and in many ways a subversive theme.

Recognised as such, love could never become the subject of large-scale public reliefs and wall paintings, but in the decoration of the pottery that was the chief ornament of the *symposion* it soon acquired considerable prominence, just as it did in song. While many large scenes show heroes involved in warfare and fulfilling other obligations to their families, their communities and the gods, and while smaller scenes may show aspects of the training and education necessary to prepare young men to meet those obligations, many others show scenes of indulgence in sex and wine (figs 13c and 39).

In the sixth century such indulgence is enjoyed vicariously by wanton satyrs, but these half-animal creatures progressively lose many of their animal attributes and by the fifth century wealthy Greeks such as those who would have used the vessels increasingly take over their roles. It was far from easy for the Greek male to admit to the integration of both values in his personality. In real life the two would often be kept separate, with the party coming only as a reward for some achievement in battle or sport or at school. One way this separation could be preserved was by having scenes from the two worlds balancing each other on either side of an amphora or on the outside and inside of a cup, as we have seen (figs 13a,b and c). The most expressive way to indicate their relation was to have a scene from the battlefield or the palaestra on the outside of a vessel where it might be appreciated, as it were while still on the shelf, and scenes of the *symposion* inside in the bowl where they would be discovered by the drinker as he finished his draught at the party. Without emphasising such a strong contrast between discipline and relaxation it was possible to pair scenes of male and female activity in the same way. In the poetry, imagery and activity of the *symposion*, heterosexual love achieved an ever increasing prominence. The theme of subversive abandon became through repeated celebration almost a subject of study.

Inevitably, especially with the growth of urban luxury, awareness of the power of women's charms increased. By the later fifth century and the early fourth the role of women and female sexuality were increasingly, if grudgingly, acknowledged outside the *symposion*. In the earlier fifth century the virgin Athena was the dominant type everywhere, encouraging military virtue and giving support to heroes such as Heracles. Around 440 BC, she still stands stiff and armed inside the Parthenon and in one pediment she strides in symbolic combat with Poseidon, but, in the other pediment, Athena's sister, Aphrodite, lies languid in her mother's lap, with her light robe slipping off her soft shoulders (figs 11, 40 and 71). Elsewhere a similar image of the sex goddess was developed in contemporary cult statues. The power of love was now recognised even in major public monuments.

40 Aphrodite reclining, detail of pediment from Parthenon, 447–432 BC.

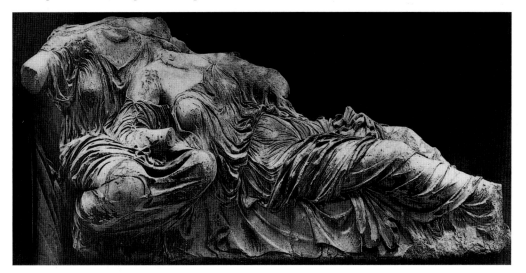

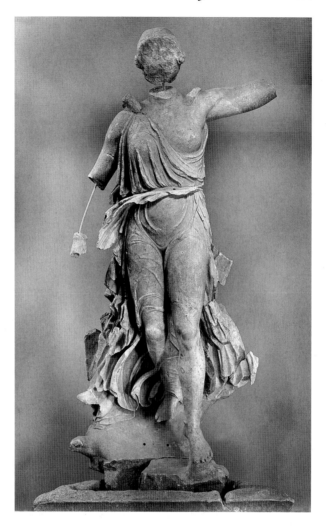

41 Nike (Victory) by Paionios of Mende, marble, *c.*420–410 BC.

The ultimate proof of this power was its exploitation to strengthen those very military virtues that it had traditionally threatened. Some of Aphrodite's erotic qualities were cleverly transferred to Nike, goddess of Victory. Nike was rarely represented before the early fifth century, when she begins to appear on painted pots. As the bringer of welcome rewards she is always more charming than Athena, but the Nike of Paionios who alights on the victory monument of the Messenians at Olympia around 420 BC goes a decisive step further; she is shown as a woman who might be desired by any exhausted soldier (fig. 41). An even more striking example of the sexualisation of the goddess is provided by the sculptures of the Temple of Athena Nike on the Acropolis in Athens. Earlier, the shrine's dedicatee had been seen as just another stiff manifestation of the warrior Athena, but the Nike figures who adorn the parapet of about 410 BC are all flexible, soft and flimsily clad (fig. 42). The martial figure of the virgin goddess who had been used to stiffen the resolve of generations of Greeks no longer had the requisite appeal to a new generation brought up on urban pleasures.

Credited with such power by men, women are likely to have welcomed the chance

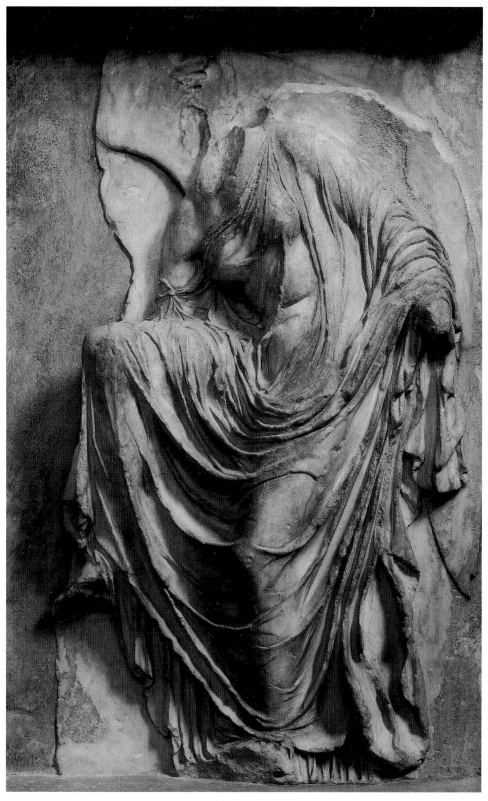

42 Nike (Victory), marble, from the balustrade of the Temple of Athena Nike, Athens, c.410 BC.

to exploit their power for their own purposes. This is certainly what Aristophanes envisages in his *Lysistrata* of the 420s BC. It obviously made more sense to exploit the power of sexual desire to stop fighting rather than to encourage it and this is exactly what Aristophanes imagines happening. His suggestion that women might bring an end to the Peloponnesian war by using the denial of sexual gratification to force men to negotiate peace acknowledges the new status of heterosexual desire just as does the contemporary Nike of Paionios. The play's discussion of the role of clothing in exciting that desire is directly relevant to the sculpture's flimsy dress. Working each in its own terms *Lysistrata* and Nike both offer sexual pleasure as the reward for ending conflict. Paradoxically it was only in Greece where homosexual love had been traditionally regarded as a principal motor behind military success that heterosexual love could be readily adapted to the same purpose.

Drinking cups decorated with victory figures were probably used to celebrate victories in other spheres than the military, and texts survive that show how the power of heterosexual desire was also acknowledged − if less blatantly and in a more controlled frame of reference − in an important area of life with a profound kinship with the military, that of education. Not long before Aristophanes wrote the *Lysistrata*, the famous teacher Prodicus caught the imagination of his male students with the story of a problem that had once confronted the tough Heracles. The hero was presented with a choice between Vice and Virtue, who were represented to him by two women, the one flimsily dressed and heavily made-up and the other simply clad and unadorned. The story carries both an implied admission that love for a woman may now be an influence on virtuous action and an implied warning that too great an interest in sex may be the source of error.

The story of the Choice of Heracles is preserved for us by Plato, who also presents the parallel distinction between Aphrodite Pandemos (Popular) and Aphrodite Ourania (Heavenly) (*Symposium*, 180–81). The one is linked to the love of the mind and of the male. It is a powerful force for good. The other is associated with love of the body and of women. As with the Choice of Heracles the comparison sets out to warn young men against desire for women, but too late, since it relies on the acknowledgement of that desire in the person of Aphrodite to make its point. Equally counter-productive is the supreme celebration of Eros, also in the *Symposium*, which Socrates credits to the wise woman Diotima. She may stress that the love that leads to heterosexual intercourse is lower than that which leads to intellectual communion, but her language is so steeped in a woman's world that, however allegorised, the real subject of her celebration can only be the love between man and woman. Many of the young men whom Plato taught must have noticed the inconsistency in his warnings. The choice between Athena and Aphrodite presented earlier in the *Iliad* had been less ambiguous. What is certain is that love would never have become such a central theme in the Platonic dialogues, dominating major works such as the *Phaidrus* and the *Symposium*, if it had not at last achieved recognition as a force that could not be denied. Centuries of attempts to create a better fighting force by warning men against women and against heterosexual love led in the end to a greater understanding of the power of both. By the fourth century BC most Greeks were ruled less by an Eris (strife) who opposed man to man on the barren field of battle than by an Eros who drew men to women in increasingly luxurious cities.

Chapter Three

GREEK ART AND
THE CULTURE OF COMPETITION

Work and Competition

The *Iliad* is a celebration of war that inaugurates the distinctive military tradition within
Greek culture. Hesiod's *Works and Days* is a poetic treatise on agriculture that marks
in a more business-like way the launch of the other essentially Greek tradition, that of
economically productive competition. If Strife on the battlefield is an unpleasant neces-
sity, Strife in the fields and the marketplace is beneficial only in its stimulating effect.
Hesiod's view of Strife in the civil context is optimistic, but we should not under-
estimate the significance of the sinister undertone implied in the assimilation with the
military context. Hesiod sees war as providing the model for civil life, because in con-
temporary Greece warfare was the necessary condition of all life and the one that had
a dominant role in defining attitudes. To his fellow Greeks, the idea that there existed
another type of conflict that was safe and beneficial would have been both natural and
appealing.

A Greek who heard or read the *Works and Days* would have recognised in the rec-
ommendations on what a farmer or sailor should do, and when, a set of rules similar
to those that he was expected to follow as a soldier. He would have understood that
while the latter improved his chances of survival, the former improved his chances of
prosperity. Hesiod's warnings of the dangers of associating with the wrong sort of
woman would have also struck a familiar note. Above all, his hearers would have recog-
nised his description of a society in which 'potter grudges success to potter and builder
to builder, and beggar is jealous of beggar and bard of bard' (*Works and Days*, 25 and
26) as evoking the Homeric image of the battlefield where 'shield presses against shield,
helmet against helmet and man against man'. The relationship is not the same but the
image of repetition and uniformity is. Just as the organisation of the army is expressed
in the patterns made by arms and men, so society can be analysed in terms of the pat-
terns formed by potters and builders, beggars and bards. The Greeks readily described
men and objects in the same terms because in their particular context they occupied
similar categories.

Competition, Imitation and Improvement

In his description of civilian strife Hesiod gives us a remarkable insight into the mechanisms of Greek economic life. His reference to three crafts in particular, that of the *kerameus* or potter, that of the *tekton*, joiner or builder, and that of the *aoidos*, bard or poet, applies those insights to the process of manufacture of what were to become its principal products. Although the particular pots, buildings and poems that Hesiod must have had in mind were not yet fully developed expressions of Greek culture – because, for instance, the buildings he refers to would have been wooden – the vases, temples and poems that would be eventually produced by these crafts were to be among the most typical products of Classical Greece. By his choice of those three crafts he seems to predict that the history of Greek culture will be nowhere better expressed than in the development of types of pottery, architecture and poetry, until in the fifth century its essence will be distilled in a red-figure vase, a Doric temple or a Pindaric ode. His words have a prophetic value, helping us to understand not so much his own period as those crucial centuries to come during which the culture we call Classical was formed.

The benefits of competition are illustrated by his own case. That he is more successful than his brother as a farmer is owing not just to his greater effort. A more decisive factor is his greater technical skill. Hesiod breaks down the farmer's year into a cycle of standard jobs and then tells how and when each can be done best. Competition, such as that between himself and his brother, leads to the constant improvement of techniques, which leads in turn to greater productivity. This is why it is so beneficial to humanity.

The other type of competition in which Hesiod was engaged was poetry. He tells us how he competed with his contemporary poets at the funeral games of Amphidamas in Chalcis where he won the tripod prize (*Works and Days*, 654–9). We know nothing of the impact of this competitive framework in his case, but we can study the impact of the competitive approach in other works that show the impact of poetic rivalry. *The Contest of Homer and Hesiod*, a poem whose origins go back at least to the fifth century, claims that the poet whom Hesiod defeated at Chalcis was Homer himself. This is an invention, but the Greeks knew well enough that other poets had measured themselves against the legendary first bard, and the fragmentary *Shield of Heracles*, an obvious emulation of Homer's description of the shield of Achilles in the *Iliad*, Book XVIII, was already credited to Hesiod soon after it was composed by an anonymous author in the early sixth century. Just as Hesiod stressed the importance of competition between practitioners of the same craft so later Greeks, interpreting Hesiod's relation to Homer in those terms, saw the *Shield of Heracles* as the product of such a competition.

As a product of Hesiodic competition the *Shield* provides an excellent illustration of its distinctive effect on culture. One aspect of this is the similarity between the two descriptions which is at first sight their most striking feature. Both are about the same length and both purport to describe metal shields with relief decoration made by the god Hephaestus. Both shields are rimmed by the god Oceanos and both contain views of town and country, scenes of marriage and of dancing, of hunting and of fighting. Some sections even correspond in detail. Imitation is apparently the principal feature of competitition. The later poet evidently had to attempt virtually the same task as Homer before he could show that he could do it better. But of course it is in the

(i) storage jars

a b c d e f

(ii) mixing bowls

a b c d e f

(iii) wine jugs

a b c d e f g h i j

(iv) drinking cups

a b c d e f g h i j

(v) vases for cosmetics, oils and perfumes

a b c d e f g h i j k l m

43 Types of vase.

doing better that the competition is most apparent and the resulting improvement is evident in the works' differences. The two principal ones are the reduction in the number of scenes from the earlier shield and the introduction of a new way of handling them. Competition encourages first of all a tendency to imitate and secondly a tendency to modify in order to produce something that may be thought of as better. The relation between the two texts is an excellent example of the competition between poets referred to by Hesiod. It suggests what the impact of competition may have been not only on building and pottery, the other two crafts to which he referred as being subject to similar competitive pressures, but indeed on all aspects of Greek civil life.

Hesiod's celebration of competition allows us to pinpoint the origin of two of the most characteristic features of both Classical art and literature, the continuity of certain themes and the tendency for those themes to be constantly re-interpreted in such a way that there seems to be some underlying continuity of direction behind stylistic change. More than in any earlier civilisation the Greeks may be said to have concentrated on making steady improvements to a limited number of typical products, the temple (figs 21 and 22), the painted vase (figs 15, 16 and 43), the male and female standing statue (figs 57 and 62–4), the relief carving of a battle (figs 67–70), the painted mythological scene (figs 65 and 66a and b), the epic, the ode, the dithyramb, the tragedy, the comedy, and so on. The type of the product remains surprisingly the same. So does

the consistency of the changes in response to ever increasing demands. In other cultures, both earlier and later, buildings, sculptures, paintings, works of literature, etc. either remain relatively constant because they satisfy their users or change dramatically in response to new demands. Egyptian statues, for example, may have followed the same patterns for millennia because those patterns satisfied the needs of those who commissioned them, until an event such as the religious revolution under Akhnaton caused a startling change. Equally, no two Egyptian temples are as alike as are large numbers of Greek ones, because each temple was made for a different patron or group of priests for a different deity responding to different needs. Only when there was an element of competition, as in the design of pylons at principal sanctuaries built under successive pharaohs, did something similar to the Greek situation occur, but this was unusual. Egypt was not ruled by strife, either in battle or the marketplace. In Greece for the first time competition was dominant everywhere. As Hesiod saw, the individual Greek craftsman or writer was in a constant state of rivalry and this encouraged him at once to imitate his predecessors and contemporaries and to endeavour to surpass them. Only thus could he guarantee that he would be recognised as being better and obtain the rewards that flowed from that.

Competition: Its Organisation and Regulation

Competition itself was not new. It had always been present in nature and had long been given a place in human social ceremonies, as in the funeral games of the Homeric epics, which replace the strife for dominance that often followed the death of a leader with a more innocuous rivalry. From the eighth century onwards, however, competition achieved an importance that it had never previously had. One of the earliest dateable Greek inscriptions in the new Phoenician-derived alphabet identifies an Athenian *oenochoe* as a prize for: 'He who of all the dancers now performs most daintily' (fig. 44). By 776 BC, the four-yearly games at Olympia had already been instituted. By the

44 Detail of *oenochoe*, inscribed: 'He who of all the dancers now performs most daintily', Attic, *c.*725 BC.

end of the century Hesiod was winning prizes for his poetry and the first potters were starting to sign their finer pieces, thus allowing their work to be identified and compared with that of rivals in the marketplace. Potter competed with potter, poet with poet and builder with builder. In political life too competition was regulated and the first constitution drawn up. At Dreros on Crete in the mid-seventh century the first Greek law inscribed on stone requires that no one shall hold the important office of *kosmos* more than once every ten years.

Hesiod himself was well aware that to function optimally competition had to be controlled: 'For Justice beats Outrage when she comes to the end of the race' he says,

cleverly using a metaphor from the world of competition itself (*Works and Days*, 217–18). 'But they who give straight judgements to strangers and to men of the land, and do not set themselves aside from what is just, their city flourishes . . .' (ibid., 224–7). Giving honest judgements and telling the truth are important for the economic life of the community. One of the so-called Homeric *Epigrams* shows how this honesty was fostered within an individual craft, that of the potter:

> Let the pots and all the dishes turn out well and be well fired: let them fetch good prices and be sold in plenty in the market, and plenty in the streets. Grant that the potters may get great gain and grant me so to sing to them. But if you turn shameless and make false promises, then I call together the destroyers of kilns . . . '
>
> *Epigrams*, XIV, 3–8

Evil spirits will punish those who seek to gain advantage over their rivals by deception. Honesty is as important commercially as is giving correct judgements socially.

The person who pursued the attack on Outrage (Hubris) and on crooked judgements most vigorously was the early sixth-century Attic statesman and poet, Solon: 'But a good system of laws [*eunomia*] makes everything appear orderly [*eukosma*] and perfect.' Solon, moreover, was able to put his principles into practice. Having achieved political power partly through the aptness of his verses, he acquired the authority to transform Athenian political and economic life by a system of reforms. These reduced disparities of wealth by introducing a simple form of graduated taxation that demanded more of the rich than of the moderately well off and by removing the burden of debt that crippled a large section of the population. They also reduced disparities of power by giving all citizens a vote in the assembly. Proper elections were organised and, since access to the highest offices was limited to the members of the richer classes, those offices could be said in effect to be available as prizes to those who accumulated the necessary wealth. Overall, by reducing differentials of wealth, Solon made competition more equal and at the same time stimulated such competition by offering power as a reward for success. Other measures too encouraged people to exert themselves. Foreigners with skills were allowed to settle in the city. Fathers were expected to teach sons a trade. In his verses he talks positively of how each person energetically pursues his own activity, whether it is trading, farming, the exploitation of craft and technology, 'the works of Athena and Hephaestus' as he called them, poetry or medicine. For him competition under the law produced prosperity and an ordered society. The close alliance of commercial and political competition established in Solon's Athens inaugurated the European tradition of associating democratic institutions with economic growth as well as with military success.

The model for all competitive activities in ancient Greece was provided by the great pan-Hellenic games, and Solon acknowledged this by appointing large sums to be paid to athletes who were victorious at Olympia and Nemea. It was during his life too that many of these games achieved formal regulation. The Pythian Games at Delphi were reorganised in 590 BC, the Isthmian Games near Corinth in 582 BC, the Nemean Games in 573 BC and the Panathenaia at Athens itself in 566 BC. The majority of the games were purely athletic/military but they became increasingly also the setting for other contests and performances. Homer was recited at the Panathenaia from the late sixth century and at the Dionysiac festival at Athens tragedy and comedy developed

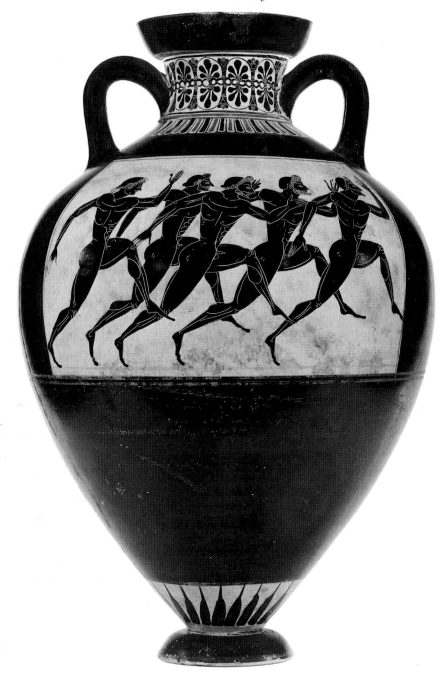

45 Panathenaic amphora showing footrace, Attic, *c.*530 BC.

in a highly competitive framework to produce the achievements of Aeschylus, and Sophocles, Euripides and Aristophanes during the fifth. Most important of all, the festivals could become major commercial events, especially at Athens, where Athenian products were displayed for the many visitors. Trade was even officially fostered at the Panathenaia by the state commissioning of prizes representing the best in Athenian craft and food production. These were the so-called Panathenaic amphorae, superb

pieces made by the best potters and painters and filled with the best oil (fig. 45). Carried off by victors and displayed in remote cities, with their representation of the sport concerned on one side and of Athena on the other, they advertised the skills both of the owner and of the Athenians. Otherwise artistic competition was more generally associated with the games through the tradition, which developed in the sixth and fifth centuries, of erecting statues of victors, particularly at the shrines at Olympia and Delphi (fig. 46). These statues of competitors inevitably became competitive commemorations in themselves.

Many more types of competitions were also arranged more or less formally throughout the Greek world. The story of the Judgement of Paris, told in the lost *Kypria*, recorded a legendary beauty competition between Hera, Athena and Aphrodite, and Alcaeus refers to a beauty competition between young girls on Lesbos. We know of a competition in carding wool at Tarentum and it has even been suggested that the association of Nike (Victory) figures with satyrs and maenads on Attic vases may indicate that there were competitions for such cavortings. Certainly the appearance of Nike figures on many such vases associated with portrayals of different activities – musical, athletic, scholastic and so on – can allude only to success in competitive performances in those areas. Such vessels, especially cups, would naturally be used at *symposia*, the celebratory drinking parties usually held to mark such victories. Pindar describes Attic pottery being used at a victory *symposion* of Thrasyboulos of Akragas. Attic pottery was

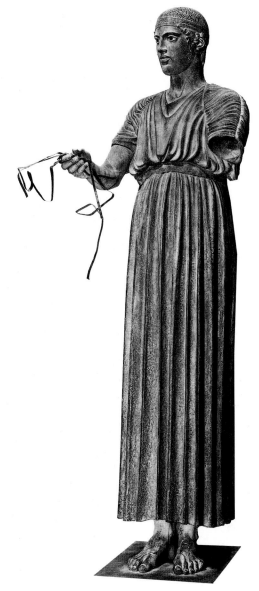

46 Charioteer from a chariot group dedicated at Delphi by Polyzalos of Gela after a victory at the Pythian Games, bronze, *c*.470 BC.

then regarded as the best and there can be no doubt that, as with the statues of victors in the Games, the product associated with commemorating the competition naturally itself became a focus of competitive performance.

The tragedies of fifth-century Athens are the most famous products of organised competitions and the most famous *symposion* of all is that celebrating a victory of Agathon at the tragedy competition of 416/415 BC, which forms the theme of Plato's *Symposium*. There we can see how the sense of competition is presented as giving form

to the after-dinner entertainment, as the wits and intellects of Athens strive to surpass each other in their praise of Love. Socrates adopts the term usually used for 'to contend for a prize in the games' (*agonizesthai*) to describe the performance of one of his fellows (*Symposium*, 194A). The Greeks regularly used the same word or cognate forms to describe rivalry in legal or public debate. In two of the most remarkable myths incorporated by Plato into the Socratic dialogues the idea of competition has an important place. In the myth of the Cave, life on earth is likened to existence in a cave where people see things only as shadows cast by a fire on the wall. Socrates imagines a competition being held, with prizes being awarded for those who can identify the shadows correctly (*Republic*, 516). In the *Phaedrus* man is likened to a charioteer driving two horses, the one representing the passions of the body, the other the wisdom of the mind. Plato describes the person who subdues the first and allows himself to be led by the latter as victor and prize-winner in an Olympic contest (*Phaedrus*, 256). In choosing such images, Plato recognised that his fellow Greeks were apt to see many activities in terms of competition, whether what was involved was running, singing, selling pots or making theories. What Hesiod had seen as the principle governing relationships between craftsmen came to govern many other activities.

Competition in Art

The statues and vases commissioned to commemorate victory in the Games must always have been made in a generally competitive spirit. There is, however, more direct evidence of competition in the field of the visual arts. Rivalry between craftsmen was continuous, but unspoken, until the late sixth-century vase painter Euthymedes asserts it in a famous inscription on one of his works. The words next to a brilliant piece of drawing boast, 'As never Euphronios', thus claiming his art's superiority over that of his most successful contemporary (fig. 47). Another text records a potter boasting of having surpassed his rivals in the thinness of his fabric, while, in the fourth century, the potter Bakchios received an epitaph proudly claiming that:

> All Hellas has judged Bakchios as by nature bearing away the first prize of those craftsmen who by their skill bring together earth, water and fire. And in those skills in which the city has established contests he has won the crowns in all of them.
>
> *Inscriptiones Graecae*, I 2 111954

The reference here is apparently to officially organised competitions. Those referred to in a vase showing potters proudly wearing victors' wreaths may or may not be (fig. 48). Official competitions between painters too are recorded by Pliny the Elder, who claims that during the time of Panainos, Pheidias' brother, competitions in painting were instituted at Corinth and Delphi (*Natural History*, XXXV, 58). In architecture the competitive element was probably more often introduced in competitions to produce designs for specific works. An Athenian inscription of 435 BC invites interested parties to submit a drawing for a particular gateway so that the people of Athens and her allies could choose a design. The designer would also receive the contract for construction. Similar competitions were held for sculptural commissions. The inscription on the base of the Winged Nike of Paionios of Mende erected at Olympia to commemorate a

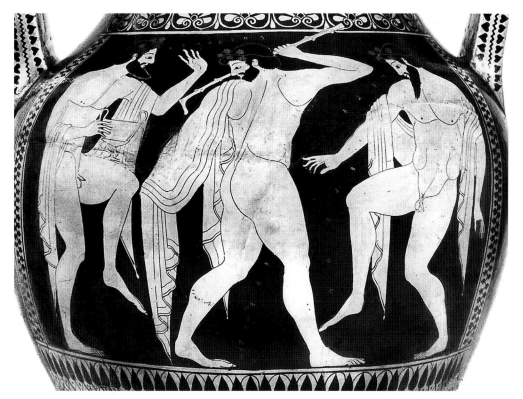

47 Revellers with inscription down left side: 'As never Euphronios', by Euthymedes, detail of amphora, Attic, last quarter of the sixth century BC.

48 Potters receiving wreaths from Athena and Victory figures, detail of hydria by the Leningrad Painter, Attic, c.480–470 BC.

49 Amazons, possibly by Polykleitos, Pheidias and Kresilas, *c.*430s BC, Roman copies after originals at Ephesus.

Messenian victory of 424 BC (fig. 41) records that the same sculptor was victorious in the competition for the acroteria or roof sculptures of the nearby Temple of Zeus. Pliny records that at about the same time two pupils of Pheidias, Agorakritos and Alkamenes, competed in the execution of a statue of Aphrodite, local feeling giving Alkamenes the palm (*Natural History*, XXXVII, 17). Nearly contemporary too was the most famous sculptural competition recorded in antiquity, that between Polykleitos, Pheidias, Kresilas and Phradmon, who are said by Pliny the Elder (*Natural History*, XXXIV, 53) to have all made statues of Amazons for the Temple of Artemis at Ephesus (fig. 49). Whether or not there was a formal competition, the sculptors who executed the originals of the various versions, which have survived in copies, must have thought of themselves as being rivals. The subject is the same, but each tries to represent it more effectively. If Pliny is right, the sculptors even agreed to be their own judges, a process that made Polykleitos the winner. Pliny records a similar competition, shortly after 350 BC, when four sculptors, Skopas, Bryaxis, Timotheos and Leochares, each worked on one of the four sides of the Mausoleum at Halicarnassus. Some have wished to identify their different styles in the surviving reliefs of the battle between Greeks and Amazons. Accounts of competitions in painting at the same period also survive. Pliny tells us that around 400 BC Zeuxis and Parrhasios entered into a competition in which the former deceived some birds with his lifelike grapes, but the latter achieved victory by deceiving Zeuxis himself with his painting of a curtain. It is against the background of such rivalry that to Parrhasios is also attributed an epigram in which he claimed to have 'carried off the prize in craftsmanship among the Greeks' (Athenaeus, *Deipnosophists*, XII, 543). This, however, did not prevent his being defeated, according to Pliny, by Timanthes in the execution of a painting of Ajax and the Award of the Armour, a prize painting of a prize-giving. Most celebrated of all was the purely private contest between the greatest fourth-century painters, Apelles and Protogenes, to draw an ever finer line which is described in the next chapter.

These examples show that the impact of competition on art reflected all the aspects of the more general phenomenon in Greece. Some competitions were officially organised for prizes; some were arranged simply as a means of getting artists to exert themselves more than they otherwise might in fulfilling a particular commission; some developed as a result of patronage being in the hands of democratic institutions whose rules allowed the members of a given body to choose between alternative designs; others were the product of rivalry in the marketplace and yet others were the self-imposed result of artists in the same field tending to think of themselves as competitors. What is striking is that all the examples date from the period from the late sixth to the late fourth centuries, during which Greek art is said to be most 'Classical', and that the majority of the examples date from the second half of the fifth century, the period at which the trend is often said to have reached its peak. Competition is not just a dominant factor in Greek culture. It is particularly associated with its most typical visual expressions. All Greek art was liable in the end to be assessed in the marketplace.

Competition and the Rise of Classical Art

It is easy to establish the importance of competition in Greek art. It is more difficult to describe the precise nature of its impact; although some of the general features of the competitive approach already emerged in the context of the *Shield of Heracles*. The chief of these was the desire to do the same thing as had been done before, but to do it better. The crucial question is: 'what does "better" mean?' In the case of the *Shield* the answer is revealed in the changes in emphasis between the two texts. The most obvious change is that what in Homeric sound like descriptions of real scenes of daily life have in the later text been transformed into what are clearly descriptions of a work of art. In the Homeric passage we are shown, besides a scene of farming, two cities, both of which are the scenes of different types of competitive strife, in one a legal dispute and in the other, war. In the vivid evocation of the legal dispute (*Iliad*, XVIII, 491–508) there is no attempt by the writer to limit his account to what conceivably might be portrayed in the conventions of relief metalwork. Once he starts to describe the scenes, which are genuinely possible subjects for relief sculpture, he is carried away by his memory of real events. He recalls the atmosphere created by sounds and lights, the sense of the motives and arguments of individuals and the succession of events in time. His eyes change focus from the shiny stones on which the city elders sit to the distant view and then back to the two talents of silver that will be awarded to the person who pleads his case most justly. Little of this could have been shown in a band of relief. The later author on the other hand, when describing a 'city' scene in a passage of almost identical length, is much more conscious of the limitations of the medium. He omits the legal quarrel, as if in admission that it is impossible to do it justice, and reduces the marriage festivities to a much more organised event described almost entirely as a linear procession with prepositions such as 'next', 'in front', 'behind' and so on, implying a constant awareness of the discipline of order imposed by a circular frieze, such as is found on surviving early shields. Both descriptions incorporate an account of a battle and between these there is a similar contrast. In Homer, unrealis-

tically, we first see the armies before the battle, then its beginning, then the real fight, with the action spreading freely over an imaginary landscape. In the *Shield of Heracles* movement in time and space is drastically reduced and we are presented with a precise moment in the battle with spectators and participants clearly enumerated and described in a friezelike manner.

Finally, throughout both texts, while Homer barely alludes to the problem of artistic illusion in such phrases as 'and the field grew black behind and seemed truly as if it had been ploughed, for all that it was gold' (*Iliad*, XVIII, 543–4), the later writer constantly reminds us of the miracle involved in representing different objects in gold, silver and bronze:

> These [the opponents of the Lapiths] were of silver, and they had pine trees of gold in their hands, and they were rushing together as though they were alive . . . There was a row of vines in gold, the splendid work of cunning Hephaestus: it had shivering leaves and stakes of silver and was laden with grapes which turned black.
>
> *Shield of Heracles*, 188–9, 296–300

Also, as if to compensate for the lack of information on the setting and the turn of events the later author gives more details about the attributes and pose of individual figures. Thus besides the accounts of the Darkness of Death in the battle scene, we have the vision of Perseus:

> his feet did not touch the shield and yet were not far from it – very marvellous to remark, since he was not supported anywhere . . . On his feet he had winged sandals, and his black sheathed sword was slung across his shoulders by a cross-belt of bronze. He was flying swift as thought . . . [He] was at full stretch, like one who hurries and shudders with horror.
>
> *Shield of Heracles*, 217–28

No figures on the shield of Achilles are described with such completeness. The Homeric text provides us with a free and almost lyrical description of the world in all its richness; the later one seems only to describe what its author feels really could have been shown on a shield given the space and materials available.

The distinction between the two texts reveals more than a change in the authors' personal interests. Each is designed to satisfy a different audience. Each answers that audience's predispositions. Through their descriptions of the two sets of reliefs the authors suggest the ways in which their contemporaries would respond to real examples of representational art. The earlier soon loses contact with the shield as artefact. As he begins his account he sees in front of him a real object, round with a bright rim and built up of five layers. But as soon as he starts to describe the representational scenes he no longer simply records what he has before his eyes. As he begins to describe the relief of the marriage celebrations his imagination takes over. No sooner has he seen a row of figures than he sees in his mind's eye the lights of their torches and hears the sounds of the songs he knows so well. When he turns to the scene of litigation he remembers the tension, the arguments and the changing reactions of the audience. In other words as soon as he is confronted with a scene he slips into a sort of reverie, which makes allusion to the detail of representation unnecessary. His memories are much more powerful than his present observations. It is as if art has no other

function than to remind of past experiences. We can well understand how someone used from youth to hearing the epic accounts of Trojan battles, and having his imagination triggered into life by each vivid phrase, would be highly sensitive to the smallest stimulus. We noted that the Homeric shield-description in its present formulation may be contemporary with the so-called Geometric style of painting, and for someone as imaginatively active as were apparently the author and his listeners the schematic representations that are typical of that period would have been all that was necessary to evoke the most intense experiences. The mere identification of a mourning scene such as that on the Dipylon amphora or a great krater would have been enough to evoke all the sight and sounds of such an occasion, the embroidered clothes, the rhythmic movement and the sound of wailing (fig. 50).

The later writer, on the other hand, keeps the shield as object ever before his eyes and suggests that in the early sixth century the typical viewer of a work of representational art would expect to evaluate it in terms of its artist's capacity to make grapes 'which turned black', fighters rushing 'as though they were alive' and a Perseus at full stretch 'like one who hurries and shudders with horror'. His viewer, instead of allowing his imagination to be stimulated, demands that the relief shapes should resem-

50 Detail of funerary krater with scene of mourning, Attic, mid-eighth century BC.

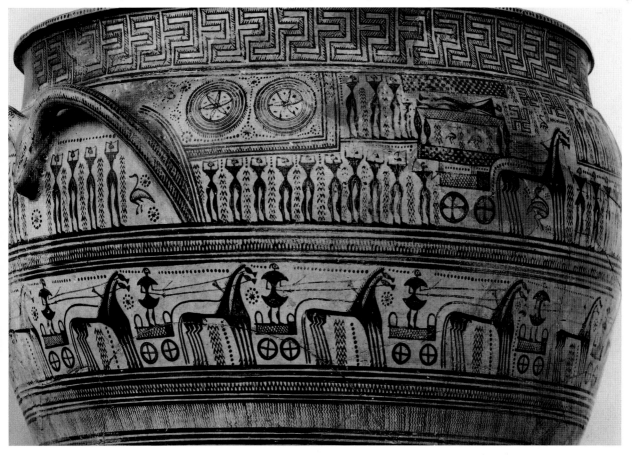

ble the things they refer to as closely as possible. A representation such as that from an Athenian vase (fig. 51) may be said to meet that critical standard.

The reason for the change in demand lies in the change in viewer. The principal transformation in Greek society between the eighth and the sixth centuries was the decline of the rural aristocracy and the rise of an urban middle class involved in commerce and the crafts. A change of patronage brought a change of values. The task of Homer was still to amuse and indirectly to glorify his aristocratic patrons by recounting the achievements of the noble warriors of the past. He would do his job well if he could fire their imagination by calling up mental pictures. With the later text we are in a different world. The author writes about the shield almost as if he was a shield-maker. Instead of allowing his imagination to be triggered he takes great trouble to describe only what he sees.

The artist's skill, which is hardly alluded to in the Homer passage, plays implicitly an important role in the later text, which comes much closer to describing a concrete object including accurate details of its layout. The details given are thus those that might interest a smith, anxious to know how this particular shield was designed, a farmer who would want to know what colour the grapes were, a sculptor who would like to know how Perseus' haste was represented, and so on. An aristocratic listener to the *Iliad* would have wanted to be reminded of how noble were the characters, how violent the battles, how clever the speeches, and the aristocratic purchaser of a tomb amphora would have wished chiefly to be reminded of how many mourners there were at the funeral, how many oarsmen on the boat and how well drilled were the warriors (figs 15 and 16). The aristocrat tends to live off memories of the old days, the craftsman to focus on the daily task of selling his wares. A farmer must always attend to getting fatter grapes and a shield-maker to making a more desirable shield, whatever this means in terms of the market.

The implication of the change of patronage is that a member of the middle class will be more likely than the aristocrat to rely on his eyes. A potter will compare one pot with another, a farmer will be watching closely the changing appearance of his produce, a merchant will constantly check the quality of his wares. Each will fail economically if he is not visually alert. All craftsmen need to be visually critical to succeed. A craftsman whose customers are themselves craftsmen needs to be doubly so. The aristocrat may be visually alert to the quality of his horses and of his men at arms, but the degree of his alertness will never be as critical since, as often as not, lineage and family will decide the contents of his stable and his guardroom just as they decide his own place in his hall. By the same token, while a community of aristocrats will be a community of people who all look at things with the same eyes, a community of craftsmen and merchants will be a community in which each specialised group will concentrate on the product in which they have expertise. In the growing cities of Greece any product would be criticised much more intensely and from more different points of view than before. Pliny the Elder tells how Apelles, the famous fourth-century painter, changed his representation of shoes because they were criticised by a cobbler, but told him to shut up when he started to criticise other items (*Natural History*, XXXV, 36, 85). Anyone in Greece making a product, be it a shield or a description of a shield, would tend to anticipate such criticism from a wide range of specialists and avoid it by trying to acknowledge the interests of many groups.

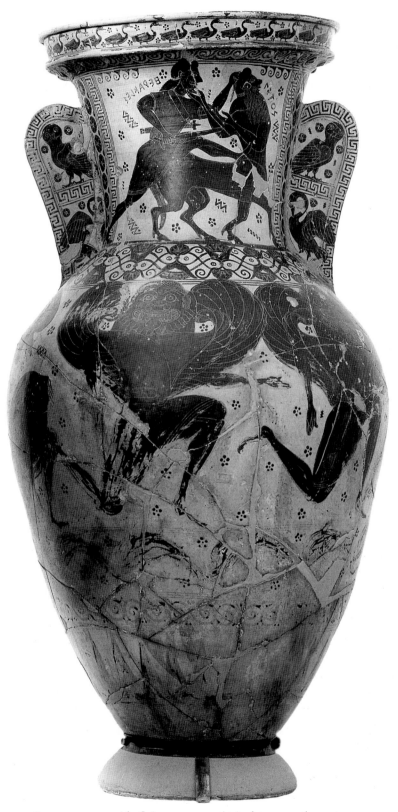

51 Funerary vase with flying gorgons, Attic, late seventh century BC.

The decline of the aristocracy and the rise of a commercial and craftsman class directly affected art. It also hastened the decline in the pre-eminence of the aristocracy in the one area in which they had always excelled, warfare. Defence is likely to have been approached more and more through the eyes of merchants and craftsmen. The selection of horses, men, boats, weapons, etc., would have become based increasingly on the sharp observations of hard-headed businessmen, and success in war would go increasingly to those cities whose citizens controlled the quality of their armies and navies with the same care that they controlled the quality of their merchandise. In Greece during the period of economic growth after the eighth century success in competition, whether between states or individuals, generated an unparalleled visual awareness, above all in relation to products. Among these products were not only pots, weapons, clothes, furniture, but also animals and people. The animals concerned were those such as horses bred for war, cattle bred for food – and above all for sacrifice – and dogs bred for hunting and male display, all contexts in which critical viewing was an essential activity. A good example of such viewing in a competitive context is provided by a relief on a statue base from Athens datable around 500 BC (fig. 52). Here two young men with their backers concentrate all their attention on the dog and cat who are about to fight. As on the relief, the people concerned were typically males whose bodies were trained and tested in exercise, athletic competition and warfare and thus subject to an even more intense scrutiny. Their wives, mothers and sisters were also subjected to visual selection in the context of marriage, as were the *hetairai* who were visually selected with no less attention as erotic playmates. In their portrayal of all of these 'products' artists worked hard to meet accepted critical standards. Awareness was highly focused. Unlike their predecessors, the Egyptians, Minoans and Assyrians, who were much less narrowly 'product' oriented, there is little evidence that Greek artists were visually alert to nature in general, to trees, flowers, the rise and fall of landscape, rivers, sea and rocks. There is equally little evidence that they looked closely at those of man's daily activities that, unlike war and athletics and drinking, were not

52 Fight between dog and cat, with onlookers, side of statue base from Athens, early fifth century BC (see fig. 80).

associated with competition in physical prowess. Neither agriculture nor the life of city or village figure more than exceptionally in the visual arts. Remarkably few topics are drawn from any contemporary reality, except indeed for a few illustrations of workshops that should be probably understood as scenes of commercial competition. The painting of a workshop for the production of bronzes on an early fifth-century Attic cup shows two craftsmen, each working on one leg of a statue under the supervision of two better dressed individuals, in a scene that, in its similarity to the relief noted earlier, suggests some level of rivalry (fig. 53). The statue in question is an aggressive armed warrior and is thus typical in its subject matter. The vast majority of Greek art that is not concerned with exercise and drinking is concerned with the representation of scenes from mythology, most often of warfare and physical heroism, which were imagined in terms of contemporary life. To review the history of Greek art is to have the impression that the Greeks constantly improved the portrayal of stereotype scenes by comparing their component parts with similar components in their environment but rarely used the skills they acquired in the process to invent new ones. Thus men, armour, horses, chariots, couches and thrones become ever more lifelike, but only as separate elements. There is little attempt to portray environments, whether interior or exterior, or otherwise to grasp the world as a whole. The reason for this can be only that the chief motor for artistic development was the type of competition that was referred to earlier. An artist might be told that his faces, or draperies, were less lifelike than his competitors and consequently might copy his rival's devices and improve on them if possible. The need was not to create lifelike scenes, only to make individual components more like the objects they represented. We can imagine generations of criticism such as that implicitly anticipated in the *Shield of Heracles*, with consumers saying things such as, 'this body is more like a body than that one', always moving the critical standards in front of the improving artists. Similar factors affected the development of painting, of relief and of free-standing sculpture. In this way competition produced a continuous pressure in one direction.

53 Workshop scenes from red-figure 'Foundry Cup' by Foundry Painter, Attic, first quarter of the fifth century BC (see fig. 81).

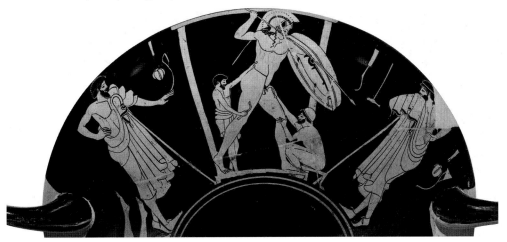

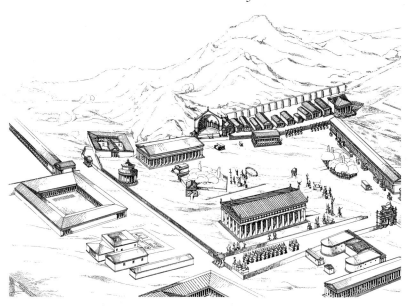

54 Olympia,
sanctuary plan with
row of treasuries top
right.

Competition and Continuous Change

Competition affected all areas of activity in Greece, but it had its greatest impact when that in two areas reinforced each other. When victory in athletic competition was associated with the making of a commemorative statue the pressures on the artist, who was already in a competitive trade situation, were doubled. A competitive sculptor working for a competitive patron made an extraordinarily powerful combination. When pottery vessels were made for a *symposion* celebrating a victory, the result was the same. Competition was also intensified when cities, who were always in military rivalry with one other, commissioned temples from competitive sculptors and architects directly or indirectly to commemorate particular victories. The frequency of such convergences in the areas of sculpture, vase-painting and temple building is a principal reason why the products of these crafts show the greatest attention to quality control. In these circumstances makers were most likely to look at their products with the eyes of demanding purchasers.

Those areas in which such convergences were most habitual were the ones in which competition was most vigorous. It was in these that the overall direction of artistic change was determined. For example, the vast majority of victories that resulted in artistic commemoration were in the field of either the athletic preparation for war or of war itself and this strongly influenced art. The statues of victors at Olympia and elsewhere were the most important works of free-standing sculpture (fig. 46). Vases made for *symposia* arranged to celebrate such victories must often have been the most splendid works of the potter. Panathenaic vases, which were awarded as prizes at the Athenian festivals, were high quality works often illustrating the activity for which the award had been made (fig. 45). Rival cities built treasuries at the great cult centres to display these and other trophies, and the competition between them produced groups of similar structures at both Olympia and Delphi (fig. 54). Temples were also often built in a spirit of competition and none more so than those of Zeus at Olympia and of

Athena, the Parthenon, at Athens, the one surpassing the other in its dimensions and ornaments as they each celebrated the defeat of the Persians in the name of different groups of allies. What was celebrated in all these works was above all physical achievement and so it was on this area that sculptors, painters and architects concentrated. Sculptors and painters who knew that it was the human body that would be their viewers' main concern worked hard at representing it ever more effectively. Architects who knew that people would seek in their temples the properties they looked for in the city's phalanxes constantly improved their ability to embody them in plan and elevation. The body and its attributes were the principal subject of Greek art for hundreds of years and it was competition in their representation that, unusually in the history of art, drove its development largely in one direction.

The type of art for which Greece is most well known is the male statue. From the time when limestone and marble statues first appear around 600 BC they begin to manifest the features that distinguish them from most statues in other cultures. They are naked. They are near in scale to the form they represent within a range from half- to twice lifesize. Although the figures appear ready to put their bodies to work, they do nothing. When inscriptions tell us whom they represent, they are winners of competitions at the Games (most of these known only from texts and from their surviving inscribed bases), individuals, such as Cleobis and Biton (fig. 55), who performed heroic feats, or warriors who died, like Kroisos, 'in the front rank' (fig. 4). The statues not only preserve the identities of the people concerned, as any inscription or image could have done, they also represent the resources that earned the subjects their distinction: firmness of stance, strength of thigh and arm, breadth of chest and shoulders, tightness of joint and solidity of muscle (fig. 56). In other cultures clothes, carried attributes, poses and actions indicate particularities of life-style, status, function or achievement. In Greece such individualisation of role was of little interest. Instead it was only the robust athletic physique and discipline of deportment desired in everyone and attained by a few that were indexed. The Greeks discovered the monumental stone statue in Egypt, where it served many functions that were of no interest to them. What attracted them in Egyptian statues was that many seemed to passess properties they looked for in themselves and it was these properties they imitated in their own adaptation of the tradition.

Those who ordered such statues, whether for the cult centre or the graveyard, found in them an embodiment of critical properties, properties they desired and properties they were reassured to find expressed supremely in some individuals. Sculptors took care to represent those properties because they were also vitally important for them, as for all members of society. Since the honour of the individual and the survival of the state depended on these properties it was these they looked for. Since those sculptors who conveyed them best inevitably attracted more commissions there was a constant pressure on them to meet rising demands. Throughout the sixth, fifth and fourth centuries this pressure led to a continued improvement in their representation and it is this process that we crudely summarise as a stylistic development characterised by increased naturalism (fig. 57).

The direction of change may be generally similar but it is not constant. In the mid-sixth century, especially in Athens under the Peisistratids, a growing association between physical success and social prestige created a growing need to add attractiveness to

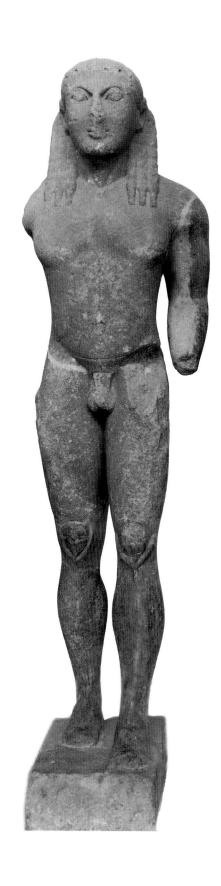
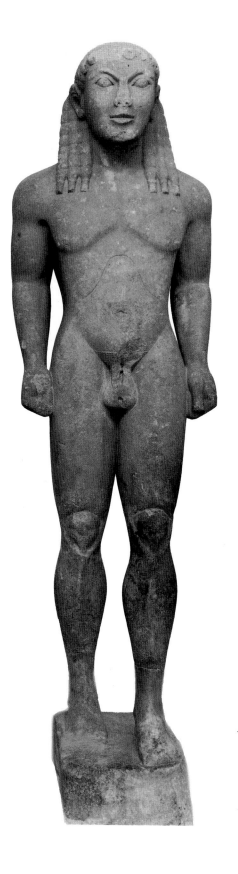

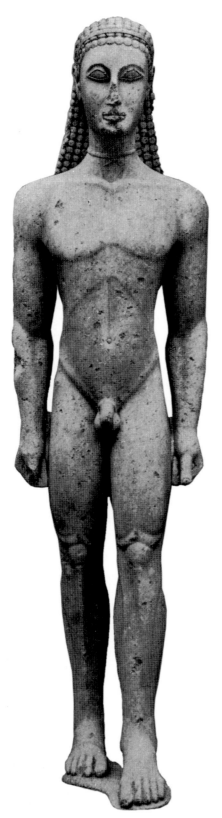

55(*facing page*) Cleobis and Biton,
marble, *c.*600–575 BC.

56 Male figure from Attica, marble,
*c.*600–575 BC.

57 Series of male statues, late seventh to early fifth centuries BC.

58(*facing page left*) 'Kritian' boy from Acropolis, Athens, marble, *c*.480 BC.

59(*facing page right*) 'Warrior A' from the sea off Riace, bronze, *c*.460–440 BC.

crude mechanical properties and this led to lighter limbs, softer modelling and a warming of the expression on the face (fig. 4). In the fifth century bronze technology allowed a greater freedom of movement, and the associated use of clay models encouraged a new attention to the modelling of flesh surfaces. At the same time the startling successes of decisive actions by individuals, from the assassination of the tyrant Hipparchus by the lovers Harmodius and Aristogeiton to the Greek defeat of the Persians, brought a new sense of the individual's ability to control his or her destiny, a new awareness of the mind as a director of action. This is most beautifully expressed in Socrates' statement that if his body were not controlled by a mind 'these muscles and bones of mine would long ago have left for Megara or Boeotia', thus running away from Athens in order to avoid the death sentence (Plato, *Phaedo*, 99). The mind was increasingly placed in the head – especially after Alcmaeon in the first half of the fifth century established the neural connection between the eye and the brain – and also in the head were concentrated the visual attributes that facilitated effective leadership. The head's ability to control the body and the importance of individual charisma are both emergent in the so-called Kritian Boy (fig. 58) and even more apparent in figures such as the Riace bronzes (fig. 59) and in the copies of portraits of identifiable leaders, such as those of Themistocles and Pericles (fig. 12). At the same time in the fifth century the new emphasis on the importance of mathematical attributes, first proposed by Pythagoras, led sculptors such as Polykleitos to embody these too (figs 30 and 31). Later, in the fourth century, when the rising power of Eros meant that the bodies of young males were, like those of women, increasingly valued for aesthetic rather than functional reasons, a new grace and charm were added by sculptors such as Lysippos (fig. 60). Throughout, it must have been the criticisms of viewers that often suggested

60 Eros stringing his bow, Roman marble copy of a bronze by Lysippos, *c.*330 BC.

61(*right*) Agias, from the Daochos monument, Delphi, marble, 338–334 BC, probably a contemporary copy of a bronze original by Lysippos.

62(*facing page top left*) Statue dedicated to Artemis, by Nikandre, inscribed on left side of skirt: 'Nikandre dedicated me to the Far-Shooter of Arrows, the excellent daughter of Deinodikes of Naxos, sister of Deinomenes, wife of Phraxos . . .', from Delos, marble *c.*650–625 BC.

63(*facing page bottom left*) Statue dedicated to Hera by Cheramyes, inscribed on the front hem: 'Cheramyes dedicated me as a delight [*agalma*] for Hera', marble, *c.*575–550 BC.

64(*facing page right*) Girl, from Acropolis, Athens, probably associated with base giving the name of Antenor as sculptor and Nearchos, a potter as patron, marble, 525–550 BC.

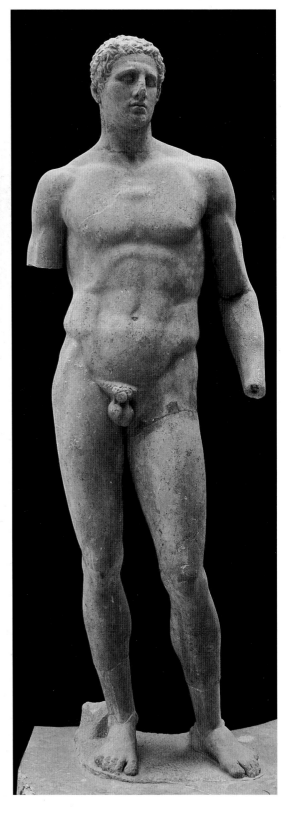

to sculptors new directions, and Lysippos showed his continuing alertness to such criticism when he made the heads of his statues smaller so that they would correspond better to the 'way real people appear' (Pliny, *Natural History*, XXXIV, 19, 65; fig. 61).

The concentration on the representation of basic physical attributes in the male statue meant that Greeks found it difficult or impossible to use the same works to represent attributes such as wealth and class, refinement and piety, which would have required different poses and the representation of clothing. In the late seventh and sixth centuries this problem was avoided by transferring their representation to female relatives, where their expression could be combined with that of more feminine virtues. It was already desirable in real-life women for them to indicate their attention to detail through complication of hairdressing, skill in crafts through quality of clothing and fidelity through gestures of submission and reverence. By adding jewelry, by simulating expensive materials, by placing offerings in the hand, by dedicating the statue in a sanctuary and above all by recording the woman's male relatives in an inscription, all these desirable qualities could be credited ultimately to the men with whom she was connected (figs 62 and 63). Female statues could thus be used to give visible commemoration both to attributes desired in women and to those required in men but difficult to combine with the full celebration of the naked body. Since women, then as now, probably enjoyed the competitive display of their husband's resources, in real life as well as art, the combination was an appealing one. Competition among sculptors to satisfy the ambitions of both men and women produced, at Athens, a sequence of more and more elaborate and attractive statues of women which provide a series parallel to those of men but concentrating on different attributes (fig. 64).

In the absence of surviving monumental painting the relatively durable record of Greek vase painting has great importance for us, and this status is further enhanced by the knowledge that this is another field in which two types of intense competition came together. Competition among potters and painters must always have been stronger than that between sculptors because rival products could be compared more easily, being often seen side by side both in the marketplace and the home. Competition at the *symposia* where such vases would be used must also have been fierce, since on such occasions rivals for dominance would be reclining together and competing in dress, conversation and physical desirability, not to mention drinking and playing games. There are many signs of a particular awareness of competition in vase painting: the use of signatures, the constant reappearance of the same vessel types and similar scenes treated slightly differently, the employment of rival painters on the same pot and above all the preference for subjects that are some form of contest. These last might be on the heroic scale of the battles of the Trojan War or on the domestic scale of the spitting game, *kottabos*. Scenes such as the famous painting by Exekias of Achilles and Ajax playing a board game bring both together (fig. 65). Given the fondness of the Greeks for recalling their heroic role-models, especially the heroes of epic, it is they who figure most prominently. By showing what heroes could do with their bodies artists could suggest that the owner had similar physical abilities and it is often precisely on the convincing portrayal of the physique that they concentrate. From the early sixth century through to the fourth there is a steady increase in the artist's ability to draw effectively the complex physical movements whose performance interested the possessors of such

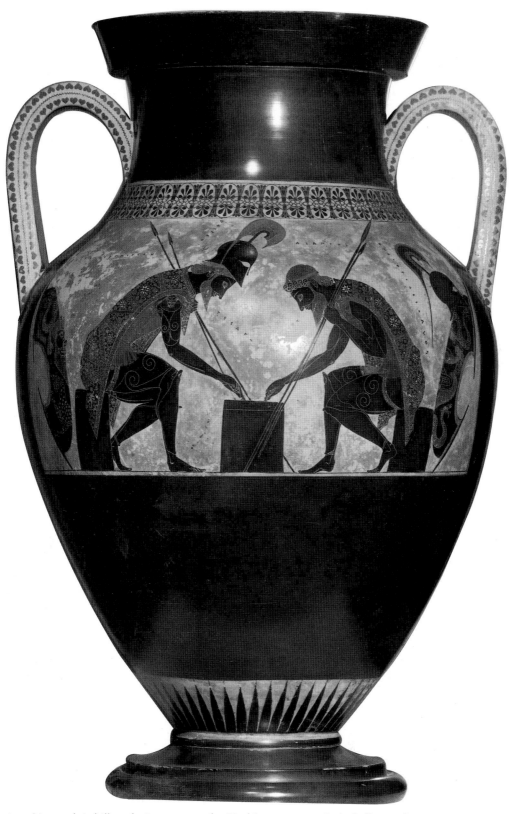

65 Ajax and Achilles playing a game, by Exekias, scene on Attic belly amphora, *c.*530 BC.

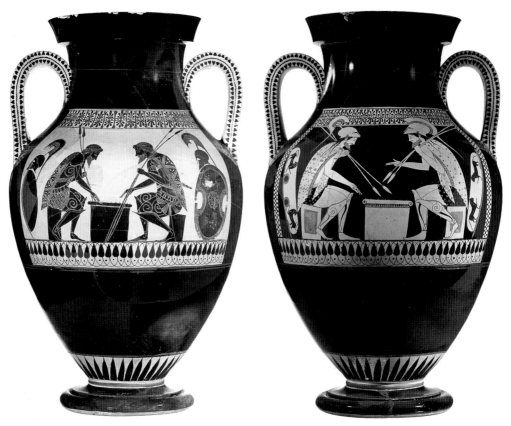

66a and b Ajax and Achilles playing a game, Attic belly amphora with scenes in black and red figure by the Andokides Painter, *c.*520 BC.

vessels. Whether the movement involved is killing or dancing, running or love-making, the artists capture more and more of its aspects. Bodies and faces, which, in the early sixth century, are either frontal or profile, start to twist and occupy intermediate positions, until in the fifth century figures are regularly shown in three-quarter views and in the fourth seem almost to tremble with life. The catalytic influence of competition in this sequence is demonstrated brilliantly by the boastful inscription of Euthymides applied to a conspicuously masterful display of three-dimensional movement of a type that Euphronios, brilliant as he was, never attained (fig. 47). Written on a vase in the late sixth century, when developments were at their most rapid, this phrase sounds like a shout of triumph in the midst of battle. Equally telling witnesses to the competitive atmosphere at the time are the so-called bilingual amphorae in which the same scene is shown on one side in the established black-figure and on the other in the new red-figure technique. A suggestive example is the belly amphora in which the Andokides painter sets out to show how the use of red figure allows him to surpass both his master Exekias' black-figure rendering of the Achilles and Ajax scene and his own (figs 66a and b). Whether one artist competes with another or the same artist challenges himself, the sense of mutual emulation in the search for a more effective

portrayal is constant. That the red-figure technique emerged as sole victor reveals much about the distinctive parameters of success. The black figure captures best the optical impression most of us have when we look at the world around us and see dark figures moving against a light background. The principal advantage of red figure is that it captures better the colour and so the material quality of the human body, which helps to explain the Andokides painter's enlargement of the figures when using the technique. This, combined with some increase in fluidity of line, was enough to guarantee its success, even if it meant abandoning a more natural silhouette of the figure against the light. This was the inevitable outcome of the competition between the two techniques, given that obtaining a representation of the body that looked more like a real one was the single overwhelming demand of patrons on artists in all media. It is the narrowness of this concern, which has its origin in the importance of the body as tool in war and athletics, that gives Greek art its characteristic direction.

Individuals competed through the commissioning of statues and *symposion* services. Cities and larger communities competed in relief sculpture and in this field too the most striking developments are associated with the most intense emulation. Not only did the decorations of one building compete with those of another, but there was competition between the sculptors working on the separate structures. Large friezes required the participation of many craftsmen, and the rivalry between them is commemorated in the legendary story, noted above, that each of the north, south, east and west sections of the frieze of the Mausoleum at Halicarnassus was made by a different sculptor, each anxious to surpass the others. It is also documented much earlier in one of the first great friezes, that of the Siphnian treasury at Delphi constructed before 525 BC (fig. 67). There, in the Gigantomachy, one sculptor has carved an inscription on the shield of one of the figures to assert that he had executed that particular group. Perhaps he was influenced by the spirit of the scene itself, which records a more violent contest? Shields were certainly often dedicated at shrines such as Delphi and Olympia with inscriptions recording the victory with which they were linked. Both the general competitiveness suggested by the frieze and its particular focus on the body parallels the situation in painting at the period and it is no surprise that the metopes of the Athenian treasury built at Delphi around the end of the sixth century go beyond the Siphnian frieze in their mastery of movement (fig. 68). Even more dramatic is the contrast between the sculptures of the Temple of Zeus at Olympia and the Parthenon (figs 69 and 70), built one after the other as rival commemorations of the victory won in the Persian Wars, the former being associated more with the mainland Greeks, the latter more with the Athenians and their Aegean allies. The figures in the metopes at Olympia, for all their energy, appear stiff and slow when compared with the ones we know best from the Parthenon. These show Lapiths and Centaurs engaged in a life and death struggle between passionate appetites and restraining virtue, a struggle in which an extraordinary range of poses is explored for the treatment of a single theme. There is a similar contrast between the pediment sculptures. Those at Olympia lack the complexity of the Athenian figures such as the mutually entwined group of female goddesses or the surging pair of rivals, Poseidon and Athena (figs 40, 71 and 73). Pheidias must have hoped that visiting Spartans, seeing the great Poseidon's discomfiture in

67 Group of giants from the frieze of the Treasury of Siphnos, Delphi, marble, before 525 BC. Inscription on shield reads: '. . . made these subjects and the ones behind'.

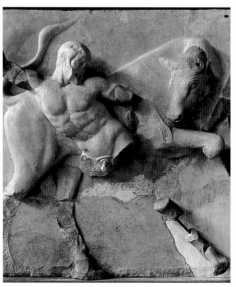

68 Heracles and the Keryneian hind, metope from the Treasury of Athens, Delphi, marble, late sixth or early fifth century BC.

69 Heracles and the Cretan bull, metope from the Temple of Zeus, Olympia, marble, second quarter of the fifth century BC.

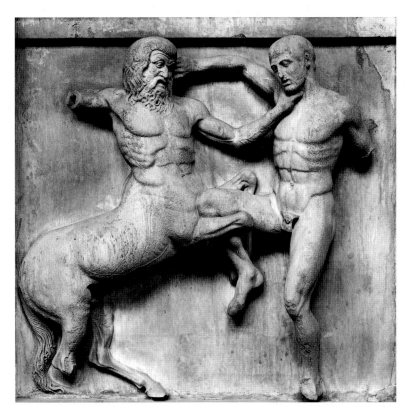

70 Lapith and Centaur fighting, metope from the Parthenon, Athens, marble, 447–432 BC.

71 (*below*) Contest between Poseidon and Athena, west pediment of the Parthenon, drawing by Jacques Carrey.

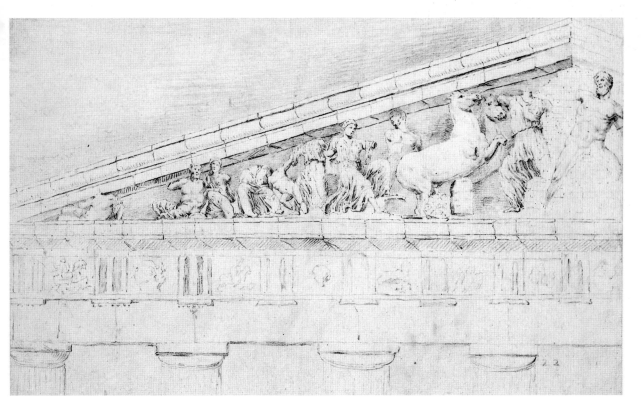

72 Temple of Hera, Olympia, after 600 BC.

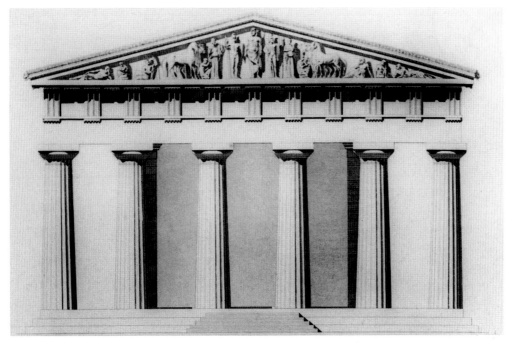

73 Temple of Zeus, Olympia, second quarter of the fifth century BC.

the contest for the rule of Attica, would hesitate to challenge such a palpably agile, fit and powerful protectress. War with Sparta was the competition that Pheidias hoped to prevent by his display of real muscle and convincing movement. If the Greeks had not had such physical contests constantly in their minds they would never have paid such persistent attention to the mechanisms of the human body.

It may at first seem less obvious how the development of Greek architecture relates to the world of physical competition, but the role of Olympia and Delphi, the centres of the two greatest Games, in the formation of the exceptional elements of the Greek tradition suggests that there is a strong connection. The forms of stone architecture that we now call Doric appeared, or at least acquired full authority, probably for the first time in the Temple of Hera at Olympia around 600 BC (fig. 72). A regular colonnade carrying an entablature surrounds a porched house or cella in a plan-type that had already appeared in wooden buildings and was now to become canonical. In the following decades column, capital, entablature and plan spread throughout the Greek world from Paestum in Italy to Cyrene in North Africa. Many small variations are found, but the principal trends are an increase in size and sculptural ornamentation, well represented by the new Temple of Zeus also at Olympia (fig. 73). Equally important is a decrease in the entasis or swelling of the column, a straightening of the profile of the so-called echinus on the capital and a strengthening of the corners by reducing the column spacing (fig. 74). This process leads eventually, in the Parthenon, to a hardening, sharpening and refining of the whole as limestone is replaced by marble and numerous mathematical variations from the strictly rectilinear are imposed, the so-

74 Parthenon, Athens, 447–432 BC, detail of corner.

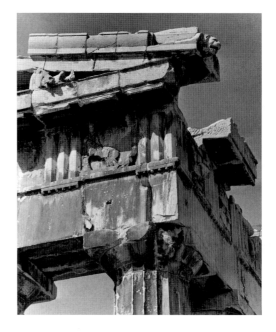

75(*below*) Temple of Hera, Samos, originally *c.*560 BC, as rebuilt *c.*525 BC and later, groundplan.

76(*bottom*) Treasuries of Cnidos, Massilia and Siphnos, Delphi, all mid-sixth century BC.

N

CNIDUS MASSILIA SIPHNOS

called refinements (figs 32 and 33). It is likely that this development emanated from Olympia, because those who went there to compete in typical contests saw the temple as the pattern for another contest, an architectural one. A similarly competitive mentality determines other characteristic features of Greek architectural history. One is that the first stone temple that we call Ionic, using a different entablature, volute capitals and deeper flutes on the columns and bases, was also dedicated to Hera and was built at Samos, replacing a wooden predecessor, shortly after the temple at Olympia (fig. 75). The series of so-called Ionic temples that follow it is less numerous than that of the so-called Doric ones, but is marked by similar trends. Since the majority of these temples are found on or near the coast of Asia Minor, a region that perceived itself as culturally different from the rest of Greece in language, music, dress, etc., it looks very much as if the two halves of the Greek world were in perpetual competition. After the inhabitants of Samos built their Temple of Hera in rivalry with that at Olympia, other communities in the two areas tried to build bigger and better versions of the two prototypes. Since, as was argued in the last chapter, all Greek temples are essentially embodiments of the properties required in a phalanx of armed warriors, this meant above all making the embodiment better. This is exactly what the ever harder, sharper and straighter lines and more mathematically elaborate plans represent. The currency of a rivalry between East and West in the Greek world emanating from Olympia would also explain why all the competitive treasuries at that centre are, as far as we know, Doric (fig. 54), while only at Delphi do we find several monuments, including treasuries, that use variations on Ionic forms (fig. 76). Delphi was the shrine of Apollo, who, being born on the island of Delos half-way between Greece and Asia, was claimed as their own by the Eastern as well as the Western Greeks. As such it was a natural focus on the mainland for both communities. Ever since the Trojan Wars conflict between East and West was the archetypal competition. The war between Greece and Persia was seen in these terms and so too, in time, was the Peloponnesian War between Sparta and Athens. The Athenians who, although they lived on the mainland, had ancient cultural affinities with the Eastern Greeks were forced to acknowledge them architecturally only slowly. The Stoa they built at Delphi to house booty from the Persian War, during which they emerged as champions of their Eastern neighbours, was a first gesture. But it was not until the Peloponnesian War forced them to depend on help from the East that they converted entirely to Ionic in the Temple of Athena Nike (fig. 42) and the Erechtheum (fig. 38). In this latter building women replace columns prominently, and it was probably at this time in the late fifth century that the story found in the Roman writer Vitruvius originated, that one column type was copied from the male and the other from the female body. It was probably also during this war situation in Athens that the two sets of architectural forms were given the names that associated them with the two principal races or population groups into which the Greek world was divided. Dorians and Ionians were supposed to have competed for supremacy after the Greek victory in the Trojan War just as they did now after the victory over Persia. Racial loyalties were fostered in order to mobilise support for war and this racial conflict acquired an architectural expression.

The increasing Athenian association with the Ionians brought with it an increasing identification with the female, and this identification was confirmed by the city's final defeat in the Peloponnesian War, which prepared the ground for a shift in the whole

77 Scene of farewell, Attic white ground lekythos, late fifth century BC.

field of competition away from the values of a war, which the city had lost, towards the values of peacetime, in which it excelled. Even though Athens later recovered much of her power, the self-image of her citizens had changed and, from the late fifth century and for most of the fourth, the chief field of competition in the visual arts at Athens is in the calmer world of the funerary vase and tomb relief and the values evoked are more private. These works show typically the dead either alone or accompanied by a servant or in the act of separation from the close family. The physical strength of males is now less emphasised, as their poses become languid and relaxed. Wealth and status on the other hand become more important, especially in the reliefs. Servants, rich clothes and jewelry all become more prominent and the monuments increase in size and quality. Even more striking is the competition in the expression of beauty of face, body and dress and in the communication of emotion through hanging heads, outstretched hands and saddened faces. Instead of physical vigour we now find beauty of body and soul, those qualities that Plato, picking up on an earlier Greek expression for a gentleman, captured in the concept of *kalokagathia*, 'beauty and goodness'. When Plato talked of the desirability of competition in this area he was evidently responding to needs that were already in the community. The race in terms of beauty and goodness was in full swing when Socrates and Plato offered Athenian youth instruction in how to improve their performance. The speed, direction and degree of improvement are apparent first in the series of white ground *lekythoi* that accompanied the dead in the tomb (fig. 77) and then in the more public series of gravestones that lined the roads out of the city (figs 78 and 79). There, in relief after relief, we feel that it is in terms of the expression of these superior sensibilities that the sculptor wishes the work to be judged. For a hundred years the series chronicles this attractive new direction of the competition in life and art, until, suddenly in 317 BC, a decree of Demetrius of Phalerum put an end to an economically exhausting competition by limiting expenditure on funerals. Competition in the commemoration of death in the end poetically brought its own demise.

78 Grave stele of Thraseas and Euandria, marble, Attic, early fourth century BC.

79 Grave stele of Ampharete, marble, Attic, c.410 BC.

The Intellectual Marketplace: Competitive Models

Competition had as great an influence as war on the Greek philosophical and intellectual tradition. We do not know the extent to which Hesiod's *Theogony*, the first Greek account of the origin of the universe and human history, was composed or performed in competition with alternative versions. Other poems of his were, as we saw. Competition between such explanations is only documented by the later sixth century when people explicitly criticise each other's accounts in a spirit that exactly matches Euthymides' contemporary taunting of Euphronios. Xenophanes criticises Homer and Hesiod (Fr. 11; Kirk and Raven, p. 168). Heraclitus criticises Hesiod, Xenophanes, Hecataeus and Pythagoras. Parmenides rather later mocks Heraclitus without naming him (Fr. 6; Kirk and Raven, p. 345). A comparison between intellectual enquiry and athletics is implicit in Xenophanes' observation that while Olympic athletes are well

rewarded those who practise his own art are not. It is explicit in the remarks of Plato relating to competition quoted earlier. It was attitudes like these that led to the invention of a story of an early contest between Seven Sages in which Thales won the prize.

It is easy to see how competing poets become competing philosophers as their verses focus more and more on explanations of the universe and nature. Understanding the way these explanations take on the properties of competitive products is more difficult, but it is essential to do so if we are to capture the special character of the Greek achievement in this area. One recurrent phenomenon that requires explanation is the habit of describing the universe in terms of artefacts. Sometimes the process by which the universe comes into being is described as if it was a manufacturing process. The first of such descriptions is that credited to Anaximander of Miletus about 570 BC. The original *apeiron* or 'boundless' substance becomes concentrated into a mass of solid matter, just as loose bits of material are brought together at the centre of a whirlpool. This becomes the earth, an object shaped like a column drum three times as broad as it is deep. As it dries out areas of water are left on the dry land. The bright lights of the sun and other heavenly bodies are said to be the product of fire emerging from bellows-like holes in fire-filled metal tubes arranged like chariot wheels. The wheel of the sun is twenty-eight times the diameter of the earth. The contrast with the Babylonian Creation story, which has its traces in Genesis, is striking. That account, composed for a people used to an all-powerful king, answers the question 'who made the earth and heavens?' This Greek version answers the question 'what sort of product are they and what was the process of their manufacture?' It represents the answer that one craftsman would give to another when asked 'what is that and how was it made?' It is an answer designed to appeal to a society of interdependent artisans and traders such as that which thrived in sixth-century Miletus, a society in which, unlike in the Near East, no individual could credibly be said to have the power to conceive of and complete any large-scale undertaking, and in which typically any particular expertise would be shared by a group. More specifically, it appeals to people whose chief experience of things coming into being was gained in the workshop. The images out of which the explanation is built would have been familiar in a world of craft production. This was an environment in which the making of a pot depended first on the mixture of earth and water, then on the purification of that mixture through the creation of a whirlpool effect that forced light impurities to gather at the centre of a vortex, then on the shaping of the cylinder of purified clay on a spinning wheel and, finally, on the controlled application of fire and air. In this environment the hottest, brightest lights were those made by a blacksmith's bellows, the column drum was the most impressive circular solid and the chariot wheel was the most comprehensible illustration of peripheral rotation. The measurements described are such as any craftsman would use to fix the relative sizes of his products. The originality of the story is due to Anaximander's and his audience's common artisan culture. In many ways the story is less rich than other accounts of Creation. Its elements are all drawn from the world of the inert and inorganic and there is no role for a maker with creative freedom. Its advantage is its materialist simplicity. By describing the universe in terms developed to describe small products Anaximander presents it as something that can be easily imagined by thinking of familiar objects. Almost anyone familiar with the products referred to could both imagine and represent Anaximander's. His universe is the ancestor of

the modern scientific model, a simple descriptive and explanatory representation of a complex phenomenon, one well suited to an audience who lived in a world that was simple in the sense that it was made up largely of a limited range of artefacts. The Milesians were comparatively recent, culturally poor, migrants from mainland Greece who settled at a remote site on the coast of Asia Minor, living in a city where they were relatively isolated from the world of agriculture and so, unlike people elsewhere, were relatively ignorant of the richness of organic nature, their field of experience limited to the products that they made and sold. It was in terms of such products that they thought. Anaximander can never have appreciated how important it was that he took his explanation of the universe from the experience of the workshop and the marketplace, but the importance soon emerged. By describing the earth and the heavens in terms of a set of products and by excluding any great Creator he invited people listening to his explanation to do what, if they were craftsmen, they might do to any product, that is to criticise it and to try to make a better version. Criticising and emending earlier Creation stories was in most cultures both unnecessary and dangerous. It was unnecessary to criticise earlier stories, such as that in the Bible, because fundamentally they made sense in terms of people's overall experiences, as they still do. It was dangerous to criticise them because that involved questioning the role of the gods. The weaknesses of Anaximander's story could be pointed out with no greater risk than was involved in criticising the work of a potter in the market. Anaximander's model of the universe is the first of many and the first to be improved. It was offered as a product and was so judged.

Anyone who compares the image of chariot wheels turning around the column with what he sees in the sky is likely to find it a deficient image and Anaximander's own pupil Anaximenes tried to improve on it. He did this with two images. One presented the heavens as a felt hat with the fixed stars fastened like nails in the inside (Kirk and Raven, p. 159); the other described the earth, as well as the sun, moon and planets, as flat 'lid'- or 'leaf'-like objects 'riding' on air (Kirk and Raven, pp. 153 and 158). Since the later texts that purport to transmit his ideas do not agree about the nature of the flat circular objects that float on air it is tempting to identify more closely a source for what is at a mechanical level an effective model. The only circular object that Greeks would have seen regularly riding on air – and also rotating – was the discus. A discus is an unfamiliar object to us, but its importance for the Greeks is well demonstrated by the fact that our word disk derives directly from the Greek *diskos*, which originally referred only to the quoitlike object still used in the modern sport (fig. 13a). There must have been times when the skies of the exercise areas of the gymnasia where young men and their competing teachers gathered were full of them. Given their frequent visibility as aerial objects – and the frequency with which they would have passed in front of the sun, obscuring it – it is not surprising to find Xenophanes actually using the term 'discus' a little later than Anaximenes to describe the sun and moon, an eclipse being caused when they 'walk on the void' (Kirk and Raven, p. 182). Since Xenophanes also rails against the prestige of athletics when compared to that of his own *sophia*, 'skill', the world of such activities was one with which he was obviously excessively familiar. As an itinerant teacher who left his native Colophon in Ionia for Sicily he would have had to look for his young male pupils in the gymnasia where they passed their time. Pythagoras appears to have been the next person to come up

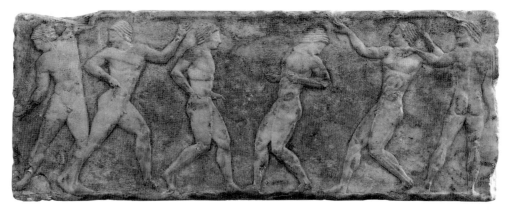

80 Ball players, side of a statue base from Athens, marble, early fifth century BC (see fig. 52).

with an object-based model for the heavenly bodies, the even better image of the *sphaira*, which again is not a geometrical abstraction, as is its modern derivative, the 'sphere', but only a 'ball' as used in the games of the young. Another Eastern itinerant teacher in the West who seems to have made an even greater virtue of necessity by developing a system of training for young men he would have been equally familiar with their equipment (fig. 80). The ball has the advantage over the discus that, besides being capable of riding on air, it corresponds better with the visual experience of palpably three-dimensional heavenly bodies such as the moon. If Pythagoras developed his image from seeing the sky of the exercise field full of balls swinging on curving paths he could also have found the inspiration for his theory of the 'music of the spheres [*sphairai*]' there too. Balls really do generate different notes as they whizz past. When Pythagoras pictured his harmonic *kosmos* he was only describing the unknown universe in terms of the familiar sky over a playing field.

Column drum, wheel, discus and ball are all artefacts, but it is significant that they come from different worlds. Anaximander's imagery comes from the workshop, that of Xenophanes and Pythagoras from the athletics field, that of the intermediate Anaximenes from both. The change probably reflects a shift in the environment in which such images were formed. This was a consequence of the increase in wealth that allowed young men in towns more time for leisure activities. The sons of successful artisans would have increasingly abandoned the sordid workplaces of their fathers for environments more associated with the upper classes and it was to these places of resort that teachers, especially itinerant ones such as Xenophanes and Pythagoras, would have gravitated. Two hundred years later the schools of Plato and Aristotle, the Academy and the Lyceum, were still only the names of suburban shrines to which places of athletic training were attached. When the newly rich young men asked their rival teachers for their explanations of the heavens, they were given answers in terms of their favourite man-made objects. Once again the Greek preoccupation with war and military training produces an important spin-off. If young men had not spent so much time strengthening their arms by throwing a discus and aiming balls their teachers would never have been presented with such a suggestive physical model of the universe. If poet/teachers had not first been close to an artisan world and then followed

young men to the gymnasia it is doubtful whether Greek cosmology would ever have developed as it did. Nor would any of this have happened if crafts and athletics had not been so important and competition in the sale of ideas so intense. People who make pots or throw balls have their heads full of images of pots spinning on wheels and balls travelling through the air and for them nothing is easier than to conceive of other phenomena in terms of that imagery. The success of early Greek science derives from its use of images that were already embedded in the consciousness of those who used its explanations.

When we come to Socrates and Plato in fifth- and fourth-century Athens we might expect this to change. It did not. Socrates was probably the son of a craftsman, a stonemason, and his pupil, the aristocratic Plato, established his school at a gymnasium, recapitulating the development noted above. Plato in the dialogues may be dealing with more and more abstract concepts but he does so using language that is heavily indebted to both sport and workshop imagery. This is especially so in his treatment of cosmology. In the *Phaedo* (110) he compares the earth once again to a ball, this time to a specific type which has 'a leather cover made of twelve pieces in different colours' and in the *Republic* (616) his description of the universe relies on a highly developed craft image, one drawn from the spinning of wool or linen. The dead hero, Er, describes how he traversed a beam of light like a column and found hanging on a chain at the end (a chain that is described as functioning like the ropes that tension the hull of a trireme) a spindle with a shaft and hook of steel. Round this spindle revolved eight whorls, one nestling inside the other, each being visible as a different coloured ring when seen from the top. The outermost is the fixed stars, the next the sun and so on. The outermost revolves in one direction and the inner ones in another and all at different speeds. Such many layered whorls never existed, although the increasing industrialisation of craft processes certainly produced more elaborate technologies, but by describing the universe in this way, not so much as a product, but as a productive machine, Plato came closer than anyone before him to presenting it as a totally integrated system.

In the myth of Er Plato brings to a magnificent culmination the earlier tradition of representing the universe as an artefact. Yet, he still fails to deal with a fundamental problem, that of the origin of that artefact, and, as if in acknowledgement of this, in a later dialogue, the *Timaeus*, he provides an equally brilliant explanation of the universe's making. Usually treated as a clever piece of speculation, this account, already outlined in the last chapter (p. 49), relies on familiarity with the workshop. What is new is that Plato describes not just the particular artefact but the elaborate management and manufacturing structure necessary to produce it. This management structure has the same complexity and integration as the mechanical universe of the *Republic*. The various elements are now explicitly presented as the products of a team working in a large factory. In this way Plato can incorporate new explanations not only of the origin of the universe but also of the relation between man and god. God is spherical and makes the universe spherical in his image. Demigods, too, he makes in his own image and they in turn make mankind in theirs; though the men they make have various ugly limbs added to the basic sphere, the head, which encloses the higher faculties. God, actually called a *tektainomenos* or craftsman, is a master craftsman who makes a masterpiece. This he sets up for his pupils the demigods to copy, having first trained

them to be as like himself as possible. They do so, but badly. The entire model for the account is the operation of a highly organised workshop, a new type of mini-factory, which was almost certainly a relatively new phenomenon in later fifth- and early fourth-century Athens. With the increase in the demand for consumer goods among a larger sector of the population, workshops expanded to become businesses. Craftsman-owners needed increasingly to delegate responsibility for production and the only way to maintain standardisation in such circumstances was to rely less on a few good assistants working independently and more on less qualified artisans working from models. Such a workshop organisation was emerging already earlier in the fifth century as is well shown on the cup with scenes of the foundry (figs 53 and 81). There naked slaves are shown doing the dirty work of casting and putting the statues together, super-vised by the well-dressed owners of the business, who were also probably the masters who made the originals from which the moulds were taken. As the century advanced and Athenians grew wealthier and wealthier the production of all manufactures rapidly increased and such workshop organisations must have become more and more common. In some fields, such as pottery manufacture, where the market also broad-ened, this led to precisely such a decline in the quality of the final product as Plato says occurred with the production of man. Without an understanding of this develop-ment in industrial production Plato is unlikely ever to have come up with his remark-able theory. He is at last able to reintroduce the divine maker of the Near Eastern Creation story, because, in the person of the craftsman-entrepreneur, there was at last a prototype for such a figure in the commercial world from which Greek cosmology had already taken so much of its imagery.

The Intellectual Marketplace: Plato's Paradigm

The single most important feature of Plato's new account to arise out of the analogy with the new workshop tradition is the notion of the *paradeigma*, the pattern or model (*Timaeus*, 28c). This word, which means something like 'that which is shown along-side', is a term already used by Herodotus, where it is applied to the drawing or model from which a bridge is built (*Histories*, v, 62). Real painted *paradeigmata* are shown hanging from ox horns on the foundry cup (fig. 81). It is inherent in the nature of the *paradeigma* that many products could be made from the same model. What makes the introduction of this notion so vital is that it also sustains Plato's most celebrated contribution to intellectual history, the so-called theory of ideas that is described in the *Phaedo* and *Republic*. The 'ideas', of which all our thoughts and products are said to be copies, and which he introduces in order to solve the important epistemologi-cal problem, 'what is the basis of knowledge?', are again not speculative abstractions but the same patterns that would be found in all the new factory-workshops. Not only does he use products such as a couch, a table or a shoe to illustrate what he means by an individual product or concept, but he also again uses the term *paradeigma* (*Repub-lic*, 500E) to describe the heavenly original from which all are copied. Other words he uses, *idea* and *eidos*, refer more generally to the 'visible form' of something and can be applied to the specific form of something natural such as a fruit or a leaf as well as to a product. Another term he uses, however, *tupos*, again takes us back directly to serial

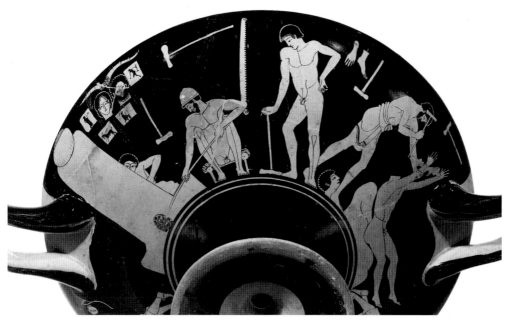

81 Workshop scene showing models or *paradeigmata* at left, from the Foundry Cup, Attic, first quarter of the fifth century BC (see fig. 53).

82a and b Gorgoneion for roof-tile, terracotta, Attic, *c.*440 BC, ancient mould and modern cast.

production in the workshop. *Tupos*, the origin of our modern 'type', derives from the verb *tuptein*, 'to strike', and refers to the master-die used to strike a coin or to the mould used to make multiple clay copies of a figurine or other object (fig. 82). Such dies and moulds, which had existed for a long time, also became more important with the widening of consumption. Taking many copies from a mould was another way in which production was increased to meet the demands of a larger market. *Paradeigma* and *tupos* were thus both features of recent innovations in workshop practice and it was familiarity with their use in serial production that enabled Plato to develop a way of explaining why all individuals appear to share a more or less perfect conceptual vocabulary. In was in this everyday world that he found the *paradeigma* or model for his 'theory of ideas'.

Isocrates and the Theory of Classical Culture

Once Plato had hit upon the idea of the *paradeigma* or model he could use it as a model in other circumstances. It serves very well to shape his notion of education. In the *Protagoras* (312) Socrates compares the sophist teacher's relation to his pupils with the craftsman's relation to his product, but it is in the *Laws* at the end of his life when he is less optimistic about education that he takes the manufacturing model furthest. In Book VII he talks of introducing *deigmata* 'demonstration samples' of perfect youth. This word *deigma*, from the same root 'to show' as *paradeigma*, probably had a double reference. In commerce it would refer to a demonstration sample of a product designed to impress purchasers. This was why 'Deigma' was the name of the trade centre in the port of Peiraeus where merchants showed their wares. In the sphere of production it probably referred to a demonstration piece made by the master for the rest of his shop to work from. Sometimes the same work may have served both purposes. For Plato such *deigmata* are models of how parents and teachers should, as he says, 'manufacture' or 'work' young people into the best shape (*Laws*, 788C). In the same vein the mother is said to 'mould' her children like wax (*Laws*, 789E). The place of education and training is treated as if it is a workshop and educators are thought of as craftsmen trying to produce the best product. Even the dialogue itself is presented as an experimental factory producing superior 'moulds' (*ekmageia*) into which young people can be pressed and shaped (*Laws*, 800C and 801D). An underlying sense that all Plato's dialogues were like workshops may explain one of their most distinctive features, the role of Socrates. His unprecedented position as an omnipresent spokesman for Plato's ideas may well be based on a desire to install him as a sort of *deigma*, who should become a *paradeigma* for readers to imitate. If so, this exploitation of the workshop model paid off, since Socrates did indeed become the universal role model for workers in the academic sphere. Plato not only presented his idea of education as a production process, he also constructed his dialogues using the production process as a model.

Plato's ideas on education are significant, but they form only a part of his enterprise and were presented in a rarefied context. The person who focused more intently on education, because it became his whole life, was Isocrates, and it is he who shows both that Plato's imagery derived from sport and the workshop was widely shared and that competition was regarded as the driving force behind the encouragement of excel-

lence in all areas of Greek life. Born in 426 BC and dying in 338 BC, Isocrates came
into the world five years after the start of the Peloponnsian War and left it just after
King Philip of Macedon had defeated the Athenians at Chaeronea, thus setting the
scene for the world conquests of his son Alexander. As the son of a prosperous flute
manufacturer whose business collapsed because of the war, as a companion of Socrates
until the latter's death in 399 BC, and as an extremely successful professional teacher of
rhetoric, he was close both to the humbling material realities and the lofty intellectual
pretensions of his period. In the second half of his long life he wrote a number of
works that were designed alternately to rally his fellow Athenians and Greeks, to
influence Philip of Macedon, and to make more generally available the insights that
he had built up in a lifetime of teaching. No one tried harder to understand the specific
nature of that phase of Athenian culture that is considered most 'Classical' and to distil
its essence.

Isocrates' finest work is the *Panegyricus* of about 380 BC, composed as if an address
to the great assembly that came together at the Olympic Games. In it he endeavours
to remind his fellow Hellenes of their destiny by analysing the sources of their par-
ticular strengths. Chief among these are the national Games. Athens, he says, has even
established festivals where it is possible to see 'competitions not only of speed and
strength, but also of words and opinions and of all other activities and for these the
greatest prizes (*Panegyricus*, 45). Elsewhere, in a more personal speech, he talks parti-
cularly about why Athens is a school for rhetoric: 'for people observe that she offers
the greatest prize to those who have this power and offers the most various fields for
exercise for those who have chosen to compete' (*Antidosis*, 295). He is even able to see
the disastrous competition between the Athenians and the Spartans in positive terms:

> they did not look upon each other as enemies but as competitors, nor did they court
> the favour of the barbarians for the enslavement of the Hellenes; on the contrary,
> they were of one mind [*homonoountes*] when the common safety was in question
> and their rivalry with each other was solely to see which of them should bring this
> about.
>
> *Panegyricus*, 85

But it is particularly in the area of the arts, both intellectual and manual, that he sees
competition as having the most positive effect:

> And it is my opinion that the study of oratory as well as of the other arts would
> make the greatest advance if we would admire and honour, not those who make
> the first beginnings in their crafts, but those who are the most finished craftsmen in
> each, and not those who seek to speak on subjects on which no one has spoken
> before, but those who know how to speak as no one else could.
>
> *Panegyricus*, 10

Isocrates here goes far beyond Hesiod in his understanding of the positive benefits of
competition and how to maximise them. Hesiod had understood the importance of
competition as a driving force. Isocrates explains the mechanism by which it operates
most efficiently. It is the most sophisticated craftsmen whom we must choose to
emulate and, instead of attempting something entirely new, we should only try to
improve on what has been done before. Elsewhere Isocrates describes how such dis-

couragement of variation affects the teacher/pupil relationship. The best teacher has pupils who are 'made in his mould and able to imitate him' (*Against the Sophists*, 170). 'Indeed, everyone would agree that those people are the most skilled in all arts and crafts who produce pupils who are most similar to each other as workers' (*Against the Sophists*, 300). As pupils we should choose the best models, try to imitate them as closely as possible and at the same time try to surpass them. The coherence of Isocrates' theory emerges most clearly when, in addressing a pupil, he employs the same range of images from commerce, art and athletics as was used by Plato when outlining his educational scheme:

> I have produced a demonstration sample [*deigma*] of the nature of Hipponicus [your father], after whom you should pattern your life as after a model [*paradeigma*], regarding his conduct as your law, and striving to imitate and emulate your father's virtue; for it would be a shame, when painters represent the beautiful among animals, for children not to imitate the noble among their ancestors. Nay, you must consider that no athlete is so in duty bound to train against his competitors as you are to take thought how you may vie with your father in his ways of life.
>
> *To Demonicus*, 11 and 12

Demonicus should do the same things as his father, but try to do them better. In order to clarify what those things are, Isocrates has presented the father as a perfect specimen, a 'demonstration sample' which should be copied as a 'model'. The parallel with Plato's *Laws* is extraordinarily close. As with Plato, three areas of Greek life, trade, art and athletics, provided models for the notion of competition in the execution of a near identical act. But imitation alone would be too backward looking. To achieve progress it is necessary to move towards something not yet existing. Isocrates was aware of this and described how ideas precede actions. In *To Nicocles*, 7, he describes how, as writers, although we often have an idea for a work that seems to offer great possibilities, the final composition may be disappointing. More allusively, at *Panegyricus*, 118, he says that anyone who wants to excel needs to plan in his mind projects that are possible, but which have an element of wishful thinking. One must first have an idea in one's mind that goes beyond what has been done before and then seek to execute it.

Isocrates offers the fullest available account of the mechanisms of cultural development within the Greek world. Born into the world of crafts and trade and having established a central position in higher education, he is able to give a privileged insight into the worlds of both art and ideas, by documenting their shared tools and methods. More than Socrates and Plato, who moved in relatively closed and exclusive circles and whose messages were chiefly directed at the initiated, he was, from his beginning as a speaker in the courts to his maturity as a public teacher, close to the real world in which most Greeks lived. His perceptive analysis of the merits of Greek culture would almost certainly have been accepted as valid by his contemporaries.

It is important to stress that what Isocrates is giving is an analysis specifically of Greek culture and that this distinguishes him from Hesiod. The eighth-century poet appears only to describe the human condition, unaware that, as described, it was unique to his environment. Isocrates on the other hand is conscious that the culture he is describing is essentially Greek. As he makes clear, especially in the *Panegyricus*, this is

essentially because the Greeks had developed institutions that were appropriate to their particular ecology. Typical are the great national Games which bring everyone together in all sorts of competitions. Particular status attaches to the Athenian games and to the function of Athens' port, Peiraeus, as a central marketplace:

> Again, since the different populations did not in any case possess a country that was self-sufficing, each lacking in some things and producing others in excess of their needs, and since they were greatly at a loss where they should dispose of their surplus and whence they should import what they lacked, in these difficulties also our city came to the rescue; for she established the Peiraeus as a market in the centre of Hellas – a market of such abundance that the articles which it is difficult to get, one here, one there, from the rest of the world, all these it is easy to procure from Athens.
>
> *Panegyricus*, 42

Isocrates realises that the need of Greek states to trade between each other both in order to fill their needs and to get rid of their surpluses explains the continuously high level of contact between them. He also senses that this situation was an important factor in fostering a sense of unity and ensuring the rapid dissemination both of product types and ideas. Athens' role is predominant because not only are the best-made products found in the Deigma of the Peiraeus but the best educated people are found in the schools of the city itself:

> And so far has our city out-distanced the rest of mankind in thought and speech that her pupils have become the teachers of the rest of the world; and she has brought it about that the name 'Hellenes' suggests no longer a race but an intelligence [*dianoia*], and that the title 'Hellenes' is applied rather to those who share our culture than to those who share a common bond.
>
> *Panegyricus*, 50

So essential was an Athenian education to being Greek that even a barbarian could become Greek by acquiring it. Isocrates realised that one of the main strengths of such an education was its narrow focus on particular goals. As he said, its main function was to concentrate the mind on useful things 'and not to allow the thought [*dianoia*] to wander' (*Antidosis*, 332). He was right. A fourth-century education enabled a pupil to decide which of a limited range of activities he wished to pursue. Further, it taught him, like a competitive craftsman, to select the best models, and, like a competitive athlete, to train to imitate and surpass them. Isocrates saw that it was just such an approach, the result not of theory but of simple competitive pressure, that had already given Greek art and Greek literature their distinctive excellences.

Isocrates could not know that Philip of Macedon's conquest of Greece (Battle of Chaeronea, 338 BC) and Alexander's conquest of the East were to transform the mechanisms by which Greek culture developed. With the establishment of several great monarchies to rule the different parts of Alexander's empire after his death in 323 BC competition – except between the rulers – ceased to be a driving force. With unparalleled wealth now concentrated in the hands of a few hereditary kings, artistic and literary activity came under the control of royal administrations. The most successful poets were no longer those who competed before the citizens of Athens but those

who received salaries in the Museum at Alexandria and elsewhere. The most important artists were no longer those who were in rivalry for the commission of commemorative statues at the pan-Hellenic sanctuaries, but those retained at Hellenistic courts. Instead of competing in finding ways to express common values, artists now responded to the changing demands of kings isolated in their courts at Pella (Macedon), Pergamum, Antioch, Alexandria and Syracuse. With this abrupt transformation of the political, social and economic life of the Greek world the continuous and unified development of art over three and a half centuries from the early seventh to the mid-fourth came to an end. The world that had produced the so-called Classical achievement ceased to exist. Only in the Athenian educational institutions and in the writings of Plato and Isocrates did the theory of competition in the pursuit of excellence on which that achievement was founded survive. The intellectual workshops of the city remained open until the early sixth century AD. Preserved in books, their tools have survived to the present day.

Chapter Four

HELLENISTIC ART AND THE CULTURE OF CHARACTER

Alexander: Paradigmatic Breaker of the Paradigm

The notion that it is useful to define a new period of Greek history, the Hellenistic period, with the death of Alexander the Great is a relatively recent one. It owes its acceptance to a general recognition that his conquests drastically changed the circumstances of life, not only for the Greeks, but also for many of their neighbours. From the moment he became king of Macedon at the age of 20 in 336 BC he embarked on a whirlwind career (fig. 83). It began with his reaffirmation of his father's territorial gains in Greece, continued with his conquests of Asia Minor, Egypt, Persia and Mesopotamia and his penetration as far as India. It ended with his death in Babylon in 323 BC. His life had been short, but so overwhelming had been his impact that it proved relatively easy for the more energetic of his generals and their successors to establish Macedonian, and thus effectively Greek, control over all the rich lands round the Eastern Mediterranean. The Antigonids in Macedonia itself, the Seleucids in Syria, the Ptolemies in Egypt and within a few decades the Attalids in Asia Minor needed only to dispute with each other the frontiers of their political and military control. With the Greek language and Greek institutions everywhere dominant, international trade flourished as never before. The rulers had plundered treasuries to pay the armies who first brought them to power. Later they consolidated their prosperity through the management of efficient systems of taxation and used this wealth to enhance their authority through the patronage of writers and philosophers, actors and musicians, painters, sculptors and architects. All these, whose skills had been developed originally to satisfy the needs of the relatively modest citizens of Athens and elsewhere, now sought wealth and security in the service of the policies and pleasures of super-rich kings. The books, performances and works of art that they provided for the new patrons still required the application of the same skills, but their character was as new and different as were the circumstances of their production. No circumstances were more important than the new material resources that became available. Besides the new, enhanced and secure grain supplies that allowed for the growth of large cities, other materials long familiar in the East now came under the control of Greek masters. Paper

83 (*above*) Head of Alexander as Zeus Ammon with Indian inscription, tourmaline, probably carved in the East, late fourth century BC (cast).

84 Details of wreath, gold, glass inlay and glass beads, late fourth century BC.

85 Alexander's conquests in a global context, the hatched area representing the lands he inherited from his father.

(*papyrus*) from Egypt and, later, parchment (*pergamentum*), named after the city of Perga-
mum, transformed book production. The tourmaline from which Alexander's head was
cut (fig. 83) may be from Sri Lanka and garnets and emeralds came from equally exotic
sources. Composite materials could be crafted using new technologies, as in the wreath
(fig. 84) which combines glass enamels and beads to miraculous effect. Precious stones
and the most precious metal, gold, could now be easily exploited by artists used more
to limestone and marble, bronze and silver. In Hesiod's terms Alexander's conquests
brought back some elements of the Golden Age. Having changed the material, eco-
nomic, social and political realities of the Greek world, they in time also changed the
nature of its culture (fig. 85).

Alexander is a figure of revolutionary importance who can be seen as dramatically
closing the gates of that period during which the quintessential Greek culture was
developed. Yet he was also very much a product of that period and owed much of his
success precisely to its institution. Trained by his father, Philip, to know the principles
and practice of Greek military discipline and educated by the Athenian Aristotle to
understand the principles of the natural order formulated by two centuries of Greek
teachers, he was in many ways the paradigm of Greek youth. Being not strictly a Greek
– his fifth-century ancestor called himself Philhellenos, 'lover of the Greeks' – he was
also a living embodiment of the phenomenon described by Isocrates in his observa-
tion that 'the name "Hellenes" suggests no longer a race but an intelligence [*dianoia*]'.
His staggering achievement could easily be seen as the ultimate demonstration of the
effectiveness of the systems of physical and intellectual training developed in Greece
over the previous centuries.

This, however, leaves out a major and equally essential feature of Alexander's success,
that it also depended on his exploiting a whole series of attributes that earlier Greek
culture had sought to suppress or at least to present as dangerous. He was an arrogant
king, who allowed himself to be ruled by petty passions and who used charm and vio-
lence to push through arbitrary decisions. He showed little interest in rational persua-
sion or in obtaining agreement either on the nature of critical situations or on the
approved methods for dealing with them. He thus flouted many of the most impor-
tant conventions of Greek life. Everything that the Greeks had done previously had
implicitly been achieved by adjusting themselves to what were seen as recognised social
and natural realities. Their activities in such areas as agriculture, navigation and religion
were governed by accepted calendars. Their legal systems they saw as appropriate
responses to the social and economic tensions within their communities. To deal with
external threats they developed particular forms of military discipline. Their philoso-
phies they formulated in an attempt to extract some order from a dangerous and unpre-
dictable natural environment. Many a fifth-century Greek would have been able to
explain the merits of these different facets of his culture, offering a *logos* or spoken
rationalisation for the existence of each. The histories of Herodotus and Thucydides,
the tragedies of the Athenian dramatists, the teachings, both of those who called them-
selves sophists, such as Isocrates, and of those who thought of themselves as philoso-
phers, such as Plato, are full of such current explanations. Again and again the basis of
such explanations would be in terms of words such as *noein*, that is in the first place
'to observe' and in the second place 'to perceive or think', or *gignoskein*, 'to know by
observation', and their cognates *nous*, *gnome*, etc. Rational abstractions and plans

founded on rational thought could be described as *dianoiai*. A principal reason for the emphasis on observed evidence, agreed knowledge, and the importance of the spoken rationalisation was that in Greece co-operation was vital. There were many circumstances in which it was necessary to convince fellow members of a group, such as a class, a citizen body, or the representatives of allied states, that since such-and-such was so then such-and-such needed to be done. People had first of all to agree about the nature of a situation and then to agree how it should be tackled to produce a particular end result. Situation, action and goal all had to be seen with the same eyes.

Alexander effectively changed all that. Motivated by sudden impulses, acting often irrationally, he was able to impose his will on a situation by the use of a combination of royal charisma, personal charm and undreamt of wealth. When he crossed the Hellespont into Asia Minor he almost certainly had no clear plan and within a few years was conquering peoples whose existence had earlier been unknown to him. At every step of his journey he was carried forward by a personal impulse that determined at once the direction and force of his movement. Seldom were words his principal instrument of persuasion. Knowledge, agreement and planning, the essential prerequisites for most earlier achievements in the Greek world, were not only irrelevant to him, attention to any one of them would have actually made it difficult for him to achieve anything at all. Hence it was that when Plutarch in his *Life of Alexander* described the first step of his long march into Asia Minor, the crossing of the Granicus river, where he first defeated the Persians, he insisted that his success was the result of the disregarding of all the traditional Greek virtues. First he dispensed with the religious scruples of his Macedonian followers whom custom forbade to fight in the month Daisius, by arbitrarily changing its name to Second Artemisius. He then disregarded the prudent observations of his generals on the depth of the river and the roughness of its banks by observing that 'The Hellespont would blush, if, after having passed it, he should be intimidated by the Granicus'. Once in the water his movements, unlike those of the trained Greek soldier, seemed more the product of *mania*, 'madness', and *aponoia*, 'senselessness', than of *gnome*, 'considered judgement'. Finally, at the turning point of the battle, instead of negotiating with the Greek mercenaries who opposed him according to convention, he carried straight on, motivated not by *logismos*, 'reasoning', but by *thumos*, 'passion'. Although Plutarch deliberately stresses the significance of this river crossing in order to evoke a comparison with Alexander's Roman rival, Caesar, at the Rubicon, the picture here painted of his hero is not the one Plutarch particularly wished to project and must be one developed in the Hellenistic period soon after Alexander's death. To show that Alexander's first great step was undertaken in such a spirit of the rejection of religious tabu, the disregard of the facts of geography, the abandonment of discipline, the flouting of social convention and the denial of reason, constituted a systematic demonstration that all those elements of Greek life on which earlier generations had prided themselves were now only obstacles on the path to true greatness. Whoever the writers were who first presented Alexander's victory in this way, they can have intended only to prove how decisively he had changed the criteria of excellence. There is certainly rhetorical exaggeration in the consistency of the portrayal, but there can be no doubt that there is enough truth in the new image of a hero to allow us to use it as the basis for an assessment of his impact. Alexander's actions were apparently based on such a different set of premises

from those of his Greek predecessors that anyone who followed his career would have been forced to review all their assumptions about the nature of man's relationship to his environment. Alexander may not have been so different in his education and background from his contemporaries, but the extent to which his success appeared to be based on a refusal to adjust his behaviour to commonly accepted perceptions or to follow well-tried methods suggested to those who studied his career that this was what set him apart.

There could hardly be a more abrupt contrast with the traditional Greek hero. Figures such as Heracles, Theseus and Achilles had obediently, if reluctantly, performed the tasks required of them and their stories were interspersed with incidents that revealed how dangerous personal impulses could be. There was an equally abrupt contrast with the type of man whose qualities were summed up by Isocrates. Indeed, the universal acceptance of the earlier heroic model and of the recent educational prototype might have been expected to have prevented Alexander's success from fundamentally affecting people's values, but for one factor. This was the dominance in Greece of the idea of imitation. It was as models for emulation and imitation that such heroes had originally acquired their prominence in Greek poetry and prose, painting and sculpture. Later too, when, in the later fifth and earlier fourth centuries, a structured education, such as is described by Plato or Isocrates, took over from these manifestations as the chief means of personal formation, it was in terms of a similar, though more abstract, notion of assimilation to a paradigm. The Greek male, who knew his Homer, who passed the statues of athletes in sanctuaries and of dead soldiers in cemeteries (figs 4, 29, 30, 46 and 55), who saw the reliefs of labouring heroes and fighting soldiers on temples and treasuries (figs 67–70) and who loitered in stoas decorated with paintings of similar subjects before going to some grove dedicated to a hero such as Academus, to train his body in the gymnasium and improve his mind listening to lectures from a wise teacher, was repeatedly presented with exemplars of physical, moral and intellectual excellence. Heroes, soldiers, athletes and teachers were all offered to him as models for imitation.

Alexander, the intelligent pupil of Aristotle, who distinguished himself physically as a hunter and a soldier and above all as the great hero who finally liberated the Greeks from the threat of foreign domination, combined features of all these exemplars. He was, however, a far more appealing model for young men of the late fourth and subsequent centuries. As an educated soldier/hero he fitted the established pattern. But as someone who had achieved so much precisely by following his impulses and acting thoughtlessly and who had not denied himself the pleasures of over-indulgence in wine, women and violence he gave the lie to many of the warnings and prohibitions contained both in the stories of earlier heroes and in the teachings of contemporary educators. Very much a man of flesh and blood, the unprecedented scale of his achievement led by the time of his death to his being viewed as a god. Alexander may have taken the *Iliad* with him in a special box throughout his campaigns, thus identifying himself as Achilles' successor in a conflict with the Eastern enemy, but by his actions and his way of life on campaign he effectively and permanently supplanted the Homeric hero as the model for later generations.

Alexander, the semi-barbarian who had exposed the weakness of the culture of the Greeks by defeating them in battle, the activity at which that culture prepared them

to excel, went on to disprove many more of the assumptions on which it was founded. Many of the paintings, sculptures and architectural projects that he either commissioned or inspired would have alerted his contemporaries to the fact that both his own view of himself and that which others had of him were quite new.

Alexander and Art

Sculpture, painting and architecture had been principal embodiments of the accepted paradigm in the Greek world before Alexander and it was inevitable that his emergence as a new paradigm should also find expression in these arts. Alexander's own use of artistic patronage suggests that he was conscious of establishing himself as a new type. According to ancient writers, he approved only portraits of himself that were made either by the sculptor Lysippos or the painter Apelles. These portrayals were unlike earlier stereotypes of rulers and soldiers. Lysippos' statues sometimes showed Alexander in a mobile pose with his neck slightly turned and looking upwards, while Apelles once showed him wielding a thunderbolt as if in acknowledgement of his Zeus-like authority. Lysippos also made two statues of Alexander as a member of a group. One of these was the group set up at Dion in Macedonia commemorating those of his companions who had died at the crucial battle on the Granicus (fig. 86). Probably it recalled directly the engagement in which Alexander, governed more by passion than by reason, charged with his cavalry at the disciplined body of Greek mercenaries who faced him, even though they were ready to negotiate an honourable submission, and so ended up irresponsibly losing many of his friends and having his horse killed under him. This group of men in violent action, mounted on horses which, however well trained, can only have been in loose formation, stressed the impulsiveness of his attack. Later another group commemorating a moment in a lion hunt where again Alexander's impulsiveness brought him into danger was erected at Delphi by his rescuer on that occasion, his lieutenant Craterus. After the monotonous rows of heroes and kings, soldiers and athletes, who populated previous dedications at this great centre of pan-Hellenic competition and whose disciplined performance of set tasks conformed to traditional standards of excellence, the portrayal of a free and uncertain confrontation of a handful of men and a wild animal provided a dramatic celebration of virtues that could not be learnt and were unlikely ever to be socially prescribed. A further remarkable evocation of the abandonment of earlier values was provided by another more private work perhaps commissioned from Lysippos by Alexander himself. This was the silver statuette known as Heracles Epitrapezius which showed the hero not erect and performing one of his many labours, but sitting cup in hand indulging in a relaxing drink (fig. 87). If, as was claimed, Alexander used this image to adorn his own table he would have made it plain that Heracles' drunkenness, which had earlier served as a pitiful lesson for young men, was now the model for his own. Not surprisingly, as is appropriate in the case of a man who was a legend in his lifetime, there is an element of myth about several of the stories concerning the artistic enterprises with which Alexander was associated. One such story is that told best by Vitruvius, that the architect Dinocrates dressed up as Heracles in order to convince Alexander that he was capable of carving Mount Athos into a gigantic statue which would hold in

86 *Alexander on Horseback*, bronze, first century BC, after an orig-
inal, probably by Lysippos, of *c*.330 BC.

87 *Hercules Epitrapezius*, Roman
marble copy of an original by
Lysippos of *c*.330 BC.

one hand a lake and in the other a city (*De Architectura*, 2, pref.). Taking Alexander as
his model, Dinocrates, who was later to design Alexander's greatest foundation, Alexan-
dria in Egypt (fig. 88), is made to suggest that just as Alexander could make
superhuman conquests so he could make
superhuman art. Another story is that
recorded most fully by Arrian, of Alexander's
bizarre building project when forced by
mutinous troops to halt his advance into
Asia. Determined to leave an appropriate
memorial, he ordered his men to construct
a vast camp with everything including beds
and mangers of a gigantic scale to convince
those who later visited the site that he, his
soldiers and his horses had been super-
beings. To the extent that these stories are
true they prove that Alexander and his asso-
ciates were capable of conceptions that far
surpassed the limits of realisability, reason-
ableness or logic. To the extent that they are

88 Alexandria, plan.

the inventions of contemporary and later writers they demonstrate what is just as important, that Alexander had so far broken the frontiers of normal Greek expectations that only in the imagination could projects worthy of him be created. Whether Dinocrates really thought of himself as a super-architect able to make a super-statue, whether Alexander or someone in his retinue really visualised a super-camp, or whether people just came to think that only projects such as these would have been worthy of him, the stories make it clear that Alexander's achievements brought a transformation of people's view of the world and of man's relation to it. This transformation was best summed up in his designation as 'the Great', which perhaps took place in his lifetime.

Responses to the Paradigm

A principal variable affecting the response to Alexander's life was a person's race or rather racial identification. For the many non-Greeks who were now ruled by the half-Greek Macedonians the principal real changes were that they now paid their taxes to a Greek-speaking and Greek-trained government and that they benefited from living in cities managed and often designed by people who inherited a strong tradition of relatively efficient citizen-based city administration. When this meant the more efficient collection of taxes the reaction could be negative. This was true of Egypt where there was also resistance by sections of the native population to Greek cultural domination. This led to the use of a new and more secret type of hieroglyphic script in temple sites and to the building of assertively Egyptian-style tombs even in the cemeteries of the new capital. The segmental pediments of some of these, which have their origins in ancient Egyptian roof types, contrast demonstratively with the triangular pediments, fluted columns and architraves of the Greek structures (figs 89 and 90). More frequent was some degree of assimilation such as that promoted by Alexander himself, who is said to have instituted a programme for providing a Greek education for thousands of young Persians. Many parents will have been happy for their children to acquire Greek ways in order to share the benefits of belonging to the ruling group.

An exceptional early example of someone who threw in his lot with the Macedonian invaders was Abdalonymus, the Phoenician king of Sidon, an early strong supporter of Alexander, although he was swept aside in the disturbed years that followed the latter's death. His sarcophagus is a revealing document of political and cultural conversion. Carved by Greek masons in Greek marble and decorated with the most refined mouldings, its general form, like the Nereid tomb (fig. 23), expresses a strong admiration for the control of material, the careful measurement and the subtlety of perception that distinguished the Greeks from their neighbours. Respect for the Greeks is even clearer in the reliefs, which celebrate precisely the attributes of physical strength and courage and military discipline that were the decisive factors in Alexander's victories. One long side shows Alexander with his Macedonian cavalry in victorious combat with Persian horsemen who seem to fall like leaves before their attackers (fig. 91). The insistent regularity of every limb of man and horse on the Greek side brings into sharp relief the fumbling agitation of the Persians. The other long side is filled

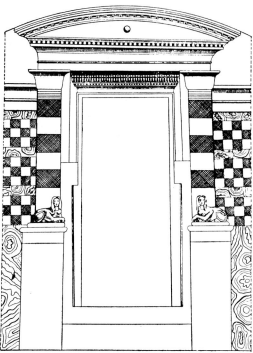

89 Tomb from Mustafa Pasha Nekropolis, Alexandria, third or second century BC.

90 Tomb from Anfoushy Nekropolis, Alexandria, interior, second century BC (drawing).

with a scene of hunting that records a second stage in the relation between the Greeks and those they vanquished (fig. 92). The Greeks are still dominant as they ride to the help of a Persian horseman who is attacked by a lion, but that horseman is now himself indistinguishable from a Greek except in his dress. Both he and his two fellows on foot at either end of the frieze act with the same rhythm and controlled vigour as their conquerors. The first scene explains why the Macedonians are superior. The second explains that anyone who joins them and learns their physical and mental skills can enjoy the same dominance. To a non-Greek such as Abdalonymus it was above all the traditional qualities instilled by a Greek education and training that gave the Macedonians victory in the contest with the Persians. For him, as for other non-Greeks, Alexander's other, less predictable qualities, would have seemed quite familiar from their own world. Instead it was the chilling machine-like efficiency of the Greeks that fascinated them and which seemed to be the single outstanding secret of their success. They could not realise that what gave Alexander his unparalleled success was his ability to use charisma and impulsiveness to drive the Greek fighting machine much farther than it could go on its own. For Abdalonymus Alexander was above all a paradigm of Greek excellence. On the first frieze he is presented as such, while in the second we are shown how the imitation of that paradigm can transform even barbarians into people with similar resources. Abdalonymus is not just celebrating Greek virtues. He is also celebrating the prin-cipal means by which they were propagated, the practice of the imitation of the best model.

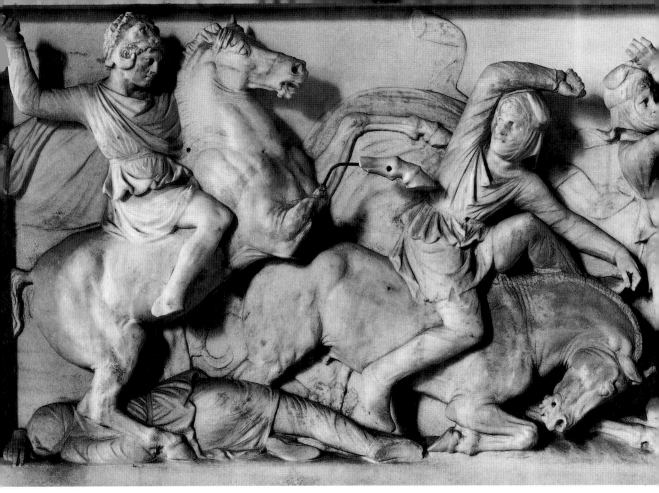

91 Battle between Alexander and the Persians, detail of the side of the Alexander Sarcophagus, *c.*320 BC, from Sidon, probably the tomb of King Abdalonymus.

92 Lion hunt, detail of the side of the Alexander Sarcophagus (see fig. 91).

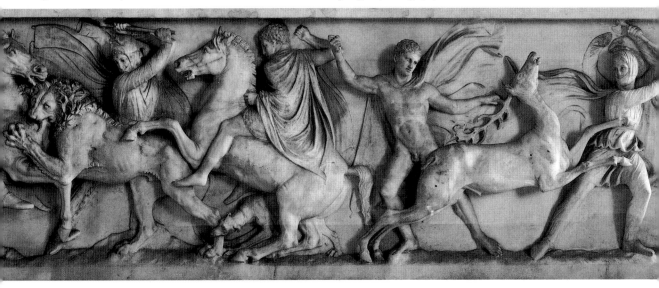

Alexander could be taken as a paradigm of the product of a Greek education and was so treated both by Greek teachers and by barbarian allies. This was in both their interests. It enhanced the status of teachers as transmitters of the most effective tradition of personal formation the world had seen. It allowed non-Greeks to become joint beneficiaries in the fortune brought by the victory of that tradition.

For those who felt that their status might rather be enhanced by their freedom from that tradition, Alexander could also serve as a paradigm of resistance to its control. The most obvious group for whom this was true were the generals who claimed to be Alexander's heirs as founders of kingdoms of their own. They had no need to make claims for their training, since that had been proved by years in Alexander's service, but they did want to assert their new absolute autonomy as kings. The most Alexander-like of his successors was Demetrius Poliorcetes, 'the besieger', son of Antigonus, the founder of the dynasty that was eventually to rule Macedon. Impulsive and dynamic as Alexander he tried in vain to gain sole control over the majority of his territories and in pursuing this ambition acquired an unrivalled reputation as much for his debaucheries as for his amazing war machines. 'There appeared in all his works a grandeur of design and dignity of invention, so that they were not only worthy of the genius and wealth but of the hand of a king' (Plutarch, *Lives*, Demetrius, 20, 3). He was most famous for building galleys greater than any built earlier, with fifteen and sixteen banks of oars and great multi-storey siege engines that rolled forward on sixteen-foot wheels making a terrifying noise, but equally typical was his commissioning of a robe decorated with representations of the world and all the heavenly bodies. Like Alexander he was quite ready to violate the religious calendar, ordering the Pythian games on one occasion to be transferred from Delphi to Athens, and he inspired others to similar acts. The Athenians at one time renamed a month in his honour and at another arbitrarily determined that existing names could be exchanged so that a festival could be held while he was present. In one of the most flagrant acts of imitation they invited him to live in the rear chamber of the Parthenon where he disported himself with the courtesan Lamia and others. Even after his death his spirit lived on. When his son sailed into the harbour of Corinth with his father's ashes he displayed them in an urn adorned with a purple robe and a diadem and attended by a company of soldiers. A famous flautist, Xenophantus, sat nearby playing a solemn tune, to which the oars kept time making a melancholy sound like mourners in a funeral procession. Almost everything that Demetrius did or inspired was unique, unprecedented and grand in scale and conception. Nothing could be further from the principles of Classical culture as represented by earlier Greek art and as enunciated by Isocrates only fifty years earlier when he claimed that the important thing was to do the same as one's predecessors, only better. Demetrius went beyond Alexander.

The 'Modern' Artist

Alexander and the ruler-generals who succeeded him were at once highly educated to perform predictably and also liberated by circumstance from the need to do so. As such they represent a new pattern for Western man. Also of a new type were the artists who worked for them, and their exploitation of a similar combination of a high degree

of skill and a high degree of self-assertion was to be just as decisive for the formation of the image of the typical artist. In some ways the independence of their individual styles in both art and life were to be matched only in the modern period. The painters and sculptors of the later fourth and early third centuries BC enjoyed a unique level of technical excellence, the result of centuries of competition, and this gave them a pride and confidence in their dealings with the new generation of patrons that allowed them to occupy the larger space that they were offered and to take from their employers the cue for a new independence and readiness to respond to their emotions. Their successors, who were frequently attached to one particular court, were increasingly both deprived of the stimulus of competition and encouraged to adopt the mental habits of dependants. A story told by Pliny about Alexander's favourite artist captures the brief moment of confidence and freedom before this happened. Alexander frequently came to Apelles' studio, and when the king used to discourse on many aspects of painting even though he was not well informed, Apelles would quietly advise him to be quiet, saying that he was being laughed at by the boys who were grinding the colours (*Natural History*, XXXV, 10, 85). As Pliny says, Apelles was bold indeed to speak in this way to a monarch who was well known for the violence of his reactions, stabbing his friends over dinner and having the philosopher nephew of Aristotle murdered when he ventured to criticise him. Later artists, brought up with such examples before them, were not so rash.

The unique combination of technical excellence and personal eccentricity associated with the artists of Alexander's period is reflected in the two principal sources for our knowledge about them. The two authors on whom the Roman Pliny ultimately depended were Xenokrates and Douris. Xenokrates, a sculptor himself and a pupil of Lysippos, left a history of Greek sculpture and painting that celebrated the technical progress of these arts to peaks represented by the work of both his master and Apelles. Douris, who claimed descent from the Greek who most anticipated Alexander in character, Alcibiades, and who was for a time the tyrant of Samos, wrote instead about the characters of artists, taking pride in recording their more bizarre exploits, of which he found many in his own and the preceding generation. Xenokrates used the intellectual framework developed by Aristotle to give structure to a traditional history of technical development. Douris, following rather Aristotle's pupil Theophrastus, himself the author of a book of *Characters*, caught the flavour of the moment and applied to the history of art the approach that he had already employed when dealing with figures from the larger stage of history. If the stories about artists such as Apelles and Lysippos that are known or believed to derive from Douris remind us of stories about such figures as Alexander and Demetrius it is because he felt that they responded to the contemporary situation in a similar way.

It is thus likely that it is to Douris that we owe the recognition of Praxiteles as the Alexander-like prototype of the artist as a passionate and unstable personality. Numerous stories describe the central role in Praxiteles' life and work of his relationship with the famous courtesan, Phryne. Their relationship, which flourished around 340 BC, was probably first triggered by Praxiteles' need to obtain a female model who had no objection to posing for him in the nude. The most famous work for which he employed her as a model was the first great totally nude statue of a woman, the Aphrodite of Cnidos (figs 93a and b). Later she supposedly also served as a model for

a painting by Praxiteles' younger contemporary, Apelles, his Aphrodite Anadyomene or Venus rising from the waves. Both artists could have legitimately claimed that their need for a nude model had its origin in the requirement to illustrate a particular story from mythology, but it is hardly surprising if the long hours spent with an attractive member of the opposite sex had other consequences. The effect on an artist of being alone with a beautiful naked woman is recorded in another story in Pliny which may derive from Douris and which also clearly assimilates the roles of ruler and artist. Alexander was so proud of the beauty of his favourite mistress, Pankaspe, that he wanted Apelles, his favourite painter, to paint her naked as he knew her. This was a bold decision and it proved a dangerous one, since Apelles fell in love with her himself. Yet what caused most surprise was that when Alexander heard what had happened he promptly surrendered his admired plaything to the artist. As Pliny says, this conquest of himself was as great as any of his victories over others (*Natural History*, xxxv, 10, 86). Perhaps Alexander realised that it was really his fault that Apelles lost his heart. He may have communicated his feelings for his mistress so warmly that he encouraged Apelles to get too far into the role of seeing her with his eyes.

Whatever the truth of the story, its central feature is that Apelles responded to impulses instead of adopting a genuinely professional attitude to his craft, and it is not unlikely that he came to feel that such a lifestyle was acceptable precisely because of the example set by his employer. The influence of Alexander as a model would also explain similar stories of impulsive behaviour on the part of other late fourth-century artists. Thus for example Pliny (*Natural History*, xxxiv, 19, 81) describes the self-critical passions of Apollodorus, a sculptor who was Alexander's contemporary. He was apparently such a harsh critic of himself that he frequently smashed his finished statues and became known as the 'madman'. At a time when everyone saw Alexander conquer the world as much because he was carried along by a passion as because he was fulfilling a plan, it is hardly surprising if lesser figures too felt free to respond to their emotions. Perhaps a similar thought led another contemporary, Melanthios, to say, according to Diogenes Laertius, that one should 'strive to put a certain wilfulness and harshness into one's paintings just like that which exists in the characters' (*Lives of the Eminent Philosophers*, 4, 18). This might mean no more than that one should show characters as wilful and harsh as they are, but the point of the story would be much more telling if he meant that artists should use the same wilfulness and harshness in their style as had their subjects in their lives. Plutarch tells us that Melanthios painted a portrait of the tyrant Aristratus, and autocrats, such as he probably was, certainly showed how such qualities brought success in the world of politics at least. A friend of Melanthios, according to Plutarch, and the artist who painted out the figure of Aristratus in order to save the painting when the power structure had changed, was Nealkes, and it was he who, according to Pliny, applied a similar wilful and impulsive approach to the solution of a technical problem. Having to paint a horse that was foaming at the bit he achieved the effect simply by throwing a sponge soaked in paint at the panel. Not that he necessarily discovered the trick himself. According to Pliny its inventor was Protogenes who was, after Apelles, the most famous painter of the late fourth century.

> A meticulous artist, he was infuriated by his incapacity to portray the foaming mouth of a panting dog, for the foam appeared only to be painted and not to have origi-

93a and b Aphrodite, Roman marble adaptation of the Aphrodite of Cnidos by Praxiteles of *c.*330 BC. Detail of marble and rear view of plaster cast.

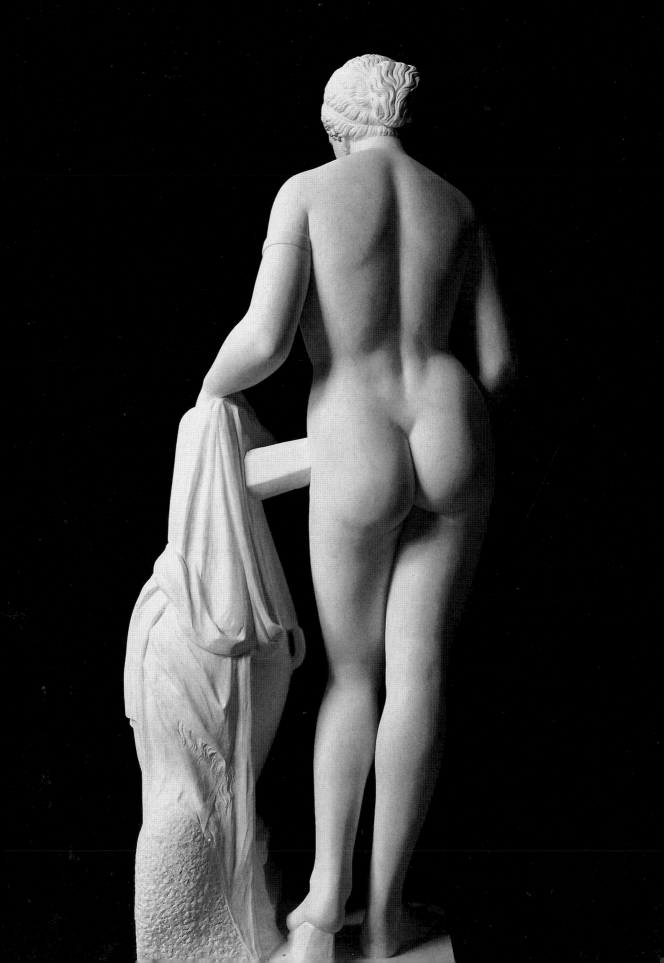

nated in the dog's mouth. Tormented by this anxiety (since he wanted reality to exist in his picture and not simply verisimilitude) he frequently wiped off the paint and changed to another brush, but . . . Finally irritated with his art because it was so obvious he dashed a sponge against the hated spot on the picture. And this sponge put back the colours which he had removed in the way that all his effort had striven for, and thus chance produced nature in the picture.

Natural History, XXXV, 10, 103

Protogenes discovered and Nealkes agreed that chance and impulse can sometimes be a greater help to an artist than the disciplined procedures inculcated by a Classical training.

'Modern' Art

Protogenes is also associated with an even more remarkable response to an unplanned situation, one in which he was matched with his great rival Apelles. Pliny tells how Apelles once went to visit Protogenes at his home in Rhodes:

Protogenes was absent at the time, but a panel of considerable size was set up on the easel and one old woman was the custodian of it. She informed him that Protogenes was out and asked by whom she should say he was being sought. 'By this person', answered Apelles, and picking up a paintbrush he drew in colour across the panel a line of the utmost fineness. When Protogenes returned the old woman showed him what had been done. They say that the artist immediately contemplated the subtlety of the line and said that it was Apelles who had come, for such a perfect piece of work could not fittingly be ascribed to anyone else. Then he himself, with another colour, drew an even finer line over the first one, and absenting himself again instructed the old woman that if the visitor returned she should show him the line and add that this was the person whom he was seeking. And this is just what occurred. For Apelles returned and, blushing with shame at the thought of being defeated, split the first two lines with a third colour, thus leaving no room for any further display of subtlety. At this Protogenes, admitting that he was defeated, flew down to the port in search of his guest.

Natural History, XXXV, 10, 81–3

More importantly, Protogenes also decided that the panel should be preserved just as it was and it eventually entered the imperial art collection where it became one of the most famous works, a blank panel marked only with three barely visible lines. Nowadays canvases looking like that are commonplace in exhibitions, but in the years just before 300 BC to treat such an object as art was remarkable indeed. The discipline and control required to make such fine lines were of course the product of an old-fashioned training, but Protogenes could never have recognised the result as art if he did not have a new readiness to accept the value of chance procedures and unintended effects. Neither Apelles nor Protogenes can have known what the result of their actions would be until the end.

In all these cases it was the artist who responded by himself to the new situation, but there must have been many circumstances in which the patron had a direct hand

in provoking an improvised response, and this phenomenon is likely to have been just as influential on artistic culture. Unfortunately we have few detailed accounts of such occasions from this period. The story of the arrival in harbour of the urn containing the remains of Demetrius Poliorcetes comes perhaps closest, but an account survives of a similar situation about one hundred years later which gives us a better idea of the sort of thing that must have happened – even if it is an extreme case. The patron concerned is admittedly a Roman, but the Romans had in many ways the same relationship to the Greeks as did the Macedonians. Like them they were 'foreign' neighbours who beat the Hellenes at their own game. Like them they suddenly found themselves masters of a culture that was not their own and treated it with a similar combination of respect and arrogance. In both cases it was a small group of generals who were exposed most directly to the tensions of the new situation. The event described in the following text may thus be distinctly Roman but the circumstances involved must have had many parallels at the time of the Macedonian conquest. The event is the games put on in the circus in Rome in 167 BC by the general L. Anicius to celebrate his part in the conquest of Greece. As a record of the eye-witness experience of a remarkable occasion it is worth giving in full:

> Having summoned the most distinguished artists of Greece and having constructed a very large stage in the circus Anicius first brought on the flute-players. These were Theodoros of Boeotia, Theopompos, Hermippos and Lysimachos, all of them most distinguished. Putting them, then, at the front of the stage with the dancers, he directed them all to play together. As they started to perform their music which was appropriate to the dance movements, he sent word that they were not playing well and ordered them instead really to fight. Since they were now rather puzzled one of the lictors indicated that they should turn and advance on each other and act as if they were in a battle. The flute-players soon caught on and taking on movements which were appropriate to their licentious characters they made a great confusion. Then, turning the middle group of dancers against those at the ends, the flute-players made unplanned [*adianoeta*] noises and each doing different things they each drew back against the others, and at the same time the dancers responded to their noises and shaking their gear, they first bore down on their opponents and then withdrew in retreat. And so one of the dancers tucked up his robe and stepping out of his place raised his fists like a boxer against the flute-player who was rushing at him. And then there was much applause and shouting from the spectators. Besides, while these two were fighting their battle, two dancers entered the dancing area with cymbals and four boxers mounted the stage accompanied by trumpeters and horn-players. So with all these people in some sort of combat the happening was indescribable [*alekton en to sumbainon*].
>
> <div align="right">Polybius, Histories, xxx, 14, quoted in
Athenaeus, The Deipnosophists, xiv, 615</div>

Anicius evidently arranged the performance with a double purpose, at once to celebrate his victory and to show off the musicians and dancers he had acquired as its fruits. Knowing the martial character of much Greek music and dance his expectation was understandable, but in the end unsatisfied. Anicius found the artistic commemoration of war inadequate and told the performers to really fight. These instructions

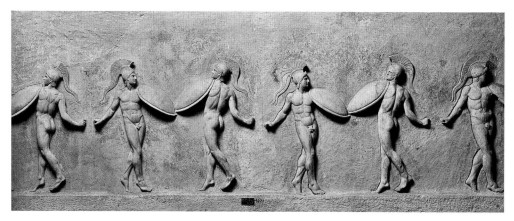

94 Warriors dancing, marble, first-century
BC copy after late fourth-century BC Attic
original.

95(*right*) Joseph Beuys in boxing match
with an art student at Documenta V.

were further elaborated by the lictor who told them that they should stage a real battle.
The performers then got the message, arranging themselves as if in individual or group
combats, with the musicians improvising unpractised or unplanned (*adianoeta*) noises
and the dancers imitating the movements of boxers. Polybius was made speechless by
the whole event and could only say that it was a 'happening' (*sumbainon*) that was inde-
scribable. It was a happening because it departed from correct procedures and devel-
oped spontaneously. It was indescribable because current language had no vocabulary
to deal with such a performance. The sounds were *adianoeta* because they were con-
trolled by no rational thought process. What happened was neither the produce of
dianoia, 'rational intention', nor analysable in terms of *logos*, 'rational thought'. The event
was thus quite alien to Greek and especially Classical Greek artistic practice and it was
indeed this practice that the artists were made to abandon. On the other hand it did
have much in common with the modern 'happening' as developed in the 1950s and
1960s, a semi-theatrical visual event in which impromptu actions involve both per-
formers and spectators in an experience of self-discovery. What the performers prob-
ably intended to evoke, a traditional military dance (fig. 94), ended up looking more
like the artist Joseph Beuys battling a critic (fig. 95). The 'happening' anticipated late
twentieth-century art in the same way as did the 'abstract' painting of Apelles and
Protogenes.

The most important aspect of the story is not the description of the performance as such, which was a one-off event, but the account of a complex relationship between Anicius, his lictors, the musicians and the dancers. In each case a transmitted wish is understood and responded to by someone further down the line of command. The wish might be communicated verbally, as probably by Anicius and the lictors, or by sound and gesture, as probably by the musicians. Each successive individual acting as part of a group tries to understand what is in the mind of the person in control and attempts to meet his expectations following his own interpretation in concert with his fellows. As a result everybody ended up doing something they had never intended to do at the beginning, their improvisation being stimulated by a ripple effect as each influenced the next rather as in a game of Chinese whispers. The dancers, who were at the end of the chain of command, were responding to a message coming down from Anicius through the lictors and the musicians, and they were doing so in their own way. The combined impact of fear of punishment and desire for reward transformed everyone's behaviour and generated a unique performance.

The two main contributory elements behind the new type of performance, the ignorance of the general concerned and the anxiety of the performers, may have been greater in this Roman example, but similar factors must have often influenced Macedonian patronage and production. Many of the new generals must have felt, as Anicius did, that Greek artists, close as they were to being able to reproduce the appearance of the human body, still failed to represent those of its qualities that were important for them. Perhaps one of the first works to reflect the new demands was the painted original of the mosaic of the *Battle of Alexander and Darius* (fig. 96), perhaps commissioned from the painter Philoxenos of Eretria by Cassander, king of Macedon around 300 BC. Unlike earlier battles with their geometrical symmetries (figs 20, 23 and 25), the Alexander mosaic captures all the physical turmoil and emotional confusion of battle, with its horses alternately collapsing and careering in and out of the

96 Battle of Alexander and Darius, mosaic from the House of the Faun, Pompei, *c.*100 BC, after an original possibly by Philoxenos of Eretria, *c.*300 BC.

97 Plan of the original setting of the
Nike of Samothrace (fig. 98), showing
the diagonal position of the prow in the
rock-filled fountain basin.

98(*facing page*) Nike alighting on the
prow of a ship, marble, from
Samothrace, probably by Pythokritos of
Rhodes, perhaps commemorating the
victory of the Rhodians over Antiochos
III in 190 BC.

scene and the frantic gestures of Darius and his fellow Persians. It is easy to imagine
how a general such as Cassander – if he was the patron – knowing what measured
perfection an artist such as Philoxenos of Eretria – if he was the painter – was liable
to produce, might have let it be known that he wanted not a disciplined commemo-
ration of the great battle, but a work that recreated all its passion and violence. The
artist has certainly made a conscious effort to reconstruct for himself the horrifying
reality of the event. The extent to which he relied on live models must remain uncer-
tain, but it is difficult to explain the vivid facial expressions and convincing poses of
both men and horses unless he made some careful studies from life.

But perhaps the closest comparison with the Anicius episode is offered by the near
contemporary Nike of Samothrace (fig. 98), which was intended as a similar celebra-
tion of a distant victory, probably a Rhodian naval triumph of around 200 BC. Again
a comparison with earlier treatments of the same subject reveals how far the sculptor
has gone in recapturing the very moment when the goddess lands on the victor's ship
(fig. 41). More than before the winged figure surges energetically forward against the
rush of wind that moulds heavy drapery around her powerful limbs and for the first
time the whole setting is recreated. Excavation at Samothrace has shown how the prow
on which the goddess alighted was placed diagonally in a pool full of flowing water,
while great rocks lying in its lower basin were threatening reminders of the perils of
any battle fought off Greek coasts (fig. 97). The Anicius story enables us to see the
vivid character of the ensemble as probably the product of an artist's sensitive response
to an impatient admiral. As he manoeuvred the boulders into place and perhaps draped
a female model in damp material he looked forward to being praised not for his craft,
but for his ability to meet his patron's demands for a convincing portrayal. The inspi-
ration behind the revolutionary character of the Nike of Samothrace, as of other impor-
tant works created in the two hundred years after Alexander, probably came from an
ignorant general, contemptuous of the rules of art.

The Patron, the Artist, the Model and the Viewer

The other new type of individual who is vital for the new art is the model. Phryne and Pankaspe are in some ways just as important for the history of culture as are Prax-iteles and Apelles. Indeed, the model is probably the unsung hero of the whole of Hel-lenistic art. Artists must have often relied on models to help them to achieve the effects desired by the new type of patron. Sometimes, as in the case of Phryne and Pankaspe, the models are likely to have had no difficulty getting into the role required of them. Whether in order to portray Aphrodite or just to be themselves, professional courte-sans such as they will have had little difficulty when asked by artists to adopt poses and expressions that encapsulated the power of love. Professional sportsmen are likely to have responded in a similar way. The boy who modelled for the bronze Jockey in Athens (fig. 99) or the bruiser who posed for the bronze Boxer in Rome (fig. 100) must have readily sensed what was required of them. Both were used to being paid to put their bodies and minds into the roles concerned.

In other cases artists must have had to spend more time first determining exactly what their patron's expectations were before working out how to satisfy them. This was perhaps most difficult when the work in prospect was a portrait of the patron and he himself the model. From the time when Lysippos became the favourite portraitist of Alexander, princes and artists must have worked together closely in the develop-

99 Jockey, bronze, *c.*100 BC.

100 Boxer, signed 'Apollonios, son of Nestor of Athens', bronze, *c.*100 BC.

101 Demosthenes, Roman marble copy after bronze original by Polyeuktos of 280 BC.

ment of the most telling image. Alexander is unlikely to have praised Lysippos for capturing the 'leonine' qualities he prided himself on unless the sculptor had realised what was needed from him (Plutarch, *De Alexandri Fortunna aut Virtute*, II, 2, 3). Artists must have got to know rulers well, both physically and psychologically. Rulers too must have acquired a new self-knowledge, when, as sitters, they struggled with the opposing desires to have their real individualities preserved and their ideal attributes celebrated.

When the portrait was of a dead or absent great man, a statesman, a poet or a philosopher, the artist may have combined information pieced together from others with his own imaginative reconstruction of what might be required before choosing some suitable person from those around him to serve as a physical model. Some such process must lie behind the creation of the original statue of the dead Demosthenes, made by Polyeuktos and erected in Athens around 280 BC (fig. 101). The energetic opponent of Alexander's father, Philip, is well portrayed in this weak body ruled by an incisive mind. The humility and frailty of the man who exhausted himself in resisting the Macedonians are apt counterpoints to the vigorous arrogance of Alexander's statues. In this as in other cases we can never know whether the body is taken from a particular individual, but as with most works of the period this seems the only possible explanation for its lifelike freshness. Whatever their subject, artists must often have had to select one or more appropriate models of the appropriate age, sex and class and then dress, pose and prepare them mentally. In the case of the Battle of Alexander or the Nike of Samothrace the task may have required little explanation. With the originals of such unusual individual figures as the playfully aggressive Boy Strangling a Goose (fig. 106), the demure Girl Sacrificing from Anzio (fig.

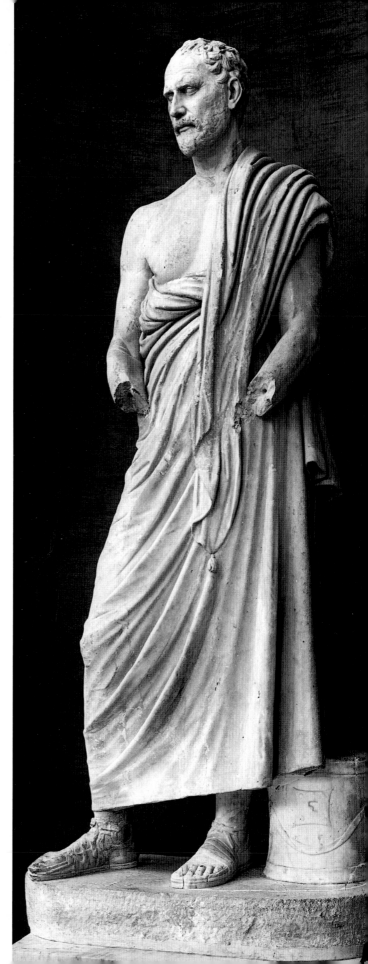

102 Sacrificing girl,
marble, c.200 BC.

102) and the debauched Barberini Faun (fig. 113), the artist, like a modern stage or cinema director, must often have gone to considerable trouble first to find a model of the correct physique and temperament and then to train them for the role. In the case of babies and animals, fruit and flowers, there was little more than selection to be done, but even this could be conceptually demanding. A mosaicist such as Sosos, who designed the Unswept Floor (fig. 103) and the Doves Drinking (fig. 104) for the pavements of the Palace at Pergamum, called on considerable powers of both observation and invention to satisfy his demanding paymasters. Unlike the artist of the sixth to fourth centuries, the Hellenistic artist could no longer rely on his ability to surpass his rivals in the execution of traditional schemata. He had rather to find a model who would best express the tastes of his patron, tastes that might be heroic or erotic, sentimental or anecdotal, or even a mixture of all these. His choice might affect the success of his art dramatically. It might also affect him personally. He might fall in love with his model as did Praxiteles and Apelles in the fourth century, or he might be eaten by it. Pliny tells the story of how Pasiteles in the early first century BC was almost killed by an escaped panther when he was down at the docks drawing a lion (*Natural History*, XXXVI, 4, 39). Whatever happened, working with a model must have affected artists' personalities since they had to work closely with and respond to beings who were very different from themselves. The artist who had to talk to rulers and babies, and touch grasshoppers and flowers, acquired an understanding of the human and the natural that became deeply embedded in his art.

The impact of this new development in the field of the visual arts must have been remarkable. Writers might watch and describe the world with ever greater attention, but they did not experience a dramatic change in the degree of their engagement with it. Painters and sculptors, who in earlier periods had mostly represented either adoles-

103 Unswept floor, mosaic, Roman copy of Pergamene original by Sosos of second century BC.

104 Doves drinking, mosaic, Roman copy after Pergamene original by Sosos of second century BC.

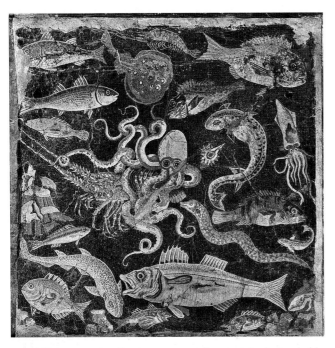

105 Fish, mosaic, Roman copy after original (probably Pergamene) of second century BC.

cent or adult Greek males who resembled themselves or adolescent or adult Greek females who resembled their sisters, wives and mothers, now found themselves having to deal with and comprehend many forms of otherness, such as slaves and prisoners, insects and plants. Patrons' demands for works of art that commemorated their wars or displayed their wealth, and did so vividly, were irresistible pressures. At the behest or suggestion of an Attalid who wanted a realistic commemoration of his victory over the Gauls or a convincing visual testimony to his dominion over the creatures of the sea (fig. 105), artists would have had to get closer to barbarians and fish than any of their ancestors, not just physically, but mentally too. This closeness they then transmitted to others. Painting's ability to freeze its subjects for lengthy contemplation, like sculpture's ability to put them within another's grasp, made the understanding of the artist available to thousands. Those who looked on Praxiteles' Cnidian Aphrodite also shared the sculptor's erotic experience (fig. 93). Some shared it so powerfully that they were even driven to embrace the statue and stain it with their lust. Those who saw Sosos' mosaic of doves on the edge of a vase shared his insights into bird behaviour (fig. 104). In a few cases we can eavesdrop on contemporary viewers, as in a *Mime* of Herondas of the later third century describing a visit by two women to the shrine of Asklepios at Kos. When one of them catches sight of some sculptures, including some by the sons of Praxiteles, who were active in the early third century, she is immediately taken by them: 'Look at that girl, dear, gazing up at that apple; wouldn't you say that she will die if she doesn't get it? And that old man, Kynno! By the Fates, that boy, how he is strangling that goose! If the stone wasn't before you, you would say the thing would speak' (Herondas, *Mime*, 4, 27–34). Later she sees a painting: 'That naked baby, if I squeeze it, Kynno, won't it leave a mark? Its flesh seems hot and throbbing on the panel' (ibid., 4, 59–62). So successfully has the sculptor captured the girl reaching for the apple and the boy strangling the goose (fig. 106) that the women react as if they too were present at the works' conception. So well has the painter interpreted the baby's pudgy flesh that the women too feel it dimple under their fingers. The art that filled the shrines and increasingly the palaces of the Hellenistic world must have constantly evoked similar reactions.

The artist's skills do not serve just to amaze the viewer with the extent of his ability to imitate life. That ability had been celebrated by viewers as long as art existed. What is distinctive is the artist's ability to make others share an emotional or physical experience. This might be either the experience had by his model, as in the case of

the girl reaching for the apple, or that had by himself, as in the case of the painting of the baby. But, as the Anicius story reminds us, the sequence of demands that led to the development of this peculiar ability often originated in a powerful patron. Although it is difficult to demonstrate the point, the intimacy with the world that was acquired and transmitted by artists at this period probably contributed to the development of one of the essential features of the make-up of Western European man. The physical pleasures of watching and touching women and babies, animals and flowers, were not discovered by Hellenistic artists, but it was they who entered them in the dictionary of culture as an available vocabulary of experience. The colours of flowers, the fragility of insects, the translucency of fish-scales and above all the softness of flesh were all established as recognised objects of sensual enjoyment as a result of the activities of Hellenistic artists. These artists were also among the first to develop and pass on the emotional sensibilities associated with that recognition. Transformed at each step, the pleasures of possession experienced by rulers were passed on by artists to ordinary viewers. Patrons made new demands on artists who then had to make new demands on their models. These models' responses

106 Boy strangling a goose, Roman copy after an original of the third or second century BC.

enabled artists to generate works of art that put new pressure on viewers, in a continuous circle that changed not just the role of art, but the response to life and the nature of human existence.

From the Viewer as Hero to the Viewer as Victim

To give more substance to this last claim we may take a look at a body of art that can perhaps be understood only in these terms. The group of works concerned has in common the theme of punishment, one traditional in Greek art. What is new, though, is that for the first time they stress the experience not of the punisher but the punished. Most can be associated with the patronage of the Attalid dynasty of Pergamum and again demonstrate the importance of patronage as a force. The most overwhelming example is the monumental frieze of the Great Altar of Zeus at Pergamum

itself. This showed in a long series of confrontations how the giants were punished by the gods for their arrogant assault on Olympus (figs 108a and b). The altar was an allusive commemoration of the victory of the Pergamene rulers over marauding Gauls. Copies survive of elements of other memorial groups set up both at Pergamum and Athens that celebrated such victories more directly including one showing a Gaul acknowledging Pergamene superiority by killing first his wife and then himself (fig. 107). These groups represented vanquished giants, Amazons and Persians, as well as Gauls themselves, but usually no victors. The only victor clearly referred to in a text is a Dionysus from the *Gigantomachy* in Athens and no copies of any such are now identifiable. All groups apparently concentrated on the fate of the defeated. Dead giants and Amazons, expiring Persians and dead and wounded Gauls all bore witness, as did the struggling giants of the Altar frieze, to the victory of the higher force over the lower.

The contrast with earlier Greek art is striking. Fifth-century reliefs always concentrate attention on the victor. Fifth-century statues all represent embodiments of excellence. The favourite subjects of reliefs, Greek Lapiths defeating half-animal Centaurs, Athenians defeating barbarian Amazons, and, above all, the brute Heracles using his strength in the service of the community by ridding Greece of monsters (figs 68 and 69), were all represented in ways that provided exemplary models for Greek males. Such portrayals encouraged both the development of physical strength and the placing of that strength at the disposal of city and nation. Statues of victorious athletes in public sanctuaries and of dead warriors in cemeteries encouraged the development of the perfect military physique and celebrated its use in socially valued contests. The Greek youth of two centuries earlier was everywhere surrounded by more perfect images of himself, all inviting him to imitate them, to make his body match theirs in physical fitness and to use it in the service of the community. Since art at that period was almost exclusively concerned with the presentation of role models for males of military age it was inconceivable that the defeated enemy should receive monumental commemoration. In the Attalid war memorials the situation was reversed. Since the defence of the state depended less on citizen soldiers, there was less of a need to present the inhabitants with military role models. Although the Pergamenes endeavoured to promote the training of young men, this was probably chiefly as a means of social control, since the Pergamene army, like that of most Hellenistic states, was largely mercenary and financed by the royal treasury. The gods and goddesses, who were the only victors certainly shown on both the Altar frieze and in the Athens dedication, could be identified most naturally not with the army but with the royal family, which constituted a similarly close-knit group of related individuals of both sexes, endowed with exceptional authority. The only figures with whom the viewer could now identify were the defeated, and everything was done to encourage this.

This is most clear on the frieze of the Great Altar because of the completeness of the evidence. Anyone approaching the altar and walking round the steps at the base found not only that the giants were his closest companions but that he shared with them the experience of looking up at the divine forces of law and order (figs 108a and b). In this situation it was inevitable that the giants' suffering touched him directly. Decisive in determining the viewer's relation to the battle is the placing of Ge, mother

107 Gaul committing suicide having killed his wife, Roman marble copy after Pergamene original of *c*.200 BC.

of the gods' enemies, the giants, next to Athena and close to the point at which the axis of approach impinged on the frieze (fig. 115). Not only is she the only figure in the scene who is also only a spectator, but shown as she is emerging at half-length from the base moulding her position corresponds closely to the viewer's own. We share her maternal distress and, looking up, join in her prayer to Athena to spare the life of Alcyoneus her beloved son. If this were not enough, normal psychological reaction would make us sense and share the vulnerability of a figure such as the pitifully naked Alcyoneus, his hair gripped by the ruthless goddess as he is bitten savagely in the breast by her snake. The sufferings of the punished, their arms twisted, their legs trodden on and their heads crushed, would everywhere have involved the viewer's body in an involuntary psychological identification with the giants, however much his mind would have preferred an alliance with the gods. The same response would inevitably have been evoked by the war memorials. We have Pliny's testimony for the affective power of Epigonos' 'trumpeter and his infant pitiably caressing its slaughtered mother' (*Natural History*, XXXIV, 19, 88), which formed part of one of these groups. We share those feelings ourselves when we look at the copy of the noble composition of a Gaul killing himself as he supports his dead wife (fig. 107). For the first time in the history of art the viewer is made to identify not with the noble heroes who fought on his behalf, but with his enemies and inferiors.

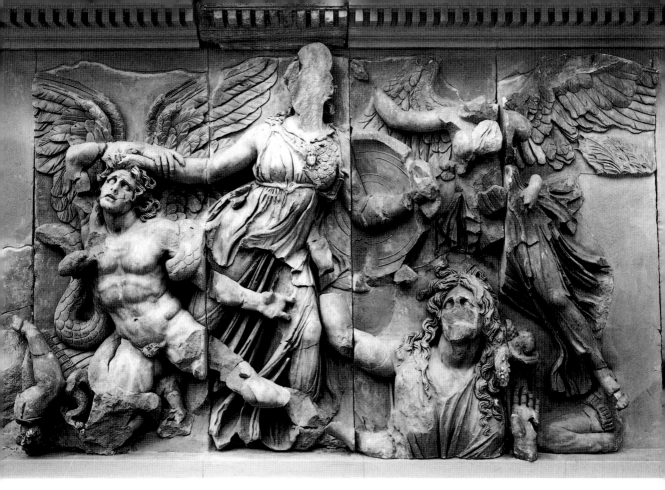

108a and b (*above*) Zeus and Athena
in conflict with giants, detail of the
large frieze of the Zeus Altar from
Pergamum.

109 Face of a biting giant, detail of
the large frieze of the Zeus Altar
from Pergamum.

110 Marsyas, Roman marble copy after Pergamene original of *c*.200 BC.

The viewer's identification with the relief figures of the Zeus altar relies on the same basic responses as did the identification of earlier viewers with the statues and reliefs of the sixth, fifth and fourth centuries, but to very different effect. Earlier sculptors laboured to produce figures with bodies whose similarity to those aspired to by prospective viewers was liable to provoke an emulation beneficial to society. The sculptors of the great frieze treated the gods' opponents in such a way that viewers could hardly escape an assimilation that suggested that they shared their shame. The shift is a consequence of a change in historical circumstances and a change in patronage. Earlier sculptors had in common with other members of their society an anxiety about the ability of their city to defend itself, and readily responded to such anxiety in works usually executed under communal patronage. The sculptors of the Great Altar were paid by the kings of Pergamum to make a monument that would confirm their quasi-divine authority and increase the moral and social distance between them and those they governed. The position of the Attalids, who ruled a mixed community with no sanction but that of wealth and military power, could be strengthened only by such implicit humiliation of their subjects.

Their artistic policy was influenced by the same factors that shaped their philosophical preferences and in the Great Altar both find expression. The Attalids had a particular interest in Stoicism and it has been well argued that the organisation of the altar's frieze reproduces their cosmology and its theme their ethics. It was the Stoic Cleanthes who in a celebrated *Hymn to Zeus* offered the divine punishment of the giants as a lesson in moral education, and the theme was subsequently taken up by Crates, honoured guest of the altar's patron, Eumenes II. Crates was also the teacher of

111 Scythian slave, Roman marble copy after Pergamene original of *c.*200 BC.

the greatest Stoic moralist, Panaetius, who was in turn the teacher of Posidonius. And it was Posidonius who observed that man is by nature torn by conflict between the 'godlike' and the 'animal-like'. The Stoic recognition of a dangerous 'animal' element in man touched a chord that could be readily exploited by the Attalids. The animal attributes of many of the giants on the altar frieze reminded the ordinary viewer of his sub-human weaknesses even as the analogy between the roles of gods and rulers confirmed the divine superiority of the royal dynasty (fig. 109).

Several other works can be grouped with the frieze as probable Attalid commissions with a similar theme. One is a group of Apollo and Marsyas, of which a fragmentary version has been found at Pergamum (figs 110 and 111). The event represented was

112a and b (*following pages*) Elderly centaur tortured by Eros, and detail, Roman marble copy after Pergamene original, *c.*200 BC.

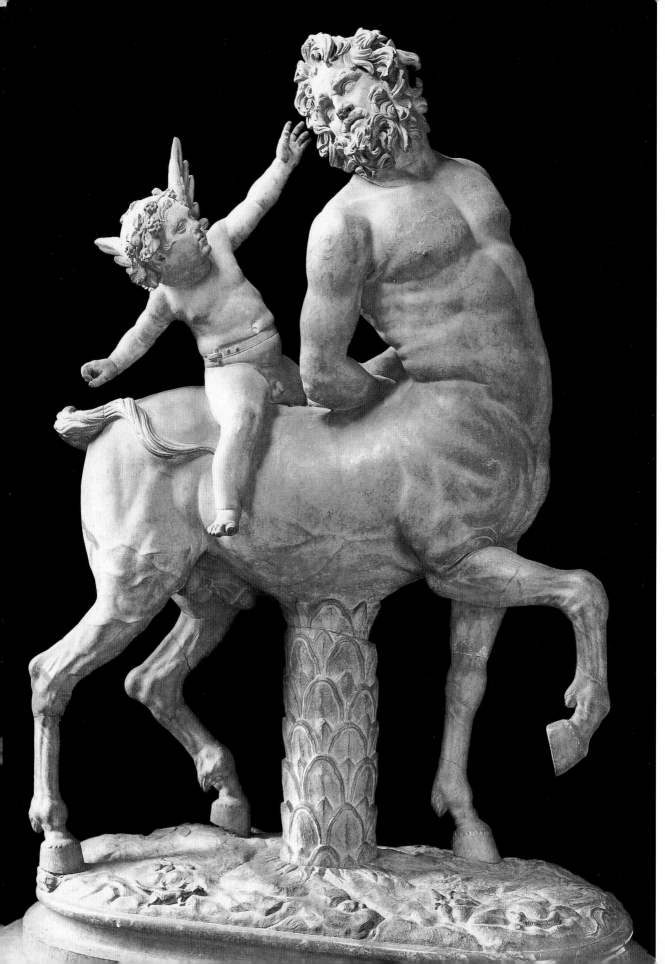

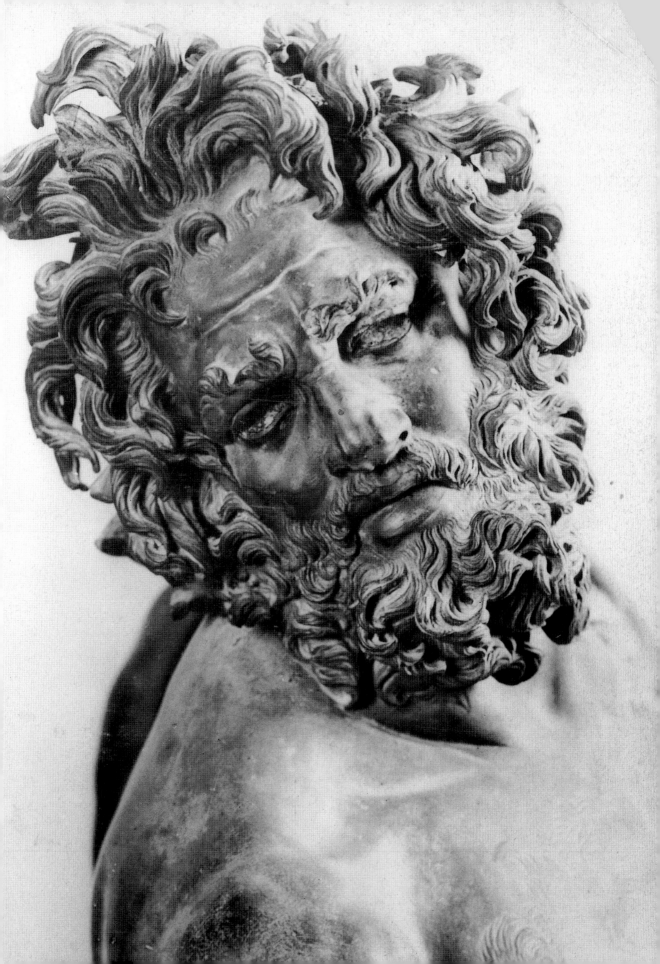

the preparation for the flaying of the half-animal Marsyas as punishment for his performance in a music competition in which he pitted the bestial sound of his own face-deforming pan-pipes against Apollo's articulate song with lyre accompaniment. Surviving copies of the group show that Marsyas was represented hung like wild game from a tree, his goatlike face twisted with pain and fear as he watches a grinning Scythian slave sharpening a butcher's knife (fig. 111). Not only is the theme of animal impulse subdued by divine authority similar to that of the frieze but the face of the Marsyas bears a clear resemblance to the face of a Dead Giant from one of the Gaul monuments. Another group known from Roman versions which recalls known Pergamene monuments consisted of a pair of Centaurs, both ridden by little Eros figures, the one young and happy, the other old and distressed, with his hands bound behind him (figs 112a and b). The notoriously impulsive Centaurs, their human upper half carried away by the physical passions of their lower, animal, limbs, well illustrate the penalty for the loss of Stoic control. Brutal punishment of the surrender to passion is also shown in the so-called Farnese Bull, which documents the savage death sentence administered to Dirce by twin brothers as recompense for her jealous torture of their mother. This subject was certainly portrayed in the shrine that a later pair of brothers, the Pergamene rulers Eumenes II and Attalus II, erected at Cyzicus in honour of their mother. Less brutal, though no less clear in its message, is the magnificent Barberini Faun, a lethargic figure in Pergamene marble who now reclines incongruously, partially restored, in the sculpture collection in Munich (fig. 113). Everything about the sagging body and bestial face suggests exhaustion after excessive indulgence. The organs below the diaphragm attract the most attention, from the nervous and undisciplined musculature of the abdomen to the wantonly displayed genitals. We know nothing of the original placing of the statue (whether the sculpture is an original or an early copy of a bronze), but if, for instance, it was displayed in or near one of the gymnasia that the Attalids fostered as a setting for the exercise of the city's youth we can easily imagine the effect it might have had on body-conscious males. The Faun embodies the antithesis of the erect and disciplined alertness that Greek athletic exercise was designed to produce. Reminded of the ambiguous energies of their own pulsating flesh and of the temptations with which they were surrounded, the adolescent viewers of such a statue may well have been shamed into using the palaestra. Like the other sculptures reviewed here it achieves its effect by first enticing the viewer into a sympathetic identification and then alerting him to the dangerous consequences should identification become assimilation.

A final sculpture, which shares important features with several of the works just discussed, is the marble group representing the Trojan priest Laocoön, flanked by his two sons, dying in the coils of a giant serpent (fig. 114a). The principal figure's pose, with its splayed legs and animated belly, recalls that of the Barberini Faun. The contorted face, with its matted hair and sensuous lips, resembles those of the Marsyas, Dead Giant and Elderly Centaur (fig. 114b). Most tellingly, face, body and pose are almost identical to Alcyoneus, Athena's victim on the Great Altar frieze (fig. 108). The similarities to these works make it virtually impossible that the original group, from which the sculpture of the first century AD now in the Vatican derives, had as its theme the story, recorded in Virgil's *Aeneid*, of the Trojan priest's undeserved martyrdom for trying to warn his countrymen about the dangers of the Wooden Horse. His contorted face and

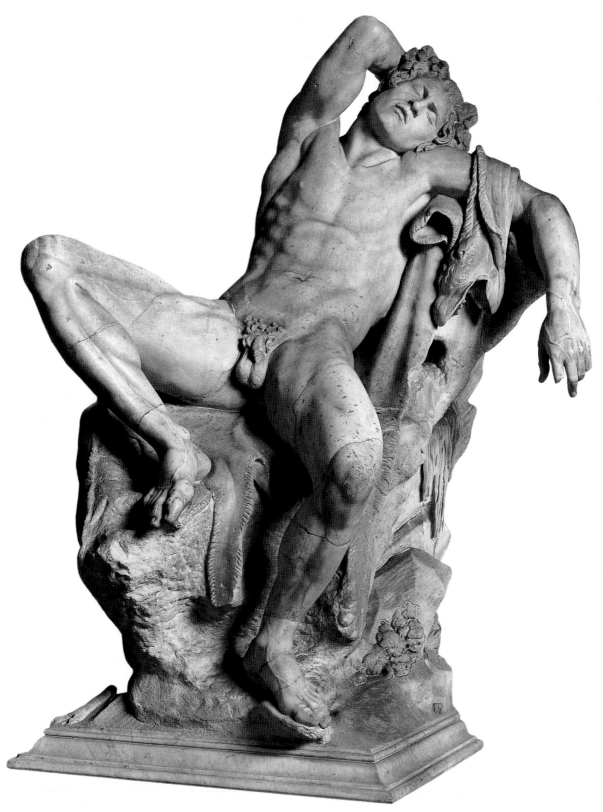

113 Barberini Faun, marble, probably early second-century BC Pergamene original.

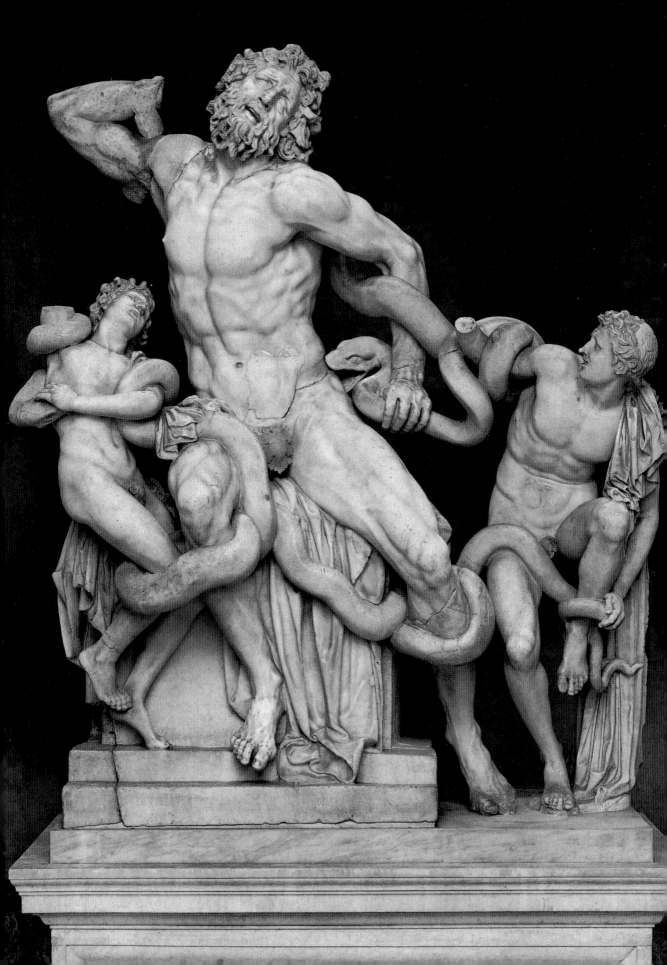

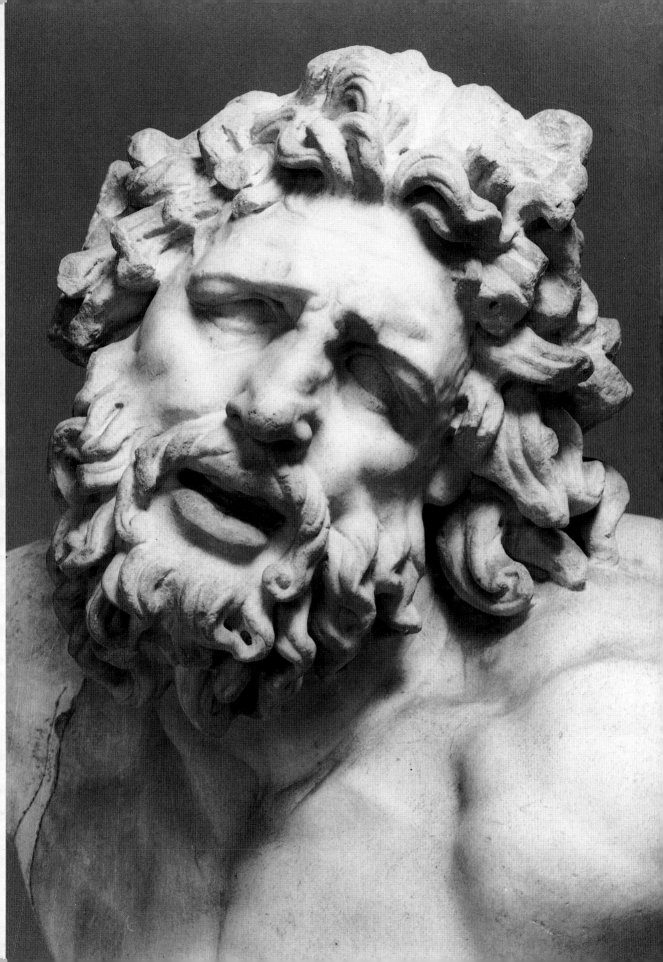

shameless pose suggest rather that he, like the other suffering figures, is being punished for a surrender to animal inclinations. Sophocles lost tragedy, *Laocoön*, had an appropriate story, known also from Hyginus and others. According to this it was lust and sacrilege, not love of his country, that brought his undoing. Laocoön was punished because he broke his priestly vows, married, and, according to Euphorion, even had intercourse with his wife in the god's own sanctuary. Such a theme is closely parallel to those of the other works. Besides which, Laocoön's Trojan race made him not only a personification of the non-Greek, but, since Pergamum was not far from the site of Troy, a close relative of the native population at whom all these sculptures were probably directed. The Trojan's combination of sacrilege and sin would have offered a later inhabitant of north-west Asia Minor a particularly powerful lesson in morality. We know nothing of where such a group might have been erected, but it is possible to come close to a dating of the three-figure group and to an understanding of its siting. The similarities between Laocoön and Athena's opponent on the frieze are well known, but the connection between frieze and group is likely to have been even more direct. After the latest restoration of Laocoön's right hand the correspondence between the poses of the two figures is very close and the role of the aggressive serpent very similar. The two figures are also of virtually identical size. There is even a remarkable parallel in both role and position between Laocoön's son and the giant's mother, both of whom are relatives who from a lower position on the right look up and raise their hands in a gesture of horror or imprecation. Also, the adjoining giant, Zeus' principal opponent, whom we see from the back, has a strong resemblance to the *Laocoön* when seen from the same position. These correspondences are so particular that one composition must be adapted from the other and the probability must be that, as so often, the larger composition incorporates a reference to a famous earlier work. Since the axis of movement of the visitor bisected the frieze exactly between the front and back views of the Laocoön-like giants, an allusion to a famous lesson in morality would have immediately forced the viewer to engage with its powerful message (fig. 115). The correspondence confirms the widely held opinion that the group derives from one originally created in Pergamum and indicates that it was invented slightly before the frieze. It also suggests that the group was prominently displayed somewhere where it could be seen from both sides, and perhaps placed completely free-standing, like the statues on the round base in the Athena sanctuary. Finally, it makes it virtually certain that the *Laocoön* was always a three-figure group and that the right-hand son's role was always critical in involving the spectator in a shared experience of horrified sympathy.

The main reason why the present group, dating from the Roman period, has confused viewers for centuries is that it almost certainly represents an extraordinary example of a scene of punishment for vice being adapted as a celebration of heroic virtue. The Roman patron who commissioned a version of the sculpture would have wanted it to portray Laocoön as victim not of his animal instincts but of a Greek god's hatred of Troy. For a Roman, a Trojan was a noble ancestor rather than an inferior alien and this is why the sculptor, who has in general exactly transposed the group, has infused the otherwise bestial face with what to an earlier Greek could only have been an incongruous nobility of sentiment (fig. 114b). Such a Greek would have recognised in the central figure a marble man, an exemplary victim of divine retribution with whom he could not have avoided identifying, but he would have found the incon-

114a and b (*previous pages*) *Laocoön and his Sons*, first-century AD copy after early second-century BC Pergamene original.

sistency between pose and expression highly confusing. Even such Hellenised Asiatics as the Pergamenes could never have accepted it. The same contrast would not have bothered a Roman, who, like us, would have seen the group much more objectively as a Greek composition adapted to commemorate an event of importance to his own culture. The Laocoön allows us to measure the dramatic increase in the distance between sculpture and viewer that followed the victory of Rome over Greece.

For a Pergamene, who still, like earlier mainland Greeks, feared barbarian attacks and who went to the gymnasium to improve his body and mind, the original sculpture's message would have been obvious and disturbing. The essential difference between him and his predecessors was that, having had the opportunity to cultivate new emotional sensibilities and to explore new psychological complexities, he no longer felt the same robust confidence in his body as a military machine. It was to someone in this state of ambiguous awareness, as conscious of his vital juices as of his armoury of muscles, that the great frieze and the originals of the *Laocoön* and the other groups were directed. The artists who created these works were heirs both to the earlier sculptors who had developed robust paradigms of physical service to society and to the later ones who, while working with individual live models, had discovered their own sensuality. Successive generations had acquired ambivalent attitudes to the human body. Sharing these attitudes the sculptors of Pergamum were well able to exploit them.

Man Caught in His Own Net

The artists of the Altar frieze were able to concentrate the attention of the viewer because they related its arrangement directly to the arriving visitor. Standing in the oblique entrance propylon, the viewer's line of sight fell exactly between the opponents of Zeus and Athena. At the same time he also found himself aligned with the perpendicular bisector of the whole monument. Held at the intersection of two imaginary lines the viewer was the subject of a new degree of control (fig. 115). He was also passively incorporated into the wider geometry of the site, since the Altar was laid out at right angles to the Temple of Athena. Unlike the other buildings at Pergamum, the two monuments dedicated to Zeus and Athena were alone in relating to a common linear grid just as the same two deities alone occupied a symmetrical position on the frieze. In both cases it was from them that order emanated. An additional cleverness of this arrangement was that they, being male and female members of a single dynasty on Olympus, conveniently recalled the male and female members of the Pergamene royal family who, as the principal patrons of the two buildings, were responsible for the overall plan of the acropolis. It was the Attalids who ultimately generated the network of lines in which the visitor was caught.

The linear geometry imposed on the acropolis of Pergamum was only a visible manifestation of a deeper intellectual order associated with royal patronage. In the great library attached to the Athena precinct scholars catalogued the variety of Greek literature and one of them, Crates, documented in his writings the 'anomalies' or deviations from regularity of Greek grammar. For all this intellectual patronage, however, the Attalids modelled themselves on their rivals, the Ptolemies, whose capital was Alexandria, the largest regularly planned city of the period (fig. 88). Ptolemy I (367–282

115 Altar of Zeus,
Pergamum, plan showing
axial lines: a and b indicate
respective positions of
Athena and Zeus on the
large frieze (see figs 108a
and b).

BC) was the first ruler to foster literary and scientific scholarship. The Greeks were probably always impressed by the scale of Egyptian temples as institutions and by the importance the priests had as guardians of a sacred knowledge, often preserved in papyrus rolls. By setting up a library and a well staffed institution, called for the first time a 'Museum' or 'Shrine of the Muses', Ptolemy could both rival the Egyptian pharaoh and create and control knowledge. In doing so he could in a sense catch his subjects – and indeed everybody – in a web of his own knowing. A principal beneficiary of Ptolemy's patronage was Euclid around 300 BC, who brought together much earlier thought on mathematics and formulated the clearest rules on the mathematical basis of experience. His *Elements*, dealing with plane and solid geometry, which became the standard work on the subject for nearly two thousand years, provided for the first time a system for the conceptualisation of surfaces and volumes. Other works, the *Optics* and *Catoptrics* (*On Mirrors*), both of which dealt with perspective or the science of seeing, provided similar systems for the geometric conceptualisation of optical experience and in doing so formed the immediate background for the exploitation of visual geometry by the Attalids. Euclid's lost *Elements of Music* must have provided an account of the mathematical basis of the aural experience of musical sound. There were many ways in which the new mathematical systems of conceptualisation contributed to the reshaping of experience in the Hellenistic world.

Sometimes the reshaping was reciprocal, with new visual experiences provoking new theoretical systems. Some aspects of the account of perspective in Euclid's *Optics*, for example, are likely to have been suggested to him by the increasing numbers of interior spaces. His propositions that 'The further parts of planes below the eye appear higher. The further parts of planes above the eye appear lower. Of those things that extend forwards, those on the right bend to the left and those on the left to the right' (*Optics*, Theorems, 10–12) sound less like a purely theoretical formulation than the account of the viewer's response to a particular type of interior space such as that of a stoa. Someone looking along the outer walk of a double stoa might indeed see it in terms of planes above and below (the continuous floor and ceiling) and lines along the sides (the mouldings on column bases and entablatures). This is exactly the effect that has been reconstructed through drawings of the Stoa of Priene and (fig. 116) and the rebuilding of the slightly later Stoa of Attalus at Athens. The impact of such a view down a long portico was, indeed, such that it was later regularly used to illustrate perspective theory, as in Lucretius (*De Rerum Natura*, IV, 429). Once such a principle had been formulated on the basis of the visual experience of architecture it could be re-

116 Stoa, Priene, second century BC, reconstruction of interior.

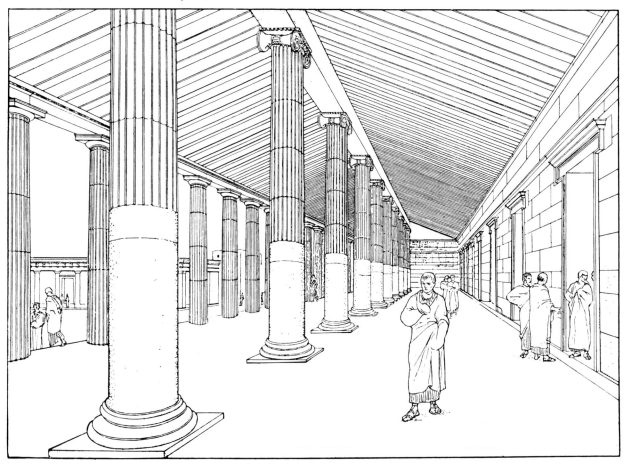

118(*facing page*) Pharos
of Alexandria *c.*270 BC,
reconstruction.

117a Agora arch,
Priene, mid-second
century BC,
reconstruction.

117b Agora, Priene,
second century BC, plan
showing the visual axis
from the agora arch and
the symmetry about it.

applied to the same field, leading to a new exploitation of effects of bi-lateral sym-
metry, as in the Agora at Priene (figs 117a and b) and the colonnades of Magnesia.
It could also have influenced painters and may have prepared the way for the sym-
metrical architectural compositions familiar from so-called Second Style Roman wall
decorations (fig. 182). Since many features of such paintings recall the Hellenistic archi-
tecture of Egypt it is quite possible that they reflect a mural tradition fostered by
Euclid's residence in Alexandria and represented perhaps in the royal palace itself, of
which no trace remains.

 It was certainly the Ptolemies who first began the process by which rulers exploited
such knowledge of geometry to dominate, or get at, others. Already under the first
of the dynasty optical experiments may have influenced the design of the lighthouse,
440 feet high, constructed on the island of Pharos at the entrance to the harbour of
Alexandria (fig. 118). The architect of this tower seems to have designed its different

stages to take account of an optical phenomenon recorded in the *Problems*, once attrib-
uted to Aristotle but now recognised to derive from his school. At *Problems* 15, 6, 4 it
is claimed that our experience of looking at a square object changes with increasing
distance. Thus, as we move farther away a square becomes first polygonal and finally
circular. Taking his cue from this supposed principle the designer of the lighthouse
made the stages successively square, polygonal and circular, as if acknowledging the
decline in visual acuity with distance. He seems to have said to himself that, since the
square can be seen only from close up, it can best be used at the bottom; since at a
certain distance, squares are seen as polygons the middle storey might just as well be
so shaped; and, since at a further distance even polygons become circles, he might just
as well use that shape for the building's crown. He may indeed have felt that by chang-
ing the tower's square section, as it rose, in harmony with optical theory he would
have increased the impression of its elevation. However we interpret it, the variation

119 Map of the known world according to Eratosthenes, reconstruction.

of the three stages, like the structure's height, which was required to mitigate the adverse impact on visibility caused by the curvature of the earth, took account of changes in visual perception over distance. The building's architect thus exploited a complex geometry to relate a solid object to a prospective viewer. By harmonising the design of the Pharos with contemporary theories of visual experience its designer may be thought of as setting up an experiment in which the king virtually compels approaching sailors to prove a geometrical theorem. Anyone who approached the Pharos was held in a cage of lines long before they had entered the city's grid plan. Later in the third century the astronomer and mathematician Eratosthenes, also working at Alexandria, was to use mathematics to make improved calculations on the diameter of the globe and to construct a map with an axis of longitude running through Alexandria, crossed by an axis of latitude at the level of Rhodes (fig. 119). By doing so he effectively extended the city's grid to cover the whole world and carried the domain of Ptolemaic science far beyond the boundaries of their kingdom.

A work that combines elements of the Pharos and the world map is the Horologium at Athens, perhaps ·financed by Pompey, a Roman heir to the Hellenistic monarchs, in the mid-first century BC (fig. 120). Designed by the astronomer Andronikos of Kirrha, it was built as a tower in the heart of a city that was then reviving as a centre of both trade and education. Each of its eight sides was carved with a relief showing the wind that blew from that direction. On top a triton-weathervane turned to point a rod at the appropriate figure. Inside a waterclock measured the hours. Through this elegant and informative structure Athens reclaimed from Alexandria her position as the hub of Greek culture.

Hellenistic rulers were able to capitalise on the controlling power of science, and especially of mathematics, only because the associated development of technology ensured that science had an impact on the material world. This can be illustrated from a study of the parallel between the refinement of catoptrics and improvements in mirror technology. Ancient mirrors were made of metal and the new wealth of Alexander's

120 Horologium of Andronikos of Kirrha, Athens, mid-first century BC.

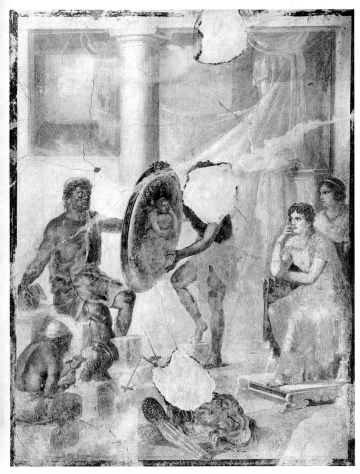

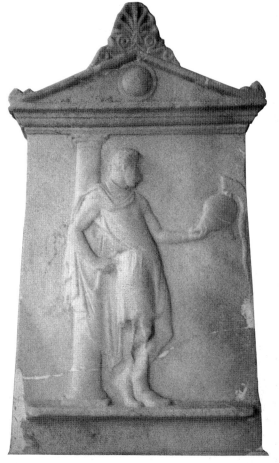

122 Thetis and the armour for Achilles, painting from Pompeii, Roman copy after a Hellenistic original perhaps by Theon of Samos of *c.*300 BC.

123 Warrior, funerary relief from Rhodes, marble, second century BC.

successors made possible larger and more shiny metal surfaces of all shapes, concave and convex, as well as flat. One consequence of the improvement in mirror production was their possible application for military purposes. This may have been appreciated already by Archimedes in late third-century Syracuse, although the story that he actually used huge concave mirrors to capture and concentrate the incendiary power of the sun's rays so that they could be redirected at the Roman navy is likely to be apocryphal. Another consequence was the recognition of various optical phenomena such as the reduction, enlargement and reversal of reflected images. Yet another, which followed from the last, is that for the first time people could easily be confronted by large images of themselves, so gaining a new level of self-awareness. The individual who now contemplated his changing reflection in mirrors of different profiles saw himself not only as an objective other but also as a victim of the laws of physics. The impact of these changes is documented in surviving copies of paintings from around 300 BC. Most poignant is the image of the fallen soldier in the Battle of Alexander and Darius,

121 Fallen warrior gazing at his reflection, detail from the Battle of Alexander and Darius (fig. 96), mosaic from the House of the Faun, Pompeii.

who gazes at his image reflected in a shield with all the impotent fascination of one witnessing his own destruction (fig. 121). What he sees, his frightened face reduced in size and the royal lion overturned, is an epitome of both the immediate reality and the ultimate significance of the event. Equally expressive is the reflection that confronts Thetis in a Pompeian copy of a painting probably made around the same date by Theon of Samos. As she inspects the arms that Hephaestus has forged in a vain attempt to provide a bulwark between her son Achilles and his fate, she finds in the shield, not reassurance, but an inescapable mimic of her sad self (fig. 122). There the divinity sits, mockingly diminished and reversed by laws of science that are as implacable as those of destiny. The triumphant emergence of scientific catoptric perspective finds its fulfilment in the expression of the knowledge of failure. A similarly pathetic self-awareness also seems to be implicit in a haunting tomb relief from second-century Rhodes (fig. 123). On it a warrior stands defenceless in his flimsy tunic gazing at his helmet which he holds with its empty face towards him. He may be remembering only his past life, like his predecessors in a similar position on fifth-century vases, but, given the new focus of his gaze, he may, like Thetis, also be looking at his own reflection in the polished bronze. If so the suggestion of soliloquy brings a first Hamlet to the European stage. In images such as these Hellenistic artists revealed the extent to which scientific knowledge gives power with one hand, only to take it away with the other.

For two centuries after 300 BC the net of science, which scholars were drawing ever tighter around the citizens of the Hellenistic world, was increasingly rendered visible by artists and architects. People, whose flesh was already becoming soft and vulnerable under the sculptor's chisel, found themselves enmeshed in painters' perspectives and planners' grids. Life in the Hellenistic world was associated with many of the pains that in later European culture were to become the inevitable accompaniments of 'progress'.

Paradigms Packaged: Education and the Copy

The Greeks' painful pleasure of living as soft and strong creatures, reflected in art and caught in a cage of science, was brought to an end by the victory of Rome. Their defeat, which began in Sicily in the late third century BC and was complete in the Greek mainland by the mid-second, removed the need both for science as an instrument of control and for bodily awareness as an instrument of education. The external force of a Roman bureaucracy, backed by a Roman army, soon replaced the instruments of internal formation on which the Greeks had relied for centuries. Mathematics, philosophy and science were no longer required to shape and hold citizens whose life was framed by Roman government. Once the threat of local conflict was removed by defeat, and a distant power was able to pay a professional army to guarantee stability, communities no longer needed to commission art that celebrated paradigmatic virtues. Nor, when individual dissent was rendered irrelevant by the establishment of a transcendent authority outside the community, was there any point in an art that reminded of paradigmatic weaknesses. Never again would art, and especially life-size sculpture, serve so vitally as mirror and model, as it did in Classical Greece, or as mirror and warning, as it did in the Hellenistic world. Art as an instru-

ment of informal communal education was redundant; so too was formal communal education in a rigid Greek mode. The resultant transformation of the roles of both art and education settled the direction of culture not just for the Roman Empire, but for the whole future of Europe.

With the passing of the anxieties that brought them into existence, the tension went out of both art and education. During the last century of the Roman Republic and the first century of Empire gymnasia such as those where the youth of Pergamum had stretched their minds and bodies became the appendages of bathing establishments, better adapted to relaxation (fig. 160). At the same time sculptures such as those commissioned by the Attalids to shame and inspire their subjects were adapted as ornaments of the villas of wealthy Romans, whose bodies were sources neither of pride nor embarrassment. Cicero in the *In Verrem* vividly sums up the difference in the status of art in the Greek and Roman worlds in the 60s BC. Working hard to convince a Roman jury that Verres' plunder of works of art from the Greek cities of Sicily is a really serious matter, he stresses that 'the Greeks are upset by – and have been upset by – nothing as much as this stripping of their shrines . . . Indeed it is amazing how much the Greeks delight in these things which we despise' (Cicero, *In Verrem*, II, 4, 59, 132 and 133). Cicero's difficulty in communicating an understanding of the Greek relation to their art is evident, but in one case he brilliantly transmits the power of art actually to get inside them. While in most cities Verres has little physical opposition, in Agrigento, in an assault on the Temple of Heracles, his henchmen meet their match when they are driven off by the citizens. The implicit sense of identity between the Agrigentines and their hero was acknowledged in a local joke, based on a pun on the governor's name (Lat. *verres*, male pig), that 'among the labours of Heracles this huge swine deserved as much a place as the Erymanthian boar' (*In Verrem*, II, 4, 43). In the defence of Heracles' statue the Agrigentines virtually took on the figure's properties. Implicitly, other cities, which lacked such an effective image with which to empathise, were more easily robbed of their treasures. Without explicating the psychology involved, Cicero is eloquent on the damage to the self-image of the Greek cities who lost sculptures and paintings to the predatory governor.

Cicero is no less effective in transmitting the relatively superficial engagement with art of the typical, and even of the exceptionally educated, Roman. This he does best in the correspondence relating to the decoration of his own villas. In one letter he casually asks his friend Atticus (so named from his long residence in Athens) to let him know if he comes across any 'statues of a "nude" type' (*Ad Atticum*, I, 6, 2). In another, after noting the purchase of 'Megarian bronzes' and telling how he is enjoying the 'Pentelic herms with bronze heads', he asks for

> as many more as possible and as soon as possible of those statues and other decorations which are appropriate to that place, to my interests and to your taste, especially those which fit a gymnasium and a xystus, or promenade
>
> *Ad Atticum*, I, 8, 2

Elsewhere we learn more of his interests when he identifies what are probably individual herm figures, a series of 'Hermheracles' (*Ad Atticum*, I, 10, 30) and a 'Hermathena' (*Ad Atticum*, I, 4, 3 and I, 1, 5). All of these are considered appropriate both to the relevant spaces and to Cicero's character, in contrast to a statue of Mars or those of

124 Female figures, bronze, first-century BC adaptations of fifth-century BC Attic originals.

125 (*facing page*) Bronze head inserted in marble herm, modern copy after first-century BC original in the reconstruction of the Villa dei Papiri, J.P. Getty Museum, Malibu.

four female devotees of Bacchus, none of which would be appropriate, as he insists to another 'refined' correspondent who is acting on his behalf (*Ad Familiares*, VII, 23, 2). When talking of art his tone is always light-hearted, as especially in a letter to his brother in which he describes the way a gardener has draped ivy on a colonnade, 'so that those figures in Greek dress appear to be cutting the trees into shape and to be selling the ivy' (*Ad Quintum Fratrem*, III, 1, 5). The figures referred to were almost certainly multiple adaptations of some highly serious Classical work, like many that have been found at Pompeii and Herculaneum (fig. 124). Cicero is not indifferent to art, indeed he writes about it with enthusiasm, but the enthusiasm is more that of someone in a restaurant than a shrine. For him art is evocative decoration intended at once to enhance the character of an environment, to reflect the preference of its owner and to illustrate the taste of his agent. Art is a passive index of someone's attributes rather than an active instrument for their development. Cicero does have a physical rapport with his sculptures. It is a desire to possess them as objects, not unlike that which ruled Verres. He shows no sign of sharing with the Greeks an unconscious responsiveness to their power to colonise him.

What a collection made on such principles might have looked like we can learn from the contemporary Villa dei Papiri, miraculously preserved under the volcanic mud of Herculaneum. Besides the library of papyrus manuscripts that give the villa its name, the luxurious complex housed a large collection of sculpture, prominent among which was a large series of marble herms with different bronze heads, probably closely parallel to Cicero's Hermathena and Hermheracles (fig. 125). In the majority of cases the heads consisted of casts from original bronzes of two or three centuries earlier, most of them of early Hellenistic rulers. Whether or not the villa belonged, as has been suggested, to Cicero's enemy, L. Calpurnius Piso, the owner obtained his art from the same Athenian sources as the great orator. Like Cicero he was happy to build a collection of heads that were conspicuously removed from their bodies, which were essential to the Greek idea of both man and art. Moreover, while the rectangular herm supports may suggest the generically *tetragonos* or *quadratus* character attributed to exemplary Greeks from Simonides to Plato, the difference of material between head and body is not compatible with an explicit assimilation between herm and torso. For the Roman collector of the late Republic, such sculptures were trophies, mementoes and emblems.

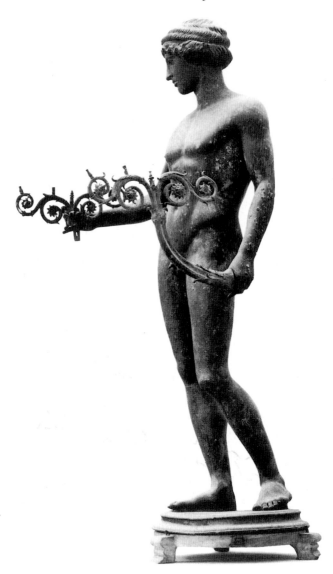

126 Lampbearer combining
the head type of an early fifth-
century girl with a male body
of similar date, bronze, first
century AD.

They lacked everything that gave Greek sculpture, whether of the Classical or Hel-
lenistic periods, its body-engaging power. This was why Romans found it easy to com-
mission or purchase such objects as the lampbearer from Pompeii, a bronze figure
combining a copy of a noble early fifth-century male body with a copy of a female
head of similar date, the whole adapted as an attractive and useful furnishing (fig. 126).
This was also why the Romans could call statues, not *eikones*, derived from *eiko* 'I am
like', or *andriantes*, derived from *aner*, 'man', as the Greeks did, but *signa*, 'signs'. For a
Roman, who could acquire portraits of half the rulers of the Hellenistic world by
sending off a letter to a friend and arranging for shipping and payment, physical power
was irrelevant, whether in a statue or in himself. The heroes of Greece could be dis-
membered and their limbs inscribed with signatures, as if they were as much products
as were amphorae or bricks.

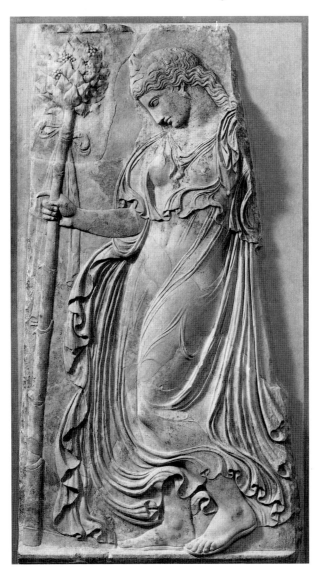

127 Maenad, first-century BC
pentelic marble copy of fifth-
century BC original, perhaps by
Kallimachos.

Athens, the Capital of Packaging

It was to friends in Athens that Cicero wrote, and Attica was the source of the Pen-
telic marble both of his herms and of those from the Villa dei Papiri. Athens, where
Greek art had been endowed with the greatest potency, was the centre of the new art
trade and of the production of the decorative replicas and adaptations necessary to
satisfy it. The trade was carried on by ship, and several wrecks of vessels that were
dragged to the bottom by their freight of bronze and marble have been exposed during
the last hundred years. In these the occasional earlier masterpieces are mixed with more
recent adaptations and copies as well as a wealth of ornamental furniture and fittings.
The most evocative selection is that from the wreck at Mahdia off the coast of Tunisia.
A number of the marbles in that cargo derive from earlier Athenian models and must

themselves be Attic in origin. Many other similar objects have also been excavated in Italy and when these bear signatures the sculptors almost all boast of being 'Athenian'. The Athenian provenance was a significant mark of excellence. It evoked the fifth century when the peak of the city's power was associated with the most intense exploitation of art and many of the copies and adaptations derived from originals of that period. It was not, however, so much the city's physical power that Roman patrons wanted to possess, as its refinement, and this is why the major works, such as the Parthenon pediments (fig. 71), were neglected in favour of delicate reliefs such as those from the Nike balustrade (fig. 42) and even more trivial subjects such as Dionysiac dancers, who were often engraved on Pentelic marble slabs or even ornamental vases (fig. 127). All tend to embody precisely the 'elegance' that Cicero's expatriate friend nicknamed 'Atticus' understood and represented so well.

We can appreciate the essence of Attic elegance best from one of Cicero's late literary works, the dialogue *Brutus*, in which the author is joined by Atticus and Brutus for a discussion on oratory underneath a statue of Plato, who best exemplified the clear Attic mind. An important section (chapters 7–13) celebrates the excellence of Attic oratory from Pericles to Demosthenes, before it was first degraded in the Asiatic school and later somewhat restored by the Rhodian. Other chapters (82–4) talk of the revival of the Attic style in Rome, complaining that too many speakers associate Athens only with dryness, clarity and refinement, forgetting the vigour and weight of Demosthenes and others. A particularly revealing chapter (18), which argues the need to follow the best rhetorical models, takes as its example the history of Greek sculpture from Canachos to Polykleitos 'whose works are finer [than those of Myron] and the most completely finished'. Polykleitos is here regarded as the best artist, an equivalent of a great Attic orator, and the extent to which the work of the so-called Neo-Attic school of the first century BC shares the characteristically extreme refinement and calculated finish associated with the majority of 'Atticist' orators indicates how both preferences are aspects of the same trend in taste. The Romans may have admired the art of Athens at the peak of its power, but it was not the power of its art that they most sought to emulate or acquire.

The principal reason for this was the predominance of the city's intellectual associations and it was these that made Athens the seat not only of the art industry, but of the education industry as well. It was the city's philosophical and other schools that were expected to endow wealthy young Romans with the knowledge, the skills and the polish that their fathers felt would enhance their prospects when setting out on careers back in the capital. Cicero, who had himself spent time as a young man both at Rhodes and Athens, insisted on his son also studying in the latter city. Greek education survived and continued to flourish, especially at Athens, as did Greek art. Like the new art, however, its influence on young Romans was minor compared to its earlier formative impact on the Athenians. For the Greek, education whether in the gymnasium or the lecture room was an integral part of his process of social formation. For the Roman, it was an occasion for a brief exposure to an alien intellectual culture, which enriched, but could not shape him. The Roman might either move easily from one teacher to another in order to explore the wide range of ideas available, as did Cicero, or could give the whole experience only peripheral attention, as did his son.

Either way he, like his oratory, could return with an Attic label, something the marbles and bronzes in his collection might share.

The Romans ensured the continuation of Greek education as of Greek art, but in both cases their involvement, unlike that of earlier Greeks, was relatively casual and depended on personal preferences. Art had formed the Greek's awareness of his body, and education had shaped his mind. The difference in the two peoples' relation to both art and self-formation is summed up in the metaphors from the world of the artefact which each used to describe the principle aspect of someone's identity. The Greek *charakter*, from the word 'to stamp', implies something fixed, imposed from outside and shared with others who have been stamped with a similar die. The Roman *persona*, from the word for 'mask' (*per-sonare*, 'to sound through'), implies something that may or may not be individual and which can be put on and taken off at will. Cicero talks typically of the '*persona* which the time and the state imposed on me' (*Sulla*, 3, 8), implying its later abandonment. He might have talked in similar terms about his formation in Rhodes and Athens. For the Roman, Greek art and Greek education were ornaments only, useful attributes to be paraded on appropriate occasions or to be put away when not needed. The Roman was visually responsive, but not easily visually dominated. He might be educated, but he was unlikely to be enslaved mentally. For the Roman, art and education came in small disposable packages. In Greece, art and education worked in their different ways as moulding machines, forces bigger than the individual, constructed by society or part of it in order first to prepare men for military service and later, as Isocrates put it, to 'stop their minds wandering' .

How then did the Romans achieve military victory over a people trained to perform best precisely in that field? After all, they lacked the powerful formative instruments of the Greeks, the art, the literature and the education. Part of the answer is that they had other highly efficient institutions for influencing people's actions. In the military field they shifted the emphasis from shaping the young, to disciplining the adult. In all fields of social life they stressed the observance of rites and superstitions and the participation in ritual. As Polybius noted in the second century BC, Roman religion and the Roman system of rewards and punishment were simply more effective instruments for controlling behaviour than anything possessed by the Greeks. To guarantee the security of their cities the Greeks surrendered much freedom of movement of mind and body in an effort to accommodate themselves to a system of self-discipline. The Romans, less dependent on craft if not on war, neither needed nor were inclined to assimilate themselves to a produced paradigm. Instead the whole community derived its underlying sense of security from the remembrance and acceptance of ancestral systems of belief. When faced with the need to go to war men carried that remembrance and acceptance with them and, besides, allowed themselves to be restrained by the fear of punishment and to be driven by the desire for reward. Roman society was characterised by a greater order, the Roman individual by a greater dynamism.

Chapter Five

ROMAN ART AND THE CULTURE
OF MEMORY

The Instruments of Success

> Can anyone be so indifferent or idle as not to care to know by what means, and
> under what kind of policy, almost the whole inhabited world was conquered and
> brought under the dominion of the single city of Rome, and that too within a
> period of not quite fifty-three years?

> Polybius, *Histories*, I, I

When the Greek historian Polybius set out, in the middle of the second century BC,
to satisfy such healthy curiosity he was writing for a Greek public that must have been
amazed to see the citizens of a small town half-way up the coast of Italy conquering
first the western and then the eastern Mediterranean. The Greeks had always thought
that if they were good at anything it was at building successful cities. This had ulti-
mately been the secret of the success of the Hellenistic world. Now an even better
city had been developed by other people. Like an expert craftsman discovering that
his competitors have developed a vastly superior product, Polybius seeks to understand
Rome's superiority. In a brief period between 220 and 168 BC the Romans had dis-
placed first the Carthaginians and then the Greeks to become effective rulers of an
area that rivalled in extent the territories controlled by Alexander the Greek and his
Persian predecessors. What must have amazed the Greeks most was that their con-
querors possessed none of the attributes that seemed so important for their own earlier
success. They had little mythology listing the achievements of national heroes. They
had hardly any history celebrating racial prowess. They had no philosophy or philo-
sophical education such as that on which Alexander and his successors had prided
themselves. Most remarkable of all there had been no paradigmatic leader, no Achilles,
Pericles or Alexander, to inspire and guide them in their expansion. For the Greeks
who felt that they knew so well how such factors had brought them superiority over
all non-Greek barbarians the success of the Romans raised disturbing questions.

No one was more troubled by them than Polybius, one of the leaders in the defence
of Greece, whose enforced detention at Rome for sixteen years after the fateful defeat
at Pydna in 168 BC afforded him an excellent opportunity to find some answers. His

conclusions have an extraordinary authority. Writing with the intellectual superiority of an anthropologist exposing the secrets of a primitive tribe, he knows that he is also the vanquished describing the victor. Looking at the Romans before education and familiarity brought Rome so close to Greece that Greek and Roman culture seemed superficially hard to separate, he can identify more clearly than any later author the special qualities of the Roman approach. Almost the whole of Book VI of the *Histories* is devoted to pin-pointing the keys to Rome's success. The features of the Roman mentality that he there isolates are ones whose ingrainedness and effectiveness were such that their survival was guaranteed for centuries to come, keeping Roman culture Roman even when its outer manifestations seemed apparently Greek.

The first element of Roman life that Polybius describes is the political system. The Roman constitution impressed him by its balance. It seemed successfully to embody features of monarchy, in the consulate, of aristocracy, in the power of the senate, and of democracy, in the power of the people. He may have been wrong to imply some equal division of political power, but he was certainly correct in seeing the importance of an implicit acknowledgement of the different interests of different groups for the survival and stability of the Roman state. It was this mutual recognition that maintained this stability for hundreds of years even after Augustus apparently gave predominance to the monarchical element by establishing the Empire after 31 BC. The emperor who failed to provide honours and employment for members of the senatorial class or *panem et circenses*, 'bread and games', for the people, risked being himself swept aside.

Even greater than Polybius' respect for Roman government was his admiration for the Roman military machine. The depth of his fascination is apparent in the painstaking detail of his account. It is as if he senses, though he could not know, that success in military matters was to be more important for the Romans than for any other people. It was by military success that the Romans first attained and then maintained world domination. It was to be success as a general that brought the individual Roman the greatest status and the greatest wealth. It was generals such as Sulla, Pompey and Julius Caesar who achieved the greatest power under the Republic and when, a hundred and fifty years after Polybius, the Empire was established by Augustus it took its name and nature from the title of the head of the armed forces, the *imperator* or 'commander'. The extent to which military experience influenced artistic activity is indicated by the way the same generals, Sulla, Pompey, Caesar and Augustus, became the greatest builders and patrons of the arts. On their campaigns they would have become familiar with the tradition of layout and organisation of the Roman camp that so much excited the admiration of Polybius and often they must have used the same architects and contractors who served them so well in the field when it came to investing their spoils in public works designed to win them support in Rome.

Two features most impressed Polybius about the Roman camp. First, its layout followed a standard pattern, but one that allowed enough flexibility to accommodate variations in the size and composition of the army (fig. 128). The camp occupied a rectangular area with the praetorium, the general/consul's headquarters, in the centre towards the rear. To right and left of this were the quaestorium or quartermaster's office and the market. In front of these were placed in a row the tents of the tribunes, usually twelve, six for each of the two legions under the consul's command. In front of these

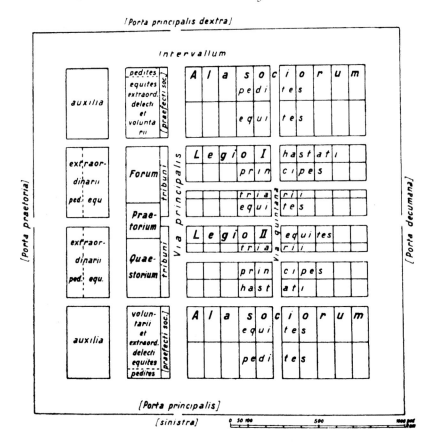

128 Roman camp according to Polybius.

again, and symmetrically arranged in rows either side of the main approach to the praetorium running from front to back, were the different sections of each legion. The first rows either side were of cavalry, the next outwards were the oldest infantry, the *triarii*, then came those in their prime, the *principes*, then the *hastati*, then beyond those the allies, first the allied cavalry and finally the allied infantry. At the rear of the camp, either side of and behind the quaestorium and market, were the special troops, the *extraordinarii*, the cavalry inside and the infantry outside. The layout of the camp reflected the hierarchy of authority and function within the army. Three institutions were placed in the middle of the camp, the high command at the centre and the two service facilities on which it depended at either side. Before them were the principal officers, the tribunes, and before them the bulk of the forces, one legion either side of the main axis, with the various elements carefully arranged according to wealth and seniority from the regular cavalry at the centre to the allied infantry at the sides. The rectangular area of the whole was divided by two main roads which crossed in front of the praetorium, and around that matrix everything was clearly arranged.

Polybius compares the arrangement of the plan to that of a town and it is true that the grid plan element was a common feature of Greek towns from at least the fifth century (fig. 88). However, far more important are the new elements that can hardly be paralleled in Greece or the Hellenistic world. As Polybius implies, they were barely

anticipated in the Greek camp for reasons that were inherent in the difference between the Greek and Roman armies and indeed societies. The Roman army and Roman society were also closer to each other in structure than those of any Greek state except perhaps Sparta, the Roman state having essentially the same organisation in war and peace. This was because, as in Greece, the principal pressure shaping the state was the need to be effective in war. In Rome this meant that the system of elections and the system of conscription were particularly closely related. The chief magistrates, the two consuls, were the principal generals (who could be supplemented by the next most senior magistrates, the praetors). Material resources were administered by quaestors who in civil life had charge of the treasury. The tribunes, though not the same as the military tribunes, had a function similar to theirs, which was to serve as the link between the aristocracy, or senatorial class, the main decision-making body, and the plebs, or people. In war they were the officers who ensured that the general's decisions were carried out. There was also a loose parallel between the 'centuries', fighting units nominally of a hundred men, and the 'centuries' into which the Roman people was divided for the purposes of elections, even if there was no civil equivalent of the centurion who commanded such a unit. The important point is that the organisation of both society and army was strictly hierarchical and that the layout of the camp provided a clear mirror of that hierarchy. Equally important was the balancing element which in the final analysis prevented the consul at the top of the pile from acquiring too much power. There were two consuls and when they were encamped together their equivalence was mirrored, as Polybius tells us, by their two camps being placed back to back. The balance between the consuls was taken up in the balance between the two legions that formed the army of each and between the two centuries that constituted each of the legion's thirty maniples. Always the balance was given expression in the plan of the camp. The camps of the two consuls were placed symmetrically either side of a dividing line, the two legions of which each was made up were placed symmetrically around the perpendicular bisector of that line and the tents of the two centurions were placed symmetrically at either end of the encampment of each maniple. Since the principal divisions were marked by roads leading from the three or four gates and the smaller sections of the encampment were arranged on a regular grid of smaller paths, the overall plan was a very image of an ordered and balanced society. Besides the pairing of similar elements there was also the balance between dissimilar ones, quaestorium and market, cavalry and infantry, Romans and allies.

Some elements of the camp derive from Greek and particularly Macedonian practice and Polybius undoubtedly over-emphasises its uniqueness for rhetorical effect. He is, however, right in his overall conclusion regarding its special properties, which derive from a broad Italic tradition. The use of axial symmetry to co-ordinate varied elements in an architectural complex was already a characteristic feature of Etruscan tombs (fig. 129) and, to judge by later houses, of Etruscan domestic architecture. It was by contrast notably absent both from Greek residential buildings and from Greek town-planning. The concern to preserve axial symmetry also lies behind another distinguishing feature of the Roman camp, the use of large-scale engineering in order to ensure that the pattern of the camp can always be maintained regardless of its site. As Polybius says, the Greeks did not maintain the same pattern for their camps because they habitually laid out their fortifications along naturally defensible lines:

129 Tomb of the Greek Vases,
Cerveteri, *c.*500 BC, plan.

The Greeks in encamping think it is most important to follow the natural strengths
of the terrain, both because they avoid the effort of entrenching and also because
they consider artificial defences inferior to those offered by nature. As a result they
are compelled to adopt all kinds of plans for the perimeter of their camps, accom-
modating them to the landscape, and often have to move parts of the army to inap-
propriate positions, so that everyone is uncertain of the placing of himself and of
his unit. The Romans on the other hand accept the effort of digging trenches and
the associated works in order that they can have a single familiar type of camp.

Polybius, *Histories*, VI, 42

The Roman general must have had an efficient administrative back-up in order to
ensure that he could always produce a standard camp layout. He must also have had
an effective command structure and staff with the appropriate technical skills. He must
have seen himself as an assertive figure, able to impose his will on nature, whether it
was the natural lie of the landscape or the natural laziness of his troops. Equally impor-
tant, he could apparently rely on his men responding positively to the consistency of
his plan. Polybius describes the almost miraculous way in which troops occupied the
site of a future camp even before construction had begun. This they were able to do
because they were guided by a complicated system of markers. A line of flags, white
for the consul's tent and red for the other main divisions, was first laid out. Then a
combination of different coloured flags and simple spears was used to mark out the
minor streets:

As a result when the legions march up and they get a good view of the site of the
camp they can recognise all its parts, since they can calculate everything from the

position of the consul's flag. Thus as everybody knows exactly in which street and which part of which street their tents are, since they all invariably occupy the same place in the camp, the entry into the camp is like the return of an army to its native city.

Polybius, *Histories*, VI, 41

Responding only to a system of signs, the army enters a piece of open country with as much assurance and speed as if it was their own town. A mechanism of social control designed to increase the army's efficiency became a source of unconscious reassurance that made the Roman soldier feel at home even when far from Italy.

Polybius' insistence on the stereotyped character of the Roman camp might for all its laudatory tone be taken as an indication of something wooden and repetitive in the Roman mind. It is thus well worth placing it alongside his equally complimentary account of the Roman tactics. For, just as he contrasted the variability of the Greek camp with the constancy of that of the Romans, so he compared the adaptability of the Roman infantry formation to the inflexibility of the Greek phalanx. The strength of the new Macedonian phalanx consisted, as in the case of its simpler predecessor, in its unity and order, a series of lines of heavily armed men about eight deep, a unit more powerful than any other when operating on a battlefield that was flat and without obstructions. Its weakness consisted in the fact that once its order had been disrupted either by the confusion of battle, or more likely by irregularities in the terrain, it became easily vulnerable. The advantage of the Roman formation, which owed much to Greek models, was its flexibility, which enabled it to respond quickly to changes in the situation. While the characteristic weapon in the phalanx of Polybius' time was the twenty-foot spear, which could hardly be moved around when used in tight formation, the characteristic Roman weapon was the short sword, which could be used for both cutting and thrusting. The soldier who used it in conjunction with the characteristic curved shield could easily defend himself by turning to face the attack from whichever direction it came. To take advantage of this fact the Roman soldier was given twice the distance in which to manoeuvre, and, more importantly, instead of having to operate as an uninterrupted line in order to obtain security from flanking

130 Roman legion in battle formation, according to Polybius.

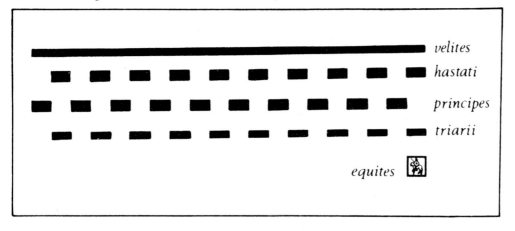

attack, the formation could be given a chequerboard plan with small units alternating with voids; so that after the first units had received the brunt of the attack a fresh series could take over. The much looser arrangement also allowed the legion to move rapidly without being unduly thrown into disorder by trees, rocks or variations in gradient. Although Polybius does not say as much, the looser Roman order was also made possible by a better organised line of command and a greater use of standards to provide a focus for both small and large units. As Polybius says, the Greek soldier can fight neither in small detachments nor on his own, while

> every Roman once he is armed and engaged can adapt himself to every place and every time and can meet any attack. And indeed he is ready and has the same preparedness whether he has to fight with the whole army or with a part of it, whether with his maniple or by himself.

Polybius, *Histories*, XVIII, 32

Paradoxically, when it comes to the field of battle it is the Greek arrangement that is invariable and stereotyped, requiring a flat uninterrupted surface, and the Roman that is adaptable to changing circumstances and terrain. Paradoxically, too, it is this variability that is now the superior property. The inherent rightness of the Roman approach is seen in the way it makes that which is inherently rigid, the camp, more fixed and that which is inherently flexible, the soldier, more free.

Polybius presents us with a view of the Roman army that attributes its success largely to the effectiveness of co-ordination, whether in the fixed plan of the camp or the flexible formation of the line of battle. The effectiveness of co-ordination in both contexts consists in the establishment of clear relations between each individual soldier, his unit and the whole army. The soldier, while well equipped to stand by himself, can also see clearly how he functions as a small element in a large machine. The key to his perception of his place in the whole is not just his familiarity with a constant scheme. It is as much his understanding of the sign language of standards. Such features had of course been characteristic of all organised armies up to and including those of the Romans' enemies, the Carthaginians and the Greeks, but the Romans brought them to their highest development. The Roman general understood the importance of planning as a means of establishing social control and the Roman soldier who knew his place in the plan acquired a sense of security that was critical to his performance.

The other feature of the Romans that Polybius saw as the source of the superiority of their system was their 'superstition': 'Fear of the gods is what keeps the Roman state together' (*Histories*, VI, 56, 6). This would become even more true under the Empire when the emperor's participation in the great processions and sacrifices of state religion provided a principal vehicle for the constant reassertion of the relationship between him and his fellow Romans. The continuing series of ever more magnificent temple buildings and the many great scenes of sacrifice – hardly known in Greece – that survive throughout the Empire provide material expression of the importance of state religion (fig. 131).

In the end Polybius' most precious and personal observations on the excellences of Roman civic life are those that relate to funerary rites (*Histories*, VI, 53). Although his remarks may not be absolutely accurate in all details, his understanding of the signifi-

131 Emperor Marcus Aurelius sacrificing, mid-second century AD.

cance of such occasions is beyond doubt. According to his account, when a famous man dies, his body is taken to the forum where his achievements are described in detail in a speech by a son or other relative, with such effect that events are directly presented to those who could never have witnessed them. Later, after the funeral, an image of the deceased, a mask wrought as a true likeness, is placed in a shrine in a prominent place in his house (fig. 132). This will then be decorated at times of public sacrifice and will be worn by a similar looking member of the family at subsequent funerals, the wearer also putting on the toga appropriate to the dead man's office, with a purple border if he was a consul or praetor, all purple if he was a censor, embroidered with gold if he had celebrated a triumph and so on. 'There could not be a more beautiful or effective spectacle for an ambitious and virtuous young man. For who would not be inspired by the sight of almost living breathing images of men famous for their excellence?' (*Histories*, VI, 53). The effect in any case was to spur on later members of the family to similar and greater achievements. These observations can be supplemented by those of Pliny (*Natural History*, XXXV, 2, 6 and 7), who tells us that such wax portraits were backed up by other commemorations. Inside the house were displays of family trees on which painted portraits were linked by lines running between them. Outside, at front doors, permanent portraits were flanked by spoils taken from the enemy. The use of artefacts both to develop the family's consciousness and to impress others was evidently well understood. As with the layout of the camp, what we are told indicates that Romans were uniquely aware of the importance of visual materials as instruments of communication and control. The way real lines marked lines

of descent on the family trees just as invisible lines marked the chain of authority in the camp shows how Roman culture depended on giving material expression to distinctive habits of mind.

Polybius was insistent that the relations between art and institutions were an important element in Rome's superiority over other states, and, although he does not give prominence to the use of art in triumphal processions, in his general celebration of Rome's secret weapons he does refer to the phenomenon, as we saw in the discussion of the performance organised by Anicius. Certainly the display of art during the ceremonies when the victorious general returned to the city and paraded the fruits of his victory for all to see had a great impact. Besides prisoners taken on the field of battle and objects of gold and silver and other works of art taken from conquered towns, paintings were also carried that recorded those achievements and similar illustrations were put up in public places. According to Pliny (*Natural History*, XXXV, 7, 22–5), paintings of battles were made from the third century BC. We also learn from him that L. Hostilius Mancinus 'placed in the Forum a representation of the site [of Carthage] and his own attacks on it' and stood by it 'explaining the details to those who looked at it', and that after Tiberius Sempronius Gracchus' campaign in 177 BC he put up in a temple 'a representation of the island of Sardinia on which were portrayed his battles' (Livy, XLI, 28). Such portrayals were regarded as useful ways of attracting admiration and electoral support and it is no surprise that it was to be Pompey and Caesar (Appian, *Mithridatic War*, XVII, 116 and 117; Appian, *Civil Wars*, II, 101) in the first century BC who made the most extensive use of such paintings in their triumphal processions. None of these works survives, but their purpose was, like that of the family trees, to convey information, with views of countries and cities being treated rather like maps with figures inserted at the appropriate place. Such views may have been as highly wrought as the Barberini mosaic from Praeneste, more compressed like the reliefs on the columns of Trajan (fig. 133) and Marcus Aurelius, and the Arch of Septimius Severus (fig. 134), or as diagrammatic as the late imperial itineraries.

From Polybius, Pliny and others, we acquire a clear picture of the distinctively Roman sensibility to the visual. Most of what they responded to, the flags and lines of the camp, the wax funeral masks, the triumphal paintings, was temporary. As the main function of these materials was to provide memorisable information, they did not need to be more permanent. That the Romans were not much interested in permanent art and architecture before the end of the second century BC is confirmed by the archaeological record, which yields little but terracottas. What is remarkable is the extent to which even after the Romans became active in the patronage of permanent stone buildings, marble sculpture and monumental painting and mosaics under the influence of contact with the Greeks, their interest in the visual continued to have the underlying character that it had earlier. Roman architecture met similar needs to the camp and Roman art similar needs to the wax masks and triumphal paintings.

★ ★ ★

132 Portrait statue (the head not original) with masks of ancestors, late first century BC, marble.

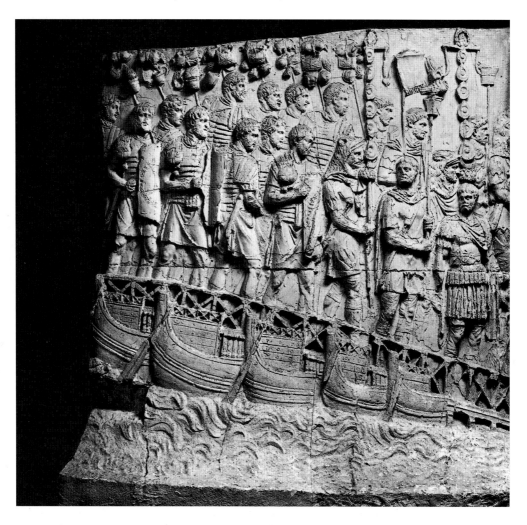

133 (*above*) Bridge across
the Danube, scene from the
Dacian Wars, detail from
Trajan's Column, Rome (see
fig. 149), AD 112–13.

134 Capture of Seleucia,
detail from the Arch of
Septimius Severus, Rome,
AD 195–203.

Augury and Mapping

One of the best example of this is the relation between Roman architecture and the rites of augury, that is, the practice of reading the movements of birds for good or bad omens. Related too were the skills required by the *haruspex* or reader of entrails who paid particular attention to the markings on the liver of the sacrificial animal. An Etruscan bronze model of a liver marked out with divisions whose names can be related to those of the augural sky shows indeed that there was a direct link between the two activities (fig. 135). Certainly Vitruvius tells us how livers were examined before the establishment of towns and camps (*De Architectura*, 1, 4, 9 and 10) and although he does not explain this act in religious terms there can be no doubt that the function of such an examination was exactly the same as that of augury which was observed on similar occasions. Both augur and *haruspex*, like, indeed, the *fulgurator* who watched for lightning, relied on the interpretation of variable signs within a constant scheme when determining the correct time and place for such important actions as the laying out of a city, the establishment of a camp and the construction of a temple.

135 Model of a liver with diviner's markings, bronze, third century BC.

There is clear evidence that the scheme at the centre of the rite of augury directly influenced the planning of towns, camps and temples. The augur's *templum minus* or *auguraculum* was marked out as an enclosure divided by two lines crossing at right angles (fig. 136), and, while temples took over both the name *templum* and the rectangular enclosure, cities and camps were typically laid out around the cross pattern of *cardo* and *decumanus*. The influence of such a scheme is visible even at Rome, where the city's layout otherwise appears largely to reflect organic growth. Thus, the great axis of the Via Lata, the broad road into the city from the north-west, is directly aligned on the *auguratorium*, the official site for taking augural observations on the summit of the Capitoline Hill, deriving its orientation from the position of Mons Albanus to the south-east, while the great Temple of Jupiter Optimus Maximus built by Tarquin, the last Etruscan king of Rome, in 509 BC on the other summit is laid out in parallel to the same line (fig. 140). All such layouts derived strength from their correspondence to sacred schemata and to each other. A town seemed more secure, stronger and more sacred because of its correspondence to camp and temple. The camp derived sanctity from its similarity to a temple and the temple security from its correspondence to a camp. Those who moved through such layouts, whether citizens, soldiers or worshippers, must all have had the cross-scheme in their heads. All would have known the critical importance of the scheme for the performance of state enterprises and many would have allowed their own lives to be governed by prophetic observations similar to those made by the augurs. Polybius rightly observed that superstition was the strongest unifying force among the Romans.

136 Cross, with augural inscription, bronze, 137 Surveyor's *groma* in use by legionary.
from Lambaesis.

 The best example of the dominance of the augur's scheme is provided by the many *coloniae* and other cities established by the Romans, first in Italy in the third, second and first centuries BC, and subsequently throughout the empire. The site might be new or an old settlement might be reformed. In the typical case a group of army veterans would be given land in an area where Roman authority needed reinforcing and a new town, usually copying the layout of a camp, built to house them (fig. 139). In such situations Polybius' observation about the soldiers being as at home in their unbuilt camps as in their own towns was aptly reversed. In such situations, too, the grid was extended outside the town through the application of 'centuriation' to the landscape. This involved the division of land into regular rectangular units using the surveyor's *groma*, a cross-shaped instrument that provided a simple tool for dividing territory, so that it could, for example, be drained effectively by parallel ditches or allotted to individuals in equal units (figs 137 and 138). Though a practical and not a ritual instrument, the correspondence between the surveyor's *groma* and the augur's *templum* must have always enhanced its authority. Even in towns the distinctions between the military, the practical, the ritual – and indeed the political – were often blurred. Besides being a convenient way of dividing up land, which had associations both with the camp and the *templum*, the grid and especially the cross were explicitly Roman. Indeed many of these towns were made into direct imitations of the capital by having a temple to the Capitoline triad sited at or near the point where the two main streets crossed. Such temples might carry the title of Capitolium and might employ a triple cella that directly recalled the great Temple of Jupiter in Rome, with its flanking shrines of Juno and Minerva. Jupiter was the main deity of Rome and, since the time of Marius, his bird, the eagle, acquired primacy as the standard of the Roman army. Jupiter was in any case distinctively the patron of the Roman army, having a shrine in the commander's *principia*. The cross pattern with a Capitolium at the centre was a marvellous mnemonic of the distinctive privileges and powers that held together first the Repub-

138 Centuriated countryside between Montelimar and Orange based on fragments of Roman marble plan.

lic and then the Empire. A citizen of a town such as Timgad, on the southern frontier of Africa, who directed his steps to the Capitolium along the *cardo* or *decumanus* was at once reminded that he was also a *civis Romanus*, or a citizen of Rome, and that the stability and integrity of the empire depended on the organisation of the army under the *imperator* or 'general in chief' (fig. 139).

139 Timgad, founded AD 100, aerial view.

We should not think of augural schemes as reflecting only early superstitions later exploited in provincial town plans. They were critical to the architectural reorganisation of Rome by Augustus and his Julio-Claudian heirs (fig. 140). While Pompey and Caesar, imitators of Hellenistic rulers, had oriented their new buildings on the Campus Martius in relation to a scientific Greek grid oriented to the true cardinal points, the first emperors gained popular support by giving greater emphasis to the ancient Italian tradition. It was Octavian himself who made the shift, modifying his predecessors' approach only belatedly, following his victory over Antony and Cleopatra at Actium in 31 BC. Already an augur, in 29 BC he celebrated the *augurium salutis*. Then, in 27 BC, he took the title of Augustus, a term that, although etymologically cognate with *augeo*, 'I increase', had long been linked with augury. This connection was already made by Ennius in his statement in the early second century BC that Romulus had founded Rome *augusto augurio* and it was in commemoration of Romulus' role as founder of Rome that Augustus laid new emphasis both on the auspicious line of the Via Lata and its termination on the Palatine. On the Campus Martius Augustus cleverly linked all existing schemata and references, placing the Egyptian obelisk at the centre of his enormous new Greek *horologium*, or sundial, in such a relation to the round Etruscan-type tumulus of his mausoleum that a line between them ran parallel to the adjoining Via Lata and ended in the rear wall of the Capitoline temple. He had already stressed the importance of this last axis, having chosen to live further along it, on the Palatine close to the site both of the traditional hut of Romulus and of an *auguratorium*, and having drawn further attention to the area by rebuilding the adjoining temple of Cybele and constructing a new temple of Apollo nearby. The Imperator's residence was directly on the augural line, just as was the *principia* or praetorium of the typical camp. The camp-city analogy was reinforced by his successor, Tiberius, who had the Castra Praetoria, which housed the imperial guard, laid out with its *cardo* and *decumanus* parallel and at right angles to the line of the Via Lata, just as was the axis of the Capitoline temple. The mysterious protection once afforded to the community by Jupiter was now guaranteed to the emperor and his subjects by the Praetorian guard. A few years later the great Temple of the Deified Claudius was then built at right angles to the same axis and Domitian finally seems to have constructed or reconstructed the *auguratorium* on the Palatine, one of the points where the first auguries may have been taken. The city now comprehensively recalled the augur's scheme of the universe. It also became the camp of the *imperator*, its security in the hands of his guard. It was both *templum* and *castrum*. Augustus and those who succeeded him embedded in the city a scheme with both religious and military associations that would have been familiar to many of the population. To those who had this matrix in their minds the emperor became a divine general presiding over the city as over the empire.

It is even possible that there is an influence on Roman planning from the scheme of the *haruspex* too. Thus the division of the city of Rome into fourteen *regiones* under Augustus was calculated so that six of them met at one point where the Meta Sudans was subsequently erected, producing an effect very similar to the six divisions around a raised circular area on the bronze model of a liver (fig. 135). The assimilation of an architectural layout to the scheme on which the official diviner relied to obtain favourable omens would have encouraged people to believe that it had been made as correctly as possible.

140 Rome, plan showing Via Lata as *cardo* with monuments related either to that axis or to cardinal points.

Art and Memory

The Roman who was familiar with the layout of the camp was used to treating architecture as a mental map. He was also used to tracing family trees in the atria of the powerful, to following sequences of historical events displayed in triumphs and to viewing military achievements illustrated on maplike perspectives. Everywhere he was habituated to the schematic representation of space and time. Many Romans would have possessed memories stored with knowledge that had been preserved and trans-

mitted to them by buildings and artefacts, none more than the members of the sena-
torial class. It was they who provided the generals who laid out camps and it was they
who lived in houses decorated with family trees. The better they understood such uses
the more successful they were likely to be.

If they were educated, and especially if they were trained as orators, they would also
have consciously developed a faculty that would have directly contributed to that
understanding, the art of memory. This technique for aiding memorisation is described
in three important texts dating from between the early first century BC and the late
first century AD: the treatise by the Auctor ad Herennium, Cicero's *De Oratore* and
Quintilian's *Institutio Oratoria*. All agree that the artificial memory system that they
expound had its origin in Greece, but no evidence for the Greek system survives and
the one they describe may be largely Roman. Whatever the date or place of its devel-
opment it was clearly considered an accepted feature of the Roman training in rhetoric
from around 100 BC. The secret of this system was to take a fixed setting, which could
be a house, a public building or even a painting, then to select a series of 'places' (*loca*)
within that setting arranged in a particular order, 'places' such as intercolumniations,
angles, arches, etc., and finally mentally to attach to each of these places 'signs' or
symbols (e.g., an anchor for 'sailing') representing the successive topics of a speech as
it was to be given. When the time came for him to speak, the orator would in his
mind move through the series of spaces 'collecting' as it were the various objects from
their 'places' to produce a miraculously fluent and well structured speech. As Cicero
says at *De Oratore*, II, 86, 354, the effect is to use the 'places' like wax tablets and the
'images' as the letters that we impress on them, only everything is done in the head.
The imaginary movement through architectural or painted space is the key to the
unfolding of the speech in time.

Although a Greek invention, such a memory system probably became a familiar
element of education only in the Roman world. References to 'places' such as arches,
atria, etc., forms alien to Greece, suggest a method specifically adapted to Rome, where
it must have seemed a real boon to those young men who sought a path to power
through their skills as speakers. It was well
accommodated to the Roman mentality.
The idea of using signs fixed in a familiar
sequence of places to find one's way in a
speech is not unlike that of soldiers finding
their way into a camp following the placing
of flags. Soldier and orator both need a
mental image of an architectural complex
in which the moveable signs are placed.
Indeed, when Quintilian recommends the
use of a house with signs placed in the
vestibule, the atrium, round the *impluvium*,
etc., the structure he is referring to is one
whose plan was almost as standardised as
that of the Roman camp (fig. 141), while
the word he uses for the symbols, *signa*, is
the same word as that used for military

141 Roman house plans from marble map
of Rome, early third century AD.

standards. The *Auctor ad Herennium* may even have the equivalence in mind when he talks of using a hand to mark every fifth 'place' and refers to a horse, a lion and an eagle as symbols. The eagle and the hand were typical military standards.

Another equivalence explicitly claimed by Quintilian (*Institutio Oratoria*, XI, 2, 25) is that between the symbols and the *notae* or 'signs' of the shorthand writer. It is almost certain that shorthand was much more widely practised in the Roman than the Greek world. Its use, like that of the mnemonic symbols, indicates a significantly greater readiness to use a language of compressed signs instead of words written out in full. This same readiness explains the characteristic Roman exploitation of abbreviations in inscriptions such as one from Pompeii, L.CAESIUS C.F.D.D. C.OCCIUS M. F. IIV. L.NIRAEMIUS A.F.D.D.S.EX PEQ.PUBL.FAC.CURAR.PROB.Q. (*Corpus Inscriptionum Latinarum*, I.1628). The difference between such an inscription and earlier Greek examples indicates a very different cast of mind. The Greeks regarded writing almost as a naturalistic portrayal of the sounds of speech, which is why they invented extra vowels to make the Semitic alphabet better able to represent their language. For the Romans letters were much more symbols making possible the recording of words as concepts, and as such they might be reduced to the minimum necessary to allow the word or concept to be recognised. Mnemonic signs, shorthand signs and inscriptional abbreviations all implied a much more symbolic relationship between sign and thought than was current in Greece.

The Romans evidently found it much easier to see words and images as parallel phenomena, with both being used to 'communicate' rather than 'represent'. This is apparent in those rhetorical texts that match words with mnemonic images. It is also well illustrated by the parallelism between text and image on many Roman commemorative artefacts. Two of the most typical are coins and tombs. With their elaborate inscriptions and complex but compressed imagery they are strikingly different from the majority of their Greek predecessors. The Greek tomb might carry a representation of the deceased accompanied by his or her name (figs 4, 29, 78 and 79). The Greek coin usually had on its two sides a portrayal of a patron divinity and an emblem or ruler portrait, possibly accompanied by an identifying inscription. The coin's user was expected only to recognise its source and possibly the period of issue and to be impressed by its quality. Roman coins on the other hand tended to bear increasingly elaborate messages. These emanate first from the issuing magistrate under the Republic and then from the emperor. An example of the former is the denarius of the aediles Marcus Scaurus and Publius Hypsaeus of about 58 BC (fig. 142). The obverse, bearing the inscription M.SCAUR. AED. CUR. EX S.C. REX ARETAS, showed Aretas, a king forced to make peace by Scaurus when governor of Syria, kneeling with an olive branch. This is the side on which Scaurus referred to one of his own recent achievements. On the other his colleague referred to the capture of a place called Privernum by one of his ancestors, a consul, in 329 BC using the inscription HYPSAEUS AED CUR. C. HYPSAE. COS. PREIVER. CAPTU. In both cases the abbreviated inscription communicates much information with the use of a minimum of letters. The coin-maker has no difficulty in using pictures as an equivalent to a text. The deed of C. Hypsaeus, the taking of Privernum, is described in letters, while the achievement of M. Scaurus in forcing Aretas to make peace is conveyed through an image. Unlike the Greek coin, which changed little and hardly needed to be read, this, the product of two magistrates in a particu-

142 Silver denarius of Marcus Scaurus and Publius Hypsaeus, 58 BC. On the obverse King Aretas kneels offering an olive branch and on the reverse P. Hypsaeus commemorates his ancestor's capture of Privernum.

lar year, has to be read using a compressed inscription and a compressed image. The two sides of the denarius can be compared with the two halves of a tombstone of the freedman Demetrius and his son Philonicus (fig. 143). Above in the pediment are the instruments of the mint where Demetrius' patron, P. Licinius Stolo, employed him. On Demetrius' side are the instruments he used in his craft of die-sinker there and on the left of Philonicus are the insignia of his more lofty office of lictor. The inscrip-

143 Tomb of Demetrius and Philonicus, late first century BC.

tions identify the two men and the two busts are carefully individualised, like the masks described in Polybius' account of funeral rites. The more realistic Demetrius is typical of portraits of the mid-first century BC, with an added emphasis on the physical toll brought by his manual work. The son has the more serene expression of a freeborn official and accords well with the type of his ruler Augustus. Busts, reliefs and letters provide a clear mnemonic of the careers of father and son.

Money, Monuments and Signs

Thousands of tombs and thousands of coins of a similar character were made throughout the Roman period. Both classes of object carried much more information than their Greek models. This may help to explain why both could be described by cognate words derived from the root *monere*, 'to advise', 'to inform'. Although the term *moneta* for money derives traditionally from the siting of the mint in the temple of Juno Moneta, its rise to popularity as an expression may well have been connected with some understanding of the monitory function of Roman coinage. The term *monumentum* for 'tomb' has its antecedent in the cognate Greek *mnema*, 'memorial', also occasionally used for a tomb, but *monumentum* is much more frequent in Latin in this context. Equally typically Roman is the use of the same term for large buildings. Temples, houses and so on could all be called 'monuments' because it was recognised that one of their principle functions was to preserve the memory of the person or persons who erected them. It was because this function was so important that so many buildings carried more or less prominent inscriptions, like that from Pompeii quoted above or the more familiar ones from Rome such as that on the Pantheon (fig. 147). It was because this function was so important that Hadrian felt obliged to preserve Agrippa's inscription on the latter structure even after he had rebuilt it. It was for the same reason that, as Pliny the Elder tells us in the passage noted earlier, the house of a family could have its portal decorated with portraits and trophies commemorating the achievements of its members, memorials that should not be removed even if the house changed owners. The best example of such a house-memorial is that of Augustus. Its entrance was decorated with wreaths of laurel and oak and a golden shield, all symbolising different achievements. To these was added the title PATER PATRIAE, 'Father of the Fatherland', awarded to him by the Senate (fig. 144). The house as a whole was also a memorial of the emperor's virtues. The simplicity of its plan, materials and furnishings were still shown to Suetonius as emblems of his qualities a hundred years after his death (*Lives of the Caesars*, Augustus, 72, 2). Building, inscription and attached objects combined to form a 'monument' of the emperor. Finally, the way all communicative arts at Rome were integrated is illustrated by the way representations of the house's portal were used on coins, *monetae*, to provide a wider diffusion for the image of virtue. Even the emperor's testament, which was inscribed both outside his tomb *monumentum* and elsewhere in the Empire, referred to the house's PATER PATRIAE inscription.

Parallel in importance to words deriving from the root *mon-* were those deriving from the root *sign-*, 'mark', 'sign'. As pointed out at the end of the last chapter, the word *signum* was applied not only to the standards and banners that were used to order

144 Coin of Augustus, with laurel and oak wreath, inscribed: OB C[IVES] S[ERVATOS] ('For the citizens who were saved'), fixed to the ortal of Augustus' house by Senatorial decree.

and transmit communications in the army but to sculptures and even paintings. *Insigne* was used for a whole range of important insignia both military and civil. Wreaths of different foliage and forms served as distinctions in the army: the *corona castrensis, civica, muralis, navalis, obisidionalis, triumphalis,* etc. In civil life togas of different types, for example, purple or white, with or without the broad band, were worn to identify the status of males of different ages and different types of ring or *bulla,* amulet, were worn on the hand or around the neck for similar purposes. In many ways rank was as clearly distinguished in the civilian world as in the army and in Latin literature all types of status were regularly identified by their insignia. In the same spirit authors regularly used the word *arma,* 'arms', to refer to military life and *toga,* 'toga', to civil. Military and civil images of the emperor were also principally distinguished by dress (figs 145 and 146). It was as an extension of this habit of defining status by dress and attributes that architectural and other forms came to be used in the same way. Thus Cicero, at *De Oratore,* III, 46, explains that columns and pediments are not just functional elements, but essential emblems of divine authority. Even in heaven Jupiter would require a pedimented portico, although, because it never rained, such pitched roofs were unnecessary there. Similar considerations made the same feature an absolute necessity for all temples on earth from that of the Capitoline triad down. The importance of such symbolism explains why Roman temples continued to have colonnaded porticoes crowned by pediments right through the Empire, even though, as other public buildings such as the baths illustrate, the use of newer architectural forms might have achieved more impressive effects. Even a sacred structure that employed these new forms, such as Hadrian's domed Pantheon, still needed the traditional pediment and columns (fig. 147). The same architectural attributes could also be transferred to divinised mortals. Cicero could refer to Caesar's possession, while still alive, of the traditional attributes

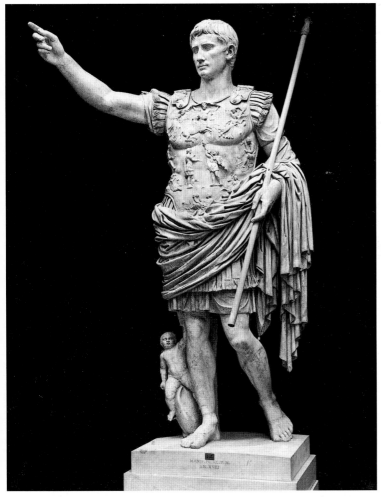

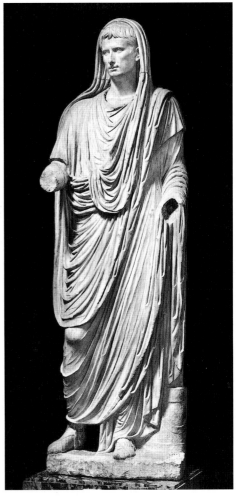

145 Augustus with cuirass, from the Villa of Livia, Primaporta, marble, early first century AD.

146 Augustus togate as veiled priest, marble, early first century AD.

of divinity: 'couch, image, pediment and priest' (*Philippics*, II, 43); and it was only a short step to transferring the pediment to the house, so that Florus could talk of the dictator having 'statues round temples, a raised seat in the curia, a pediment on his house' (Florus, *Epitome*, 4, 2). Already under Claudius we find the pediment being coupled with the more traditional insignia on the imperial residence, as Suetonius tells us: 'Claudius fixed a naval crown on the gable of the palace' (*Lives of the Caesars*, Claudius, 17, 3). Later, Domitian constructed a much greater palace on the Palatine with a façade prominently decorated with pediments and columns and had it reproduced on his coins (fig. 148). The message would have been clear to everyone even without Martial's poems, which compare Domitian's palace explicitly with the dwellings of Jupiter on earth and in heaven (*Epigrams*, 7 and 9). Romans were used to reading the signs that defined important façades.

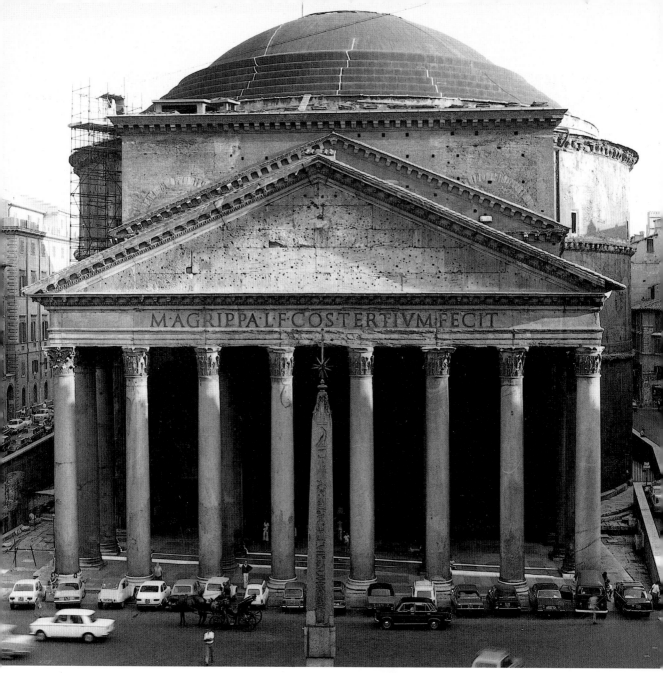

147 Pantheon, Rome, *c.*AD 125, exterior (see also fig. 201).

What made the pediment such a potent sign was not simply its association with the temple. To a Roman used to perceiving social relationships diagrammatically its shape reinforced and informed its meaning. Its broad base rising to a single point made it seem to them the very epitome of the structure of society. This is why texts frequently refer to an individual's ascent to the top of the pediment's *fastigium* or 'gable' of power. The arch has many of the same properties as the gable, and Seneca in the first century AD brings this out when he expressly describes it as a series of stones rising to a central

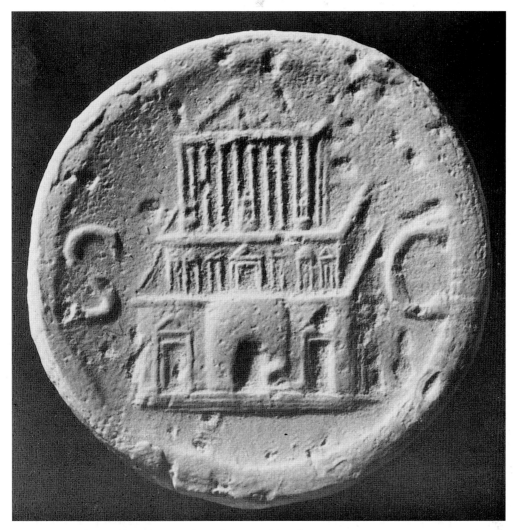

148　Coin of Domitian showing his palace on the Palatine, Rome, *c.*AD 90.

keystone (*Epistulae*, 90). Although he credits this description to the Greek writer Posidonius of the first century BC the Greeks do not normally appear to have thought of the arch in this way. The Romans, however, did, and their fondness for arches built out of two series of balancing voussoirs rising to a sculpted keystone (fig. 157) suggests that they sensed in the masonry structure an organisation similar to that of society. Flights of steps were experienced in a similar way and promotion was regularly described in terms of advancement by *gradus*, 'steps', to the highest honours. The highest magistracy, the consulate, could thus be described as the 'highest step' in an imaginary stair. Steps were as much an index of status as were pediments. They were as essential on the front of a temple as were pediment and columns. The more important the deity the longer the flight. Steps and changes in level generally were equally important in the field of secular architecture. One of the principal reasons for developing the imperial residence

on top of the Palatine hill was so that it should be approached by a long ascent, as was the Temple of Jupiter on the nearby Capitol. Republican magistrates occupied raised podia in the basilicas where they gave judgement and the *suggestus*, the raised chair referred to by Florus in the Curia, became the distinguishing mark of the emperor or his representative in similar contexts. So dominant had the habit of measuring status by relative height become by the first century AD that when Pliny the Elder came to explain the origin of the idea of placing statues on commemorative columns and arches he could simply state that the 'principle was to raise those represented above other mortals' (*Natural History*, XXXIV, 12, 27). Although he attributes too great an importance to this 'principle', he certainly correctly identifies a major reason for the popularity of such honorific monuments, especially under the Empire when the emperor was almost the only person to receive such honours (fig. 149). In a less emphatic context the same principle explains the Roman tendency to place honorific statues on high moulded bases quite different from those of their Greek predecessors (fig. 150). The relative height of the base then became a direct measure of relative status. An additional effect of such bases was to deny the Greek notion that the statue was a realistic substitute for the person. While the low Greek base often left the viewer and statue standing on almost the same level, preserving the illusion of a confrontation between real people, the Roman statue, isolated on a pedestal usually bearing a prominent inscription, could be seen only as a commemorative token, a *signum* on a *monumentum*. Only when the inscription had been read, the size and material of pedestal

149 Column of Trajan, Rome, AD 112–13 (see also fig. 133).

150 Statues on pedestals in the Atrium Vestae, Rome, second to fourth centuries AD.

and statue noted, the identifying attributes of the figure, gesture and dress interpreted and the personality expressed in the face recognised, could the statue be said to have achieved the purpose for which it was set up.

Monuments and Memory

The parallel between the function of the rhetorical memory system and the public *monumenta* suggests the possibility of direct links between them. Memory systems relied on placing images in a series of architectural places so that they would stick in the memory of the speaker. The purpose of the public sculpture of ancient Rome, sculpture that was almost always installed in an architectural environment, was to impress itself on the memory of the viewer. The basic principle of the memory system is described by Cicero: 'one must use many places [*loca*] which are prominent, spread out, with moderate intervals between them; while the images [*imagines*] should be active, sharp, distinctive, such as will readily suggest themselves and impress themselves on the mind' (*De Oratore*, II, 87, 358). The public buildings of Rome as erected and decorated over the next three hundred years embodied this principle brilliantly, as we can see from the best portrayal of them on the tomb of the Haterii, a family of building contractors (fig. 151). There we see how clear, distinctive images were carefully arranged at moderate intervals in prominent positions in order to imprint the message of the monuments on those who saw them. The 'places' used are exactly those recommended

151 Relief from the tomb of the Haterii showing monuments constructed under the Flavians (see also fig. 163), late first century AD.

by the Auctor ad Herennium in his memory system, 'intercolumniations, niches, arches' (III, 16, 29). Cicero refrains from going into detail about the memory system since, as he says, it is already 'widely popularised', presumably among precisely those ambitious young men who sought financial and political advancement through their skill at oratory and who were to use *monetae* and *monumenta* to such effect for the same purpose. If they were enabled to memorise their own speeches by peopling some remembered building with mnemonic images, they could well have applied the same technique in the real buildings that they put up to provide memorials of their own and the state's achievements.

This transference of the memory system to the real world may have affected the development both of Roman architecture and Roman sculpture. A tendency increasingly to assimilate buildings to arrangements of *loca* could well explain why during the first centuries BC and AD the external articulation of Roman public buildings increasingly exploits the use of those 'intercolumniations, niches and arches' favoured by the Auctor. Structural developments, such as the employment of concrete, certainly facilitated the increased use of the arch and the niche, and a desire for the display of wealth directly led to the ever increasing use of columns and half-columns, but it is extremely likely – and the Haterii relief would confirm it – that the desire to develop a visually effective or memorable setting for communicative sculpture directly encouraged a proliferation of such forms. In a more general way, the desire to concentrate on making buildings more effective as communications is also likely to have encouraged an increasing concentration on the façade relative to the rest of the building, something that is a distinctive feature of Roman architecture as opposed to Greek and especially of Roman imperial architecture.

In both developments the *scaenae frons*, or monumental rear wall of the theatre, may have played a catalytic role. Already in the Greek world of the second century BC theatres were acquiring elaborate permanent scene buildings with one or two rows of columns, but it was in Rome in the first century BC that such structures attained a new level of complication. Most remarkable was the temporary theatre erected by Scaurus in 58 BC and decorated, according to Pliny (*Natural History*, XXXVI, 4–8), with 360 columns arranged in three rows as well as 3,000 statues. There can be little doubt

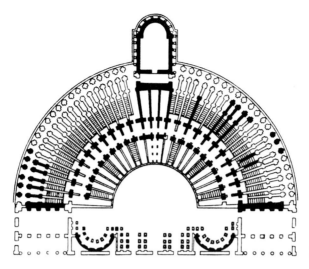

152 Theatre of Pompey, Rome, 55 BC, plan.

that the number was intended to represent the days through which the world turns during the solar year and it is tempting to relate it to the memory system of Metrodorus of Scepsis. According to Quintilian (*Institutio Oratoria*, XI, 2, 22), this was based on a series of 360 places found in the 12 signs of the zodiac. Metrodorus was a contemporary of Scaurus' father, himself a well-known orator, and was the protégé of Mithridates of Pontus. Scaurus was Pompey's lieutenant in his war against that same leader and it was wealth acquired in that war that paid for his extravagances as aedile. Since Metrodorus was celebrated as the greatest memory expert by both Cicero and Quintilian and since he was known for his hostility to Rome, it would have been an attractive idea to use a device associated with his name in a celebration and commemoration of Rome's triumph. We do not know how the statues were arranged or what they represented, but to judge by the use of imagery and inscription on Scaurus' coinage mentioned earlier they could well have been arranged as signs in relation to the 360 columnar 'places' so as to impress a message of victory on the memory of the Roman people. If the collection of statues and the 360 columns represented Rome's domination over the whole world they would have had the same significance as the number and variety of the wild beasts from many areas that were slaughtered in games on the same occasion.

Scaurus' temporary theatre worked so well as a propaganda monument that Pompey soon began a permanent theatre of similar magnificence (fig. 152). Its association with world conquest was indicated by the Temple of Venus Victrix situated at the rear of the seating in the centre. Plundered Greek works of art filled the portico behind the stage and a variety of exotic beasts were despatched at its inauguration. Little is known of its *scaena*, but the Severan marble plan of Rome shows that it already employed a colonnade which balanced rectangular recesses around a central curve framing the so-called royal door representing the entry into the royal palace that figured so frequently in tragedy. Nothing is known of the use of sculpture on this *scaena*, but there was a statue of Pompey elsewhere in the theatre, at the foot of which Julius Caesar was soon to be slain (44 BC), which may have been the one later placed above the theatre's 'royal door' by Augustus (Suetonius, *Lives of the Caesars*, Augustus, 31) as a memorial both of

Pompey's lost power and of the martyrdom of Augustus' adoptive father. Caesar himself planned a theatre to celebrate his authority, but it was erected only by Augustus who named it after his heir Marcellus, who died young. Subsequently his eventual successor, Tiberius, put up a statue of Augustus in this theatre, probably in the same position as that of Pompey in his, as the centrepiece of the *scaena*. Certainly imperial statues were put up in a similar position elsewhere, as probably at Orange. The rich columnar screens of later, first-, second- and third-century theatres must often have been adorned with sculpture. Whether or not particular stage fronts were intended as 'mnemonics' of empire, a possible influence of memory systems on their architecture may be discernible in their exploitation of complicated rhythms. Typical are the alternations of projections and recessions, and of curvilinear and rectangular niches, of the use of varying materials and different types of flutings to reduce the confusion of the extended series of shafts. Before such arrangements appear in architecture in the later Republic and early Empire they are already anticipated by the Auctor ad Herennium, who recommends that in order to avoid confusion in a memory system every fifth and every tenth place should be given a distinguishing mark. This is not to suggest that all such metrical arrangements indicate that the buildings in which they appear were intended to function as a set of 'places'. This can have been the case only occasionally. What is likely is that an understanding of the means used to impose order in complex memory systems would have helped patrons and their architects to minimise confusion in complex façades. Most Roman buildings were paid for by individuals who intended that they should enhance their power or status. They were thus built with more of an emphasis on making an impact on the viewer's consciousness and memory than those of any earlier culture, and it would have been quite natural for them to take account of such current theories about mental proclivities. Even if there was no direct influence from memory theory the ideas found there illustrate the sort of approaches that might have been generally current. We have only to go back to Polybius' explanation of the Roman camp, where, for instance, centurions' billets were placed at the ends of rows of tents, to find a broader basis for such principles of organisation.

While little is known of the degree to which *scaenae frontes* generally were intended to be experienced as mnemonics of world domination, there is direct evidence for this function in other related structures. One such is the Sebasteion recently excavated at Aphrodisias, erected to commemorate the reign of the emperor Claudius (fig. 153). The intercolumniations of three superimposed orders were filled with sculptural groups commemorating various provinces including the recently conquered Britannia, and it is possible that the three orders, Doric, Ionic and Corinthian, which here for the first time certainly appear as a series, were a similar evocation of comprehensive sway. Fifty years later at Miletus an enormous *nymphaeum* or monumental fountain was erected in honour of the father of the emperor Trajan and thus of the emperor himself (fig. 155). This too combined a rich series of sculptures with three rows of columns, one above the other, although here the resemblance to the *scaena* was suggested more directly in the series of projections and recessions. Here, as in many cities of the second and third centuries where such *nymphaea* large and small were erected, the message of the *scaena* was brought out of the theatre into the forum where it would imprint itself on the memories of all the citizens and not just theatre-goers. The combination of such a structure with a fountain basin guaranteed that the message would certainly be

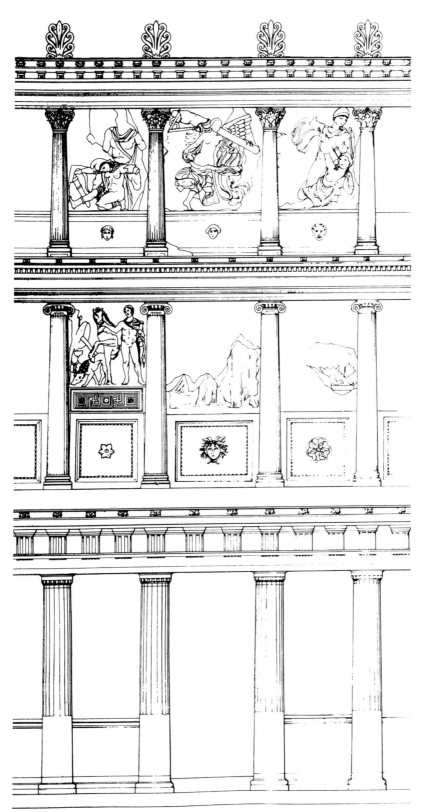

153 Sebasteion, Aphrodisias, second quarter of first century AD, reconstructed elevation.

154 Septizodium, Rome, dedicated in AD 203, drawn by Maarten van Heemskerk.

received, if only subliminally, by all who were tempted by the sight, sound or taste of refreshing water. Another related structure was the Septizonium or more properly Septizodium erected by Septimius Severus (fig. 154) as the southern façade of the imperial residence on the Palatine, a point from which it could greet and impress all who arrived in the city from the south, especially those coming from the emperor's native Africa. Probably also a fountain, its name suggests that it must have been decorated with statues representing the seven planets. These would have referred to the astronomical universe in rather the same way as did the 360 columns of Scaurus' theatre, their purpose being once again to publicise the universal domination of Rome and of the emperor himself. Yet another building that should be placed in the same category is the Pantheon as rebuilt by Hadrian (figs 147 and 201). This remarkable round structure was almost certainly dedicated to the seven planetary deities and the imperial family. As originally built by Agrippa, who wanted according to Dio to call it an Augusteum, it certainly possessed statues of Augustus and himself in the portico and of Julius Caesar inside. Probably also inside from the beginning were statues of the planetary deities. We know that it later housed statues of three of them, Mars, Venus and Diana, and seven such statues could be appropriately placed in the seven major niches that are hollowed out of the external wall. Since the hemispherical dome also rises to a height identical to the building's diameter, so that it can be understood to contain a sphere, this volume may again represent the world. Sitting in the building to give judgement, Hadrian would appear as world ruler, surrounded by the planetary deities and associated with Julius Caesar, Augustus and Agrippa, at one time Augustus' possible successor. The Pantheon was always an exceptional structure and should perhaps be thought of as resembling a *scaenae frons* curved round into a circle. Its arrangement of three curvilinear recesses flanked by four rectangular sections is found in many theatres either in the *scaena* itself or in the front of the *pulpitum* or stage. Whether in the theatre or the *nymphaeum*, in the Septizodium or the Pantheon, architecture could be carefully modulated for communicative effect, just like the phrases of a well composed speech.

★ ★ ★

155 Fountain building, Miletus, early second century AD, reconstruction.

Vespasian's Architectural Memory System

The Kaisareion at Aphrodisias was the first structure certainly to have employed the three Greek orders, Doric, Ionic and Corinthian, in a vertical series and it is likely that this combination was intended to carry the same message of universal domination as the sculpture. A similar combination has often been claimed for the Theatre of Marcellus, which would, indeed, have been an appropriate place for the usage to appear. Planned by Caesar, built by Augustus and subsequently adorned with his statue, the Theatre of Marcellus was once the principal setting for celebrations of Roman world power. This at least was the case until the construction of the Colosseum (fig. 156), the only building in the Roman world, besides the Kaisareion, to have firm evidence for the use of Doric, Ionic and Corinthian one above the other on its exterior, with an extra Corinthian row at the summit. Conceived under Vespasian to house the great games at which emperor and populace met to witness the many peoples and animals of the empire fighting and killing each other, it provided the theatre for the commemoration of an endless triumph. The combination of all the foreign orders on the exterior was a visible reminder of this. The other order that ran round the top of the inside of the building may well have developed this idea. Though damaged in the late Empire it is likely that this colonnade originally had capitals of the so-called Composite order, which first appears in this and other Flavian edifices and which may have been invented as a consciously 'Roman' form. As a combination of elements of the two best Greek orders, the volutes of Ionic and the leaf-covered bell of Corinthian, it is a striking symbol of the way in which the Romans took things from the territo-

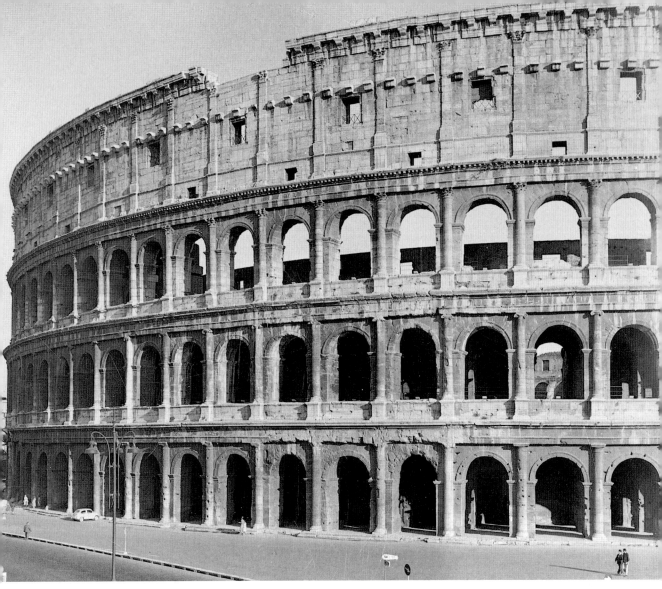

156 Colosseum, Rome, dedicated AD 80, exterior.

ries they conquered and did with them what they wanted. The thought that lies behind the contrast between the variety of the separate orders on the outside and their combination inside is also close to that expressed by Martial in one of the poems he wrote in celebration of the building's construction. As he says of the spectators who come from all the provinces of the empire to acknowledge the emperor at the inaugural games: 'diverse sounds the speech of the peoples, yet their voice is one, as you are called true father of the fatherland' (*Spectacula*, 3). So effectively does the Composite capital express its meaning that it also appropriately appears at the same time on Titus' triumphal arch and recurs later in the similar arches of later emperors (fig. 157). The orders of the Colosseum formed a set of 'signs' well calculated to impress the amphitheatre's meaning on the memory of those who saw and used it. The sculpture that filled its aches and intercolumniations would have functioned in the same way (fig. 151).

There seems to be a general relation between the memory systems popularised in

rhetorical education and the way architecture and sculpture were used on many Roman monuments. There may also be a more precise parallel between the way the memory systems were transformed in the period between the late Republic and early Empire and contemporary developments in art. One important change in the way memory systems are described between the Auctor ad Herennium and Quintilian is apparent in the discussion of the mnemonic images. While for the Auctor these are 'images' (*imagines*), for Quintilian they are typically 'signs' (*signa*). This change in vocabulary suggests a shift from a more 'representational' to a more 'symbolic' relationship, and 'images' used by the two different authors change in line with this. In one *imago* the Auctor proposes a genuinely pictorial image of 'Domitius raising his hands to heaven while he is lashed by the Marcii Reges' for the phrase '*Iam domum itionem reges*'. In another, in order to represent a case where a man is charged with killing another by poisoning in order to obtain an inheritance and where there are many witnesses, he visualises a man lying ill in bed with another at his bedside holding in his right hand a cup and in his left tablets and on the fourth finger ram's testicles (*Ad Herennium*, III, 21, 34). Quintilian goes into less detail but the images he uses suggest a more shorthand approach. His reference to a 'sign for navigation such as an anchor, or for warfare such as some form of weapon' (*Institutio Oratoria*, XI, 2, 19) implies less a pictorial representation, more a language of symbols. Quintilian gives no reason for his new

157 Arch of Titus, Rome, AD 80–85, detail.

158 Aeneas sacrificing to the household gods, detail of the Ara
Pacis, Rome, dedicated 9 BC (see also fig. 188).

approach, but his signs have the advantage of reducing things to their simplest essentials and avoiding complication and accidental detail.

The temptation to connect this change from 'image' to 'sign' with developments in art is encouraged by the remarkable parallel between Quintilian's ideas and the frieze of the contemporary Temple of Vespasian (fig. 159). This shows the paraphernalia of sacrifice arranged between *bucrania* or ox-skulls. The hat, the whisk, the jug, the knife, the axe, the dish for catching the blood, are all arranged in such a way as to provide a veritable mnemonic of the rite correctly fulfilled, with the ox-skull as its final product. The purpose of the relief is the same as that of earlier friezes referring to sacrifice. Only what had before, as on the altar of the Augustan Ara Pacis, been communicated through a naturalistic portrayal of the event, an 'image', is now communicated through a reduced set of 'signs' (fig. 158).

159 Entablature with sacrifical instruments, from the Temple of
Vespasian, Rome, AD 80–90.

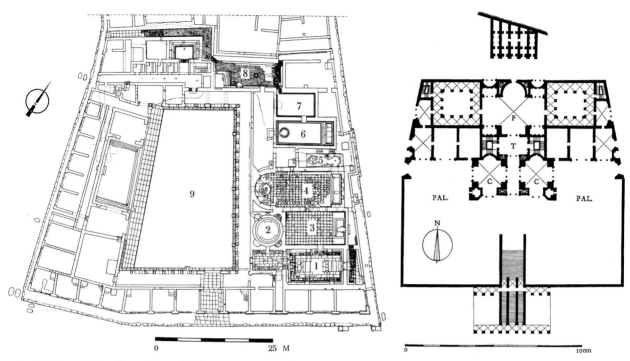

160 Stabian Baths, Pompeii, early first century BC, plan.

161 Baths of Titus, Rome, inaugurated AD 80, plan after Palladio.

There is a similar parallel between the changing approach to 'places' (*loca*) in the two rhetorical writers and the development of Roman architecture. While the Auctor talks without elaboration of 'a house, an intercolumniation, a niche, an arch' (*Ad Herennium*, III, 16, 29), suggesting no connection between them, Quintilian describes in some detail how his signs can be placed sequentially, as in the different rooms of a house, in a group of public buildings, in a long journey or the circuit of a city wall. The Auctor still thinks of buildings and parts of buildings separately, with little sense of their organisation in space. Quintilian, on the other hand, has no difficulty in conceiving of the spatial organisation of a larger architectural complex. The Auctor's perceptions are as appropriate in the early first century BC, when individual rooms and buildings were still only loosely related, as were Quintilian's to his own time nearly two hundred years later, when it was becoming common practice to arrange sequences of rooms and buildings along axes in such a way that all were related according to an overall scheme. After the Stabian Baths at Pompeii of *c.*80 BC (fig. 160) the Baths of Titus (fig. 161), one of the first of the great symmetrical imperial bath complexes, present a dramatic contrast.

A further indication of the relation between the development of the memory system and of Roman art is the way the Auctor spends much time on the images and little on the places, while Quintilian spends more on the places and less on the signs. In general there is a parallel shift in art during the same period, with painting and sculpture being more dominant at the beginning and architecture at the end. Thus for example, Cicero's letters of the mid-first century BC referring to villas show him to be

most interested in obtaining appropriate sculpture to decorate them, while Pliny the Younger in his, which were written in the early second century AD, concentrates almost entirely on their architecture. What this means in reality can be appreciated by comparing the high quality art (fig. 96) and unremarkable architecture of the House of the Faun at Pompeii with buildings such as Nero's Golden House and Domitian's residence on the Palatine (fig. 148), where the role of architecture is that much greater. Works of painting and sculpture are increasingly placed in such a way that our experience of them is controlled by their architectural setting. In the House of the Faun, the masterpieces of Hellenistic art, such as the Alexander mosaic, dominate the environments they occupy. In the House of the Vettii, also from Pompeii, as we know it in its last state before the eruption of Vesuvius in AD 79, the garden sculpture is all carefully positioned in relation to the enclosing peristyle, just as one might imagine Quintilian's signs to be in relation to a circuit of walls, and the paintings are with equal rigour subordinated to the overall framework of painted architectural elements (fig. 162). There is no doubt that the two successive accounts of the memory system to some extent passively document changes in a typical educated Roman's response to the man-made environment. It is, however, also possible that autonomous developments within memory theory may have actively influenced both the shaping of that environment and the formation of those responses. The system presented by Quintilian, with its sequential spaces and its neat symbolic 'signs', appears more effective than that presented by the Auctor, and such a system would also be even more effective if applied to the design of 'monuments' rather than to the memorisation of speeches. Quintilian's new formulation of memory theory must have served to confirm and accelerate existing trends within art and architecture.

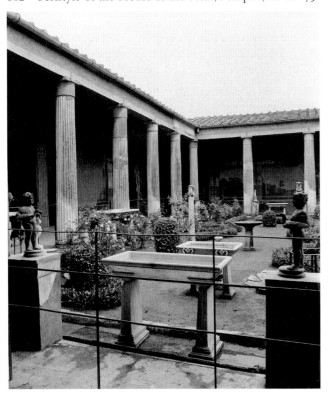

162 Peristyle of the House of the Vettii, Pompeii, AD 61–79.

Quintilian, the first rhetorician appointed with imperial authority, whose text book was to remain the standard treatment of the subject, was well placed to have a wide influence, and no individuals were in a better position to benefit from that influence than his patron, Vespasian, and his sons. As members of a dynasty lacking any legal claim to be the inheritors of the power of Caesar and Augustus, they needed to use every instrument in their grasp to cement and certify their authority. Perhaps no one felt this need more urgently than Vespasian's immediate heir, Titus. He was of an age to have been influenced by the great teacher of rhetoric, and it was he who commissioned the Temple of Vespasian with its great frieze (fig. 159), who constructed his eponymous baths with their sequential organisation (fig. 161), and who supervised

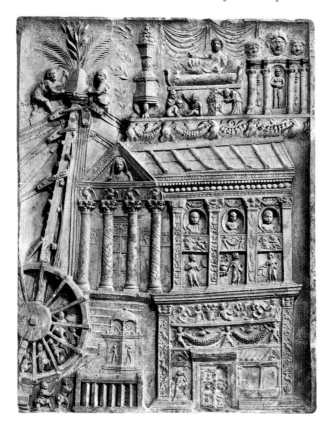

163 Construction of a tomb, relief from tomb of the Haterii (see also fig. 151), late first century AD.

the use of the orders on the Colosseum (fig. 156). He also probably conceived of his arch as a mnemonic of empire (fig. 157). If there were indeed a new consciousness in the design of these and other Flavian monuments it would explain the character of the remarkable reliefs on the monument of the Haterii who were probably the contractors for many of them (figs 151 and 163). The unparalleled series of buildings not only documents the Haterii's participation in that enterprise, in its identification of every capital-type and its careful representation of every frieze relief and every niche figure, it also seems to constitute the mnemonic of an extraordinary memory system. Better than the buildings themselves it details the impact of Quintilian's memory theory on imperial architectural policy.

Money and Monuments in the Later Empire

If the attitudes revealed in the texts on memory can be assumed to have had a wider currency, they may enable us to understand general developments in those arts where an impact on the memory was most important, and where also a monitory intention is implied in the name. Typical would be the coinage, *moneta*, and state monuments, both of which classes were used to disseminate political propaganda. The same would be true of sepulchral *monumenta*, which in the Roman world were above all intended to commemorate the life and virtues of their occupants.

The importance of coins for propaganda purposes increased rapidly during the first century BC with references to the exploits of distinguished ancestors giving way to the celebration of contemporary achievements. Augustus, having attained monarchical powers, found in the mint a ready-made vehicle for the consolidation of his authority. Throughout the Empire payment for goods and services relied on the exchange of coins, which were like minute posters. In much the same way as his will, which was publicly inscribed in many cities after his death, the coinage documents both Augustus' claim to rule and the merits of his achievements, beginning a tradition that continued under the other Julio-Claudians until the death of Nero in AD 68. On reverse faces victories, buildings, virtues, etc., all of which could be credited to the emperor, were epigrammatically identified by more or less simple portrayals of figures, architecture, and symbols accompanied by brief texts. On obverses the head either of the emperor or occasionally of a member of his family was usually surrounded by his titles. Then, with the accession of Vespasian in AD 69, a different pattern emerges. Topical references diminish in favour of the celebration of more lasting qualities, many of which retain their popularity for two hundred years. Among these *Abundantia* (Abundance), *Aequitas* (Equity), *Aeternitas* (Eternity), *Annona* (Corn supply), *Clementia* (Clemency), *Concordia* (Concord), *Constantia* (Constancy), *Felicitas* (Happiness), *Fides* (Faith), *Fortuna* (Fortune), *Liberalitas* (Liberality), *Libertas* (Freedom), *Pietas* (Piety) (fig. 164), *Providentia* (Providence), *Pax* (Peace), *Salus* (Safety), *Securitas* (Security), *Victoria* (Victory) and *Virtus* (Courage) figure repeatedly. Representations and texts are simplified and thus more easily memorable. If only subliminally, the citizens of the Empire were constantly reassured of the emperor's virtues and the advantages they procured for all. At the same time even references to contemporary events were increasingly reduced to instantly recognisable stereotypes of the most important moments when the emperor manifested himself to the people or the army. Such were the *Adlocutio* (Address), the *Adventus* (Arrival), the *Congiarium* (Largess) (fig. 165), the *Consecratio* (Deification), the *Decursio* (Parade) and the *Profectio* (Departure). By this means the vast majority of the emperor's subjects, who would probably never witness such manifestations, were constantly reminded that they had in fact taken place. Those who were present might handle 'souvenirs' of the event daily. Indeed coins bearing an *Adlocutio* or a *Congiarium* or a *Liberalitas* might be dispensed on those very occasions. The coin would then become a mnemonic of its own role in political exchange. One of the strongest indications that the mnemonic function of coins was increasingly recognised is the emergence tentatively in the first century AD and decisively in the second century of coinlike objects whose weight and materials made them unsuitable for circulation. These are the forerunners of the modern medal, whose function is almost entirely commemorative. The ability of a coin's type to impose itself on the memory was so well understood that this function could be separated from that of providing a medium of exchange. The gift of such medals on the occasion of the emperor's accession was a limited guarantee that the receiver would remember that event and all that it implied.

Two characteristic traits of Roman coinage thus emerge in the late first and early second centuries AD, at just the time that Quintilian was giving attention to the problem of memory. Whether there is any connection is uncertain, though those who were trained by him and those who later read his book are unlikely to have been untouched by the direction of his thoughts and he may himself be participating in what was already a wider a debate. What is beyond doubt is that the increasing

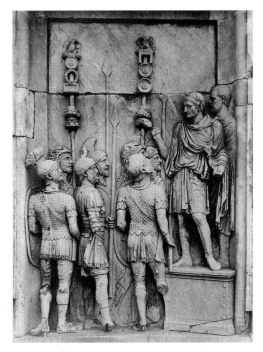

164 (*above left*) Aureus, Julia Domna, AD 213, with *Pietas*.

165 (*above right*) Sestertius, Nerva, AD 97, with *Congiarium*.

166 Marcus Aurelius addressing the legions, *Adlocutio*, relief of mid-second century AD, reused in the Arch of Constantine, *c*.AD 315.

prevalence of a limited range of types in which key words were associated with appropriate visual emblems responds well to his criticism of a memory method that relied on the constant creation of new and elaborate images (*Institutio Oratoria*, XI, 2), while the subsequent appearance of purely commemorative 'medal-like' issues implies a new focus on ways of impressing propaganda on the memory. For whatever reason, most imperial issues after the first century AD have reverses on which the representation is designed to illustrate a concept that can be summed up in one word and can be said often to serve as a sign for that word, and the concept to which it alludes.

There is a close parallel between the miniature reliefs on coins and medallions and the larger sculptures found on public buildings. Indeed in a sense the coin obverse provided a key to the subsequent reading of these larger reliefs. While the coinage made extensive use of inscriptions to identify personifications, and to explain which imperial attribute was indicated by a particular action, monumental reliefs usually had no written accompaniment beyond the dedication inscription of the whole structure. The interpretation of the sign language of such reliefs thus depended on the viewer's memory of the current 'dictionary' of coin types. This at least was the situation from the late first century AD onwards. Earlier, as we have observed, both coin types and public sculpture had tended to be invented on an *ad hoc* basis, albeit using existing conventions. Thus it is little use turning to Augustan coinage for help in interpreting the sculptures of the Ara Pacis, which are independent compositions in the Hellenistic tradition. By the time of Marcus Aurelius, on the other hand, almost all of the series of panels from his reign that were later reused on the Arch of Constantine could be readily identified as signs for events and virtues commemorated on contemporary or earlier coinage (fig. 166). Most obvious would be the appointment of a ruler (*Rex Datus*), address to the troops (*Adlocutio*), the arrival after a victory (*Adventus*), the departure for the campaign (*Profectio*), the largess indicating the emperor's *Liberalitas*, the sacrifice

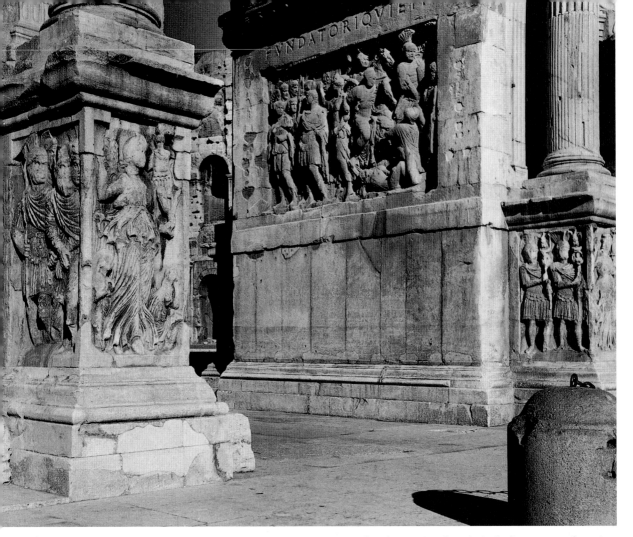

167 View of the Arch of Constantine, Rome, c.AD 315 (see also figs 168 and 222), including a reused section of Trajanic frieze, c.AD 117, showing a battle scene with the victorious emperor, with added inscription: FUNDA-TORI QUIETIS (to the establisher of peace).

representing his *Pietas* and the reception of prisoners suggesting his *Clementia*. Particularly revealing of developments in the late Empire is the fate of the great Trajanic frieze also reused on Constantine's arch. What had once been a vast pictorial composition mixing scenes of war and peace was broken into four separate sections in such a way that each became a sign rather than an image. This was most clear in the case of the two sections placed prominently either side of the central arch, since each was, unusually, given an explanatory inscription. A section full of incident showing Trajan on horseback in the midst of battle, a scene that suggested a VIRTUS coin type, was identified by the text LIBERATORI URBIS, 'To the liberator of the city', and the other showing a scene of battle, but including a figure of the emperor being crowned by Victory and received by the goddess Roma, was entitled FUNDATORI QUIETIS, 'To the establisher of peace' (fig. 167). Each was reduced to a mnemonic of an imperial attribute similar to those commemorated in Constantinian coins inscribed *Victoriae laetae princ perp*, stressing the emperor's virtues in battle, or *Beata Tranquillitas*, referring to the fruits

168 West end of the Arch of Constantine, Rome, c.AD 315 (see also figs 167 and 222) including, above, a reused section of Trajanic frieze, c.AD 117, showing prisoners, and, below, a Constantinian roundel of setting moon, with a section of Constantinian frieze, showing departure from Milan.

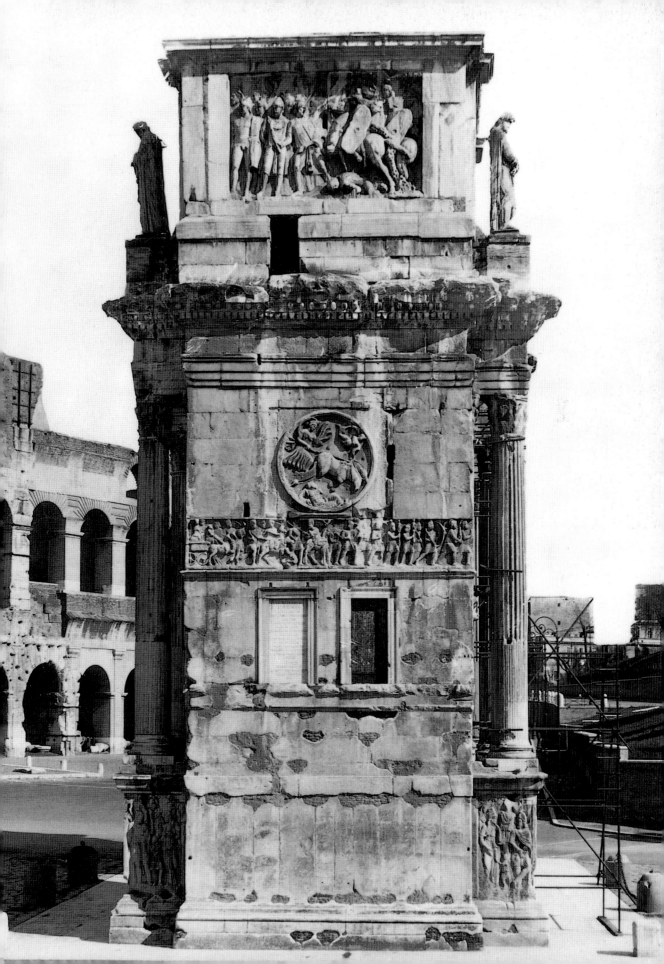

of his victories. The other two sections placed at either end of the attic, although lacking inscriptions, are made to carry a similar pair of unitary significations balancing the toil of war with the fruits of victory. That the one follows from the other is indicated by the two Constantinian medallions underneath; the rising sun under the combat is placed appropriately at the east end and the setting moon under the prisoners to the west (fig. 168). The two panels follow each other as night's rest follows the day's labour. Besides which the choice of rising sun and setting moon assimilates the pair of medallions to a *Profectio* and *Adventus*, the familiar visual emblems of the proper inauguration and successful conclusion of an imperial campaign. The signs are carefully chosen and placed to achieve the best presentation of Constantine's triumph.

However, the full import of the breaking up of the Trajanic frieze emerges only when we examine the main Constantinian contribution to the arch's decoration – the great frieze that runs round the whole monument, with two sections on each face and one on each end. The entire story of the war with Maxentius is reduced to four set pieces which, although nominally portrayals of events, are also reduced to single signs (fig. 221). On the west end is the departure from Milan (*Profectio*), then on the south face come two battles, the siege of Verona and the battle of the Milvian bridge, and finally on the east end is the arrival at Rome (*Adventus*). These four scenes of war are centred on the face away from the city, while the last two scenes on the north face towards the city celebrate the emperor's authority at Rome, itself summing it up in two familiar signs, the speech in the Forum (*Adlocutio*) and the Largess (*Congiarium*), the first documenting the acknowledgement of Constantine's authority and the second

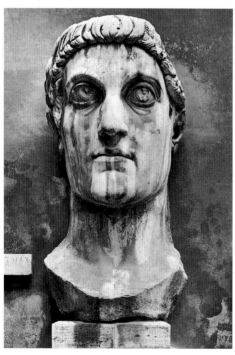

169 Colossal head of Constantine from the Basilica of Maxentius (Constantine), marble, *c.*AD 320.

(the last in the series of six reading from left to right) literally indicating the pay-off for his subjects. The reduction of historical narrative to these six sign-scenes can be compared, as was surely intended, to the spiral frieze of Trajan's Column which illustrated that emperor's two Dacian campaigns (fig. 149). There, although some of the later signs such as the *Profectio* of the *Adlocutio* already appear, in general we feel that we are presented with a documentary account backed up with much accurate representational detail in which the desire to record events takes precedence over the need to concentrate only on what is significant. Constantine's frieze is less like an 'image' and more like a set of 'signs'. Instead of the history of an uncertain conflict in which victory is attained chiefly through the devotion, discipline and energy of Trajan and his troops, we have the celebration of Constantine's completion of a military campaign in which his victory was almost preordained, since, as the arch's main

inscription tells us, he was 'inspired by a divine mind'. Taken together the six scenes represent almost the fulfilment of a ritual in which step follows correctly fulfilled step. An intermediate stage between the Trajanic and Constantinian friezes is provided by the spiral frieze of the Column of Marcus Aurelius where already history begins to take on the predictability of ritual as the army is led to victory by a philosopher / emperor supported by the gods.

Memorials of the Dead

The remaining class of major sculptural monuments of the later empire are the sarcophagi, the stone coffins that, from the second century onwards, replaced the ash urns and wall monuments popular in the preceding centuries and which in some ways recall even earlier Etruscan tomb chests. The change from cremation to inhumation implies an important change in attitudes to death. After AD 100 more and more people became concerned with the after-life and many believed that their actions in this world, their virtues or their membership of a mystery religion might help them to a better life in another. Such attitudes discouraged people from allowing their bodies to be cremated. They also led to a general change in the character and role of funerary imagery. The tombs of the republican and early imperial periods are chiefly concerned to preserve the memory of the dead individual as he or she was in life by recording as much information as possible on appearance, family relationships, offices, employment, etc.

The sarcophagi of the late Empire seem rather to support their occupants' claims for a better after-life based either on an affirmation of his or her virtues in this world or on a statement of his or her belief in the next (figs 172–6). In the earlier period there were a number of ways in which the memory of the dead individual might be preserved. The principal one was the inscription that gave his or her name and possibly details of a career; next in importance was the portrait bust or *imago* which was often a startlingly accurate record of age and health, including an enumeration of physical imperfections (fig. 143). More unusually the tomb might include sculpted portrayals either of activities in which the deceased had been involved or of instruments essential to his job, whether the tools of a trade or the insignia of an office. A remarkably elaborate example of a tomb in which all features were combined is that of the baker Eurysaces and his wife on the edge of the city of Rome (fig. 170). Its

170 Tomb of the baker Eurysaces, Rome, late first century BC.

owner was identified by inscription and he and his wife were portrayed by statues. The tomb itself was composed of stone cylinders, which are thought to represent the corn measures essential to his enterprise, and the baker's activities were represented on the frieze. As often at Rome signs, in this case the inscription and the corn measures, have their part to play, but they serve as a mnemonic of reality and are backed up by more directly imitative or as we would say representational images, the portraits and the reliefs. It is worth noticing that the Romans differentiated, as the Greeks did not, between imitation, the reproduction of the appearance of something, and representation, the recalling of something, so that it is presented to the mind in all its essentials, which could be done equally well by words, written or spoken, a picture or sculpture or even a building. Cicero, for example, talks of the temple of Concord 'representing' the memory of his consulship (*Pro Sestio*, 11, 26), while the distinction between imitation and representation is well made by Horace: 'If some person fiercely imitates the ferocity of Cato with a stern face and his dress by putting on a short toga, will he not "represent" his morals and behaviour' (*Epistles*, 1, 19, 14). The distinction is also alluded to by Quintilian when he distinguishes between an orator 'imitating' emotions and his 'representing' them. The essence of the distinction is that an imitation affects our senses directly, presenting them with a completely formed substitute for the real thing, while a representation affects the mind itself, working through the senses, but concentrating chiefly on conjuring up an image or experience to the imagination; it literally 're-presents' in the sense that it enables the mind to re-construct or re-call something no longer present. In this sense the whole tomb re-presents the memory of Eurysaces using the inscription and corn measures to remind us who he was, while the portrait and relief frieze offer more completely imitative images of him and his activities to our eyes.

The typical sarcophagus of the second, third and fourth centuries AD functions in quite a different way. The two elements that were most important earlier for preserving the memory of the deceased, the inscription and portrait, tend to shrink in size or even vanish (fig. 171). Indeed in many sarcophagi on which the dead person is identified with a figure on the sculptural decoration, that figure is the only one without a finished face. Apparently such sarcophagi were bought from workshops ready

171 Sarcophagus with unfinished head of deceased between tritons and nereids, mid-second century AD.

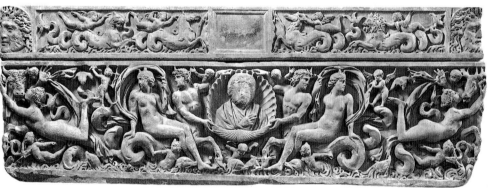

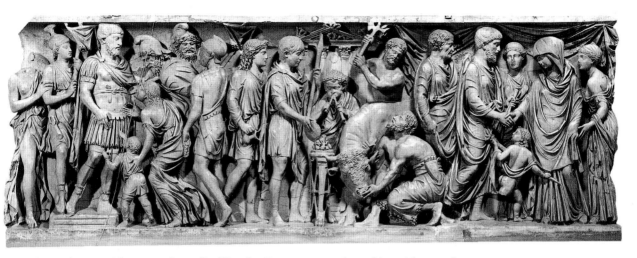

172 Sarcophagus with scenes from the life of a Roman general, marble, mid-second century AD.

finished and it was up to the purchaser to have a portrait added. That this sometimes did not happen indicates that for many people the preservation of individual features was not a critical function of the monument. The reason for abandoning cremation in the first place and for preserving the body in a sarcophagus was to give the individual both a better chance of a life after death, and, if the person had not had a good life already, a chance of a better one hereafter. It was thus to improving those chances that the sculpture chiefly addressed itself. Hence, even when the sarcophagus illustrates activities with which the individual was associated during his or her life, these are chosen typically because they commemorate significant virtues. Thus on an Antonine sarcophagus from Mantua three events are shown from the life of a Roman general, from left to right, his treatment of prisoners, a sacrifice and his marriage, three scenes that is that illustrate three major Roman virtues, Clementia, Pietas and Concordia (fig. 172). Another slightly later sarcophagus from the Via Tiburtina shows similar scenes on its lid and a much more ambitious tableau of battle on the front in which the general leads his troops in battle against Germanic cavalry. Here the supreme qualities of virtue, physical and moral excellence are recorded with great brilliance, although the face of the general (and of his wife) are left uncarved (fig. 173). The trophies that flank the scene are also 'signs' of virtue, as Cicero had indicated long ago in the *De Inventione*, 23: 'he erected trophies which all peoples saw as the insignia of military virtue and the *monimenta* of victory'. In these and other sarcophagi we find scenes carefully selected from a general's real life in order to emphasise his virtue. In others the battle scene has no reference at all to a real activity and serves only to suggest the deceased's qualities, by assimilating him and/or her to some heroic character from mythology, as in the sarcophagus of about AD 250 in the Vatican where the central group of Achilles carrying the dead Penthesilea after their great combat probably tells us that a husband and wife have 'fought the good fight' (fig. 174). Lion and boar hunts on sarcophagi have the same function. The virtues of their occupants are heroic and give them the hero's right to a superior existence in the hereafter. The same right was claimed by the occupants of the fine series of sarcophagi with scenes of the Labours of Hercules.

173 Sarcophagus with battle between Romans and German cavalry, from Via Tiburtina, marble, second half of the second century AD.

174 Sarcophagus with Achilles and Penthesilea with portrait faces, marble, c.AD 250.

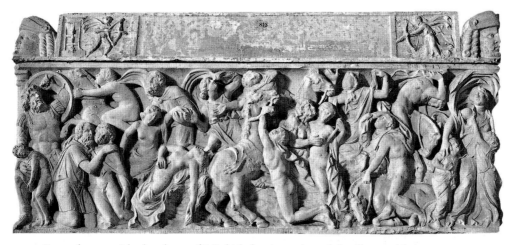

175 Sarcophagus with slaughter of Niobids by Artemis and Apollo, marble, *c.*AD 150.

The virtues of the occupants of all of these are understood to be heroic and to give them a recognised right to immortality.

Even earlier than these sculpted statements that assert a belief in the rewards for virtue are those that illustrate the related belief in the punishment of vice. Already in the early second century there are scenes of divine punishment. Typical are those that show either the gods collectively destroying the giants for their pride, or Apollo and Diana shooting Niobe and her children (fig. 175), or Diana procuring the death of Actaeon. A concern with the avoidance of error is the mirror of the pursuit of virtue and both emphasise the new focus on the relationship between morality and the after-life in the middle and late Empire. The attitudes implied were widespread but they may well have been particularly fostered by the example of the two emperors who dominate the second century. These are Hadrian (fig. 216) and Marcus Aurelius (fig. 131), the latter chosen by the former to be his eventual heir. Both showed a new concern with virtue and both were occupied with the problem of the deathlessness of the soul. It is appropriate that it is under their rule that sarcophagi first assert the connection between morality and the after-life.

For both Hadrian and Marcus Aurelius physical virtue should be accompanied by intellectual enlightenment. Both wore the beard principally associated with Greek philosophers, and each in his different way pursued wisdom. At the same time also during the second century bearded figures of philosophers holding scrolls appear on sarcophagi, often accompanied by the Muses as female equivalents, thus allowing both husband and wife a claim to higher knowledge. Among wealthier Romans there was a decisive resurgence in the tradition represented by Pythagoras, Plato and the Stoics that wisdom brought the soul closer to immortality.

Increasingly too a belief in immortality and resurrection was directly affirmed. Many reliefs show stories in which such a belief is more or less illustrated. Typical were those of Bacchus and Ariadne, the Rape of the Leucippides by the Discouri, and Hercules and Alcestis. By the third century Dionysiac resurrection imagery was particularly popular, including the Triumph of Bacchus, figures of the seasons and scenes of vintage. The changing of delicate fleshy grapes into a stable and storable chemical offered an

excellent model for the secure future desired by the fragile human being. The god of transformation and renewal in this world was in a good position to offer a new existence in the next.

The idea of associating some testimony of merit with burial was an old one, but at Rome it had taken on a new importance with the content of the speech in praise of the dead, which was a regular part of the funeral of prominent Romans, being easily turned into stone or bronze. One of the best examples is the long inscription that Augustus had set up in front of his tomb a year or so before his death. This, his *Res Gestae*, a record of his good deeds, was a plea before earthly judges recording as much good testimony as possible, including accounts of such hard evidence as decorations and inscriptions.

> For these services I received the title of Augustus by decree of the Senate. My door-posts were decked with laurel, a civic crown placed above my door and a gold shield was placed in the Curia Julia; that this last was decreed to me by the Senate and people of Rome because of my Courage [*Virtus*] Clemency [*Clementia*], Justice [*Justitia*] and Piety [*Pietas*] is testified by the inscription on it.
>
> Augustus, *Res Gestae*, 34

Augustus wanted the *Res Gestae* in front of his tomb to be read as evidence in the same way as the inscription in the Curia. So too did those who commissioned the later imperial sarcophagi with scenes so precisely illustrating qualities of *Virtus, Clementia, Pietas,* etc. Augustus was concerned to leave at his tomb testimony to be assessed by those who might judge him in this world. Many of those who commissioned the reliefs on second- and third-century sarcophagi were probably more concerned with judgement in the next. That is why the reliefs contain information not only about their moral qualities but also about their beliefs about the after-life.

This is presented as testimony not only to the living in this world but also before those who preside over access to the next. This means that the reliefs are in a sense legal evidence presented to judges and as such they may be again understood as 'signs'. They would thus correspond to the 'signs' discussed by Cicero in the context of effective pleading in the criminal courts (*De Inventione*, 1, 20, 47): 'a sign is that which is presented to one of our senses and signifies something which can plainly be read from it'. The reliefs on second- and third-century sarcophagi are signs to be read by judges concerned to assess the dead in terms of both their moral qualities and their beliefs.

Christianity: A Contract for the After-life

The general notion of testimony to moral excellence was an old one, as indicated by Cicero's near contemporary Cornelius Nepos: 'we can offer many testimonies of the moderation and wisdom of Timotheus' life' (*In Timotheum*, 4, 2). New attitudes to the after-life, however, gave it a new importance. This is most apparent in the funerary art of the growing community of Christians, the one group whose teachings on the subject have survived owing to their eventual triumph over all others in the fourth century. Christ's life, death and resurrection are presented in Acts as testimony of his message and Stephen is named as the first of many *martyroi*, that being the Greek word for

'witnesses'. Subsequently during the centuries of persecution that preceded the Edict of Toleration of AD 313 many thousands of Christians bore witness to their virtue and testified to their belief by their sufferings and deaths, confident that the witness's crown would win the reward of everlasting life. For Ignatius, bishop of Antioch, martyred under Trajan, the perfect end was for an animal to devour his body like a literal 'sarcophagus': 'Once I have died a martyr's death I will become a freedman of Jesus Christ, and I shall arise in him as a freeman' (Ignatius of Antioch, *Epistle to the Romans*, 4, 1).

Christianity was unusual in offering the opportunity of the direct testimony of martyrdom, but for most Christians it was obviously easier to testify to their belief through art rather than action. Many Christians, especially at Rome, testified modestly to their virtues and beliefs through the painted decorations of their catacombs and the sculptures of their sarcophagi. Among figures testifying to belief are the male philosopher type either holding or reading from a scroll representing the Testaments and the female *orans* figure with hands raised in invocation (prayer) (fig. 176). The nature of the

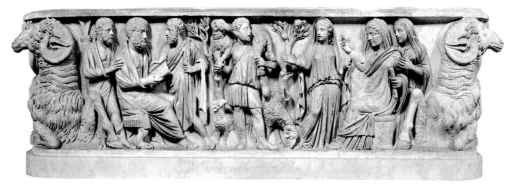

176 Sarcophagus with *orans* and philosopher, *c.*AD 270.

deceased's belief is illustrated by the figures of Jonah resurrected from the body of the whale, of the soul resurrected in baptism, of Noah rescued from the Flood, of Daniel saved from the lions, of the three boys protected from the fiery furnace, of Susannah defended from the false accusation of the elders, and, most frequently, by the figure of the Good Shepherd carrying the sheep that he has saved. All figures illustrate the belief in Christ's ability to give the soul eternal life in the 'peace' of paradise. We may well be intended to understand the figure with the scroll to be reading these very stories, just as the figure praying may be understood as explicitly asking to be saved in the same way as were the scriptural prototypes. The sculptures and wall-paintings are best understood less as illustrations of events than as the subjects of readings and the contents of prayers. For the person who commissioned them they constitute a reassuring record of personal faith.

More importantly they also document actions that are of interest to the Almighty, actions that might be reviewed as evidence in the Last Days. Proving your belief is one way into heaven: 'He that believeth hath everlasting life' (John 3: 36). Even if the sculpture and paintings were not legally admissible evidence they might be considered as

having some documentary value. This was because the quasi-legal certainty of Christianity as a religion was in the end one of its main attractions. Many other religious sects offered moral guidance and many offered rewards in the after-life, but none presented itself as such a coherent legal framework. Much of Christ's message was phrased in legal terminology. The Old and New 'Testaments', or 'Wills', were legal documents that recorded old and new 'covenants'. Christ himself was 'surety for a better testament' (Hebrews 7: 20). Baptism was a rite given legal authority by the 'sealing' on the forehead. The Devil was a *diabolos*, 'false accuser', and Christ a legal representative who at the Last Judgement could plead as an 'advocate with the father' (1 John 2: 1). The authority of this framework explains why when Ignatius looked forward to life after his martyr's death it was in terms of being legally freed. His death set in motion a formal process like that which turned a slave into a freedman. Fundamental to Christianity's appeal was that it took ancient Jewish ideas of a covenant between God and man and dressed them up in the legal language of Greco-Roman justice, with witnesses, advocates and a last judgement. The cross sealed Christ's new covenant and promised protection at judgement day. Perhaps Christianity's greatest single attraction over other religions making similar claims for a life to come was this quasi-legal organisation. It was almost certainly more to enhance this than for any other reason that the first churches built after the Edict of Toleration adopted the form and layout of the basilica, the typical setting for the administration of justice in the Roman world. The construction under Constantine of the churches of the Lateran and St Peter in Rome and others in the Holy Land in close imitation of such basilicas as the Basilica Ulpia in Trajan's Forum now provided a para-legal setting for what was already a para-legal relationship (figs 177 and 178). A covenant regularly renewed in a hall of justice offered unrivalled security at the moment of judgement.

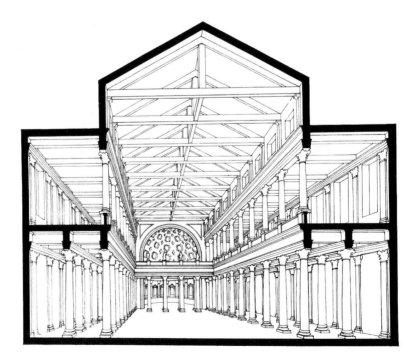

177 Basilica Ulpia, Rome, *c.*AD 110, reconstruction.

The use of the form of the basilica for the earliest Christian churches is highly significant. So too are the names by which the buildings of early Christianity were known, *memoria*, 'memorial', *tropaeum*, 'trophy', or *martyrium*, 'shrine of a witness'. Buildings such as St Peter's in Rome (fig. 223) and the Holy Sepulchre in Jerusalem were not thought of as the 'house of the god' (*aedes*) or the 'meeting place of his devotees' (*synagoga*), as had been the major buildings of other religions. They were instead monumental signs, mnemonics, trophies, testimonies, which derived their meaning by metaphor from some area of Roman life where signs were already accepted, the memory system of the rhetorician, the sign language of war, or the language of the law courts, where proofs in the form of signs were widely accepted as evidence.

The Sign of the Cross

The principal key to the legal framework of Christianity was the sign of the cross. The power of the cross had grown consistently as the Church expanded. The cross on which Christ had died for man was the very symbol of his victory over death. The witnesses who went willingly to their deaths for their faith were only responding to Christ's challenge to them to take up the cross and follow him (Matthew 16: 24). At an early stage the 'seal of God' that the servants of God receive on their foreheads in Revelation as a guarantee of God's protection (Revelation 7: 3; 9: 4, etc.) was identified as the cross and accordingly the baptised received the same sign as the mark of their entry into the Church. Tertullian around AD 200 says that whatever we are doing we should always trace the mark on our foreheads (*De Corona Militis*, 3). Such a mark was of course invisible and in that lay its power. To preserve that power and also to avoid attracting persecution the cross was regularly concealed in art under some other cross-shaped object such as an anchor or a boat under sail, two cryptic emblems that Clement of Alexandria (*Paedagogus*, III, 11, 59: 2) recommends Christians to use on their seals. Clement remarks in the same passage that the figure of a fisherman serves the same purpose: 'it will remind us of the apostle and of the children fished

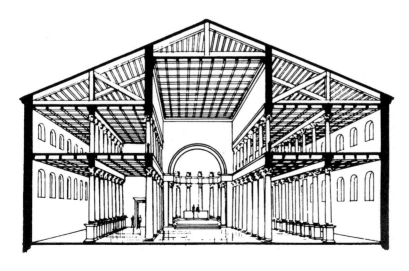

178 Basilica on Golgotha, Jerusalem, *c.*AD 335, reconstruction.

from the water', thus confirming the additional mnemonic function of such signs. But the most important aspect of the cross, and one that is emphasised by his recommendation for its use on seals, is its legal function within the overall context of God's covenant.

No one exploited the magical-legal authority of the cross more than the emperor Constantine. Indeed it may not be going too far to suggest that it was a desire to exploit the power of that sign that attracted him to Christianity in the first place. There is certainly little evidence for his interest in the new religion before he incorporated the cross, perhaps together with the Chrismon, the monogram of the first letters of Christ's name, on his standard during the Battle of the Milvian Bridge, which brought him his crucial victory over his rival Maxentius. Different accounts tell how the emperor either had a vision of the flaming cross accompanied by the inscription 'By this conquer' or saw the same sign in a dream and that he then attached the Chrismon/cross insignia to his standards. Most probably he simply capitalised on a growing belief in the life-saving power of the secret Christian sign. Christians who followed Clement and saw the cross in a ship's mast had probably already recognised the sign also in the similarly shaped cavalry standard, the *vexillum* or *labarum* consisting of a vertical post with a crossbar from which fluttered a banner. If there was already a secret current of opinion that found reassurance in this reading of a military standard, Constantine could only gain by sharing and disseminating the same view. The addition of the monogram grew out of a similar recognition that Christ's 'name' was the other protective sign besides the cross with which the foreheads of the chosen were marked in Revelation (22: 4). For those who knew – and even for those who had just heard it whispered – the *vexillum*/cross combined with the Chrismon/name constituted a double promise of salvation. How successful the assimilation between cross and standard was is seen in the way the cross is later itself commonly described as a 'standard' or a 'trophy of victory' and is shown as both on sarcophagi (fig. 179). When Constantine led his troops into battle protected by the sign that above all others was thought to guarantee victory over death he hit on an extraordinarily powerful visual idea. To publicise this he had a cross inserted into the right hand of his great statue in the basilica he had taken over from Maxentius. At the same time he added an inscription that credited his success to 'This salvation-bringing sign', and which also claimed that the cross was the 'true proof of bravery', thus implying that the emperor himself, by taking up the cross, was following Christ like a true martyr or witness. In Constantine's hands the power with which the secret sign had been charged by three centuries of devotion was suddenly revealed to stunning effect.

Charged with the traditional authority at once of a legal seal, and of a military standard, both objects called *signa* by the Romans, the sign of the cross had a greater power than any image. Indeed it is important that the cross is never referred to as an image or representation of the cross, but always as a sign (*signum, semeion*). There is no doubt that this practice was influenced by Moses' prohibition of 'images', but the cross as sign could never have achieved the status it did by the fourth century if all sections of the population of the Roman Empire were not by then mentally ready to acknowledge its power. Part of their readiness derived from its similarity to earlier seals and standards, the two principal 'signs' in the civil and military worlds. Other factors were its resemblance to signs, symbols and schemata that were already current among different

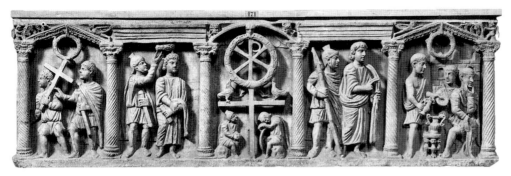

179 Sarcophagus with cross/*vexillum*, fourth century AD.

groups. For the superstitious Romans, who already took signs very seriously, it recalled the augural cross that guaranteed the security of city and camp. For the Pythagoreans it recalled the capital Greek upsilon or Y which they used to indicate their secret knowledge of the choice of two alternatives facing humanity, the one leading to death and the other to immortality. For someone familiar with Egyptian religion it recalled the ankh, symbol of life-giving light. The power of the cross to hold the attention of the late Roman world was based on the cumulative importance of similar signs. Between them all the cross was in a sense a common denominator.

Those to whom it meant least were Greek pagans and philosophers. When Paul at 1 Corinthians 22 says that 'the Jews demand a sign and the Greeks wisdom' he rightly contrasted the cultural and religious values of the Greeks and the Jews. The Jews, like other non-Greek cultures, believed that divinities communicated with man through signs such as miracles and they looked for a sign they would recognise as a proof of Christ's divine authority. The Greeks, who had come to see a cosmic intelligence as the ruling principle of the universe and who sought to assimilate themselves to that intelligence by increasing their own understanding, sought rather in Christ's wisdom for a proof of his divinity. The claim that Paul advanced in the next verses was that the Crucifixion was both a sign that should satisfy the Jews and a proof of God's wisdom that should satisfy the Greeks. By the fourth century that claim had been justified. The cross could be seen by inhabitants of the Roman Empire both East and West as offering legal evidence and almost mathematical proof of God's plan for man's redemption.

For this to happen the world had to be turned upside down. St Paul already in the first century recognised that the values of Christianity were the converse of those of Classical culture. The Greeks saw the Crucifixion as a 'stupidity' (*moria*), the Christians saw it as a revelation of God's wisdom (*sophia*). God's 'stupidity' is wiser than man and His weakness is stronger than man. Few among the Christians at Corinth were powerful or wise or of high class. God had chosen those things that the world thinks stupid and weak and contemptible in order to bring down the wise and the strong. A principal attraction of Christianity was that it inverted the values of Greek and Roman society. Under paganism the supreme image was a representation of the most powerful deity, Zeus/Jupiter. Under Christianity the supreme image was the cross. The change from an over life-size naturalistic image of Zeus, such as that by Pheidias at

Olympia of *c.*450 BC, to the small and simple sign of the cross was emblematic of an inversion of values. Pheidias provided evidence of his and his fellow Greeks' wisdom and power and status by making an image that directly captured the wisdom, power and status of the greatest of the gods. The values of public art and religion in Greece in the fifth century BC corresponded to those of society. It was strength of body and mind that had just brought the Greeks victory over the Persians. The sign of the cross commemorated other strengths and another victory, the strength of the soul and victory over death. It was equally powerful whether marked in water on the brow of the baptised, set in jewels on the casing of the True Cross at Jerusalem or made visible in the ground-plan of a church such as St Peter's. Even a cross marked on the empty air with the finger promised to the weak and inferior of this world admission to the elite of the next. It was not that the worldly values of the fourth century AD were very different from those of eight centuries earlier. Rather that the values of the other world had become so influential that they affected those of this.

Constantine's statue in the apse of the Basilica of Maxentius was as gigantic an embodiment of power, wisdom and status as Pheidias' great statue at Olympia (fig. 169). Yet the only way he could assure himself of his power, demonstrate his wisdom on the highest matters and provide proof of virtue in the noblest field was to take in his hand the flimsy emblem of the cross. Backed by its magic power over death he could conquer his enemies in battle and claim entry into the City of God after having ruled in the City of Man. The statue was the proof of his wisdom, power and status in the terms of the secular and pagan worlds and the cross was the proof of his wisdom, power and status in spiritual and Christian terms. Put in another way, like the Greeks of St Paul's phrase, the pagans would read his *sophia* from the statue and the Christians, like St Paul's Jews, would find in the cross the approved *semeion* or sign. Nothing demonstrates better the importance of the 'sign' in ancient Rome than the ultimate triumph of this simple configuration.

Chapter Six

ROME AND THE CULTURE OF IMAGINATION

Beyond Reason

'For it was Rome which first showed that the power of speech [*logos*] could not reach everything' (Aelius Aristides, *Orationes*, 26, 6). When a brilliant young Greek indulged in this hyperbole soon after Hadrian's death he was hinting at an elusive truth. Although he was referring directly to Rome's physical appearance (fig. 180), the city becomes implicitly an image of empire, and when he compares her appearance, as he does with great persuasion, to falling snow, rising mountain peaks, the soil of the earth and ultimately the sea he tries to capture a grandeur and infinity that belong to both. The whole mystery of Rome he sums up by reference to the correspondence between the city's Latin name, Roma, and the Greek word for 'physical strength', *rhome*. In Greek both could be written the same way. Before the Roman empire the power of other cities and countries had been within the compass of that act of analysis and description summed up in the Greek word *logos*, rational speech. The power that was Rome placed her beyond the most celebrated power of Greece, reason.

If the Greeks crossed a new threshold when they showed how the confusion of the experienced universe and the complexity of man's behaviour could be brought within the bounds of comprehensibility and order by the application of reason, the Romans crossed another, one whose significance is still little understood, but which effectively transcended those same bounds using the power of the imagination. First the generals of the late Republic and later the emperors of the first and second centuries AD created a world in which not only they themselves and those who benefited most directly from the new wealth and power, but a whole population shared the experience of a transformation in man's relation to his environment. Worshippers at Sulla's shrine of Fortuna Primigenia at Praeneste in the early first century BC had an early taste of this, but it was left to the users of the great imperial baths of Titus (fig. 161), Trajan, Caracalla and Diocletian to know how far the transformation could be taken. The visitor who mounted the terrace of the Baths of Caracalla in the early third century (fig. 181) found himself in a new world nearly a quarter of a mile square where the familiar laws of nature no longer applied. The multiform painted vaults far above were supported by shifting walls and colonnades clothed in exotic marbles. The baths them-

180 Rome, showing the Circus Maximus and Palatine, from a model in the Museo di Civiltà Romana.

selves provided a series of alien microclimates ranging from the cold swimming pools to the steamy atmosphere of the sweating room. Nature responded obediently to human whim and fancy, offering fountains, lawns and gardens. Art offered him such spectacles as the Farnese Bull and hundreds of square yards of mosaic floor. A willing personnel of barbers and philosophers, masseurs and librarians, could offer him almost any pleasure or stimulation his mind or body might crave. There was little relation between what he found there and what nature would have offered him on the same spot five or even two hundred years earlier. The rich in their houses and villas could spend longer in reduced versions of such wonderlands, but the emperor himself could hardly ask for more. Even his palace was dwarfed by the spaces of the people's baths. Everybody, from the emperor to the ordinary citizen, was able to spend some time in an environment that was entirely artificial, a world of fiction no longer subject to the laws of nature. In earlier times this had hardly been possible for the most powerful individual, let alone for a whole community. Not until the nineteenth and twentieth centuries was it to be true again.

This transformation in man's relation to nature did not occur without considerable strain, and the signs of this are already visible in the first century BC. Such was the impact of the transformation on the minds of those exposed to it that its effects were

181 Baths of Caracalla, Rome, AD 212–16, from a model in the Museo di Civilta Romana.

felt even after the resources to make it possible ran out in the fourth century. People who have to some extent lost contact with reality have a greatly enhanced ability to survive on their imaginations.

Metamorphosis and the Magic of Augustus

Aristides in the second century AD welcomed the fact that Rome was beyond the reach of *logos*. A hundred and fifty years earlier such a view would have been regarded as new and dangerous. Vitruvius writing on architecture around 25 BC could criticise the contemporary tendency to reject wall-paintings that imitated real architecture and landscapes in favour of irrational conflations of architectural and natural forms:

> But these which were copied from real things are now disapproved of by unbalanced tastes. For now they paint on plaster monsters rather than sure representations of definite objects. Instead of columns they erect fluted reeds; instead of pediments decorative panels with curling leaves and volutes. Again, candelabra are shown supporting images of shrines and above their roofs many shoots rise with volutes having figures seated in them in an irrational way; other stalks carry divided figures some

with human some with animal heads. Such things neither are, nor can be, nor ever have been. Thus new tastes have forced bad judges to condemn good art for lack of quality. For how can a reed support a roof or a candelabrum the ornaments of a pediment, or a stalk so slender and soft carry a seated figure, or how can flowers and half-figures grow out of roots and stems? Yet when people see these falsehoods they do not criticise them, but delight in them instead and never think whether any of them could be or not. Minds clouded by poor judgement are not able to recognise that which is permitted by traditional rational principles of appropriate decoration. For paintings cannot be approved of which do not correspond to the truth, nor should they be judged correct just because they are executed with skill and refinement, but only if their handling follows sure principles with no deviations.

De Architectura, VII, 4

What offends Vitruvius in the new type of wall decoration is its abandonment of the principle that all art should follow the example of natural reality. Art should be limited to the representation of things that really could exist. A painted building should be one that could be built and should not include elements from the plant and animal world. A painted creature should be of a single species and not an invented mixture.

These protests are no idle rhetoric. Earlier wall decorations, now conventionally identified as the Pompeian First and Second Styles, had, like other forms of painting and sculpture within the Greek tradition, portrayed only what was, what had been or what might be, whether it was mythology, history or everyday life, landscape or architecture (fig. 182). The new style of decoration, the so-called Third Style, so well-known from Pompeii, shows buildings that could not possibly exist. Besides having slender forms they often incorporate natural forms in architectural roles and are liberally populated by creatures of mixed parentage (fig. 183). More remarkably, far from being an isolated deviation, such works were to become the dominant trend, virtually replacing the earlier styles with their fidelity to the rules of art and nature. Vitruvius expresses the fear of someone standing at a turning point in the history of art, when, after six hundred years, the studious imitation of reality begins to be replaced by free and fantastic invention. His contemporary, Horace, is appalled by the same trend in literature:

If a painter would join a horse's neck to a human head and clothe a miscellaneous collection of limbs with a varied plumage, so that a beautiful woman above would end in a black fish below, would you, my friends, be able, if you saw it, to refrain from laughing? Believe me, Pisos, a book whose empty fictions were fashioned like a sick man's dreams, so that neither foot nor head could be credited to a single form, would be just like such a painting. You may say that painters and poets have always had equal power of bold invention. We know it and we seek and give the same licence; but not to the extent that the wild would mate with the tame, snakes mate with birds or lambs with tigers.

Ars Poetica, 1–13

A few lines later he explains how such distortions occur, comparing the writer's fancy to the moist clay of the potter:

You begin a wine jar. Why does it become a jug even as the wheel turns? . . . Most

182 Wall-painting from a villa at Boscoreale, *c.*50 BC, so-called Second Style (see also fig. 212).

183 Wall-painting from a house at Pompeii, *c.*AD 50, so-called Third Style.

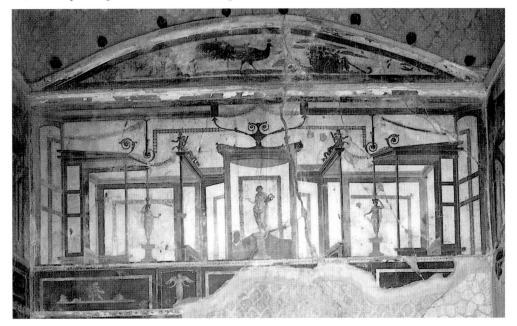

poets are deceived in pursuing only the semblance of what is right . . . one who desires to elaborate his subject in an unnatural way paints a dolphin in the woods and a bear in the waves.

Ars Poetica, 21–30

The correspondence in tone between the two authors is so close that they must both be addressing similar phenomena, even if in poetry the trend was not so strikingly visible and if the critical standards that in later centuries ensured that Horace should be preserved also deprived us of personal knowledge of the works he detested. We are left with no recordings of the mad performing poet with whom the *Ars Poetica* ends. We can only guess at what the poetic equivalent of Third Style frescoes might be. Both, though, were seen by their critics as being irrational and false in terms of the values slowly built up by the Greeks, values that the emperor Augustus, indirect patron of the two writers, was anxious to have promulgated. Similar values were also publicised in the work of another author whom he sponsored, Virgil. The *Georgics* tells how agriculture thrives when every action is chosen and timed to fit nature's scheme. The *Aeneid* too offers an epic image of a hero governed by moral standards.

Augustus may have been anxious to disseminate such conservative values among his contemporaries, but he did not allow them to limit his own expression. In the architecture and interior decorations with which he was himself directly associated he did not observe Vitruvian rules. Vitruvius dictated that according to the cardinal principle of decorum temples to manly deities, such as Mars, should be in the Doric order. The

184 Temple of Mars Ultor and Forum of Augustus, Rome, dedicated 2 BC (see also figs 187 and 190).

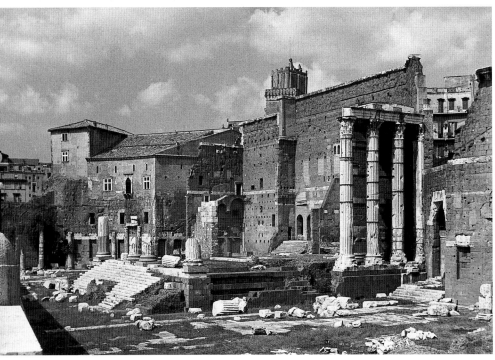

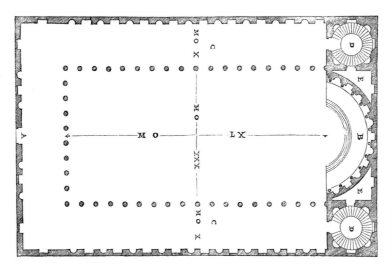

185 Basilica according to Vitruvius, *De archictectura*, plan after Palladio.

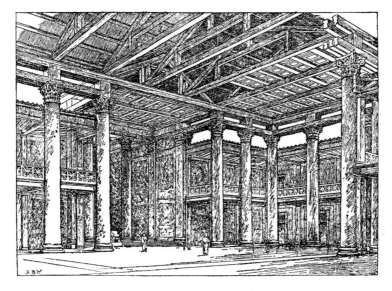

186 Basilica designed by Vitruvius at Fanum Fortunae, *c.*20 BC, reconstruction.

Temple of Mars Ultor, which was the centrepiece of Augustus' Forum, was in exuberant Corinthian (fig. 184). Its apsed termination is nowhere accommodated among Vitruvius' temple forms. Again, Vitruvius gives one set of rules for the design of a basilica (fig. 185) and then describes the much freer version he built for Augustus at Fanum Fortunae (fig. 186). Instead of a rectangular box he laid out one long space with another broken out of the side beyond a curved exhedra. Instead of short freestanding columns of uniform height he introduced giant supports with smaller ones attached lower down. In Augustus' own house on the Palatine, although much of the decoration would have been approved by Vitruvius, some walls breach the principles of Vitruvius and Horace to create a world of fantasy. Elsewhere it is the law of nature itself that is denied. On the Ara Pacis dedicated in Rome in 9 BC the luxuriant vegetation that celebrates the fertility of peace performs wonders with lush acanthus sprouting the leaves and buds of several other species (fig. 188). The greatest miracle is suggested at the top of the hybrid plant, with the assimilation between the curving

fronds of the palmette and the wing feathers of the swan perched alongside hinting at a more remarkable transformation. Whatever principles were propounded by others in his name, Augustus himself often flouted them.

The main reason why he did so was to establish his status as absolutely superior to that of other men. This might just have produced an aesthetic anarchy, such as existed under his predecessors. His aesthetic, however, although full of licence, was still directed by some purpose. What he wanted to do was not just to show his power, but to show how it had benefits for his subjects. By combining disparate elements in just the way that his writers discouraged he could communicate the benefits of his rule. Above all he demonstrated his ability to take the resources of the whole empire and combine them for the benefit of the people, placing the natural and cultural wealth of the Mediterranean and beyond at the disposal of the citizens of Rome. This programme is most apparent in his Forum. There he brought together and combined the treasures of the world as no one had done before. Under their feet the Romans trod coloured marbles from alien mountains. Around them they saw the trophies of campaigns in distant provinces. The architecture of the complex included the original caryatids from the tent of Alexander, copies of the caryatids of the Athenian Erechtheum, stone shields decorated with heads of the great Egyptian god Jupiter Ammon, antique paintings by Apelles and new statues of the great men from a thousand years of Roman history. All was compressed into a single hieroglyph of Roman power. In the centre of the Forum, in the cella of the Temple of Mars Ultor itself, the pilaster capitals sprouted leaves that sprouted horses that sprouted wings in as novel an invention as any derided by Vitruvius or Horace (fig. 187). The Greeks had patiently studied the laws of nature, of history and of art and had carefully adjusted their actions to those principles. Augustus made clear that he had transformed nature, changed history and taken control of art. He showed how he had reshaped the world so completely that earlier laws could be unmade and rewritten. His was the achievement, its beneficiaries the Roman people.

An evocative witness to that achievement and a poet who had the courage to challenge the rules of Vitruvius and Horace was Ovid. The fifteen books of his *Metamorphoses* or *Changes of Form* are a veritable hymn to transformation as a universal principle. It is a monumental history of the world in terms not of rational material actions by gods, heroes and humans, as the Greeks had written it, but as a chronicle of examples of miraculous change and transubstantiation: 'My purpose is to tell of bodies which have been transformed into shapes of a different kind.' His tale begins effectively with the shapeless and disordered mass of primordial chaos and ends with Augustus ruling the world. In between we are led from Creation, through the changing sequence of the Gold, Silver, Bronze and Iron Ages to the Flood, then past the recreation of the human race from the stones cast by Deucalion and Pyrrha and on through the myriad transformations chronicled in Greek

187 Capital from the Temple of Mars Ultor, Rome, late first century BC.

188 Detail of the Ara Pacis, Rome, showing acanthus sprouting other plants, dedicated 9 BC (see also fig. 158).

myth until Aeneas transports the remnants of Troy to Italy where the community reemerges as Rome founded by Romulus, who dies and is transformed into a god. In the last book, Pythagoras, the Greek philosopher who had himself moved to Italy, epitomises the story in a long speech reviewing the mutability both of nature and of human history until Troy is reborn as Rome. The whole poem ends with a dramatic sequence of images. The Greek god Asklepios migrates by boat to Italy in the form of a snake and emerges as the Latin Aesculapius on the Tiber Island. Caesar becomes a god. Finally, one man, Augustus, controls all habitable lands and even the seas. In this epic, composed only a decade or two after Vitruvius, Horace and Virgil's *Aeneid*, Ovid rewrites human history, so that the principle on which the power of Rome and Augustus is founded becomes a universal thread. The neat categorisations of Greek science that would distinguish stone from flesh, hair from leaves, Troy from Rome, Greek from Latin and man from god are replaced by a Roman view that anything can become anything else. It was a poignant response to this vision that Ovid was exiled by his admired emperor before the work was completed. It is tempting to guess that, whatever the professed reason for the sentence, Augustus disapproved of the literal exposition of a message that was more mysteriously expressed visually.

One of the most obvious form of metamorphosis is that involved in the making of any work of art. There the raw materials of nature are turned into something else or a representation of it, a process that is explicitly referred to in two poems of Catullus written under Augustus' adoptive father and model Julius Caesar. The poem on the wedding of Pelius and Thetis begins dramatically with a reference to the 'pine born on mount Pelion', which becomes the ship *Argo*, while another tells the story of his own yacht the *Phaselus*, which began life as a forest in Asia Minor, was then brought to Italy and ended its life sailing on Lake Sirmio. A playful image that had begun life as a rare figure of speech in Hellenistic epigrams is already half way to becoming the grand vision of Ovid. Horace too employs the same idea in *Satires*, I, 8, though in a more dubious context. A statue of Priapus tells how it began life as a fig tree, narrowly escaped being made into a stool, and now stands on land that was a paupers' cemetery before it became the garden of Augustus' supporter the wealthy Maecenas. There it witnesses the nocturnal activities of a couple of witches who fabricate two images, one of wool and one of wax, and burn them, only to have their rites rudely interrupted when Priapus' wooden buttock, heated by the fire, splits open with a loud crack. For Horace the idea of metamorphosis is perceptively associated with magic.

Probably at some time between the poems of Catullus and of Horace a real work of art was made that anticipates Ovid's epic on a much grander scale. Still visible at the downstream end of the Tiber Island in Rome is a large mass of travertine which has been carved into the shape of a ship's stern decorated with a bust of Aesculapius holding a snake (fig. 189). The island, which housed the god's shrine, is thus assimilated to the boat that brought him, with the vestigial remains of the petrified vessel suggesting that the boat had turned to stone in proof of the permanence of his removal from Greece to Italy. Ovid took the journey of Aesculapius as emblematic of the migration of the beneficial aspects of Greek culture to Italy. He also, in the middle of Book XIV, described how the ship of Alcinous 'slowly hardens' and 'rock covers its planks' (*Metamorphoses*, XIV, 564 and 565) in an exact re-enactment of the stages of transformation of the Tiber Island. The date of its transformation is uncertain. If, as is usually

189 Tiber Island turned into a boat, Rome, probably first century BC.

thought, it is of the mid-first century BC, Ovid's text may be directly inspired by the island's metamorphosis. If it is of the first century AD, and the placing of an Egyptian obelisk at the centre of the island in imitation of a mast can hardly be earlier, the inspiration may have worked the other way round. Whichever sequence is correct, either Tiber Island or text may have eventually inspired Claudius (AD 41–54) with the idea of filling with stone the gigantic ship used by his predecessor, Caligula (AD 37–41), to transport an obelisk from Egypt, so turning the vessel into an island mole protecting the harbour of Rome's port at Ostia. The closest we can get to linking this aspect of Ovid's theme to the artistic activity of Augustus himself is through the boast credited to that emperor by Suetonius, that he 'found Rome brick and left it marble' (*Lives of the Caesars*, Augustus, 28). This implies that Augustus was proud to have transformed the substance of the city from a low grade local material to a high grade one imported from far away, and if any building illustrated the same idea it was the Forum of Augustus itself, which was surrounded on the outside by a huge wall of rough local tufa but which inside was entirely covered with polished marble. Anyone who passed the arch separating the city street from the Forum would have experienced an almost magical transformation in his ordinary environment (fig. 190).

Metamorphosis of Nature

The transformations of the late Republic and early Empire were impressive enough, but those that were wrought in the first century AD were far more thoroughgoing.

190 Rear entry wall of the Forum of Augustus, Rome, showing the Temple of Mars Ultor inside, late first century BC (see also figs 184 and 187).

Individuals were able to indulge their whims and the emperors came to see that they could use the control of nature as one of the most effective demonstrations of their power. As Suetonius said of Caligula: 'he constructed moles in rough and deep seas, made cuttings in cliffs of the most resistant flint, raised plains to the level of the tops of mountain and by digging brought mountain peaks down to the level of plains' (*Lives of the Caesars*, Caligula, 28). His successor, Claudius, used similar skills, but turned them to the common good, as in the adaptation of the boat used to transport an Egyptian luxury into a defence for Ostia, the port of Rome, deliberately designed to ensure the city's vital supply of Egyptian grain. For him a demonstration of power over nature was an excellent way of making up for his lack of the military achievements of his exemplary predecessors Augustus and Tiberius. Even the one great military campaign he entered on, the conquest of Britain, was probably intended not so much to demonstrate his might over the unimpressive islanders as to prove his power over water by extending the empire beyond the 'Ocean', as the inscription on his triumphal arch recorded. The same control over water was proved by his digging of an enormous tunnel so that the Fucine lake could be drained in one go at a great performance accompanied by gladiatorial contests. More important, though, for the people of Rome was his improvement of their water supply, by building a vast new aqueduct, the Aqua Claudia, just as he had guaranteed the crucial supply of grain by building the new harbour at Ostia. The theme of all these works he articulated in a new architectural treatment that emphasised a similar control over stone. Their most unusual feature is their use of a new and emphatic form of rough masonry. The best example is the double arch that carries the Aqua Claudia over two of the main roads into Rome just when they enter the city (fig. 191). At the bottom are arches of what looks almost like raw rock. Above, too, the stone is left extremely rough, even on the columnar elements that traditionally had been the objects of the most refined handling. Not that the treatment is uniform. While the columns themselves are not just rough, but actually made up of blocks shaped like roughed-out capitals, the capitals they carry are relatively finished. The piling up of capitals in different stages of completion and the variation of treatment from rough to smooth throughout the structure suggest that it is intended to express transformation, the metamorphosis of rock into architecture, nature into art. At

191 Porta Maggiore, Rome, *c.*AD 40.

192 Harbour portico, Ostia, *c.*AD 40.

Ostia a different but similar combination of rough and smooth masonry in the shafts of a grand portico in the harbour can be interpreted in the same way (fig. 192). Since both are exceptional we may connect their character with their settings on buildings chiefly associated with the supply of raw materials. Water and corn were the principal needs of the Roman populace and the rusticated masonry is used at two places where citizens could witness the two materials entering on the last stage of their journey. The stone half-way to being finished was an appropriate expression of the fact that the corn was half-way to becoming bread and the water half-way to becoming a bath, a drink or indeed to being mixed with flour to make dough. Those who saw the stone in a state of transformation would be reminded of the emperor's magic in arranging for the transformation of the other substances. It was fitting that the basement of the Temple of the Divine Claudius, built after his death, should makes a last final display of the same device (fig. 193). The two storeys with their alternating bands of rough and smooth travertine rising between the rock of the Aventine and the finished marble of the shrine were a worthy commemoration of the emperor's distinctive achievement.

Nero (AD 54–68), however, succeeded Claudius and he reverted to self-indulgence

in his transformation of a large part of Rome from city back into countryside, building his Golden House between the Esquiline and the Palatine hills overlooking a lake that resembled a sea surrounded by acres of fields, vineyards and woods. This transformation was then wisely reversed just as decisively by Vespasian and his sons, as Martial tells us (*Spectacula*, 1, 2). The private pool was replaced by the public Colosseum and the area in which Nero had replaced the houses of the poor with a park was covered with a new bath building, the Baths of Titus. Martial approved of the latter transformations. Other writers could see their disturbing side. Pliny the Elder, writing at the same period, voices deep anxieties at the way Nature's well balanced order had been turned on its head:

> Promontories are opened to the sea and the whole of nature is flattened; we carry away what were intended to provide natural borders separating nations; ships are made to carry marbles and mountain ranges are transported hither and thither through the sea, the wildest part of nature.

Natural History, XXXVI, 1

Juvenal a little later expresses himself more personally and more acidly. He goes to a simple fountain and finds it covered with marble. He even warns his friend not to try and escape the city by going to the nearby hills, as he will find that the city has got there before him. Juvenal also protests at the transformation of culture, which is as bad as that of nature and amounts almost to a natural phenomenon. There are, he warns his reader, so many immigrants from the East that Rome has become a 'Greek city' and 'the Syrian Orontes has flowed into the Tiber'. The Greek, he says, actually survives by maintaining a state of constant metamorphosis. In response to your demands he will be 'a grammarian, an orator, a geometer, a painter, a masseur, a prophet, a tightrope-walker, a doctor or a magician' (Juvenal, *Satires*, 3). In every aspect of life the old categories whether of Greek philosophy or of Roman common sense were dissolving as the Empire expanded.

One of the most remarkable productions of this new world is the surviving section of the *Satyricon* of Petronius, probably written about AD 60. It begins with a vigorous attack on the new and extravagant Asiatic style of rhetoric, concluding that the best rhetorical education should begin with

193 Substructures of the Temple of Divus Claudius, Rome, AD 50–60.

194 Temple of Vespasian, Pompeii, AD 69–79.

firmly established only under the Flavians when there was a new need to reassert Italian authority over Greece. Both these new features also combine previously distinct architectural elements. One is the alternation of segmental and triangular pediments, which is the dominant theme of the precinct wall of the Temple of Vespasian at Pompeii (fig. 194) and a striking feature of the Porta dei Borsari in Verona. The other is the alternation of arched and rectangular-headed niches, usually also curved and rectangular in plan, which appears in the great fountain wall attached to the base of the Temple of Claudius and which recurs frequently in the Domitianic palace on the Palatine (fig. 195). Such variation is unheard of in Greek architecture and had never before been so systematically introduced into Roman buildings, although hesitant combinations of such elements had occurred earlier. Both variations introduce a sense of shifting and changing into what had previously been a relatively static art.

The most specific feature is the alternating pediment, and its distinctiveness is emphasised by the fact that the segmental pediment is rarely found by itself, unlike the triangular, which had been, of course, the universal form, ever since its appearance in ancient Greece. The origins of the segmental pediment are fairly clear. It first appears in tombs in Hellenistic Egypt, where it is associated with an Egyptian rather than Greek architectural style (fig. 90). We can indeed be sure that it was a prevalent feature of the architecture of Lower Egypt. On the Barberini mosaic it occurs frequently and exclusively in the bottom half, which apparently represents the Nile Delta. Its regional associations are probably related to the light reed and brick materials used in that area,

195 Palace of Domitian, Rome, *c.*AD 90, view of interior.

while the buildings of Upper Egypt probably always made greater use of masonry construction, as indeed they do in the mosaic. If it had long served to distinguish Lower from Upper Egypt it could easily have been used by the Egyptians after Alexander's conquest to distinguish their culture from that of the invaders, as it appears to do in the tombs of Alexandria (figs 89 and 90). If the segmental pediment had already acquired national Egyptian associations, in opposition to the triangular form of the Greeks, when the Romans came to Egypt as conquerors of both they would have found it easy to recognise this polarisation between the two cultures they most admired. It may have been Sosius, a companion of the orientalising Antony, who, once rehabilitated by Augustus after Actium, commissioned a new interior for the Temple of Apollo Sosianus, which exploited the combination of segmental and triangular pediments for the first time. If this is so and the reconstructions are correct (fig. 197), the alternation of forms along the sides of the interior could have been seen, in the same way as the Greek and Latin libraries in front of the slightly earlier Temple of Apollo on the Palatine, as a celebration of the emperor's power to create an alliance of two national cultures. Indeed the extraordinary pagoda-like form, which places a triangular pediment under concave cornices, known from fragments and shown on the end wall of the reconstruction, would have been an even more eloquent symbol of their integration. However, whether or not the rhythmic alternation of segmental and triangular pediments was introduced under Augustus, it was only under the Flavians that it became a regular feature of Roman architecture. For Vespasian and his heirs such a forced combination could effectively express exactly the same arbitrary control as the combination of Ionic and Corinthian capitals in the new Roman/Italic form. Rome had the power to force the separate peoples of her empire to become one.

There is no precise connection between the system of alternating pediments and that of alternating niches, but they do have in common both the property of alternation and the mixing of angular and curved forms. In the case of the pediments it is certain that the two forms developed separately in different areas. With the niches this is less clear. There is only a general truth to the proposition that, while the Greeks avoided the arch and the apse and normally used only the horizontal entablature and the straight wall, the Romans revelled in the architectural possibilities offered by both curved elements. There was, however, one area of life in which angularity was associated with the Greeks and curvilinearity with the Romans in a quite decisive manner.

196 Greek pallium (*left*) and Roman toga.

This was in dress. The typically Greek pallium was always characterised as rectangular and the toga, which only free Roman citizens, Virgil's *gens togata*, could wear, was rounded (fig. 197), the former being indeed made from a rectangular piece of cloth, the latter from a nearly semicircular one. The national associations of the two shapes were already recognised in the first century BC when we are told that the Roman citizens in Greece put on 'rectangular' clothes in order to avoid the anti-Roman violence during the Mithridatic war (Athenaeus,

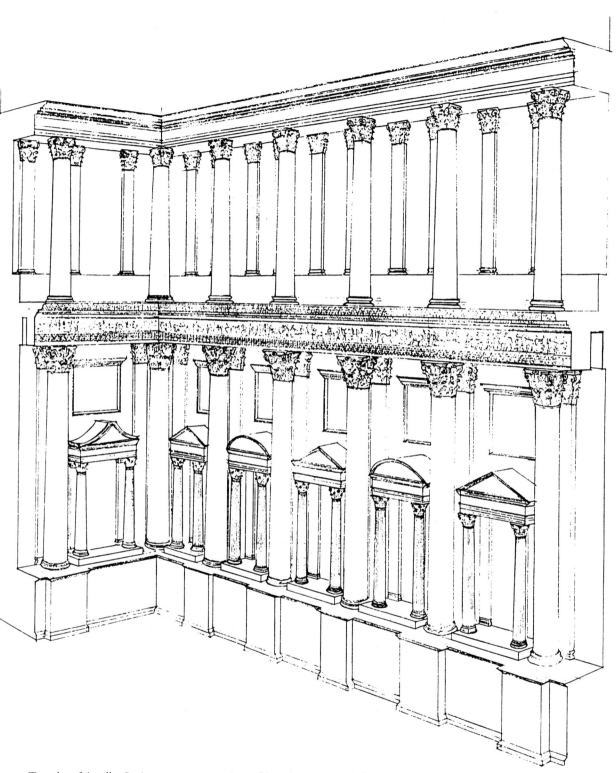

197 Temple of Apollo Sosianus, reconstruction of interior, *c*.20 BC (after Viscogliosi).

Deipnosophists, V, 213), while Dionysius of Halicarnassus insists that the toga is 'not rectangular, but round' (III, 61). The contrast between the pallium and the toga soon came to be seen as the neatest way of distinguishing Greek and Roman culture, as in the opposition between the *fabula palliata*, a comedy with a Greek character, and the *fabula togata*, one completely Roman. At a more personal level Cicero sneers at a 'Greekling' juror, who wears now the pallium and now the toga (*Philippics*, V, 14), already noting how Roman rule turns Greeks into chameleons. The change from rectangular to rounded clothing was an important feature of Roman life. Most foreign clothes were rectangular like that of the Greeks; so foreigners changed from rectangular to rounded clothes when they became Roman citizens and slaves did the same when they became freedmen. Even Romans themselves, who increasingly wore the simpler rectangular dress for everyday, would consciously change into a toga for those occasions when it was required, as for attending the theatre or the lawcourt and for going to dinner. Juvenal sneered that some Romans would wear the toga only when they were dead. The positive associations attaching to the round in the Roman world may help us to understand why, while the Greeks had often insisted that the good man was square, *tetragonos*, Horace in the quintessentially Roman *Satires* says that the best man is 'smooth and round, so that nothing external can attach to the polished surface' (II, 7, 86 and 87). Whether or not it was for related reasons, the Romans came to express similar preferences in other areas, or at least to see round forms as the culmination of a development. On a small scale Varro tells how a table type started off rectangular and ended up round (*De Lingua Latina*, 5, 118). On a large scale, the city of Rome itself began as *quadrata* and ended up as *urbs/orbs*. Horace even satirises the new fashion for rebuilding and remodelling houses in terms of a patron who alternately 'destroys and builds, and exchanges round forms for square ones' (*Epistles*, I, 1, 100).

How can all this help us to understand the alternation of niches? One way in which there is a correspondence between the above observations and the use of rectangular and curved forms in architecture is that the latter are almost always given predominance. Another is that large curved niches and apses are regularly found in places to be occupied by the emperor or his representative on occasions when the toga would be the appropriate dress, as at state receptions or when legal affairs would be transacted. It is even true that the theatre, where the alternation of rectangular and rounded forms is most frequent, in the front of the stage, in the stage-building itself and elsewhere, as at Taormina (fig. 198), is also the place where *palliata* and *togata* performances might succeed each other. In the same way perhaps the earliest striking example of a structure with an alternation of rectangular and semicircular niches is the tomb of the Freedmen of Augustus, all individuals who would have taken off square clothes in exchange for round ones. Here they may be a direct allusion to change to a superior dress. Later the suggestion may be that both are acceptable. This would explain the popularity of the alternation during the period in the first century AD when tensions between freedmen and citizens, Greeks and Romans, were at their peak and when the assertively Romanising Vespasian succeeded the Graecophile Nero. The alternation of niches may be understood as accommodating these tensions within a rhythmic order shaped by Roman might.

The alternations of pediments and niches both have different roots and are not strictly parallel, but in view of the underlying opposition between the angular and the

198 Upper terrace of theatre, Taormina, early second century AD.

curved and the association of the curved shape with Rome it was at least possible for both sets of forms to be understood as alluding to a Graeco-Roman dualism. The earliest major surviving example of the alternation of pediments in Rome itself is in the Forum of Trajan, where a remarkably rich series of pediments adorns the elevation of the Market, with segmental forms breaking into and dividing triangular ones (fig. 199). Trajan's complex is an admirable demonstration of the Roman ability to combine many things into one: market, basilica, library and commemorative column. Within the library there was also a symmetrical balance between two structures, one housing Greek and the other Latin books. The dominance of the segmental form on the façade of the market may celebrate the ultimate dominance of Rome. The same may be true of the Pantheon as rebuilt by Trajan's heir, Hadrian, the building with the most forceful combination of curved and straight forms yet (fig. 201). Although the pediments of the aedicules of the main interior axis are triangular and those on the cross axis are segmental, perhaps because the latter are here associated with Egyptian and the former with Greek culture, the curve is decisively pre-eminent in the niches. The recesses on the minor diagonal axes are rectangular with horizontal entablatures, the two on the cross axis are curved in plan but are spanned by horizontal entablatures, while only the main one opposite the entrance is curved in both plan and elevation. Even the floor is made up of an alternation of round and square panels, while in terms of overall design the whole building can be seen to combine a rectangular portico with a circular principal space. Hadrian is known as the emperor who was most scrupulous about observing the balance between the parts of his empire. He spent as much time in the Greek and Egyptian East as in the Latin West. The *Historia Augusta* (Hadrian, 22) tells us that at dinner he wore at some times the toga and at others the pallium. In Athens he built an arch with inscriptions that on one side referred to the city of Theseus and on the other the city of Hadrian, and the combination of rectangular and curved niches with triangular and rounded heads in the theatre at Taormina, which is probably Hadri-

199 Trajan's Markets, Rome, early second century AD.

200 Hadrian's Villa, Tivoli, AD 118–34, Canopus.

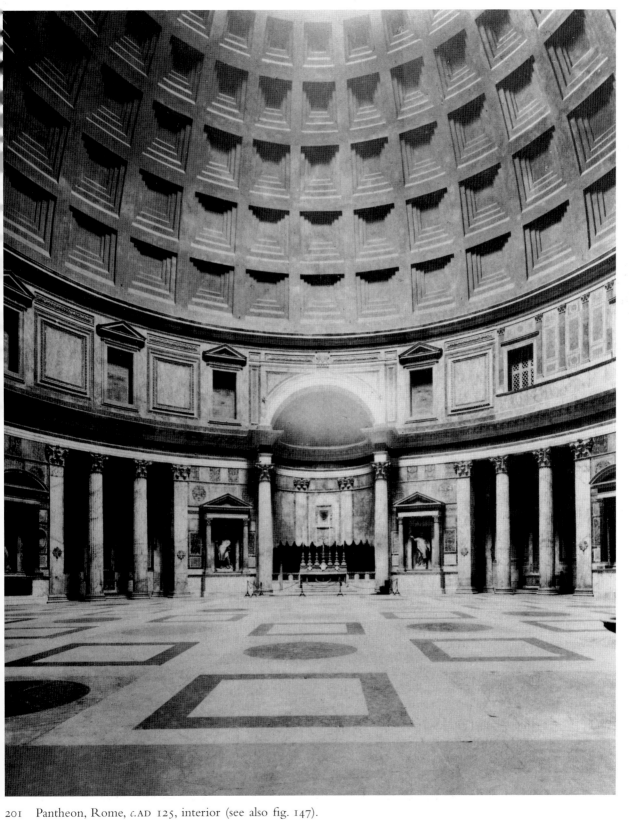

201 Pantheon, Rome, *c.*AD 125, interior (see also fig. 147).

202 Hadrian's Villa, Tivoli,
AD 118–34, Piazza d'Oro.

anic in date, may be a less explicit acknowledgement of the equality and succession of Greek and Roman traditions in once Greek Sicily (fig. 198). Inscriptions reveal too that Hadrian also planned to commemorate his favourite Antinous in monuments in both the Graeco-Roman and Egyptian styles. His villa at Tivoli is another stunning combination of exotic elements and associations. One part was named after a place in Egypt, Canopus, and others after places in Greece, such as the Academy and Tempe. Around the pool, which probably represents Canopus, and where Greek and Egyptian sculptures were juxtaposed, a portico was built of alternating straight and curved architraves (fig. 200). Elsewhere we find alternating semicircular and rectangular niches and even vaults that are made up of alternating curved and flat sections. To the west a terrace was built with alternating curved and rectangular niches and behind it two dining-rooms. One of these is entirely rectangular, the other has curved end walls. It is tempting to think that the emperor might have worn the toga in one and the pallium in the other. We may never know the precise thinking behind Hadrian's many exploitations of the rectangular and the curved, but it is hard not to connect it with his unique desire to balance his interest in the parts of the empire. At the same time the predominance he accords to the curved form can be related to his rigorous insistence that the senators and *equites* should imitate him in always wearing the toga in public in Italy. A general recognition of the ultimate sovereignty of Rome is implicit in the predominance everywhere of the curved over the rectangular. The amazing flowing vaults and bending walls of the so-called Piazza d'Oro section of the villa are the ultimate demonstration of the transcendent authority of the Roman curve, which may be why the Greek architect Apollodorus expressed his resentment at the emperor by mocking his architectural taste for 'pumpkin' shapes (fig. 202). Even Hadrian's mausoleum, which placed the circular tomb of Augustus on top of the square form favoured by Greek rulers, could be understood as an epitome of the relation between Greek and Roman cultures (fig. 203). The Roman empire had brought the possibility of independent life and mutual respect to the troubled communities of the Mediterranean, but it did so only by asserting its overwhelming energy and power.

203 Hadrian's Mausoleum, adapted as Castel Sant' Angelo, Rome, begun AD 134.

Roman Style as the Style of Transformation

The way of handling forms that emerges as characteristic in the last paragraphs amounts to a genuine architectural 'style', one distinctively Roman. There are hints of it already in Sulla's temple of Fortuna Primigenia and elsewhere, but it is only in the period between Claudius and Hadrian that it becomes a coherent and fully developed means of expression. Its principal attribute is its exploitation of the metaphor of *imperium*, commanding authority, authority over nature, over people and over culture, authority to combine, to meld and to transform. In a remarkable way it fulfils Virgil's programme in the *Aeneid*, when he contrasts the art of the Greeks, which concentrates on imitating nature, with that of the Romans, which is to 'spare the conquered and defeat the proud' (*Aeneid*, VI, 853) The 'art' of Greece follows nature, that of Rome contradicts it. It improves the situation of those who are naturally vulnerable and denies the naturally superior their power. Virgil realised that the Romans' relation to the world was new. Still, Virgil was talking only of Roman statecraft. Neither he nor his contemporaries had seriously conceived of the possibility of a Roman style of art. Under Augustus literature and the visual arts were still measured by the standards of the Greeks and, although the subject matter of the *Aeneid* or the Ara Pacis sculptures might be Roman, the form is taken in the one case from Homer and in the other from Athenian and Pergamene reliefs. It is significantly not until the later first century AD and the early second that a concept of a truly Roman style emerges, especially in the context of rhetoric.

This is most clearly stated by Quintilian in his comparison between Greek and Latin:

> We cannot be so elegant; **let us be more forceful.**
> They win in terms of refinement; **let us excel in weight.**
> Their sense of propriety is more sure; **let us surpass them in our copiousness.**
> Even the lesser talents of the **we are usually driven by larger sails;**
> Greeks have their harbours; **so let them be filled by a stronger wind.**
> *Institutio Oratoria*, XII, 2, 36 [author's arrangement]

Quintilian had been appointed the first official teacher of rhetoric by Vespasian and wrote his book in retirement under Domitian. Hadrian's attitudes would have been shaped by him. It is hard not to connect the self-conscious development of a Roman style of architecture with his recommendations on the Roman style of oratory. The buildings of the Flavians and of Hadrian, especially the palace on the Palatine (fig. 148), the villa at Tivoli (figs 200 and 202) and the Pantheon (figs 147 and 201), do indeed excel anything earlier in their weight and copiousness. The sail image is particularly suggestive, coming so close in time after Pliny the Elder's celebration of the power of canvas as the material that in a sense held the empire together. The Colosseum itself was covered by a large sail-like textile suspended from masts, which was furled and unfurled by a team of sailors. Many late first- and early second-century vaults were decorated with stuccoed imitations of tented canopies (fig. 204), while the domed structures of Hadrian indeed recall large sails filled with wind. Even the alternations of rectangular and curved pediments, entablatures and niches, noted earlier, have close parallels in Quintilian's linguistic structure of alternating clauses. In both text and architecture Greece and Rome are in balance, but in both Rome is stronger and more dynamic. For that is the essence of the Roman style.

Immediately following the last passage Quintilian identifies yet another characteristic of Roman oratory. The Greeks did not use *sententiae* such as were developed by Cicero. As Quintilian tells us, the property of these brief but powerful phrases is to strike the mind. They often achieve their impact with one blow and by their very brevity they stick better and are more persuasive because of the pleasure they give us. The architectural equivalent of the *sententia* is not so obvious, but it could be argued that the compressed power of a single monument such as the Pantheon is genuinely comparable. The same could be said of the complex yet relatively small individual elements within Hadrian's villa such as the dining-rooms, the Teatro Maritimo and the Piazza d'Oro. Of these it could be said, as Quintilian said of *sententiae*, that they 'stand out better when everything around them is undistinguished and modest' (*Institutio Oratoria*, II, 12, 7). The rambling and informal nature of the villa as a whole enables these brilliant set-pieces to strike us more forcefully. There is of course no necessary connection between the world of rhetoric and that of architecture, but in the case of the late first century it is not unnatural to find some relation between Quintilian's ideas and contemporary imperial patronage. Vespasian and his sons were very much concerned to reassert Roman cultural values in the face of a constant infiltration of Greek ideas, with which they had become especially tainted under Nero. The appointment of Quintilian as an officially recognised teacher and the commissioning of a major series of buildings from the Colosseum to the Domus Flavia were both part of this programme. When Quintilian ended his great work, which was to be the school textbook of many generations, with an attempt to define the Roman style, he was certainly hoping to affect more than rhetoric. His purpose was to shape the Roman mind.

Quintilian was not an isolated figure. Slightly later Tacitus in his *Dialogus* has Marcus Aper recommend the use of a vigorous modern style in a speech that is itself an 'impetuous torrent', even if it is not expressly characterised as Roman. A speaker should hold his audience's attention by the 'rush of his arguments, the colour of his *sententiae*, or the brilliance and elegance of his descriptions' (*Dialogus*, 20). Older authors were

204 Vault decoration, Golden House of Nero, Rome, *c.*AD 65.

dry. 'For speech, like the body of a man, is beautiful when the veins don't show and the bones cannot be counted, but when a temperate and wholesome blood fills the limbs and swells the muscles and a ruddy glow covers the sinews' (*Dialogus*, 21). Interestingly enough Aper also argues for the new style by analogy with the contemporary taste in architecture: 'One might just as well think that modern temples are weaker because they are built not with coarse concrete and ugly tiles, but shine with marble

and glitter with gold' (*Dialogus*, 20). The best house is not one that keeps out only the rain and wind, but one that delights us visually. Furnishings should not only be functionally sufficient but should be ornamented with gold and gems, so as to make people pick them up and look at them again and again (*Dialogus*, 22). With a slightly different emphasis Pliny the Elder's nephew, Pliny the Younger, writes to Tacitus emphasising the importance of the force and weight that comes with size. As he says, again making a vivid comparison with art, such objects as statues, reliefs, paintings, people, animals and even trees are better if they are bigger, provided that they are beautiful. The speech he likes best is that of Odysseus, like a winter snow fall, dense, continuous and copious (*Letters*, I, 20). Pliny the Younger and Tacitus were both self-conscious advocates of the merits of the essentially Roman, as had been Pliny the Elder, even if they despaired at the excesses of many of their contemporaries, and the same was already true of Petronius, who a few decades earlier had already described the education of the orator in such a way as to contrast the flowing vigour of Roman style with that of the Greeks: 'Then let Roman authors flow round him and unimpeded by the Greek language let them, swelling, change his taste' (*Satyricon*, 5). The qualities of strength, force and copiousness, and the references to the flow of liquids, the blowing of winds and the falling of snow are not absolutely new in the language of rhetoric, but they had never before been singled out as the most desirable quality of a modern style, still less of one that was decisively Roman.

The scale and swelling mobility of the buildings of the Flavians and Hadrian are apt expressions of this style in architecture, and the marble veneers that bring colour and reflected brilliance to the surfaces of the Domus Flavia and Hadrian's Villa are just the figures of architectural speech that are required, as Aper observed, to catch and hold the viewer's attention. But sculpture and wall-paintings were exploited just as brilliantly to express Rome's new power. The compressed Composite capitals, the rich mouldings and the projecting and receding entablature of the Arch of Titus are accompanied by huge relief friezes of the emperor's triumphal procession, which pull the spectator through the central passage with all the 'overwhelming force' that Quintilian saw as the best expression of Roman genius (figs 157 and 205). The same is true of the Cancelleria reliefs celebrating his brother Domitian and of the Trajanic reliefs that now adorn the Arch of Constantine (fig. 167). In the throne room of Domitian's Domus Flavia the alternating round and rectangular niches that rippled round its walls were filled with enormous green basalt statues, which have precisely the blood that 'fills the limbs and swells the muscles' beloved by Aper and the huge scale desired by Pliny (fig. 206). In the gigantic oval fountains that flanked the great triclinium across the court the alternating niches were drenched in a cascade of water that was as 'dense, continuous and copious' as Pliny's snowfall (fig. 207). In wall-painting the powerful projections and recessions and alternately straight and curved entablatures of the so-called Fourth Style, which was developed in the last years of Nero and which characterises the most brilliant decorations done at Pompeii under Vespasian, evoke the same properties, just as do the figure paintings they frame (fig. 208). Some of the increasing richness is only the natural result of competitive pressures that had been operating for two centuries, but it is inconceivable that the dramatic increase in energy and scale which is evident in all the arts from the end of Nero's reign through that of Hadrian is not at least in part brought about by an attempt to articulate a truly Roman style at a time

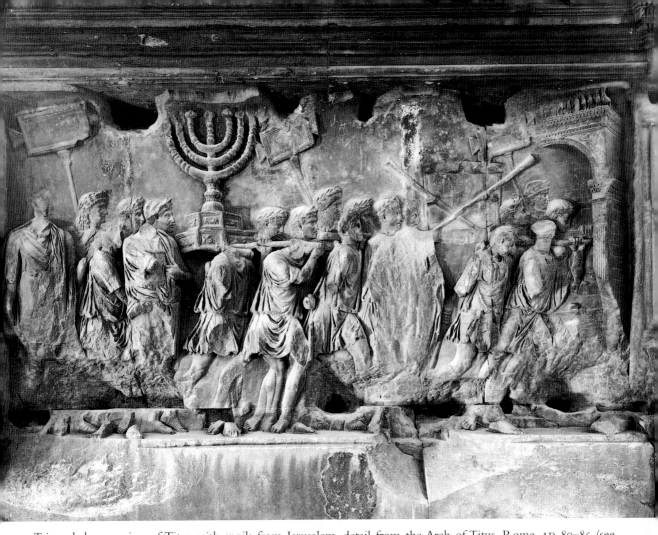

205 Triumphal procession of Titus with spoils from Jerusalem, detail from the Arch of Titus, Rome, AD 80–85 (see also fig. 157).

when Greek and other tastes both in art and in life seemed to be sapping the empire's vitality. From Nero's master of ceremonies, Petronius, through the Flavians' protégé, Quintilian, to Trajan's admirer, Pliny the Younger, in the field of rhetoric, the most self-conscious and articulate art, the theme is a recurrent one. Rome had transformed the world almost without thinking about it and was in danger of being swallowed by the monster it had created, and especially by the Greeks it had first enslaved and then liberated. The political and cultural anxieties that this provoked brought a new reflectiveness on Rome's distinctive achievement and the need to give it forceful expression.

The Empire of the Imagination

The Roman achievement did not only transform the world. It also forced a transformation in the way the world was seen, and not just by Romans but by everyone. As Augustus' contemporary Strabo says in his *Geography*, his task is of a new scale, since

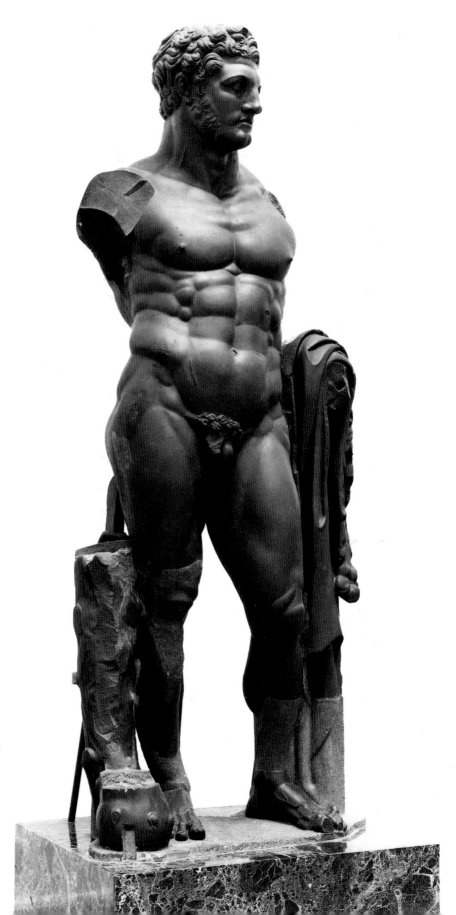

206 Hercules statue
from Domitian's palace
on the Palatine,
Rome, green marble,
*c.*AD 90 (see also figs
148, 195 and 207).

207(*above*) Fountain, Domitian's palace on the Palatine, Rome, *c.*AD 90 (see also figs 148, 195 and 206).

208 Wall-painting from a house at Pompeii, AD 69–79, so-called Fourth Style.

the Roman conquest of the world means that he has to deal with the whole of it. As a consequence he cannot treat everything and is forced to make a selection of what is important. The book, he suggests, should be appreciated in the same way that we appreciate a colossus in terms not of detail but of overall effect. This means, for example, that he has to find a way of grasping countries in terms of their basic shapes and overall dimensions, so that Sicily becomes a triangle, Spain an ox-hide, the Peloponnese the leaf of a plane tree and Sardinia a footprint. The bigger the territory the more schematic has to be the treatment. When he comes to continents his categories are very simple: Europe has the most irregular shape, Libya (that is, Africa) the most regular and Asia is in between.

Strabo's analogy between the Roman Empire and a colossus hints at the notion that the Roman achievement might be associated with a preference for works of art on a new scale. If so, the scale of this new art would require it too to be seen in a

209 *Opus sectile* wall panel from Nero's palace on the Palatine, Rome, *c.* AD 60.

different way. As with the map and the colossus, detail would become confusing and undesirable and instead it would be necessary to schematise. In a general way this line of argument looks forward to the whole history of Imperial art, asserting at the outset that the detail found in Classical and Hellenistic Greece is rendered inappropriate by the very scale of the new culture. At a much reduced level it may help us to understand the remarkable relationship between two splendid examples of marble *opus sectile*, which probably once formed part of Nero's new wall decorations of the Domus Tiberiana on the Palatine (figs 209 and 210). One has many of the mouldings and floral motifs that one expects from a work in the Greek tradition. The other is clearly based on the same design but every detail is simplified to produce a pattern that relates to its pair in just the same way that a triangle relates to Sicily. This is most clear in the border, where in the first a delicate curving shape in pale yellow Numidian marble repeats itself in a way that suggests the flow of water by recalling its ripples and eddies,

210 *Opus sectile* wall panel from Nero's palace on the Palatine, Rome, *c.* AD 60.

while in the other the complex curves and natural colours are replaced by a simple black and grey herringbone-like effect. The effect could still be taken to suggest water, but the impression is less of a real river and more of a river's diagrammatic representation on a map. Equally explicit is the change in the way the surrounding egg-and-dart pattern is treated. On the first panel the elements are carefully shown as if foreshortened, preserving a three-dimensional effect. On the other exactly the same elements reappear, but with no attempt to show any recession. The same contrast exists in the main field of the design. On the first panel a four-leaf pattern repeats against a matrix of organic curves. In the second a star pattern, not unlike that in the corners of the first design, is decorated with a pattern of geometrical circles that can be seen as a schematisation of the four-leaf motif. Whatever the artist or artists had in mind the result is something of great rarity in the history of art: two totally different approaches to the representation of basically the same phenomenon, one being traditional and the other new. Since the traditional one emerges from a Greek tradition and the other is new and has the schematisation that Strabo saw as being a new property required by the 'Roman' experience, it is not impossible that (although the excavation reports do allow for the existence of even more) the two panels should be seen as a pair. If they were, they might have functioned rather like the twin Greek and Latin libraries that Augustus erected in front of the Temple of Apollo, also on the Palatine. Certainly, over the ensuing centuries the naturalistic detail, three-dimensional effects and colours of the one were increasingly dropped in favour of the simplification, flatness and chromatic simplicity of the other. What is most important about the pair is that both were paid for by the same wealthy client and both were made by the same group of artisans. However the difference is understood, the change cannot reflect the influence of the factors usually used to explain the so-called decline of Roman art, the reduction of material resources, the degradation of the culture of patrons or the rise of spirituality. For example, while the sinuous lines of the one required elaborate chisel work, the straight lines of the other could have been achieved simply by mechanical sawing. More man-hours would have been needed for the one than for the other, although both are of equal visual interest. It is thus hard to believe that the two contrasting panels would have been made had there not been an interest on the part of the patron in exploiting two types of responses, one relying more on a pleasure in the recall – if not the imitation – of nature and the other acknowledging the pleasure of savouring the experience of compression and reduction, even of abstract minimalism.

Strabo faced up to the problem of finding a way to reduce and simplify his giant task, but his work is still monumental. A hundred years later, in the early second century AD, L. Annaeus Florus, seeking to review Roman history in a single *Epitome*, or 'cut-down' work, sought to bring the whole great subject within a small compass by taking his clue from the geographers:

> Since the magnitude of the subject is an obstruction and the diversity of material disrupts the attention, I will do what map makers do. I will compress the whole image into a brief table, bringing a lot together for the contemplation of the emperor, so that I will show him the whole great subject simultaneously in a balanced way.
>
> *Epitome*, I, I, 3

211 Hadrian's Villa, Tivoli *c.* AD 120, plan (see also figs 200 and 202).

As an example, he imagines the life of the Roman people over the period of seven hundred years as the life of a single man going through four phases. Later he uses more picturesque similes to summarise complicated phenomena, comparing the spread of Roman power through Italy to a forest fire. He also uses colourful images to impress smaller details on his readers' minds: Roman galleys attacking the enemy with their beaks are like animals and Caesar's rage is like a flood or a fire. The link with the observations on rhetorical style in the last section are clear. Rome and the Romans are conceived as dynamic forces, almost natural phenomena. At the same time, his talk of presenting the emperor with a balanced picture of history that can be perceived all at once recalls the function of the nearly contemporary Hadrian's Villa. The villa with

its elements recalling sites in Greece and Egypt (fig. 211) is an epitome of the Roman empire just as Florus' book is an epitome of Roman history. In both cases it is the size of the subject that makes such compression necessary.

The use of similes from nature is an important instrument for both Strabo and Florus as they attempt to grasp the size of Rome's achievement, and the same approach is used by others in descriptions of man-made objects such as buildings. Calpurnius Siculus provides a poetic description of the wooden amphitheatre that Nero constructed in Rome in AD 57. The countryman who describes it to a friend says how it rose up to heaven, and how 'just as this valley comes together in an open plain and the bending sides with their sloping woods form a concave curve between the mountains, so there the curving sides enclose a sandy plain and bind the central oval with their twin masses' (*Eclogues*, 7, 23ff.). What gives this description its greatest interest is that it describes the wooden structure in terms that are much more applicable to the Colosseum of fifteen years later (fig. 156), an edifice that even today looks like a man-made mountain. It is as if the designer of the new permanent amphitheatre tried to build a monument that embodied properties that had been until then only imagined in inflated descriptions. The close association between the new descriptions of buildings as natural phenomena and the new style of the Flavians is also apparent in Domitian's new palace, which is the first Roman building to be the subject of several inflated encomia (fig. 148). Typical is Martial's epigram that addresses the building's architect: 'Heaven and the North Pole, you have conceived in your pious mind, Rabirius, you who have built with miraculous art the palace on the Palatine' (*Epigrams*, 7, 56), or another that says: 'you could believe that the seven hills were rising up together. Ossa when it carried Thessalian Pelion was not so lofty' (*Epigrams*, 8, 36). Domitian, who commissioned the palace, encouraged the writing of such descriptions. Rabirius would have known how his work would be described in hyperbolic language and this can have only stimulated him in his design of a vast complex which is indeed more like a range of lofty mountains in scale, substance and profile than any previous building. In the late first and early second century AD architecture, sculpture and painting all respond to the challenge of rhetorical description. Not only was there in the visual arts an attempt to create a Roman style as proposed by the rhetoricians, there was also a general attempt to assimilate buildings, sculptures and paintings to the language in which they would be described.

Rhetoric and the Education of the Imagination

The increasing disjunction between the objective properties of things and their descriptions, which is such a feature of literature under the Empire, has often been regarded simply as an index of cultural decline. The assumption has usually been that a description of an object, be it a person, a building or a painting, should correspond as closely as possible to that object as physically constituted. A critical test of a description would be whether intelligent people applying rational judgement would assent to it. The increasing inflation of descriptions during the period from the first to the fourth centuries and beyond is lamented as an indication that such standards were no longer being applied. What is true of literature is also true of art. While sculptures and

paintings of the first century AD still record much information about an object, its physical properties and circumstances, by the fourth century there is so little detailed information that it would be difficult to use an image from the period as a source of accurate knowledge. A first-century BC or AD painting might record details of muscu- lature, pose and expressive gesture as well as information on lighting and spatial rela- tionships (fig. 212). By the fourth century there might be little more than a schematic frontal view of a figure consisting of little more than an outline filled with patches of colour, with only vestigial references to shading and perspective (fig. 213). Rational viewers could never agree that the painting accurately recorded what they saw. Admit- tedly, in art the trend is not normally as severely censured as it is in literature, since it is argued that movements such as Neoplatonism and Christianity expressly discouraged attention to the appearances of material reality, but since the trend affects all types of art and not just that commissioned by Platonists and followers of the new religion it is still generally regarded as a phenomenon parallel to that in literature, a symptom of cultural degradation. Indeed, there is some recognition that the decline of art is influ- enced by that of literature, since the key to the latter is the rising influence of rhetoric on education. The 'word' or 'speech', *logos, oratio*, had been developed by the Greeks as a tool specifically adapted to capture the truth. Now that speech was employed above all for inflation and exaggeration the minds of successive generations became impreg- nated with false values and were no longer able to maintain the earlier standards.

This fundamentally negative view of the stylistic development with which the Roman Empire is associated is justified only if the values of earlier Greek culture are the ones by which it is judged. If truth to nature and to natural laws is essential to excellence then the literature and art of the Empire are indeed in decline. However, as we have seen, the foundation of the Roman achievement was the denial of nature as understood by the Greeks. The Romans prided themselves precisely on their ability to controvert natural laws. The Greek felt that his success and happiness depended on his following nature as closely as possible, the Roman discovered that he could achieve far more by making nature respond to his desires. The Greeks had developed elaborate philosophies to enable people to follow nature as they saw her. Whether the philosophy concerned was Platonic or Aristotelian, Stoic or Epicurean, the underlying principle was always that all one's actions, one's ethical and aesthetic priorities, should be adjusted to a particular view of nature. The Romans denied nature her authority and thus made such philosophies irrelevant. The Roman could convince himself of his independence of natural laws by flouting them daily in his actions. The philosophical implications of the realities of this new situation were as great as those of any philoso- phy. They have to be taken seriously by anyone who seeks to understand Roman art and culture. For the inhabitant of the Roman world the denial of truth and the inver- sion of ethical and aesthetic principles were as important as following them had been for their Greek predecessors. Seen in this context the increasingly false descriptions of literature and the increasingly inaccurate representations in art could become demon- strations, not of Roman decline but of Roman triumph.

Emperors such as Augustus, Claudius, Vespasian and Hadrian all in different ways took pride in their new ability to deny natural laws and rhetoric showed how to deny reason. It had not always been so. The main divisions of rhetoric had been fixed by Aristotle as 'deliberative', that is, public political oratory, 'judicial', that is, the oratory

212 Lady playing cithara, wall-painting from a villa at Boscoreale, *c.*40 BC (see also fig. 182).

of the courts, and 'demonstrative', the oratory of display, chiefly concerned with the praise or blame of a person or object. Originally, in fourth-century Athens, the first two classes, which had been much concerned with clarity and precision, had been the most important and the same had been true in the late Roman Republic. Only with the establishment of imperial control over both political and legal life in the first century AD did the balance between the genres fundamentally change. By then, although students of rhetoric were expected to practise speaking on imaginary political and legal themes from the past, the only form that was still practised as a truly live art and actually enjoyed a new vitality was 'demonstrative' oratory. The importance of flattery as the currency of advancement brought the art of praise to the centre of the stage. It was this class of speech that accordingly formed the main element in education. Its treatment by Quintilian is thus of considerable significance.

One feature of his approach is that he felt that the 'demonstrative' genre could as

213 'Roma Barberina', wall-painting, fourth century AD.

easily be called the 'laudatory' since that was its predominant part. His analysis of praise is thus of particular interest: 'It is proper to praise that it amplifies and ornaments its subject' (*Institutio Oratoria*, II, 7, 6). The concept of amplification is essential to praise, just as attenuation or making something smaller is essential to blame. Later he discussed amplification in detail: 'The first form of amplification or attenuation consists in the word used to describe something; as when we describe someone who has only been beaten as murdered or someone who is just dishonest as a robber . . .' (*Institutio Oratoria*, VII, 4, 1). The primary means of amplification is thus exaggeration, making something greater than it is, and Quintilian's example shows that this means giving a false impression of it or lying about it. Elsewhere he discusses amplification as it affects the emotions: 'For the force of eloquence is that it not only brings the judge to the view that is the natural conclusion from the evidence, but excites in him emotions that are either quite alien to the case or at least much greater than those inherent in it' (*Insti-*

tutio Oratoria, VI, 2, 24). The successful orator should make his audience think that his subject is 'more something' than it really is and should create in them a response that is more intense than it of itself would generate.

Quintilian then goes on to explain how this control over the audience's emotions can be achieved:

> So if we want to give our words the appearance of truth we must identify ourselves with those who really feel such emotions and from this state of mind will come a way of speaking which will have such an effect on the judge . . . It is thus of primary importance that we should feel those feelings which we wish to induce in the judge, that we are moved ourselves before we try to move someone else. And how are we to become moved ourselves? . . . I will try to explain. What the Greeks call *phantasias* we call *visiones* and by experiencing these visions images of absent things are so vividly presented to our imagination that we seem to see them with our very eyes and to have them before us. Anybody who is susceptible to these will have a great power over the emotions of others . . . When our mind is unoccupied or filled with empty hopes or day-dreaming we are beset by these images I am talking about: we travel, voyage, fight, address public meetings, enjoy wealth beyond our means; and we seem not to think these things but actually to do them. Should we not put this weakness of ours to some use? If I am complaining a man has been murdered, shall I not bring before my eyes all those things which are likely to have happened? Will not the murderer suddenly burst in? Will not the victim collapse? Will not the blood, the pallor, the last scream and finally the death rattle be there in my mind?
>
> *Institutio Oratoria*, VI, 2, 27–31

The ability to form a mental image of something when it is not before our eyes is essential to enable us to give conviction and vividness to our speeches. 'Even at school the student should be moved by the real situation he is speaking of and should imagine it to be true for him . . .' (*Institutio Oratoria*, VI, 2, 36). The stimulation of the visual imagination is an essential part of education. The man who can see things in his mind's eye that are not in reality before him will be a better speaker – and Quintilian also tells how writers need the same ability. The same imaginative faculty is essential for the other element of praise, ornament:

> The ornate is something more than the clear and the probable . . . It is a great virtue to talk about our subject with clarity and as if it is before our eyes. For our speech does not achieve enough nor rise to its full power if it only reaches the ears and if the judge feels only that he is being told the facts on which he has to make a decision rather than having them represented before him and made visible to his mind's eye . . . We shall make things clearly manifest as long as they resemble the truth: and it will be quite permissible to add false details of the sort which often happen . . . And this, which in my opinion is the greatest skill in oratory, is easily explained. We have only to fix our eyes on nature and follow her . . . Indeed an excellent way of illuminating our subject is to use similes . . .
>
> *Institutio Oratoria*, VIII, 3, 61–72

Again it is the bringing before our mind's eye that is important and the addition of false details that contributes to the effect. Similes provide a good excuse for the intro-

duction of additional material and we have already seen how Statius, Quintilian's contemporary, used them in his descriptions of the Domus Flavia.

A central element in the new rhetorical education established at the end of the first century was thus the development of the student's own visual imagination and of his ability to control that of others. Moreover this ability was particularly important for the achievement of the two effects of amplification and ornament that were the heart of laudatory rhetoric. Besides, not only was it inherent in the visual imagination that it did not need to be limited by the reality of what was presented to our eyes, it was actually desirable for one to be able to imagine the exaggerated and the false.

The category of inflated praise discussed by Quintilian was not of course new, but a pride in a rational response had before inhibited its use, as is illustrated by this account of an unsuccessful early attempt to exploit it at the court of Augustus:

> At Maecenas' banquet there was a rectangular table alongside his couch, of the largest size and superb beauty; as might be expected, the guests found various ways to praise it. Iortius could not invent any original extravagance, so in an interval of silence he remarked: 'But my dear fellow guests, there is something you have not noticed; it is round and exceedingly circular.' Naturally there was a burst of laughter at this undiluted piece of flattery.
>
> Plutarch, quoted in Aelian, Fr. 108

At this date such a claim that a square object was in fact round was not taken seriously. People simply could not agree with a description that did not correspond with the evidence of their eyes. By the time of the Flavians on the other hand, as Quintilian's observations suggest and the descriptions of Domitian's palace confirm, this attitude no longer prevailed. Indeed, as we have argued, such non-objective language had apparently already had an effect on the way buildings were designed.

The Educated Imagination and the Work of Art

In the long run, though, the new approach to praise had an impact on the development of the representational arts of painting and sculpture that was even greater. This is because the reading and writing of descriptions of such works became a principal instrument of rhetorical education, resulting in the appearance of a number of collections of texts describing works of art during the second, third and fourth centuries. The most important are those of Philostratus the Elder in the later second century, of Philostratus the Younger in the early third and of Callistratus in the fourth. That there is a relationship between these texts and the contemporary art is suggested by the fact that not only do these descriptions appear at precisely the period when art itself was becoming less and less descriptive, but that the character of these descriptions changes in a precisely inverse relationship (figs 214 and 215). As art becomes less descriptive, the accounts of art become more so. Thus if we take the third and fourth centuries, when it is generally recognised that art contains less and less visual information, and compare the descriptions of the elder and younger Philostratus and of Callistratus, which span the same period, each successive writer seems to see more in the paintings and sculptures he describes than his predecessor.

214 Centaurs and wild animals, mosaic from Hadrian's Villa at Tivoli, early second century AD or earlier.

In Philostratus the Elder there is most information on what is happening in the scenes he describes, and many different actions are enumerated in order that the story can be followed. In his grandson's book, on the other hand, less attention is paid to the actions and much more to what the actual participants look like. A good example is provided by a comparison of the 'Hunters' (Philostratus the Elder, *Imagines*, 28) and the 'Meleager' (Philostratus the Younger, 15). As in other cases the actual appearance of the individuals concerned is given in much greater detail by the later writer. The elder Philostratus' description of the central hunter is typical:

> The youth's garment is a chlamys bellying out in the wind: in colour it is the sea-purple which the Phoenicians love, and it should be prized above other purple dyes; for though it seems to be dark it gains a peculiar beauty from the sun and is infused with the brilliancy of the sun's warmth. And from shame of exposing himself unclad to those about him he wears a sleeved chiton of purple which reaches half-way down his thighs and likewise half-way to his elbows. He smiles, and his eye flashes, and he wears his hair long, but not long enough to shade his eyes when the wind throws it into disorder. Doubtless many a one will praise his cheeks and the proportions of his nose and each several feature of his face, but I admire his spirited-

215 Wild animal hunt, staged, mosaic, fourth century AD.

ness; for as a hunter he is vigorous and is proud of his horse, and he is conscious of the fact that he is beloved.

This can be compared with his grandson's parallel description of Meleager:

Meleager in an attitude of defence throws his weight upon his left foot, and watching closely the boar's advance, awaits his onset securely with couched spear . . . The youth is sturdy and well developed all over; his legs below the knee are firmly knit and straight, well able to carry him in the foot-race, and also good guardians for him when he fights in the hand-to-hand contest; the upper and lower parts of the thigh are in harmony and the lower leg and the hip are the kind to make us confident that the youth will not be overthrown by the boar's attack; his flanks are broad, his stomach lean, his breast protrudes a little, his arms are well articulated and his shoulders join in a strong neck, providing it with a firm foundation; his hair is ruddy, and at this time stands erect because of the vehemence of his attack; the flash of his eye is very bright, and his forehead is not relaxed but all instinct with passion; the expression of his face does not permit a word to be said of its beauty because it is so tense; he wears a white garment that does not reach to the knee, and his high boot that reaches above the ankle gives him secure support in walking; and letting his scarlet mantle hang in a fold from his neck he awaits the beast.

While the older writer tells us, for example, what he knows about sea-purple and what he can guess about the reasons for wearing a sleeved chiton, or praises generally his subject's spiritedness, the younger gives a full and relatively objective description of his pose, the shape of his body and dress and a detailed account of his hair, eyes and facial expression and what they tell us directly of his psychological state. The contrast between the two descriptions is the more intriguing because it almost exactly parallels the contrast between the description of the shield in the *Iliad* and that in the later *Shield*. In

that case too the earlier account is an imaginative reconstruction of an event, while the later purports to be an analytical description of what could be seen if such an event was represented in a work of art. The difference is that now the description of the work of art is much more a product of the imagination than the description of the scene. This is most clear in the way in which the descriptions of the younger Philostratus almost always, as here, read more into the painting than can ever have been visible, especially in terms of complex states of mind. An example of this feature can be found in his account of a group of hunters:

> You see the midmost of them, how he has raised himself and has turned towards those who lie above him, to whom it seems to me he is relating the story of his conquest and how he was the first to bring down one of the two wild beasts which are suspended from the tree in nets, a deer apparently and a boar. For does he not seem to you to be elated and happy over what he has done? The others gaze on him intently as he tells his story: and the second of them as he leans back on the couch seems to be resting awhile and planning soon to describe some exploit of his own in the hunt. As to the other wing of the company, the man next to the central figure, a cup half-full in one hand and swinging his right hand above his head, seems to be singing the praises of Artemis Agrotera, while his neighbour, who is looking towards the servant, is bidding him hurry the cup along.
>
> <div align="right">Philostratus the Younger, 3</div>

In the elder Philostratus' description of the group of boar hunters there is instead of this legible vitality a much stiffer characterisation of general attributes:

> One shows in his face a touch of the palaestra, another shows grace, another urbanity and the fourth, you will say, has just raised his head from a book.
>
> <div align="right">*Imagines*, 28</div>

Callistratus, writing probably more than a hundred years later towards the end of the fourth century, represents yet another step in the same direction. He sees even more than the younger Philostratus. He describes only one painting, the *Madness of Athamas*, but the contrast with the earlier texts is clear:

> For though the figure was in reality without motion, yet it seemed not to retain a fixed position; instead it astonished those who saw it by its semblance of motion. Ino too was present, in a state of terror, trembling slightly, her face pale and corpselike through fright; and she embraced her infant child and held her breast to its lips letting the nurturing drops fall on the nursling. The figure of Ino was hastening towards the promontory of Sceiron and the sea at the foot of the mountain, and the breakers that were wont to surge in billows were spreading out in hollows to receive her, and something of Zephyrus pervaded the waters as he with shrill blast lulled the sea to rest. For in truth the wax beguiled the senses into thinking that it could apply the art of imitation to nature's works. And sea-dolphins were sporting nearby, coursing through the waves in the painting, and the wax seemed to be tossed by the wind and to become wet in imitation of the sea, assuming the sea's own qualities.
>
> <div align="right">Callistratus, 14</div>

Callistratus sees not only emotion more vividly but motion too. For him there is almost a transubstantiation of materials as the wax surface of the painting seems to be blown and to flow like real water. The precision and fullness of his sensual response is even more remarkable in the descriptions of marble and bronze statues:

> There was a grove, and in it stood Dionysus in the form of a young man, so delicate that the bronze was transformed into flesh, with a body so supple and relaxed that it seemed to consist of some different material instead of bronze; for though it was really bronze, it nevertheless blushed, and though it had no part in life, it sought to show the appearance of life and would yield to the very finger-tip if you touched it, for though it was really compact bronze, it was so softened into flesh by art that it shrank from the contact of the hand. It had the bloom of youth, it was full of daintiness, it melted with desire, as indeed Euripides represented him when he fashioned his image in the Bacchae. A wreath of ivy encircled the head – since the bronze was in truth ivy, bent as it was into sprays and holding up the curly locks which fell in profusion from his forehead. And it was full of laughter, nay, it wholly passed the bounds of wonder in that the material gave out evidence of joy and the bronze feigned to represent the emotions. A fawn-skin clothed the statue, not such as Dionysus was accustomed to wear, but the bronze was transformed to imitate the pelt; and he stood resting his left hand on a thyrsus, and the thyrsus deceived the beholder's vision; for while it was wrought of bronze it seemed to glisten with the greenness of young growth, as though it were actually transformed into the plant itself. The eye was gleaming with fire, in appearance the eye of a man in a frenzy; for the bronze exhibited the Bacchic madness and seemed to be divinely inspired, just as, I think, Praxiteles had the power to infuse into the statue also the Bacchic ecstasy.
>
> Callistratus, 8

What makes these descriptions the more remarkable is that the language emphasises that they relate to the actual experience of the writer, as in the description of a sculpted Eros: 'one could see the bronze coming under the sway of passion; as one looked a ruddy colour shone out from the end of the curls and when one felt the hair it yielded as though soft to the touch' (Callistratus, 3). Bronze and marble actually change colour and substance as Callistratus surveys them.

The development in the descriptions of the elder and younger Philostratus and Callistratus is consistent, but one difficulty in interpreting the texts is that there is considerable uncertainty what the works referred to actually looked like and indeed to what extent the descriptions are purely imaginary. If all the works described were contemporary with the writings and those described in the later texts were indeed also executed later they would, of course, almost certainly have been less detailed as illusionistic natural representations, which would only make the development in the texts even more remarkable (figs 216 and 217). And even if all the works were older museum pieces in the same style the development is still striking. In any case surely no ancient works of painting or sculpture had the vividness suggested by the descriptions of either Philostratus the Younger or Callistratus.

These descriptions are among the most remarkable and characteristic products of the later Roman Empire, without parallel earlier, and they must have had an impor-

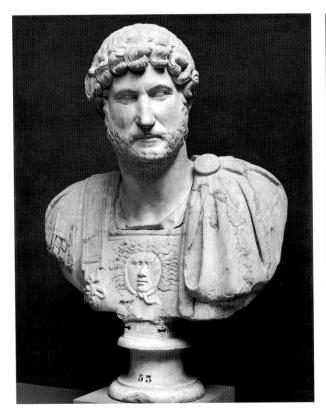

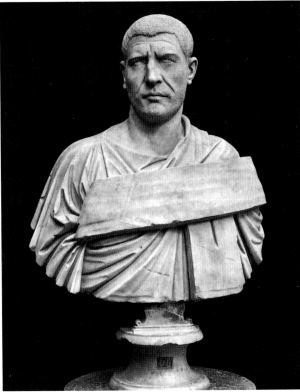

216 Hadrian, marble, *c.*AD 130.

217 Philip the Arab, mid-third century AD.

tant role. We cannot be sure of their function, but the elder Philostratus claims expressly that his descriptions were composed for the guidance of the son of the wealthy owner of a picture gallery, and the books of the younger Philostratus and Callistratus can be seen as bringing the genre up to date. All three are operating in a rhetorical tradition and all three are probably giving lessons in the visual imagination. Quintilian argued that the orator needed to develop the capacity to imagine things that were not there, and it is quite possible that it became recognised that one of the best ways to encourage this faculty was to show young men how they could make themselves see more things in a painting than were actually visible in it. By testing a student in front of an object such as a painting it was possible directly to measure his ability to use amplification and ornament as Quintilian recommended. The youth of the later Empire were the first generation specifically trained to imagine more than they saw. Moreover, as each generation passed, the requirements of amplification would force them to depart more and more from their optical experiences. Once a description of an object had become commonplace it was necessary to search for a yet more extravagant response. As with Iortius in the context of Maecenas' table, the need to compete in praise would have produced a constant escalation of vocabulary, only now such inflation and even lying would not be laughed at but rather would attract admiration and emulation.

It is this intensification of imagined experience and amplification of verbal comment that is likely to have been the single strongest influence on stylistic change in the late

Empire. The best trained young orators would have become the wealthiest patrons. For the most ambitious of them the more lifelike the portrayal the more difficult it was to display their skills. The best subject of their rhetorical performances was rather a reduced and schematic representation. To describe such works in the language of a Philostratus the Younger or a Callistratus was to make their ability to see what was not there all the more miraculous. Not only are they likely to have shown an increasing preference for works in a simplified style, the artists and craftsmen who worked for them would have responded to this preference by reducing the naturalism and the refinement of detail in their products. The overall trend of change in all the arts from the second to the fifth centuries AD is most easily explained by this remarkable new phenomenon. The better the patron's imagination the more abstract could be his art. The situation in the twentieth century has not been exactly the same, but the correlation between the rise and spread of abstraction and the progressive enhancement of the critic's and consumer's capacity for verbal response in an increasingly competitive environment offers a suggestive parallel to late Antiquity. If the marble inlay pictures (fig. 218) from the basilica belonging to one of the wealthiest Romans of the fourth century, Junius Bassus, consul in AD 331, share properties with some of the most admired works of 'modern' art it is because they are the product of a culture that shared with, say, Paris in the 1930s some similarities in sophistication.

Imagination and the Psychology of Perception

It might still be argued that an inflation of vocabulary is one thing, but that it cannot be taken as an indication of the real enhancement of a mental faculty. After all we in the late twentieth century may know that visual responses are learned and that seeing is an activity that takes place in the brain as much as in the eye, but it could be thought that such a sophisticated view was quite alien to antiquity. Fortunately, however, there is substantial evidence for a new awareness of the role of the mind and especially of the imagination in perception at precisely the period and in precisely the rhetorical circles that concern us.

A relative of the two Philostrati and better known than they as both a teacher and writer was Flavius Philostratus, born on Lemnos around AD 170. One of his most important works was the *Life of Apollonius of Tyana*, a biography of one of the wisest men in antiquity, who lived in the later first century AD. In a startlingly perceptive passage in the *Life* the great sage explains the nature of spectator-response to his disciple Damis. After first restating the familiar opinion that painting is imitation, Apollonius goes on to ask what we are to think of the animal shapes that people see sometimes in cloud formations. They cannot be made by the great gods for their amusement,

> . . . rather these shapes are without meaning and carried through the heavens without any divine intervention and it is we who having an inborn mimetic faculty turn them into forms and make them . . . The mimetic art has two sides; one consists of imitation using the hand and the mind, that is painting; the other consists of making images with the mind alone
>
> *Life of Apollonius of Tyana*, 2, 22

Having established that the mind has a mimetic faculty that enables it to see forms where none exist, Apollonius goes on to show that this faculty is also being employed even when we look at paintings where we normally think that the act of form-giving has been completed by the artist:

> But I do not think that you would claim that painting always uses colours. For earlier painters worked only with one colour, and only later did they go on to use four and even more; and outline drawing and working without colour just with effects of light and shade we should call painting too. Indeed in these works too we see resemblances; we see form and expression, modesty and boldness, and this even though they are entirely lacking in colour, and although no blood is represented and no colour of hair or beard; and people are shown in the same colour whether they are brown or white, and even if we were to draw one of these Indians with a white line he would still seem to be black; since his flattish nose, straight locks, prominent chin and the cast of his eye would turn what we were looking at black and represent an Indian to anyone who looked with intelligence. Whence I would say that those who look at works of painting also need a mimetic faculty. For no one would appreciate a painting of a horse or bull unless they had formed a mental image of the animal represented.

Life of Apollonius of Tyana, 2, 22

The whole passage is astonishing for its insight into the essential role of the brain in the process of perception, as in the notion, for example, that merely recognising the profile of an Indian would change the colour of his face. It also shows that at least one person in the ancient world realised that the whole development of Classical art as an instrument for recording as much information as possible about the natural objects represented had, in a way, been quite unnecessary, since even with a minimum of information the eye helped by the brain can see perfectly well. Indeed the contrasting of the manual imitation of the artist and the intellectual imitation of the spectator leaves us in little doubt that the activity of the spectator is higher than that of the artist, which means that viewing schematic representations would be a more worthy occupation than viewing ones that were fully elaborated. Besides which, the explicit comparison between early and late Classical art can be seen to constitute an open invitation to turn the clock back by returning to something similar to the earlier mode. Apollonius provides evidence for the existence of a theoretical framework both for the fostering of a faculty of visual imagination and for a parallel acceptance, if not approval, of decline in artistic naturalism.

From Images in Clouds to Pictures in Marble

The close relation between Apollonius' observations and late Antique descriptions of representational works of art is well indicated by a passage in which he says of a relief sculpture: 'you would say that the earth is stained with blood although it is bronze' (*Life of Apollonius of Tyana*, 2, 22), exactly anticipating the language of Callistratus' descriptions two hundred years later. More important, however, are his observations on the perception of images in the unformed masses of clouds, since these provide an

even more suggestive analogy with a quite different class of descriptive texts, those that contain descriptions of the appearances of different marbles. The use of slabs of coloured marble on floors and walls is a particularly characteristic feature of architecture from the first to the sixth centuries AD (figs 218–21). Such decorations also figure prominently in architectural descriptions and, since what is being referred to from first to last is always un-carved rectangular slabs of the same limited range of materials, it is a useful comparative exercise to observe the changes in the writers' responses.

218 Panel of giallo antico marble, with surrounding elements of cipollino, rosso antico and porta santa, House of Telephus, Pompeii, AD 50–79.

219(*below*) Hylas dragged into the water by nymphs, marble inlay panel from the Basilica of Junius Bassus, Rome, second quarter of the fourth century AD.

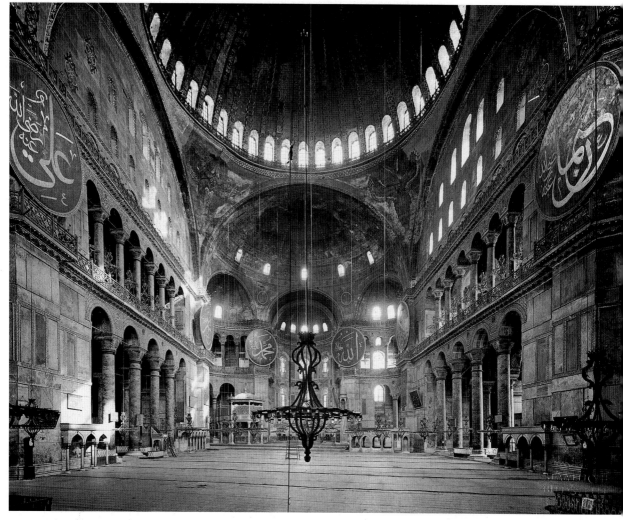

220 Hagia Sophia, Istanbul, AD 532–7, interior.

Pliny the Elder writing in about AD 70 in the context of the *Natural History* is the
most objectively scientific in his vocabulary, generally talking only of 'stains' and
'colours'. When he refers to other things being seen in marble it is either in the context
of anecdotes of primitive people's experiences or as a philological gloss, as when
ophites, 'serpentine', is said to have snakelike figuration. Statius, on the other hand,
writing in a poetic/rhetorical mode only a few years later is already prepared to see
more: 'Here is the Libyan, here the Phrygian stone; here the hard stones of the Spar-
tans shine green [*virent*]; here is the curved onyx and here the veined rock which is
the same colour as the sea . . .' (*Silvae*, 1, 2, 148ff.). The different marbles are identified
mainly by their provenance with additional information on their figuring, as with the
onyx, or their colour, as with the green porphyry from Laconia. The hint of assimi-
lation to things in nature is subdued, as in *virent*, a term usually applied to verdant
plants, or in the comparison with the sea. Only in one case does Statius go further:
'Here too is the slab from the mountain of Amyclaean Lycurgus, which is green, and
imitates in rock the soft grass' (*Silvae*, 2, 2, 90–91). But even there the reference to grass

221 Hagia Sophia, Istanbul, AD 532–7, narthex (see also fig. 226).

serves chiefly to make possible the clever contrast between the hard and the soft material. Clearly, though, an important development had begun and by the time of Sidonius Apollinaris in the mid-fifth century we are much closer to mistaking the marble for something else: 'Here is Synnadian, there Numidian stone, making a false impression of old ivory; then comes a shining green row of grassy marble from the Laconian crag' (*Carmina*, 5, 37–9). The Numidian marble actually deceives Sidonius into thinking it is ivory and the Laconian marble is actually grassy. In a verse inscription for a new church in Lyons Sidonius goes even farther:

> Marble diversified with a varied gleam covers the floor, the vault and the windows; in a multi-coloured design a verdant grassy encrustation leads a curving line of sapphire-coloured stones across the leek-green glass . . . and the field in the middle is clothed with a stony forest of widely spaced columns.
>
> *Epistulae*, 2, 10, 13–15, 20 and 21

Here the marbles are no longer identified by provenance, but are chiefly characterised by metaphors of colour deriving from the world of vegetation. This in turn allows Sidonius to see the floor of the church's nave as a field and the colonnades as a wood.

Even this, however, is sober stuff compared with some of the descriptions of Hagia Sophia in Constantinople a century later (AD 532–7), especially those of Paul the Silentiary (fig. 219). One of the most vivid gives a contemporary visual and psychological response to the marble pulpit, sadly now lost:

> and as an island rises amidst the waves of the sea, adorned with cornfields, and vineyards and blossoming meadows, and wooded heights, while the travellers who sail by are gladdened by it and are soothed of the anxieties and exertions of the sea; so in the midst of the boundless temple arises upright the tower-like ambo of stone adorned with its meadows of marble, wrought with the beauty of the craftsman's axe. Yet it does not stand altogether cut off in the central space, like a sea-girt island, but it rather resembles some wave-washed land, extended through the white-capped billows by an isthmus into the middle of the sea . . .
>
> *Descriptio Ambonis*, 224ff

Such an overwrought account of a simple geometrical configuration of sawn slabs suggests that sensitivities were now so heightened that, not only were architects inspired to surpass their predecessors in designing buildings whose volume and curvilinearity of mass and surface evoked landscape features, but viewers were indeed ready to see natural representations in the purely abstract. In his description of the slabs set into the new church's narthex Paul the Silentiary confirms this:

> Upon the carved stone wall curious designs glitter everywhere. These have been produced by the quarries of sea-girt Proconesus. The joining of the marbles resembles the art of painting for you may see the veins of the square and octagonal stones meeting so as to form devices: connected in this way, the stones imitate the glory of painting.
>
> *Description S. Sophiae*, 605–16

Here Paul is evidently drawing attention to some of the most remarkable marble panels from Hagia Sophia. These are sets placed above the doors at the main entrance, which

have been cut, split and juxtaposed so as to generate configurations suggestive of stand-
ing figures, their hands raised in prayer (fig. 220), as if encouraging others to join them
in literal obedience to the biblical injunction 'Enter into his gates with praise'. Proof
that they were intended to be experienced in this way is provided by the holes drilled
to represent eyes. Only the craftsmen who first clothed the building are likely to have
added this detail, demonstrating that they, as Paul said, saw the slabs as human silhou-
ettes and expected others to do likewise. Not only did late imperial viewers have
heightened visual imaginations enabling them to see more than was represented, but
artists in acknowledgement of this consciously made works lacking representational
detail for them to look at. The symmetry of the relationship between a growth in the
imagination and a decline in representation that we pointed to in the world of
painting and sculpture is precisely documented by the correspondence between the
appearance of these slabs and the character of contemporary descriptions of the great
church. People in the sixth century really saw living figures in veined marble.

Apollonius of Tyana was evidently not alone in his sensibilities, or, at least, he was
no longer alone by the time Hagia Sophia was built. His analysis of the subjectivity
of perception thus offers a key to the broad trend of late imperial aesthetics as they
were beginning to emerge in the other texts. Indeed he can be closely linked to the
tradition that those texts represent. A contemporary of Quintilian and supposedly a
friend of Vespasian, Titus and Nerva, his ideas would have received official sanction at
the same moment as those of the great rhetorician. Hadrian later owned a collection
of his letters and his disciple Damis wrote a *Life* that was in circulation with transcripts
of letters throughout the second century. More importantly, there is a direct connec-
tion between Apollonius and the rhetorical descriptions of paintings with their height-
ened spectator response through the familial link between Flavius Philostratus, the
author of the present *Life*, and the other two Philostrati. In his other major work, the
Lives of the Sophists, Flavius Philostratus makes clear how both he and the other
members of the family were central to the main intellectual stream of the later Empire.
The sophists in question were the teachers of rhetoric who provided the best in edu-
cation in the second and third centuries and who flourished thanks to the direct impe-
rial patronage that went back to Vespasian's original appointment of Quintilian. Such
men acquired enormous wealth and influence, as did the celebrated Herodes Atticus,
one of the richest men of the second century, and were often employed at the impe-
rial court, as was Flavius Philostratus himself in the circle of Septimius Severus and
Julia Domna. Others associated with the same group were Apuleius, author of the *Meta-
morphoses*, and his contemporaries Lucian and Achilles Tatius, who both made similar
contributions to the new genre of fiction. Since the last three have also all left us elab-
orate examples of rhetorical descriptions of works of art they prepare the way for
us to recognise a close connection between the art of literary fiction and the art of
seeing more than is there. Both arts involve inventing something in one's imagination
that does not exist physically. From Quintilian and Apollonius, through the
novelists to the writers of rhetorical descriptions, we are dealing with the main stream
of official culture. Its principal focus was a concentration on the development of the
imagination.

★ ★ ★

The Rise of the Imagination and Material Decline

The reasons for this official encouragement of the development of the imagination are complex. One was probably a desire to provide a field of activity for minds that were largely unemployed, a field that because it denied reality would never be politically dangerous. Instead, the development of the imagination would ensure that people would be less conscious of whatever might be the unpleasant realities of their lives. The decline of the empire in political and economic terms would be of little interest to people who lived in a fantasy world. The situation in the Roman Empire is thus the reverse of that in Classical Greece. There the development of natural philosophy is associated with a need to make people aware that their survival depended on an understanding of particular chains of cause and effect. The Greek city states had fostered an educational system that encouraged a concentration on physical realities, whether they were military, commercial or medical. To do this they had to a large extent killed off the imagination. The Roman emperors took control of the welfare of their citizens. They needed to convince them that it would be unnecessary and unproductive for them to interfere in the processes of government. They encouraged a sense that people lived in an unreal world by providing many forms of artificial and unnatural entertainment in amphitheatres and baths. In those settings people came to experience things they could have only imagined before. The contemporaneous reactivation of the imagination through the new system of rhetorical education meant that even without such settings people were increasingly able to transcend reality. Living increasingly in a world of fantasy they might hardly notice the symptoms of political and economic decay that became ever more visible in the second, third and fourth centuries.

An excellent example of the way a heightened imagination could withdraw attention from a declining economy is provided by the development we have noted in visual arts. The impoverishment of the Empire, especially at the centre, meant that there was less and less money to provide the highly finished craftsmanship of the first centuries BC and AD. This might anyway have led to a progressive simplification of forms as in the reduction of shading in painting and of modelling in sculpture. As it was, since viewers were able increasingly to see the information such devices recorded whether it was there or not, their use was superfluous anyway. The visual imagination made up for the deficiencies of material resources.

The enhancement of the imagination may have contributed to the collapse of the Classical tradition of artistic naturalism, but in one field, religion, it facilitated a staggering growth. The inhabitants of the Empire who had acquired the capacity easily to imagine themselves to be incredibly rich when they were poor and travelling in exotic lands when they were at home, as Quintilian described, were well adapted to respond to the priests of the new and not so new mystery religions who promised eternal life and unearthly bliss to those who believed and shared their rites. It would have been difficult to tempt a Classical Greek with the idea that he might be rich if he had nothing, strong if he was weak, happy if he was miserable and most alive when he was really dead. All the evidence would have convinced him that these were false dreams. For someone living in the third- or fourth-century Roman Empire, someone used to living as much in his imagination as in reality, someone who might have been trained

to follow Quintilian's recommendation of describing people as murdered when they were still alive, such apparently unrealistic promises would have fitted perfectly with the patterns of his existing inner life. Moreover, just as the simplification of art made the use of the visual imagination ever more essential, so the degradation of life in the here-and-now made dreaming of a better one hereafter even more attractive.

Dreams and Visions; Conversion and Transubstantiation

Day dreaming is easier if the imagination is more alive. So too is belief in the significance of true dreams and visions. Certainly such manifestations of an inner life become more acceptable in a community that shares an acknowledgement of the importance of fantasy. Which is why both the recording of dreams and their use as guides to action become more frequent through the Empire. In the centuries that had passed since the Homeric period dreams and other visionary appearances had played little part in history or literature, having been suppressed along with other manifestations of subjectivity that threatened the security and clarity of the rational and objective mind. From the second century AD onwards they have a greater importance than they had perhaps ever had. They have a significant role in novels such as the *Golden Ass* and in many later works of poetry and prose. They also apparently had a place in medicine and in rhetoric, at least in the works of the orator Aelius Aristides, which describe dreams linked to the cult of Asclepius at Pergamum. The field, however, in which they had the greatest power was religion. From the time of the visionary Revelation of St John the Divine in the late first century dreams have always had a central role in Christianity, and it was through dreams that Constantine was more than once inspired as he initiated the process that was to lead to the Christianisation of the entire Roman world.

A feature of Constantine's dreams or visions was their exploitation of transformations, seeing something familiar adapted to a new context. One example was the dream that led him to add the ChiRho monogram to his standards in preparation for the decisive battle with Maxentius at the Milvian Bridge. Another was the vision he had before the Council of Nicaea (AD 325). In this a great structure with its pediment supported by twelve columns represented the future unity of the Christian Church supported by the apostles. The emperor's dreams allowed him to visualise traditional Roman forms, such as military emblems and temple façades, converted to Christian use, and in life he encouraged just such transformations, as in the change of the axis of the basilica built by Maxentius from length to breadth. Even more exceptional was his incorporation of so many sections of earlier reliefs in his triumphal arch that it became a veritable epitome of the transformations of Roman art and culture from the early second century (fig. 222). At one moment we seem to be looking at a Trajanic monument, at another a Hadrianic one, at another one that is Antonine. Only when we realise that all the emperors' faces have been changed to that of Constantine and that his reliefs occupy the principal positions, is it clear that the ultimate form of the transformation is Constantinian. In the arch's inscription there is an ambiguous hint at the emperor's own transformation by conversion or at least divine intervention: DIVINAE MENTIS INSTINCTU, 'by the inspiration of the divine mind'. More explicit is the removal from the arch of the Composite capitals, traditional emblems of the transforming power

of the Roman triumph, and their transposition to the new Christian monuments such as the basilica of St Peter's. In that building in particular the association of Composite capitals with the arch over the altar allows them to create effectively a new *arcus triumphalis*, as that part of the church was known by the eighth century, thus changing a triumph over secular enemies into a greater triumph over death, while the fact that there were twelve of them suggested equally eloquently both the literal fulfilment of Christ's promise that it was on Peter that his Church would be founded and Constantine's own vision at Nicaea (fig. 223). The adaptation of the traditional forms and even the dimensions of the traditional secular basilica to the new churches is part of the same movement or metempsychosis by which the soul of pagan Rome migrated to the new institutions. The ultimate celebration of that migration was the refounding of Byzantium on the Bosphorus as New Rome, an essentially Christian replacement for pagan Rome and the future capital of the Empire.

222 Arch of Constantine, Rome, *c*.AD 315.

223 St Peter's, Rome, *c.*AD 330, interior of transept, drawing by Maarten van Heemskerk, showing (behind) new St Peter's under construction.

However far Constantine went in the process of conversion, his interest in the new religion certainly fits with his interest in encouraging a belief in the possibility of almost miraculous change. One of the principal attractions of Christianity for him, as for many of his subjects, was almost certainly the prominence it gave to the idea of change and metamorphosis. Death could become life at the moments of both baptism and death and the ultimate celebration of Christ's triumph over death was the eucharist when bread became flesh and wine blood. For Roman citizens of the fourth century, trained to imagine the unreal, to see that which was not there and to become what they were not, Christianity was quite simply the religion that responded best to their mental proclivities. As with Apuleius' conversion to the religion of Isis at the end of his *Metamorphoses*, conversion to Christianity was the ultimate transformation and belief in its benefits the ultimate demonstration of the imagination's ability to bring fantasy to life.

Chapter Seven

THE CULTURE OF
THE CHRISTIAN CHURCH

Closing the Schools

Still vigorous and successful in the second and third centuries AD, by the sixth the Classical world had ceased to exist. Its collapse was not only the result of external pressures and internal decline; it was also deliberately brought to an end in the name of a cultural revolution. Economic and military problems did admittedly lead to a fatal weakening of the Empire. The rupture of the Rhine frontier in AD 404 and the Sack of Rome in 411 were severe blows. But equally decisive were the centralised decisions that brought the epoch to a measured end. Constantine began the downgrading of the Olympian and other cults that had provided a backbone to Greek and Roman life when he gave Christianity the role of a state religion. Rome itself he demoted by founding his new capital in the East. Theodosius I (AD 379–95) accelerated the process of transformation by cancelling the funding of pagan rites and bringing to an end the 1,100-year sequence of the Olympic Games. Theodosius II followed the assault on institutions with an attack on buildings, ordering in AD 435 the destruction of all temples in the central diocese of Constantinople. The intellectual centres, where the leaders of the early Church had themselves been educated, survived the longest, but they too found their nemesis in an edict of Justinian in AD 529 which closed the Academy at Athens. The victory of Christianity meant not just the defeat of paganism but the extinction of a whole tradition. Not only was it increasingly difficult any longer to be pagan, it was increasingly necessary to be Christian. New institutions were set up to enforce orthodoxy and strengthen the Church's authority. Constantine himself began this process. He summoned the first great Council at Nicaea to promote unity and agreement on issues of theology. He also transferred the Lateran, a major imperial palace, and other properties to the Bishop of Rome to mark his status at the apex of an organisation that, especially in the Western Church, paralleled that of the emperor's own administration, with bishops, literally *episkopoi*, 'overseers', based in provincial capitals supervising the priests and churches in their areas. For the first but not the last time in the history of Europe, skills and systems developed to secure peace, facilitate

224 S. Apollinare in Classe, Ravenna, AD 533–6, interior with apse mosaic showing (above) the Transfiguration and (below) S. Apollinare in Paradise, and, on arch, the two cities of Bethlehem and Jerusalem of the seventh century AD.

trade and encourage the payment of taxes across vast areas were used to impose conformity not just of behaviour but of thought.

The culture of Christianity, as it crystallised around a kernel of belief of extraordinary promise, had little time for the cultures that preceded it and on whose achievements it relied. The cultures of war and of competition, which typified ancient Greece and whose success had ensured that they had survived the rise of Rome, now became marginalised or were transformed. The culture of character that Alexander's worldly achievements had fostered was now anathema. Even the cultures of memory, which sustained Rome's ascendancy, and of the imagination, which that ascendancy had indirectly nourished, now waned. The people of Europe and the Mediterranean, who had for centuries pursued strength and knowledge, honour and wealth, power and pleasure in this world, now concentrated on improving their prospects for salvation and bliss in the next. The present opinion of their fellow men became of little importance for those who worried about the future judgement of God. Whether forced or persuaded, men and women shunned the temples, the schools, the theatres, the amphitheatres, the baths and the workshops of painters and sculptors which had had until recently such an important role in their lives. Driven by the fear of philosophy, luxury and idolatry, and the zeal for chastity, poverty and simplicity, the members of the new Church happily destroyed a world that their ancestors had built with tools shaped originally in the Greek workshop.

The Christian and the External World

And yet this picture of an abrupt change of life-style is deceptive. In many ways the activities of Classical civilisation were not so much rejected as transformed and adapted to the new priorities. While the athletics, science, literature and art of the Greeks, and the sensuality and delight in fiction of the Romans, were all attacked as incompatible with the new religion, each survived in a new form. The physical exercises of the runner were replaced by the no less physical disciplines of the monk and the hermit. To the rigorous life of the pagan contestants succeeded that of the Christian athletes. The intellectual skills that had once been applied to defining the laws of nature were now applied to interpreting God's purpose in Creation. As cosmology declined theology gained vitality. In the field of letters the love song was replaced by the hymn and the speech by the sermon. Secular painting and sculpture and the worship of images may have been subject to increasing criticism but all the visual arts received a new and even greater concentration in the Church. In many ways the Christianisation of the Roman world relied not on the rejection of earlier material needs and physical practices, but on an elevation and intensification in the level of their experience. Christianity thrived by taking the needs and pleasures that had long preoccupied the population of the empire and making them available in condensed or distilled form. Things that successive emperors had found it in their interest to provide were now offered by priests.

Experiences that had been available on a large scale in public buildings and open spaces were now supplied in reduced form in church. Instead of looking for a large supply of water to wash with weekly in the baths, people now went to the bap-

tistry once in their lives to find a few drops to cleanse them of their sins. Instead of expecting the emperor to guarantee the supply of real loaves, Christian converts attached great importance to an often distant participation in the eucharistic meal. Instead of going to the games to see the shedding of real blood in large quantities, people could now at communion consume that of Christ. Instead of witnessing real slaughter in the amphitheatre, believers could regularly hear it described in readings during the liturgy. Instead of refreshing themselves by wandering through extensive and well-watered public parks they now needed only to go to church where columns and marble floors evoked the trees and streams of Paradise. As travel became more difficult, paintings and mosaics in the same buildings reduced the distance to the Heavenly Jerusalem to a few paces (fig. 224). Even at home books provided access to the same experiences. There is an extraordinary match between the material requirements of the citizens of the earlier Empire and the symbolic gifts of Christianity. The Church offered its members an epitome of the resources once offered by the emperor throughout his dominions. No longer available in quantity and substance they could still be enjoyed in reduced essence. Not only did each church contain an epitome of the resources of the Roman Empire, the building itself became an image of another empire, the kingdom of heaven, an embodiment of that Heavenly Jerusalem that descended to earth in the Revelation of St John. So effectively did the Church substitute for the earthly empire that Augustine had no difficulty in conceiving of the Christian community as a City of God destined to replace the City of Man which was best embodied in the city of Rome. For him and his fellow Christians the Sack of Rome far from being regretted was to be welcomed as a milestone in the fulfilment of the divine plan.

The ease with which people's responses changed should not lead us to underestimate the mental energies absorbed in the new approaches. The spread of Christianity was greatly helped by the earlier heightening of particular faculties of the late Classical mind. Without the development of the imagination during the previous centuries satisfaction with such reduced experiences and with a reality that was frequently purely conceptual would have been impossible. Without the development of rhetorical education there would have been neither the army of teachers ready to propagate illusions nor the audiences predisposed to go along with them. The habitual stimulation of the fantasy in front of art prepared people to accept even allusive portrayals of the as yet unseen. The liberation of the mind from rational constraints by the reading of fiction removed a principal obstacle to belief in the miracles of scripture. The leaders of the new clergy were trained in this rhetorical ambience and many of the most influential church men, such as Augustine, were themselves renegade teachers of the subject. The skills that inspired and strengthened faith in Christ's message were ultimately the skills of the late Roman orator.

Yet it was not only the educated who had the ability and inclination to trust the mysteries of baptism and the eucharist. Other groups willingly accepted such mysteries for quite different reasons. Women, for example, were very often the first to put their hearts and wealth behind the new religion. Typical were Constantine's mother Helena and later Augustine's, Monica. Many reasons can be proposed for this, but one likely contributory factor was that they had always been more used than men to living a life of the imagination. Spending more of their time deep inside their houses they would often have had to build up a picture of the world based on what they heard

from men. They were thus, even better than men, already equipped to share the visions of the fathers of the Church. Since their image of the earthly Rome derived as much from description as direct observation, accounts of the Heavenly Jerusalem would obviously also have had a greater power. Men who expected to build up a picture of their own city from direct experience might have found it harder to trust the tales of the priests. Women were perhaps the group most susceptible to the Christian message because they were conditioned by habit to use their imaginations. Men had to be conditioned by rhetorical training. When the words of the skilled orator entered the ears of the enclosed woman, amazing things could happen.

A vivid example of how two such individuals could use their imaginations to share or rather build a new world is provided by Augustine's account of one of his last conversations with his mother. Sitting with his dying parent at a window of a house in Ostia, overlooking a garden, the two of them almost talked themselves into Paradise, the educated teacher and the uneducated woman being equally able to create a world that existed only in their heads. Together they asked

> what is the character of the future life of the saints, a life which no eye has seen, no ear heard and no heart conceived of. We panted after the upper streams of Thy fountain, the fountain of life, which is with Thee . . . And when our conversation had led us to that end, so that no pleasure of the carnal senses seen in the brightest corporeal light seemed worthy of comparison, or even mention, beside the pleasantness of that life . . . step by step we ascended through all corporeal things and walked through heaven itself whence sun, moon and stars shine upon the earth.

Finally they agreed that

> if for any man the tumult of the flesh is silent, if the fantasies of the earth, of the waters and of the air are silent, if the poles of heaven are silent and if the soul can surpass itself by not thinking about itself, dreams too will be silent and imaginary revelations . . .

and eventually it might be possible to hear God directly, as they almost could at that moment (*Confessions*, IX, 10). As Augustine says, the vision of the fountains of heaven made them forget the view into the adjoining garden. What they saw in their minds was more real than what they saw with their eyes.

The Christian and the Internal World

Even more essential for the success of Christianity than the readiness of two or more people to share an imaginary world was the ability of a single individual to construct such a world on his own. It is certainly this talent that all believers needed if their faith was to last after leaving church. Augustine gives an excellent picture of the extraordinary scale and power of the early Christian mind. One of the most vivid passages of the *Confessions* describes his experience of his memory:

> And I come to the fields and wide palaces of the memory, where are the treasuries of innumerable images brought into it from those things perceived by the senses. There is hidden whatever we think, as we increase or diminish or vary in any way those things which the sense has touched. There is hidden anything else which the

memory has recommended to it and stored away, that is anything which has not yet been absorbed and buried in forgetfulness. And when I am there I ask whatever I want to be brought out, and some things come out immediately and others are sought at greater length and brought as if from more obscure containers; some things rush out in groups and while we look for and seek something else they jump into the middle as if saying 'perhaps it is us you are looking for?' and these I drive back with the hand of my heart from the face of my memory until the thing I am looking for is discovered and it emerges from the secret depths.

Confessions, x, 8

Augustine's reference to fields and palaces stored with images makes it likely that his memory had been shaped by the devices of the rhetorician, but what he describes is no passive mnemonic system. Instead he has developed the 'places' where the orator puts the 'signs' designed to help him remember his speech into a spacious inner world. There some memories are lost, some only hidden and hard to extract, while others with a life of their own push themselves forward and offer themselves unbidden. He even describes himself as walking around inside his own memory and using his hand to fend off those memories that rush at him unwanted. Augustine is himself amazed at the complexity of his inner life and goes on to remark how odd it is that people travel to admire high mountains, huge seas and broad rivers, yet pass their inner selves by, although they are already stored with such grand phenomena. He also notes how self-sufficient is memory, since when we remember an object we may actually also smell it or taste it. The memory houses an inner world that is just as real as that outside.

Augustine's slightly older contemporary, Prudentius, has a similar sense of interior space, but one that extends throughout his physical, mental and spiritual consciousness. His *Psychomachia* or *Soul-Battle* is a poem that describes the inner conflicts of the Christian and tells 'how the soul is strengthened to fight and expel sins from our hearts' (*Psychomachia*, 5 and 6). Virtues and Vices confront each other on foot, on horse and in chariots in a bloody conflict that spreads through the whole landscape of the body. 'In our hearts conflicting loves battle' and 'War rages in our bones' (*Psychomachia*, 902 and 903). At the end of the conflict Faith and Concord establish a camp. 'No part of man's soul lies hidden in some forgotten niche of the body.' Then the spirit of God builds a temple for the soul's privacy and 'with pure desires the heart of man gives honour in its holy place' (*Psychomachia*, 845). The temple is a four-square walled structure inspired by the heavenly city of Revelation and, in commemoration of Proverbs 9: 1, it incorporates a seven-columned structure to house Wisdom. In the landscape of the body battles are fought and buildings are constructed. The theme of bloody conflict first presented to the Classical world in the *Iliad*, and a popular subject of literature and art throughout the pagan centuries, is now transposed from the surface of the earth to the body's inner spaces. It is there that the lusts and fears of our organs meet the higher spiritual qualities favoured by God. There are fought the most important conflicts, those that determine the fate not of our family, city or country, as they did for the ancient Greek, but that of our soul. For Prudentius as for Augustine what went on within us is was far more interesting than what went on in the world.

What gave importance to what went on inside us was that it was our inner life above all with which God was concerned. What happens to our bodies is for Him of little significance compared to the state of our souls. To understand how far this went

we have only to read Augustine again on the subject of rape. We may not be surprised that in the City of God he welcomes the sack of worldly Rome, but we may be shocked by his lack of concern for the associated rape of Christian virgins. As far as he is concerned the only women who should regret their experience were those who had been in any sense psychologically involved in it. Anyone who was totally unmoved by violation had lost nothing of any importance in God's eyes. For more than a thousand years rape had been a physical event with profound importance in history and culture. At the beginning of the Classical world the rape of Helen and the associated dishonouring of the house of Menelaus had led inexorably to the Greek vengeance on Troy. At Rome the rape of Lucretia found an equally certain response in the maiden's suicide, and the loss of a Vestal Virgin's chastity required the taking of her life. Now the whole system of earthly honour and shame, crime and punishment, was deemed an irrelevance. For Augustine what happened to the body was irrelevant too. The only thing that mattered was what happened to the soul. Nor was it just a question of shifting the area of emphasis from the physical to the spiritual. Equally decisive was the abandonment of a system that depended on the objective assessment of an event by outsiders in favour of one that left the individual alone with his or her God and Judge. Only the individual had an inkling of what might have gone on in his or her soul; and ultimately the only being who knew perfectly a person's spiritual state was God.

Many an early Christian must have learnt to hold conversations within him- or herself, addressing God in the name of his or her soul, pleading, excusing, asking, in a life and death negotiation with the Almighty. Such dialogues offered an opportunity to explore the self that had never existed earlier and out of them emerged a new extension and intensification of self-consciousness. The degree of self-awareness that emerges is nowhere more apparent than in Augustine's *Confessions*, a work often claimed to be the first autobiography. In its thirteen books Augustine addresses God in many tones, alternately recording, explaining, puzzling. Talking with an intense recall, he rehearses his life in extraordinary detail, from his infantile struggles to understand language by watching the body movements of his parents to his participation in the noisy religious debates of his proud maturity. Finally at the end of his physical, mental and spiritual odyssey he invites God to enter his soul in fulfilment of His plan and endeavours by a series of allegories to explain how man relates to nature. For nature is not there for itself, but, as the Bible story of the Creation indicates, is there to be interpreted. The holy authors are like the firmament, and the society of bitter people is like the sea and the zeal of pious souls is like the dry land and the works of mercy done in this life are like plants bearing seeds and trees bearing fruit and the gifts of the Holy Spirit are like the shining bodies of heaven. Augustine is desperate to show God that he understands the deepest significance of his Creation; talking to Him changes the meaning of everything. As he revolves all that he has read and heard of God's message he reshapes his view of the world. In the workshop of his mind nature is remade to serve only God's purposes. It is not what he knows about nature that is important or what he sees, but what he thinks about it following the hints in holy scripture. Those who read his book are only overhearing him think aloud for God's benefit. By writing down his thoughts he shows his readers the importance of such an inner life of which the Deity is the principal witness.

The new intensity of the inner life of at least some people probably encouraged another phenomenon that marks the end of one tradition and the beginning of another: this is the habit of silent reading, which is also described in the *Confessions*. Augustine professes real wonder at seeing his hero, Ambrose of Milan, reading without saying the words. 'When he was reading his eyes were led over the pages and his heart searched for the meaning, but his voice and tongue were silent' (*Confessions*, VI, 3). Augustine's reaction reminds us of what we might easily forget, that reading in the ancient world normally meant reading aloud, whether one was alone or in company. Since writing began as transcribed speech this was the natural practice. Augustine is not really sure why Ambrose starts to read silently, but it is easy to understand how, if life's meaning was confirmed not by man but by God, reading silently could be a testimony that this was understood. A further advantage was that it allowed time for reflection and meditation on the words. Reading aloud encourages us to go straight through, because silent breaks would confuse the meaning. Reading silently allows the activity to be pursued at any pace with any number of breaks. It is much better adapted to accommodate the meditations on words and meanings such as are found in the *Confessions*. It is also happily in harmony with the Old Testament commendation of silence in God's presence (e.g., Zechariah 2 : 130). Similar factors would have also led to the development of silent prayer. Christ had specifically criticised those who pray in public to show off to other men (Matthew 6 : 5), saying: 'But thou when thou prayest, enter into thy closet, and when thou hast shut thy door, pray to thy Father which is in secret; and thy Father which seeth in secret shall reward thee openly' (Matthew 6 : 6). Obviously to pray in public, but silently, would have the same effect of proving that it was done only for God. The prayers of both pagans and Jews had usually been public and voiced and such performance was usually essential for their efficacy. For them to become secret and silent required enormous inner confidence in God's present witness in the heart. The development of silent reading and silent prayer is one of the most remarkable transformations brought about by the rise of Christianity. It marks a major step in the development of the private person with a hidden consciousness.

The same need for privacy shaped another feature of the new Christian world, the deliberate avoidance of the cities whose construction had been one of the great achievements of the preceding thousand years. People like Augustine aspired to an existence without external stimulation, arguing that only then might it be possible to hear God speak directly (*Confessions*, IX, 10), as he and his mother almost did in Ostia.

Others took the more decisive step of going into the country or even better the desert as hermit or monk, following St Anthony (AD 251–356) the leading figure in the first movement to solitude in the Egyptian fastness, someone who knew 'that a man should pray in secret unceasingly' (St Athanasius, *Vita S. Antonii*, 3). There was only one great risk associated with the heightening of inner alertness which was a consequence of this silent lonely life. The hermit might seek God, but the Devil was not far away and it was often difficult to distinguish his temptations from the visions sent by God. The temptations of St Anthony himself were the most celebrated. There was room in his vast imagination for all manner of monsters, women and others who sought unsuccessfully to bring him to damnation. Only slightly less famous were the temptations of St Benedict of Nursia (*c*.480–*c*.543) who was largely responsible for

introducing monasticism to Europe and who wrote the so-called Benedictine Rule. The way temptations were triggered when real experiences provoked the memory and imagination is well illustrated by the story of how the Devil came to Benedict in the form of a black bird that followed him around until he frightened it away with the sign of the cross. The bird's departure was, however, immediately followed by his remembering a woman he had once known and his then being almost carried away by his emotions. Only when he noticed a thick patch of nettles and briars and threw himself naked into them and rolled around until his whole body was in pain and covered in blood, could he conquer the pleasure and drain off the poison of temptation (St Gregory the Great, *Dialogi de Vita*, 2, 2). The space that the devout created in their hearts might be filled by unwelcome, as well as welcome, experiences. Yet the watchful survived. Living inside himself, the Christian could wander like Augustine through the rooms of his memory, as long as he was careful to ward off the unwanted. If he was like St Anthony who remembered what he had heard and read so well 'that his memory served him for books' (St Athanasius, *Vita S. Antonii*, 3) his mind might even serve him as a library.

Christian Building Blocks

Such abilities, though, were for the few. Besides, the prodigious memories of the early saints died with them. The schools in which they were trained were closed and the tools and methods on which education depended fell into disuse. Later Christians were left with many doubts about their nature and their future. In this condition, they had alongside the apparatus of religion one principal support, the imagery of scripture as it had been developed by early Christian writers. If we want to know what an early medieval Christian felt like, we can hardly do better than read the so-called *Shepherd of Hermas*, written in the second century AD, which contains one of the most reassuring compendia of imagery. A near canonical text of the early Church, this text was not one of the most popular of the later Middle Ages, but its metaphors reappear in many that were. One of its most powerful images is that of the human being as a tree planted in a field. The care that the young tree needs, the growth it experiences and the uncertainty of its fate all relate to the experiences of anxious souls. So too does the image of human beings as stones, the best of which, in colour, substance and form, will be used to build the new Church, represented by a 'great tower built upon the water with bright square stones' (*Vision*, 3, 2). Hermas is anxious to understand the meaning of the different types of masonry in and around the tower, and this is explained to him. 'The square white stones that fit exactly in their joints are the apostles and bishops and doctors and ministers' (*Vision*, 3, 5). 'Those that are rough are those that have known the truth but have not continued in it nor been joined to the saints . . . Those that have flaws in them are those that keep discord in their hearts against each other and live not in peace' (*Vision*, 3, 6), while the round stones 'are such as have faith but also carry with them the riches of the present world' and so would need to have that burden removed in order to become square and useable. The imagery of wood and stone, the familiar building materials of their environment – and we may compare the rough stones with Claudius' unfinished masonry – helped them to think of their

weak flesh as of more lasting value. Like the ancient Greek who understood his place in the phalanx in terms of a square block in a wall or a post in a fence, the Christian thought of his place in the Church as a timber or stone. The main difference was that the Greek, with no knowledge of an uncertain inner world, doubted more the quality of his form rather than the nature of his substance. The Christian, deeply troubled by his inner landscape, worried most about how good was the wood or stone of which he or she was made. Both Greek and Christian, however, when they thought of their relation to the principal institutions on which their security depended, the phalanx and the Church, thought of themselves as made of hard workable materials. The similarity and differences between them are well illustrated by a comparison between the Greek male nude statue and the stone slab men who line the narthex of Hagia Sophia (figs 225 and 226). Both are made of solid marble, but while on the Greek statue it is the tool-like limbs that are represented in all their instrumental substance, in the narthex figures it is their interior being that is mapped by the evanescent veining. Like an x-ray image of the spiritual, the curving lines brilliantly suggest the inner life that was alluded to in the Vision of the *Shepherd of Hermas* and in the *Psychomachia*. The parallel is especially close in the context of the Vision where the varying quality of the faithful was indicated through the image of stones with different colours and different faults. Also analogous in spirit to the Vision is the rigid rectangularity of the slabs. Whereas the defective rounded stones rolled away easily from the tower, the slabs, like the unflawed blocks of which the tower is built, are fixed and stable in their position. The contrast is the same as that between the rolling boulder-like Hector and the Myrmidons in their well-built wall. Yet, while even the most *tetragonos* Greek statue could never really be built into a wall, the orant in the slab, being genuinely four-square, could be literally built into the church. There the rectangular Christian could fulfil the vision of St Paul at Ephesians 2 : 20: 'and ye are built upon the foundation of the apostles and the prophets, Jesus Christ himself being the chief corner stone; in whom all the building fitly framed together groweth into a holy temple in the Lord.'

Christ himself, then, is a *lapis angularis*, often understood not as 'corner stone' but as 'angular stone', and the Old and New Testaments, if they are to function as effective foundations, should also be block-like, which is what they became. Until the fourth century AD books had always been preserved on continuous scrolls that were soft and cylindrical. From the later fourth century they were increasingly made, in the modern manner, of separate sheets bound between hard covers in a codex (fig. 227). Since this development is closely linked to the decline of paganism and the rise of Christian literature the hard-covered cuboid book became emblematic of the new spiritual knowledge. On such blocklike books a durable Church could be founded, an institution palpably more reassuring than its rivals, Judaism and Greco-Roman philosophy, the teachings of both of which were proudly preserved on scrolls. Those who read, learned and inwardly digested the new more solid texts acquired a closer affinity with the blocks needed in a well-built church. The imaginary Church that all had in their heads, whether constructed of block-like scriptures or of block-like believers, was a secure refuge.

By a reflex process such imagery also increased the psychological significance of the real religious buildings that in the period between AD 500 and 1000 often offered the

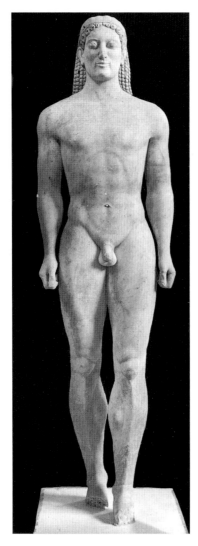

226(*above*) Praying figures, detail of fig. 221, split marble slabs, from the narthex of Hagia Sophia, Istanbul, AD 532–7.

225 Funerary statue of a warrior (see fig. 4), marble, *c.*525 BC.

best protection both for people and artefacts. Hermitages, monasteries and churches were built and in them the books containing the wisdom of Christianity were read and meditated on. Fortunately, too, many of those that contained the wisdom of paganism were also copied and preserved; so, although for nearly a thousand years the books of the Classical world were little read, the hard knowledge they contained was preserved.

When economic and political resurgence led the Italians to explore their lost national heritage and other nations to follow them in a return to the sources of European culture, the books were there to serve as a physical memory system. In the fifteenth and sixteenth centuries scholars could wander through them again at will. Using the unique inner resources developed and maintained by the Christian life they could experience them with a concentration and intensity unknown in Antiquity. Meditated on like scripture, the works of Homer and Plato, Cicero and Virgil, acquired an extraordinary power, which enabled the Classical world to be experienced again as full

of vitality. Those who were used to communing and conversing with prophets and apostles, evangelists and saints, now found an equal intimacy in the company of pagan poets, historians and philosophers. Works of art, too, could be meditated on. Like the images in churches, ancient statues and paintings could be gazed at and venerated. Like monasteries, the galleries that housed them could be silently paced. Those who sought the even closer company of the ancients could, like religious pilgrims, travel to Rome and to Greece and walk in their footsteps. Everything pagan was experienced using mental resources developed and strengthened within a Christian tradition. Those who looked at the material remains of the Classical world did so with eyes educated by centuries of Christian devotion. Nor could they stop themselves turning Greece and Rome into an earthly paradise, fit to match in secular terms the heavenly Jerusalem. During the period from the fifteenth century to the present day the extraordinarily varied history of a thousand years has became consolidated for most people into an ideal vision of a single Classical world. This responds to their desire for a perfect home in the past populated by exemplary ancestors. The vision that resulted has often been highly idealised. Only thus could it bring happiness to people who might otherwise have continued to be as deeply troubled by their corruptible humanity as they were during the so-called Middle Ages.

Most of the thousands of volumes that have been written on the Classical world have tended to keep that perfect vision alive. This little book, like others written recently, offers another view. In its pages can be met some of the neglected evidence on the varied nature of the cultures of Greece and Rome, evidence which, to use Augustine's words, we have for too long been pushing back from the face of our memory.

227 Scroll and codex.

Bibliographical Note

The most important sources for this book are the writings of Classical authors. Almost all are available in the Loeb Classical Library editions, which give both the original Greek or Latin texts and their English translations, the latter often providing the basis for the versions presented here. Additional early philosophical texts can be found in G.S. Kirk and J.E. Raven, *The Presocratic Philosophers: A Critical History with a Selection of Texts* (Cambridge, 1962); Early Christian and Byzantine texts in J.P. Migne's *Patrologia Graeca* and *Patrologia Latina*; Paul the Silentiary in C. Mango, *The Art of the Byzantine Empire 312–1453* (Englewood Cliffs, 1972); and inscriptions in *Inscriptiones Graecae* and the *Corpus Inscriptionum Latinarum*.

The secondary literature on the Classical world is vast, and of great richness, with some of the best writing having been produced in the last decades. The following selection of some English texts includes both handbook surveys and more personal investigations.

CLASSICAL WORLD, GENERAL

Boardman, John, Jasper Griffin and Oswyn Murray, eds, *The Oxford History of the Classical World*, Oxford, 1986.

CLASSICAL WORLD, BY PERIOD

Murray, Oswyn, *Early Greece*, second edition, Cambridge, Mass., 1993.
Osborne, Robin, *Greece in the Making, 1200–479 BC*, London, 1996.
Hornblower, S., *The Greek World 479–323 BC*, London, 1983.
Rostovtzeff, Michael, *The Social and Economic History of the Hellenistic World*, 3 vols, Oxford, 1941.
Balsdon, J.P.V.D., *Life and Leisure in Ancient Rome*, London, 1969.
Millar, F., *The Roman Empire and its Neighbours*, London, 1981.
Brown, Peter, *The Making of Late Antiquity*, Cambridge, Mass., 1978.

CLASSICAL ART, GENERAL

Boardman, John, ed., *The Oxford History of Classical Art*, Oxford, 1993.
Boardman, John, *The Diffusion of Classical Art in Antiquity*, Princeton, 1994.
Burford, A., *Craftsmen in Greek and Roman Society*, Ithaca, 1972.

GREEK ART, GENERAL

Pollitt, J.J., *The Art of Ancient Greece: Sources and Documents*, Cambridge, 1990.
Richter, Gisela, *A Handbook of Greek Art*, London, 1959.
Robertson, Martin, *A History of Greek Art*, Cambridge, 1975.
Sparkes, B.A., *Greek Art (Greece and Rome: New Surveys in the Classics*, 22), Oxford, 1991.
Spivey, Nigel, *Greek Art*, London, 1997.

GREEK ART, BY TOPIC

Boardman, John, *Greek Gems and Finger Rings: Early Bronze Age to Late Classical*, New York, 1970.
Coulton, J.J., *Greek Architects at Work*, London, 1977.
Cook, R.M., *Greek Painted Pottery*, London, 1972.
Dinsmoor, W.B., *The Architecture of Ancient Greece*, London and New York, 1950.
Lawrence, A.W. (revised by R.A. Tomlinson), *Greek Architecture*, New Haven and London, 1996.
Pollitt, J.J., *The Ancient View of Greek Art: Criticism, History and Terminology*, New Haven and London, 1974.
Richter, Gisela, *The Portraits of the Greeks*, London, 1965.
Stewart, Andrew, *Greek Sculpture: An Exploration*, New Haven and London, 1990.
Stewart, Andrew, *Art, Desire and the Body in Ancient Greece*, Cambridge, 1997.
Spivey, Nigel, *Understanding Greek Sculpture: Ancient Readings, Modern Meanings*, London, 1996.

GREEK ART, BY PERIOD

Early Greece
Charbonneaux, Jean, R. Martin and F. Villard, *Archaic Greek Art, 620–480 BC*, London, 1971.
Hurwit, Jeffrey M., *The Art and Culture of Early Greece, 1100–480 BC*, Ithaca, 1985.
Richter, Gisela, *Korai: Archaic Greek Maidens; A Study of the Kore Type in Greek Sculpture*, London, 1968.
Richter, Gisela, *Kouroi: A Study of the Development of the Greek Kouros from the Late Seventh to the Early Fifth Century*, New York, 1942.

Classical Greece
Pollitt, J.J., *Art and Experience in Classical Greece*, Cambridge, 1972.
Robertson, Martin, *The Art of Vase-Painting in Classical Athens*, Cambridge, 1992.
Webster, T.B.L., *Art and Literature in Fourth Century Athens*, London, 1956.

Hellenistic
Onians, John, *Art in the Hellenistic Age: The Greek World View 350–50 BC*, London, 1979.
Pollitt, J.J., *Art in the Hellenistic Age*, Cambridge, 1986.
Smith, R.R., *Hellenistic Sculpture: A Handbook*, London, 1991.
Stewart, Andrew, *Faces of Power: Alexander's Image and Hellenistic Politics*, Berkeley, 1993.

ROMAN ART, GENERAL

Andreae, Bernard, *The Art of Rome*, New York, 1977.
Brilliant, Richard, *Roman Art from the Republic to Constantine*, London, 1974.
Henig, Martin, ed., *A Handbook of Roman Art: A Comprehensive Survey of All the Arts of the Roman World*, Ithaca, 1983.

Pollitt, J.J., *The Art of Rome, c.753 BC–AD337: Sources and Documents*, Englewood Cliffs, 1966.

Ramage, Nancy H., and Andrew Ramage, *Roman Art: Romulus to Constantine*, Englewood Cliffs, 1991.

Strong, Donald, *Roman Art*, New Haven and London, 1995.

ROMAN ART, BY TOPIC

Brilliant, Richard, *Gesture and Rank in Roman Art: The Use of Gesture to Denote Status in Roman Sculpture and Coinage*, New Haven, 1963.

Brilliant, Richard, *Visual Narratives: Storytelling in Etruscan and Roman Art*, Ithaca, 1984.

Boethius, Axel (revised by Roger Ling and Tom Rasmussen), *Etruscan and Early Roman Architecture*, Harmondsworth, 1976.

Hannestad, Nils, *Roman Art and Imperial Policy*, Aarhus, 1986.

Kleiner, Diana, *Roman Sculpture*, New Haven and London, 1992.

Ling R., *Roman Painting*, Cambridge, 1991.

Macdonald, William, *The Architecture of the Roman Empire*, vols I and II, New Haven, 1965, and New Haven and London, 1986.

Vermeule, Cornelius, *Roman Imperial Art in Greece and Asia Minor*, Cambridge, 1968.

Wallace-Hadrill, Andrew, *Houses and Society in Pompeii and Herculaneum*, Princeton, 1994.

ROMAN ART, BY PERIOD

Republic and Early Empire

Bianchi Bandinelli, Ranuccio, *Rome, the Centre of Power: Roman Art 500 BC–AD 200*, New York, 1970.

Boatwright, M.T., *Hadrian and the City of Rome*, Princeton, 1987.

Favro, Diane, *The Urban Image of Augustan Rome*, New York, 1996.

Zanker, P., *The Power of Images in the Age of Augustus*, Ann Arbor 1988.

Late Roman Empire

Bianchi Bandinelli, Ranuccio, *Rome, the Late Empire: Roman Art AD 200–400*, New York, 1971.

Elsner, Jas, *Art and the Roman Viewer: The Transformation of the Roman World from the Pagan World to Christianity*, Cambridge, 1995.

L'Orange, Hans Peter, *Art Forms and Civic Life in the Late Roman Empire*, Princeton, 1965.

Among the author's own works that anticipate or expand on ideas in this volume are:

'Abstraction and Imagination in Late Antiquity', *Art History*, 1980, pp. 1–24.

'The Roots of the Normative Tradition in Greek Art, in Greek Trade and Greek Games', in *Proceedings of the XIIth International Congress of Classical Archaeology*, Athens, 1985, pp. 197–202.

Bearers of Meaning: The Classical Orders in Antiquity, the Middle Ages and the Renaissance, Princeton, 1988.

'War, Mathematics and Art in Classical Greece', *Journal of the History of the Human Sciences*, Spring 1989, pp. 39–62.

'Quintilian and the Idea of Roman Art', in *Architecture and Architectural Sculpture in the Roman Empire*, ed. Martin Henig, Oxford, 1990, pp. 1–9.

'Idea and Product: Potter and Philosopher in Classical Athens', *Design History*, 1991, pp. 65–73.

'Architecture, Metaphor and the Mind', *Architectural History*, 1992, pp. 192–207.

'Tabernacle and Temple and the Cosmos of the Jews', *Architecture and Traditional Systems of Belief. Proceedings of the Traditional Cosmology Society*, London, 1992, pp. 133–49.

'I wonder . . . A Short History of Amazement', in *Sight and Insight: Essays in the History of Art and Culture Presented to E.H. Gombrich at 85*, London, 1994, pp. 11–33.

'From the Double Crown to the Double Pediment', in *Alexandria and Alexandrianism*, Malibu, 1996, pp. 127–39.

Illustrations

27 Boundary stone from Athens, marble, *c*.500 BC, Athens (photo author).

28 Hermes Propylaios, marble, Roman copy of a late fifth-century BC original by Alkamenes set up at the entrance to the Akropolis, Archaeological Museum, Istanbul (after Richter).

29 Pollis as warrior, tomb relief from Megara, marble, *c*.480 BC, J.P. Getty Museum, Los Angeles (photo museum).

30 Doryphorus, by Polykleitos, marble, Roman copy of a bronze original of *c*.440 BC, National Museum, Naples (photo DAI Rome).

31 Geometry of Doryphorus (after Rumpf).

32 Parthenon, Athens, 447–432 BC (photo DAI Rome).

33 Parthenon 'refinements' diagram (after Korres).

34 Remains of earlier temples set into the wall of the Acropolis, Athens, after 479 BC (photo author).

35 Horsemen, detail of frieze from the Parthenon, 447–432 BC, British Museum, London (photo museum).

36 Marshal and horsemen, detail of frieze from the Parthenon, British Museum, London (photo museum).

37 Women, detail of frieze from the Parthenon, British Museum, London (photo museum).

38 Detail of porch of the maidens (the 'Caryatid Porch'), and west façade, Erechtheum, Athens, 421–406 BC (photo Alison Frantz).

39 Dancing female musician and drunken revellers, detail of a vase by the Foundry Painter, Attic, early fifth century BC, Fitzwilliam Museum, Cambridge (photo museum).

40 Aphrodite reclining, detail of pediment from the Parthenon, 447–432 BC, British Museum, London (photo John Mitchell).

41 Nike (Victory) by Paionios of Mende, marble, *c*.420–410 BC, Olympia Museum (photo DAI Athens).

42 Nike (Victory) figure, marble, from balustrade of Temple of Athena Nike, Athens, *c*.410 BC, Akropolis Museum, Athens (photo Alison Frantz).

43 Types of vase.

44 Detail of an *oenochoe*, Attic, *c*.725 BC, National Museum, Athens (after von Bothmer).

45 Panathenaic amphora showing footrace, Attic, *c*.530 BC, The Metropolitan Museum of Art, New York, Rogers Fund, 1914 (photo museum).

46 Charioteer from a chariot group dedicated at Delphi by Polyzalos of Gela after a victory at the Pythian Games, bronze, *c*.470 BC, Delphi Museum (photo Alinari).

47 Revellers, by Euthymedes, detail of amphora, Attic, last quarter of the sixth century BC, Antikensammlung, Munich (photo Hirmer).

48 Potters receiving wreaths from Athena and Victory figures, detail of hydria by the Leningrad Painter, Attic, *c*.480–470 BC, Torno Collection, Milan (after Blümner).

49 Amazons, possibly by Polykleitos, Pheidias and Kresilas, *c*.430s BC, Roman copies after originals at Ephesus (drawing Marion Cox).

50 Detail of funerary krater with scene of mourning, Attic, mid-eighth century BC, National Museum, Athens (photo Hirmer).

51 Funerary amphora with flying gorgons, Attic, late seventh century BC, National Museum, Athens (photo Alison Frantz).

52 Fight between dog and cat, with onlookers, side of statue base from Athens, early fifth century BC, National Museum, Athens (photo Alison Frantz).

53 Workshop scenes from the red-figure 'Foundry Cup' by the Foundry Painter, Attic, first quarter of the fifth century BC, Antikensammlung, Staatliche Museen zu Berlin – Preussischer Kulturbesitz (photo museum).

54 Olympia, sanctuary plan with row of treasuries top right (photo Yale University Press, London).

55 Cleobis and Biton, marble, *c*.600–575 BC, Delphi Museum (photo Ralph Lieberman).

56 Male figure from Attica, marble, *c*.600–575 BC, The Metropolitan Museum of Art, New York (photo DAI Rome).

57 Series of male statues, late seventh to early fifth centuries BC (copyright C.H. Smith).

58 'Kritian' boy from the Acropolis, Athens, marble, *c*.480 BC, Akropolis Museum, Athens (photo Marburg).

59 'Warrior A' from the sea off Riace, bronze, *c*.460–440 BC, Archaeological Museum, Reggio Calabria (photo Hirmer).

60 Eros stringing his bow, Roman marble copy of a bronze by Lysippos, *c*.330 BC, Capitoline Museum, Rome (photo Alinari).

61 Agias, from the Daochos monument, Delphi, marble, 338–334 BC, probably a contemporary copy of a bronze original by Lysippos, Delphi Museum (photo Marburg).

62 Statue dedicated to Artemis by Nikandre, from Delos, marble, *c*.650–625 BC, National Museum, Athens (photo Alison Frantz).

63 Statue dedicted to Hera by Cheramyes, marble, *c*.575–550 BC, Samos Museum (photo DAI Athens).

64 Girl, from the Acropolis, Athens, probably associated with base giving the name of Antenor as sculptor and Nearchos, a potter, as patron, marble, 525–500 BC, Acropolis Museum, Athens (photo Alinari).

65 Ajax and Achilles playing a game, by Exekias, scene on belly amphora, Attic, *c*.530 BC, Vatican Museums (photo Hirmer).

66 Ajax and Achilles playing a game, belly amphora with scenes in black and red figure by the Andokides Painter, Attic, *c*.520 BC, Boston Museum of Fine Arts (photo museum).

67 Group of giants from the frieze of the Treasury of Siphnos, Delphi, marble, before 525 BC, Delphi Museum (photo Ralph Lieberman).

68 Hercules and the Keryneian hind, metope from the Treasury of Athens, Delphi, marble, late sixth or early fifth century BC, Delphi Museum (photo Alison Frantz).

69 Hercules and the Cretan bull, metope from the Temple of Zeus, Olympia, marble, second quarter of the fifth century BC, Olympia Museum (photo Alison Frantz).

70 Lapith and Centaur fighting, metope from the Parthenon, Athens, marble, 447–432 BC, British Museum, London (photo museum).

71 Contest between Athena and Poseidon, west pediment of the Parthenon, drawing by Jacques Carrey, British Museum, London (photo museum).

72 Temple of Hera, Olympia, after 600 BC (photo Yale University Press, London).

73 Temple of Zeus, Olympia, second quarter of the fifth century BC (after Curtius).

74 Parthenon, Athens, 447–432 BC, detail of corner (photo Alison Frantz).

75 Temple of Hera, Samos, originally *c.*560 BC, as rebuilt *c.*525 BC and later, groundplan (photo Yale University Press, London).

76 Treasuries of Cnidos, Massilia and Siphnos, Delphi, all mid-sixth century BC (after Dinsmoor).

77 Scene of farewell, white ground lekythos, Attic, late fifth century BC, J.P. Getty Museum, Los Angles (photo museum).

78 Grave stele of Thraseas and Euandria, marble, Attic, early fourth century BC, Antikensammlung, Staatliche Museen zu Berlin–Preussischer Kulturbesitz (photo museum).

79 Grave stele of Ampharete, marble, Attic, *c.*410 BC, Kerameikos Museum, Athens (photo DAI Athens).

80 Ball players, side of statue base from Athens, marble, early fifth century BC, National Museum, Athens (photo Hirmer).

81 Workshop scene showing models or *paradeigmata* at left, 'Foundry Cup', Attic, first quarter of the fifth century BC, Antikensammlung, Staatliche Museen zu Berlin–Preussischer Kulturbesitz (photo museum).

82 Gorgoneion for roof-tile, terracotta, Attic, *c.*440 BC, ancient mould and modern cast, British Museum, London (after Higgins).

83 Head of Alexander as Zeus Ammon with Indian inscription, tourmaline, probably carved in the East, late fourth century BC, Ashmolean Museum, Oxford (cast) (photo museum).

84 Details of a wreath, gold, glass inlay and glass beads, late fourth entury BC, J.P. Getty Museum, Los Angeles (photo museum).

85 Alexander's conquests in a global context, the hatched area representing the area he inherited from his father (after Bamm).

86 Alexander on horseback, bronze, first century BC, after an original of around 330 BC, probably by Lysippos, Archaeological Museum, Naples (photo Alinari).

87 Hercules Epitrapezius, Roman marble copy of an original by Lysippos of *c.*330 BC, British Museum, London (photo museum).

88 Alexandria, plan.

89 Tomb from Mustafa Pasha Nekropolis, Alexandria, third or second century BC (photo DAI Cairo).

90 Tomb from Anfoushy Nekropolis, Al-exandria, interior, second century BC (drawing, after Adriani).

91 Battle between Alexander and the Persians, detail of side of the Alexander Sarcophagus, marble, *c.*320 BC, from Sidon, probably the tomb of King Abdalonymus, Archaeological Museum, Istanbul (photo Hirmer).

92 Lion hunt, detail of side of the Alexander Sarcophagus (see fig. 91) (photo Hirmer).

93 Aphrodite, Roman marble adaptation of the Aphrodite of Cnidos by Praxiteles of *c.*330 BC, Rome, Vatican Museums, detail of front view of marble and rear view of plaster cast (photos DAI Rome).

94 Warriors dancing, marble, first-century BC copy after late fourth-century BC Attic original, Vatican Museums, Rome (photo Anderson).

95 Joseph Beuys in a boxing match with an art student at Documenta V, Kassel (after Veit Loehrs).

96 Battle of Alexander and Darius, mosaic from the House of the Faun, Pompei, *c.*100 BC, after an original possibly by Philoxenos of Eretria *c.*300 BC, National Museum, Naples (photo DAI Rome).

97 Plan of the original setting of the Nike of Samothrace (fig. 98), showing the diagonal position of the prow in the rock-filled fountain basin (Don Johnson).

98 Nike alighting on the prow of a ship, marble, from Samothrace, probably by Pythokritos of Rhodes, perhaps commemorating the victory of the Rhodians over Antiochos III in 190 BC, Musée du Louvre, Paris (photo Marburg).

99 Jockey, bronze, *c.*100 BC, National Museum, Athens (photo Hirmer).

100 Boxer, signed 'Apollonios son of Nestor of Athens', bronze, *c.*100 BC, National Museum, Rome (photo DAI Rome).

101 Demosthenes, Roman marble copy after bronze original by Polyeuktos of 280 BC, Vatican Museums, Rome (photo DAI Rome).

102 Sacrificing girl, marble, *c.*200 BC, National Museum, Rome (photo Anderson).

103 Unswept floor, mosaic, Roman copy after Pergamene original by Sosos of second century BC, Vatican Museums, Rome (photo Anderson).

104 Doves drinking, mosaic, Roman copy after a Pergamene original by Sosos of the second century BC, National Museum, Naples (photo Anderson).

105 Fish, mosaic, Roman copy after original (probably Pergamene) of the second century BC, National Museum, Naples (photo Anderson).

106 Boy strangling a goose, Roman copy after an original of the third or second century BC, Capitoline Museum, Rome (photo Anderson).

107 Gaul committing suicide having killed his wife, Roman marble copy after Pergamene original of *c.*200 BC, National Museum, Rome (photo Anderson).

108 Zeus and Athena in conflict with giants, detail of the large frieze of the, Zeus Altar from Pergamum, Antikensammlung, Staatliche Museen zu Berlin–Preussischer Kulturbesitz (photo museum).

109 Face of a biting giant, detail of the large frieze of the Zeus Altar from Pergamum, Antikensammlung, Staatliche Museen zu Berlin–Preussischer Kulturbesitz (photo museum).

110 Marsyas, Roman marble copy after Pergamene original of *c.*200 BC, Uffizi, Florence (photo Alinari).

111 Scythian slave, Roman marble copy after Pergamene original of *c.*200 BC, Florence, Uffizi (photo Anderson).

112a Elderly Centaur tortured by Eros, Roman marble copy after Pergamene original of *c.*200 BC, Musée du Louvre, Paris (photo Alinari).

112b Elderly Centaur tortured by Eros (see fig. 112a), detail of face, Musée du Louvre, Paris (photo DAI Rome).

113 Barberini Faun, marble, probably early second-century BC Pergamene original, Glyptothek, Munich (photo Hirmer).

114a Laocoön and his sons, marble, first-century AD copy of early second-century BC Pergamene original, Vatican Museums, Rome (photo Hirmer).

114b Laocoön (see fig. 114a), detail of face (photo DAI Rome).

Index